Walking Rome's Waters

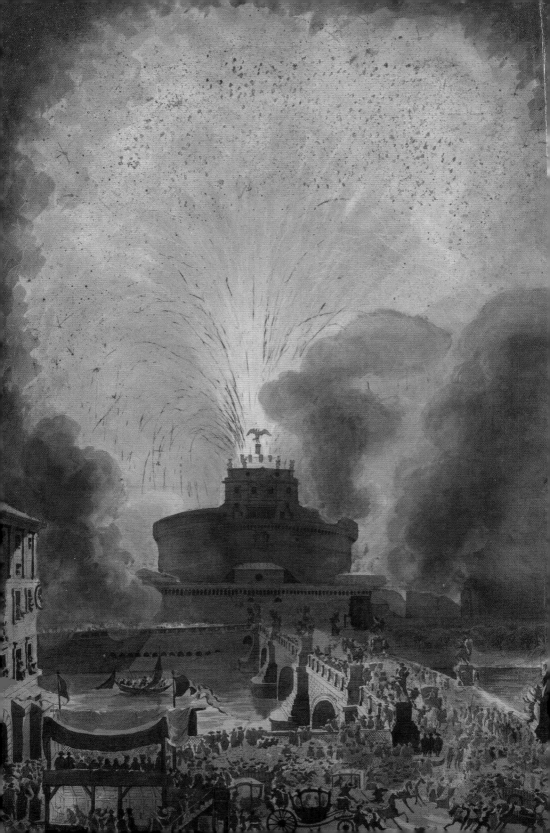

Walking Rome's Waters

Katherine Wentworth Rinne

Yale University Press, New Haven and London

Published with assistance from the Charles S. Brooks Publication Fund.

yalebooks.com/art

Designed by Jeff Wincapaw
Cover designed by Jeff Wincapaw
Set in PS Fournier Std type by Maggie Lee and Jeff Wincapaw
Printed in China by 1010 Printing International Limited

Library of Congress Control Number: 2024939962
ISBN 978-0-300-27637-4

A catalogue record for this book is available from the British Library.

This paper meets the requirements of ANSI/NISO Z39.48–1992 (Permanence of Paper).

10 9 8 7 6 5 4 3 2 1

Cover illustrations: *(front) Lo Specchio* (The Mirror), Baths of Caracalla. Hannes Peer in collaboration with Paolo Bornello, 2024. The fountain evokes ancient bathing pools. Photo by Katherine Wentworth Rinne, 2024; *(back)* Villa Pamphilij. Photo by Carrie Beneš, 2023.
Frontispiece: *The Girandola at the Castel Sant'Angelo.* Designed and hand-colored by Louis Jean Desprez; etched by Francesco Piranesi, no date. Metropolitan Museum of Art.

Their names are writ in water:
Leonardo Lombardi (1928–2021)
Norman Marcus Roberson (1941–2008)
And always, for David Rinne, who gave me Rome

Contents

Acknowledgments

I began walking Rome's waters in 1992, which means that my acknowledgments list will be prodigious, although I'll mention only a small number of persons whose support has been crucial. So please bear with me, as every one of them deserves more thanks than I can ever repay.

Dr. Girolamo Bardi, former director of public relations at ACEA, Rome's water and electricity board, deserves special thanks. Working alone in Rome without funding or sponsorship, I contacted Dr. Bardi. He was a person of astounding magnanimity, and like everyone I met at ACEA, was passionate and proud to carry on the traditions of Marcus Agrippa, builder of the Aqua Virgo (19 BC) and founder of Rome's first Water Board. At our initial meeting in 1992, he gave me articles and books, simply saying, "Return them before you leave." He provided drivers with golden keys who took me to aqueduct springs, the inner workings of the Fontana di Trevi, Fontana dell'Acqua Paola, and Fontana del Mosè (Moses Fountain), and distribution centers around the city.

Mirka Beneš, James Wescoat, and Nichole Wiedemann accompanied me on my first "water walk" in 1996. Don Bartlett was a trooper when we visited Parco degli Acquedotti (Aqueduct Park) in 2006. I walked Rome's waters with the three goddesses, Dolce, Luce, and Pace (Ann Barrett, Victoria Reed, and Donna Vaccarino), for two weeks in July 2009. Kenny and Paul Crabwell also joined me that year. I have continued lively discussions with participants from the 2011 NEH Rome Seminar led by Vernon Minor, especially Kate Bentz, Heather Graham, Jonathan Hunt, and Ayana Smith. Rebecca Sunter was my invaluable teaching and editorial assistant in 2014.

My friends and colleagues in Rome, Jeffrey Blanchard, Beatrice Bruscoli, Alessandro Camiz, Bruno Caracciolo, Allan Ceen, Jeremy Chalfant, Lucy Clink, Laura Genovese, Giovanni Isidori, Kristin Jones, Terry Rossi Kirk, Anthony Majanlahti, Patricia Osmond, Heleni Porfyriou, Tom Rankin, Pia Schneider, Emma Tagliacollo, and Lila Yawn, were unstinting with their intellectual support, with some, like the indefatigable Bruno Leoni, even sleuthing in archives and taking photographs for me up to the last minute.

Like ever-flowing Roman springs, friends across the globe, all of them lovers of Rome, have been lavish with their insights, time, hospitality, financial assistance, and, frankly, patience. I sincerely apologize if I have forgotten to mention anyone. Hadley Arnold, Ruth Barolsky, Arthur Beale, Karen Bermann, Gary Brown, Nick Camerlenghi, Marco Cenzatti, Meredith Clausen, Elizabeth Cohen, Thomas Cohen, Joe Connors, Francisco del Corral, Margaret Crawford, Ron Delph,

Harry Evans, Bill Fain, Dan Garness, Doris Guerrero, Korje Guttormsen, James Harper, Mark Henry, Sharon Horvath, Patricia Jessee, Elaine Sewell Jones, Lynne Lancaster, Evie Lincoln, Morna Livingston, Jessica Maier, Katja Marasovic, Jane McKinne, Sarah McPhee, Natsumi Nonaka, Sandra Phillips, Paulette Singley, Christine Theodoropoulos, Stephen Tobriner, Bill Wallace, the aptly named Mike Waters, Cecily Young, and, especially, Paul Barolsky, Mirka Beneš, Pamela Long, and Rabun Taylor continue to shower me with their sparkling intelligence, priceless friendship, and boundless liberality.

In addition to countless generosities, Jeff Balmer, Elisabetta Bianchi, Camilla Di Nicola, Beth Fagan, Sam Gruber, James Hill, Sebastiano Luciano, Liz Marlowe, Roberto Meneghini, Rabun Taylor, and Thaïsa Way kindly allowed me to publish their photographs and original maps. I am deeply grateful to my friends Paul Barolsky, Sandra Forrest, and Reuben Rainey who read early drafts, either in part or whole. Their comments were invaluable and helped me to keep my head above water.

Vincent Buonanno gave me access to his astounding collection of sixteenth- to eighteenth-century prints and books that celebrate Rome's urban history. I could not have completed this project without his unfailing magnanimity and that of the Brown University Digital Library staff, who provided me with digital files. The cost of obtaining image permissions would have been prohibitive without the munificence of private collectors like him, open-handed museums, and libraries. The Metropolitan Museum of Art, the Getty Research Center, the Library of Congress, and, most especially, the Rijksmuseum of Amsterdam have made high-quality digital copies freely accessible for publication. Wikimedia has been especially important as a forum for talented photographers to present their work and make it available for free use. Each photographer's name is included among the credits.

I have been fortunate to receive many fellowships and grants to support my research over the last thirty years. A Graham Foundation Grant allowed me to spend 1994–95 as a visiting scholar at MIT, where Dean Bill Mitchell and Professor Attilio Petruccioli guided my earliest research. A 1996–97 senior Fulbright Fellowship gave me free rein to work independently in Rome. I returned in 2001–2 with a John Simon Guggenheim Memorial Foundation Fellowship, and again from 2004 to 2006 with funding from the National Science Foundation.

Several residential fellowships created luxurious environments where I was surrounded by intellectually stimulating colleagues and staff. As a senior fellow at the Dibner Institute for the History of Science and Technology at MIT in 1998–99, I entered a wholly new universe of scholarship that allowed me to approach my work from fresh directions. David McGee and Nicolás Wey Gómez were especially supportive. My 2002–3 year as a senior Kress Foundation fellow at the Center for Advanced Studies in the Visual Arts at the National Gallery

of Art was a year spent in heaven. I was surrounded and supported by a host of seraphim and cherubim, including Jean Campbell, Caroline Elam, Peter Lukehart, Gwen Ajello Mahler, and Therese O'Malley, among many others. During summer 2012 and fall 2018, I held residential fellowships in the Department of Garden and Landscape Studies at Dumbarton Oaks. There, too, delicious discussions (and savory lunches), especially with John Beardsley, Michael Lee, and Anatole Tchikine, supplied much-needed sustenance, and the gardens created a joyful working environment.

Since 1997, when I became an associate fellow at the Institute for Advanced Technology in the Humanities at the University of Virginia, Shayne Brandon, Chris Jessee, Worthy Martin, Doug Ross, Giovanni Svevo, John Unsworth, and others have provided technical support, with funding from the National Endowment for the Humanities in 1997–98 and 2006–7, and a Kress Foundation Digital Humanities Grant in 2023. Since 2020 I have been a visiting scholar in the Department of Landscape Architecture at the University of Virginia, where I am affiliated with the Center for Cultural Landscapes. Professors Bradley Cantrell and Beth Meyer have been especially welcoming.

I have had the honor to share my research at conferences, symposia, and professional and cultural organizations, and to teach in architecture and landscape architecture programs at several institutions. I am especially grateful for these opportunities. Students keep you on your toes. This was especially true of the the the Iowa State University landscape architecture students in the Summer 2001 Rome Water Studio. Among them, Carrie Becker, Luke McHugh, Michael Odum, Nathan Siems, Diane Witt, and Nicole Wroblewski, were perfect companions for discovering Rome together, and I learned more from them than they learned from me.

Not only have I walked every street within Rome's walls many times, it seems (although not in fact) that I've worked at every library and archive there, too. No scholar of Rome can survive long without plunging into the very deep waters of the Archivio di Stato di Roma, the Archivio Storico Capitolino, the Archivio Vaticano, Biblioteca Vaticana, Biblioteca Casanatense, Bibliotheca Hertziana, and the Biblioteca Nazionale Centrale di Roma. Librarians and archivists have been welcoming throughout, especially at the Archivio di Stato, where Paolo Buonora often saved me from drowning. The librarians and archivists of the American Academy in Rome are always generous with their time and expertise, in particular, Denise Gavio, Sebastian Hierl, and Christina Huemer.

Walking Rome's Waters is a synthesis of thirty years of research and many fields of scholarship. Corralling this amount of material has sometimes been daunting. Readers may fret that some topics are glossed over quickly, but to give them all their due, each chapter would be its own book. I have been diligent to bring everything up to date, but some infelicities have no doubt crept in, and inevitably I will have failed to include some references, for which I apologize. Finally, I have

published two books and many articles that draw from my research, so some phrases and sentences from those publications reappear here in modified form.

I thank Katherine Boller and my anonymous readers for opening the publication taps at Yale University Press. I am also indebted to the Charles S. Brooks Publication Fund for its support with the production of this book. Rachel Faulise, Alison Hagge, Laura Hensley, David Luljak, Elizabeth Searcy, Owen Silverman, Jeff Wincapaw, and Kati Woock of the editorial and production staff have worked tirelessly to help me realize this book.

Introduction

Whether you know it or not, even if you are only out for a stroll, walking is a mindful act—one that propels you along whatever mundane or glorious path unfurls before you. Water is your connection to the entire blue world: focusing on water, you become conscious of nature and allow that awareness to take on the life force of a gushing spring. And when you are in Rome, or think about Rome, you are immersed in the complicated world of humankind and its numberless histories.

Water created Rome, a city that over time became the capital of an empire; the seat of the Catholic Church; a center of culture, arts, and learning; the capital of Italy and a failed Fascist government; and an engine of modern Italy's tourism machine. Water is Rome's backstory; its eddies and whorls twist and flow throughout the city's history. By walking slowly through Rome, you'll encounter a spectrum of water's sensory experiences and perhaps begin to interpret the city in new ways.

This isn't a guidebook that lists museum opening hours and descriptions of artworks (unless they are specific to water); there are no hotel recommendations or restaurant tips. Those books abound. This book is different. It offers a way to engage with Rome's topography and history through essays that propose paths through Rome and the Campagna (its surrounding countryside) on easy, mostly short (but also some longer) walks, following water as it flows through gravity. Longer walks can be broken down into shorter excursions that are indicated by a symbol (); this symbol is also used to set off narrative that is tangential to the chapter's pilgrimage. Distances along the paths shown in the maps are approximate and, as in Rome, they are given in kilometers; 1 kilometer equals 0.62 miles. A few essays simply invite you to relax as you follow along from your armchair. One of these introduces Rome's fabled ancient and modern aqueducts. Another essay metaphorically pulls you underground (where hidden springs and streams still flow), to illuminate how Rome's complex topography has been transformed since antiquity in efforts to restrain or encourage water's flow. In another essay you circle Rome, flying over its villa gardens and public parks, where fountains and water-loving plants flourish.

The word "pilgrimage" appears throughout because each essay is conceived as a pilgrimage, a meaningful walk; but this is not a book about religion. The historian Hilaire Belloc made a pilgrimage from France to Rome in 1901. In *The Path to Rome,* he writes that for him (as with most pilgrimages), the walk had to be a little difficult to demonstrate how dearly he held communion with a

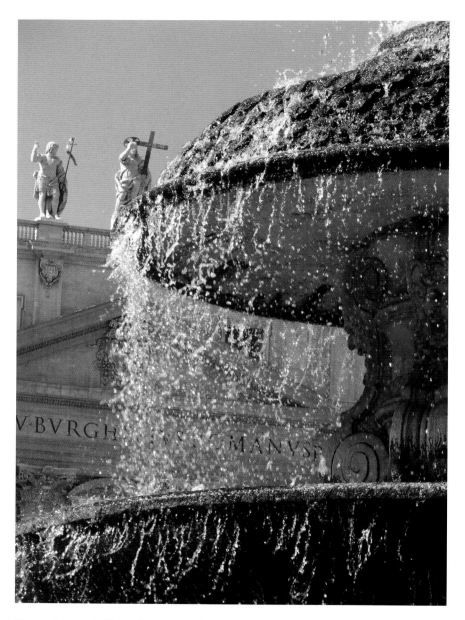

Fig. o.1. Fountain in Piazza di San Pietro (detail). Carlo Maderno, 1614.

sacred person, place, or event. Visiting Mecca in Saudi Arabia, Mount Hua Shan in China, Santiago de Compostela in Spain, or other holy shrines can involve an arduous pilgrimage of weeks or months of difficult but joyous walking. The pilgrimages proposed here don't involve sacrifice, nor do they ask for allegiance to any god, but they do ask for an awareness of the sacrality of water. The pilgrimages are intended to help you discover Rome as you attune your senses: for water's sounds; fountain sightings; water's smells inside a dark garden or under a blazing sun; cooling breezes generated by a rushing cascade; electrifying jolts from plunging hot hands into cold water; and the satisfying sharp, clean taste of water from one of Rome's hundreds of public drinking fountains. Ideally, water awareness will percolate into your being like rain into the earth.

Rome is defined by water as it flows through spatial, social, artistic, and historical spheres of the city. Water is everywhere. One of the wonders of Rome—a city of a million wonders—is water's flagrant abundance (fig. 0.1). Fountains are everywhere. Many of them are landmarks you can use to orient yourself or to tether dreams. They make handsome reference points and a perfect place to begin, even though there is more to Rome's water history than its fountains.

Sextus Julius Frontinus, water commissioner to emperors Nerva and Trajan, wrote an administrative report between AD 97 and 98. He mentions 591 public fountains meant for drawing water. Two inventories of the city's monuments during Constantine's reign (AD 306–337) counted 1,352 public fountains, eleven imperial baths, 856 smaller public baths, and 144 public latrines scattered among all the hundreds of temples, administrative buildings, libraries, palaces, and housing blocks. By the tenth century there were only smaller public baths and a handful of fountains; the ever-flowing aqueducts ceased flowing many years earlier. Some aqueducts were restored beginning in the late sixteenth century, and now Rome has more than two thousand fountains; most are for drinking, but some—such as the Fontana di Trevi (Trevi Fountain) and Fontana dei Quattro Fiumi (Four Rivers Fountain)—are among the most fabled in the world.

Roman public fountains are busy and full of life, with great splashes and jets and plenty of rippling waves. Like the Romans themselves, forever out on the streets shopping, eating, and taking a *passeggiata,* the fountains are vibrant, gesticulating, noisy, and thoroughly enjoyable. Rarely does a calm reflective surface mirror some sober palace façade. Those fountains are generally in private courtyards and monasteries, and even then, they are not common in Rome. The few exceptions, such as the noble Fontana del Senato (Senate Fountain) (now denied a jet of water that would have shot from the center of its basin), often reflect contemporary water conservation efforts rather than urban narcissism.

The fountains are also very sexy. They speak not only of the generosity of Romans, but also argue for frankness and voluptuousness. In 1955, Eleanor Clark,

a noted travel writer, remarked in *Rome and a Villa* that Rome's fountains are not *objets d'art* "held off from life and treated with respect as they would be anywhere else"; rather, she wrote, "there is a closeness, an imminence of touch around them that nothing in our life has except dreams and sex." She understood their visceral pull on our attention and emotions, and that, like dreams and sex, they are deeply primordial and can be flamboyant, invigorating, and life-affirming—that they are immediate and physical and make us glad to be alive. Certainly no one seems happier to be alive than the Romans.

The fountains, in a real sense, represent the tip of the proverbial iceberg—only the most visible and accessible elements of a secret hydrological world that spans and shapes Rome's entire history. The subterranean metal, stone, and terra-cotta conduits—linking them together for nearly twenty-eight hundred years—create a warp of infrastructure onto which the patterns of daily life continue to be woven. The fountains are the most eloquent of civic artifacts, revealing and celebrating this underlying order. When originally built, each fountain linked closely to the daily life of a neighborhood. After showering a piazza with a dazzling spray or with a drinking fountain, the runoff water then flowed to horse troughs, laundries, or industry before finally sluicing the drains.

Each fountain is part of a hydrological system that includes springs, streams, marshes, the Tiber River, floods, and rainwater, as well as sewers, aqueducts, wells, conduits, and cisterns, all linked across Rome's topography through the law of gravity (fig. 0.2). Aqueducts, like rivers, have a distinct watershed—only in reverse. Rivers gather water from individual springs, streams, and brooks into a single channel, while the channel of each aqueduct branches out to serve individual fountains, which mimic natural springs.

What this book proposes, in contrast to the groaning shelves of guidebooks, is that no fountain can be understood in isolation, nor can it be appreciated fully without some knowledge of its water source—its aqueduct and the springs that feed it—and to its specific location within the city. Each fountain is part of a family, and like most family members, they share a certain genetic code that accounts for common, sometime quirky characteristics—even if they were moved to new neighborhoods, like adopted children.

Until the late nineteenth century, a vast yet simple aqueduct system exploited gravity to distribute water to Roman fountains. Today, in other cities, many contemporary, mechanically pumped fountains rely on computer programs to shoot water into apparently gravity-defying acrobatics, enormous plumes, or nearly horizontal fusillades of pellets or spray; they can be replicated anywhere, from Paris to Las Vegas deserts or the Florida coast. But gravity systems, like Rome's, exploit and enhance water's natural abilities as it flows through its watershed. Allowing for seasonal variation in volume (more autumn and winter rain and snow mean more water the following spring and summer), a fountain's design reflects the

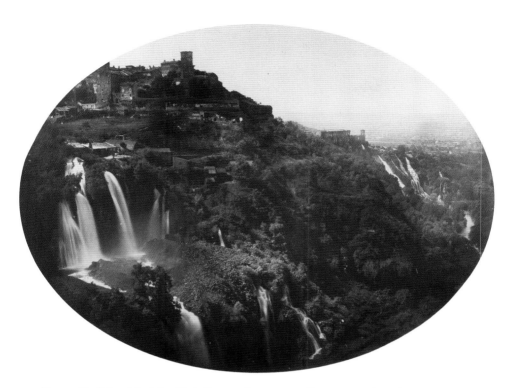

Fig. 0.2. *The Valley of the Anio, with the Upper and Lower Cascatelle, Mecenas's Villa, and Distant Campagna.* Robert Macpherson, by 1858. Metropolitan Museum of Art.

distinct, inherent possibilities of water at a specific location. Even with technicians sometimes regulating the flow, Rome's fountain acrobatics flaunt their relationship to gravity. Whether the water shoots in a lofty jet, falls in a rushing cascade, bubbles from a low nozzle, or slips slowly over a stone lip, it does so because the symbiosis between gravity and topography has been exploited by the design. Each fountain's topography links it simultaneously backward and forward to the other fountains in its system, to its aqueduct, to its source outside the city, and to the hydrological cycle itself.

To follow water is to reveal how it percolates through every aspect of Rome's history, how Rome is literally drenched with meaning through water. Perhaps there will be things you've never noticed but that suddenly enhance your understanding of a particular place—things that have eluded your cone of vision, such as flood inscriptions and holy water fonts, or things that you might take for granted, such as drinking fountains. You might begin to connect the dots, to understand how the fountains relate to each other, and to their aqueduct, and to their ancient springs outside the city. You might begin to imagine, hear, and smell the water that pulses and flows beneath Rome's streets.

When in Rome, I take friends and colleagues on "water walks" to trace the flow of aqueduct water as it moves through the city in underground conduits from fountain to fountain. Like the water, we follow gravity. One advantage of an itinerary like this is the opportunity to gain an appreciation of the nuanced complexity of Roman topography and history. Foremost is the opportunity to look closely at some of the most important and famous features of Rome—its fountains, ruins of ancient baths, its aqueducts, and the Tiber River. Another advantage, appreciated by many, is that we typically begin our day at the top of one of the hills and then slowly descend toward the Tiber just in time for lunch or dinner.

Perhaps the most distinctive advantage of this type of itinerary is that we begin to construct a different kind of mental map of Rome. Instead of looking at isolated objects, we look at the expressions of an infrastructure that tethers them, and indeed the entire city of Rome, together. We don't jump from the Colosseum to an ancient temple, then a baroque church, and then back to another temple simply because they still survive or happen to be in the same neighborhood. Rather, this kind of itinerary allows us to cut vertical topographical sections through the city that reveal the hidden framework of aqueducts, fountains, villa gardens, vineyards, medieval apothecary gardens, cloister wells and fountains, holy water fonts, bathing facilities, laundries, latrines, drains, and sewers that together allow urban life to flourish.

I wish I could tell you that Rome is in perfect working order, but that will never be the case. Some of the city's most beautiful fountains desperately need cleaning or repair or are entirely without water. Hundreds of diseased pines and plane trees have been cut down leaving large urban expanses without shade, while only saplings have replaced them. Meanwhile, the river at and below the Tiber Island is a wild forest with trees sprouting all along the banks. Because Rome's parks are well used, they can be a bit run down and Rome's streets are never without potholes, crowded buses, and traffic, especially as work progresses on the still-incomplete Metropolitana subway system. This is a Jubilee Year, 2025, which means the city is even more crowded than usual. But, as in past jubilee years, Rome should sparkle as best it can, and, as always, be welcoming to strangers. Rest assured that without exception free, cold, and delicious water will flow from the city's public drinking fountains.

So, with all that in mind, let's cut the first topographical section . . .

Notes concerning the bibliography

Given the scope of this book—nearly three thousand years of Rome's water history—the bibliography should be at least three times longer. But *Walking Rome's Waters* is intended for a general audience, not only for scholars with PhDs. So, rather than include footnotes to obscure books, each chapter has a short bibliography related to the specific topics discussed there. Some books will shower you with facts, which in turn will lead to other publications and archival documents to help you plunge more deeply into a topic. All of these books are listed in full in the complete bibliography at the end, which also includes subject bibliographies that bring together the most important resources for a specific topic, for example, the Tiber River.

Most readers won't be able to head to the Vatican Library to check a reference or find rare books at a local library. But, if you're inclined to learn more, I've included as many general books (with such archival gems published within their pages) as possible and directed you to the best of those in each category. As often as possible, these resources are in English, but some are in Italian. For example, Robert Thomas's "Geology of Rome, Italy" (1989) and Peter Aicher's *Guide to the Aqueducts of Ancient Rome* (1995) are excellent introductions for their subjects, and Thomas Ashby's *The Aqueducts of Ancient Rome* (1935) is indispensable. For fountains, Cesare D'Onofrio's *Le Fontane di Roma* (1986) tops the list, and for villas and gardens, David Coffin's *The Villa in the Life of Renaissance Rome* and *Gardens and Gardening in Papal Rome* (1979 and 1991) should be your first resources. Sometimes the best source really is ninety years old, but more recent publications are plentiful.

1

The Pilgrimage of Water in Rome

🌿 Aqua Virgo Pilgrimage: Porta del Popolo to Trevi Fountain, ~1.3 kilometers (including the spur through the Pincian Gardens, ~1.6 kilometers)

Rome is among the world's most hallowed pilgrimage destinations. As Mecca draws pious Muslims and Jerusalem beckons reverent Jews, the Eternal City's numinous qualities draw millions of devout Christians to undertake a pilgrimage there, just as they have for nearly two millennia. Visiting the most venerable sites, culminating at St. Peter's, the mother church of Catholicism, the processional journey often reinvigorates faith among believers, providing a reflective pause in yearly routines.

Millions more arrive in Rome with secular agendas and take touristic, educational, gastronomic, and retail pilgrimages. Indeed, when in Rome, I dedicate a full and fervent day to my own "Sacra Giornata di Acquistare le Scarpe" (Sacred Day of Shoe Shopping), when I visit each of my favorite stores like so many shrines along a sacred way. Although shoes are crucial to any foot-propelled pilgrimage, my interest lies in rededicating Rome's vital role as a city of reflection by divining water's hidden course beneath our feet (in shoes, old or new) as it flows out to public fountains in an otherwise parched city. Just as religious pilgrims stream through the Eternal City, sustaining and reinvigorating it with every step, so too water nourishes and rejuvenates Rome with every drop.

Called the source of a garden's soul, water is perhaps the source of a city's soul as well. If so, nowhere is this clearer than in Rome. Its ancient foundation myth recalls that the twin babies Romulus and Remus, set adrift in raging floodwaters, were washed ashore on the rustic banks of the Tiber River that today, bound within embankments, carves a serpentine path through Rome's urban core. It is this river, the Tiber, that the poet Virgil affirms is closest to the gods, although he might not say that today; it is horribly polluted.

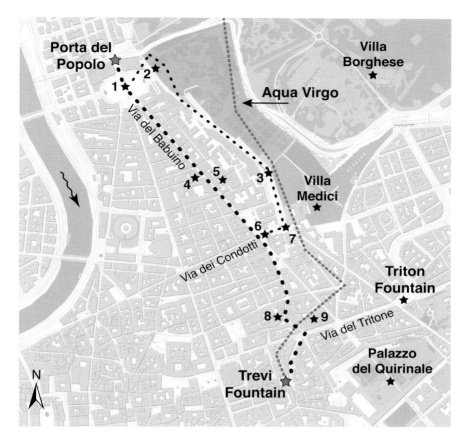

Fig. 1.1. AQUA VIRGO PILGRIMAGE: 1) Fontana dei Quattro Leoni (Four Lions Fountain), 2) Giardini del Pincio (Pincian Gardens) overlook, 3) Fontana della Palla di Canone (Cannonball Fountain, or Fountain of the Brimming Bowl), 4) Il Babuino, 5) Fontana degli Artisti, 6) Fontana della Barcaccia, 7) Scalinata di Spagna (Spanish Steps), 8) Fontana del Bufalo, 9) Aqua Virgo ruins.

The orator Cicero declared Rome to abound in springs: some ancient ones still flow but are now imprisoned in conduits and drains, no longer deemed useful, fouled by urban development. But the karst and volcanic soils of the surrounding Campagna, countryside, still harbor hundreds of abundant springs holding a seemingly inexhaustible, although seasonally variable, water supply. Some of them still feed Rome's aqueducts, which in turn feed the fountains, just as in antiquity. The springs, aqueducts, and fountains provide a physical armature, a warp, onto which the weft of Rome's history and daily life has been continuously woven for nearly twenty-eight hundred years. Stepping into a water pilgrim's shoes opens a door into Rome's tapestry of time and place.

Anyone who has visited Rome will recall the extraordinary benediction of water splashing and spraying everywhere. Like no other city, Rome is

heartbreakingly generous—water gushes into fountains with reckless abandon and bubbles from hundreds of neighborhood taps. Little drinking fountains grab hold like barnacles on palace and church walls. No façade is too aloof that it might not, someday, sometime, support its own nymph or satyr spewing water into a sidewalk basin, an offering to all passersby.

Rhapsodized by poets, tourists, and artists, the fountains are essential to Rome's identity and are part of its citizens' everyday environment, profoundly important to their collective unconscious—what Eleanor Clark calls their "repository of memory." What persons from drought-plagued regions might see as an astounding extravagance, foolishness even, Romans see as a right of citizenship. Ever-flowing, the fountains symbolize the abundant goodwill of the Romans themselves: to give water freely, to family, neighbors, and strangers alike, affirms a genuine openness of spirit. At times this openhandedness with water will be tested; even Romans are human.

Stupefied by the beauty of Rome's fountains, most tourists gawk, then heave a wistful sigh, toss a coin, take a selfie, perhaps take a sip, and walk away. But water pilgrims actively and deliberately engage with each fountain, probing for answers to its purpose and meaning while marveling at its beauty. Architect Charles Moore's advice to me when I began my first water pilgrimage to Rome was "Follow where the water leads you." In essence, this means following water back to its source. It also means allowing gravity to pull you along with the water's flow, since gravity is still the organizing principle.

To surrender to water's inexorable forward journey is to track the flow of history; to sense the emerging shape of the ancient city morphing into medieval, Renaissance, and modern Rome; to understand the highs and lows of topography; to derive pure enjoyment; to enter Rome's repository of memory; and to embrace water's sacred spirit. Anyone, regardless of creed, can become a devout water pilgrim in Rome. Nondenominational, water is central to most religions, blessing the atheist and agnostic, too. Every religion consecrates water for its own purification rituals, yet none can contain it, name it, or claim it exclusively. Water is ecumenical, ours in which to take solace or pleasure, to drink, or to cleanse our soul, as we follow where it will lead.

How do we consciously follow water through the city? Where will it lead? Since the eighth century, Rome's pilgrims consulted guides, such as the *Einsiedeln Itinerary* or the early twelfth-century *Mirabilia Urbis Romae* (Marvels of the City of Rome), that pointed out ancient and Christian monuments to help navigate the city and identify the newly risen churches amid the crumbling ruins. The fountains give clues to trace water's flow, but the story lies mostly hidden beneath Rome's streets, in subterranean infrastructure. Urban dowsers, our bodies become divining rods.

Today, Rome has six aqueducts: the Felice, Paola, Peschiera-Capore, Pia Antica Marcia, Vergine, and Vergine Nuova. For me, the most compelling is the Acqua

Vergine, the Virgin's Aqueduct, which, according to legend, was discovered by a virgin in 19 BC. Its purity and brisk taste once made it Rome's favorite drinking water. Although no longer potable unless treated, its water fills many of the city's most famous ornamental fountains—the Trevi, the Barcaccia, and those in Piazza del Popolo, Piazza Colonna, Piazza Navona, and Piazza della Rotonda—all in the low-lying Campo Marzio, the alluvial plain on the left (east) bank of the Tiber.

Built by Marcus Agrippa as the Aqua Virgo to serve his public bath (some ruins still stand near the Pantheon), the low-pressure aqueduct still draws water from the same subterranean springs located at Salone, about sixteen kilometers outside the Mura Aureliane (Aurelian Walls). The Virgo flowed throughout the medieval period—Rome's only aqueduct to do so—although in a degraded and reduced state. Then, from 1560 to 1570, it was fully restored back to its source and many new fountains were built: the first of these was in Piazza del Popolo, completed just in time for the 1575 Holy Year when nearly three hundred thousand pilgrims came to Rome. Now called the Acqua Vergine, it terminates at the Trevi Fountain (1732–62). In *The Marble Faun,* Nathaniel Hawthorne sees that "some sculptor . . . had gone absolutely mad in marble," but as Clark explains, the Trevi is water's "royal chamber of the dream." In his competition entry, Nicola Salvi, the fountain's architect, portrays "a welter of water" and "foaming cascades" that "seem to be emerging from the hidden veins of the Earth."

Since the Middle Ages, Christian pilgrims have come to Rome along the ancient Via Flaminia and entered through the **Porta del Popolo,** the northernmost gate in the Aurelian Walls. They began by crossing the piazza and heading south toward Via Papalis, the primary road leading eastward to St. Peter's. They were thirsty after their long journey, but the piazza lacked drinking fountains (like most of Rome) until 1575.

Today, Piazza del Popolo is a good place to begin a pilgrimage of Vergine water. Straight ahead there is the **Fontana dei Quattro Leoni (Four Lions Fountain),** completed in 1829 at the center of the piazza (replacing the original fountain) (fig. 1.2). Within a few years of the 1575 Jubilee, a dedicated laundry fountain and a horse trough stood in the piazza near the original fountain. All have disappeared.

The lions are poised at the foot of an ancient Egyptian obelisk, brought to Rome by Augustus (r. 27 BC–AD 19) in 10 BC for the Circus Maximus; Pope Sixtus V (r. 1585–90) relocated it to this piazza in 1589. Although added later, the lions are apt symbols for the first fountain to dispense life-giving Vergine water, since, long into the Renaissance, many thought that the mother lion's gentle licking of her newborn cubs not only stimulated respiration by removing the amniotic sac, but also encouraged their hearts to beat. Here, rather than licking cubs, each lion ejects a continuous whistle of water from perpetually puckered

Fig. 1.2. Fontana dei Quattro Leoni (Four Lions Fountain) (detail), Piazza del Popolo. Giuseppe Valadier, 1829.

Below
Fig. 1.3. *Panoramic View of Rome from Monte Pinchio.* Photographer unknown, ca. 1909. Library of Congress. Notice Porta del Popolo (right) and St. Peter's dome on the horizon (left of center).

lips that, splashing into receptive basins, quickens our own heartbeat and helps give purpose to our pilgrimage.

The huge oval piazza is filled with fountains. First are two drinking basins to the right and left of Porta del Popolo. Not unlike the holy water fonts at the entry to every Catholic church or the ablution fountains outside each mosque, they introduce an idea of Rome as an urban-scale basilica, with water as its liturgy: entering the piazza, we become acolytes. Ornamental cascades erupt at the far ends of the grand oval, and, drowning out the traffic's noise, waterfalls rush down the Pincian Hill to the left. Completed in 1936, the mechanically pumped Acqua Vergine Nuova feeds the waterfalls.

At this point, only X-ray vision can help us follow the Vergine's flow: the

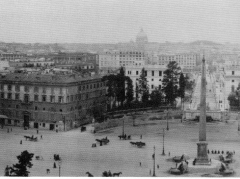

aqueduct is off to the east, hidden under the Pincian's slope. Behind the tiered roads and gardens, a stone and concrete aqueduct channel runs about three meters above the piazza level, gradually descending from north to south. Since we can't slip inside the Pincian Hill, we can walk up the hill to the **Giardini del Pincio (Pincian Gardens) overlook** to gain a different perspective. Here, in Rome's first public park—it was Napoléon's idea at the beginning of the nine-teenth century—the channel is nearly thirty meters beneath the hill's crest. Perched above the waterfall (seen from the piazza), there's a spectacular view of Rome: the Aurelian Walls, Porta del Popolo, scores of bell towers and cupolas, the Pantheon dome, the London plane trees that snake along the Tiber wall, and in the distance Monte Mario, the pine trees along the crest of the Janiculum Hill, and St. Peter's (fig. 1.3).

With the aqueduct channel and water far below, it isn't illogical to ask, "Where are the Vergine fountains?" since this hilltop location renders them ineligible for a gravity-flow system. In the late sixteenth century, the force of will (and money) overcame gravity's force to bring water to the Villa Medici (south of our vantage point), now home to L'Académie de France.

Formerly owned by Cardinal Ricci da Montepulciano, the villa gardens were relatively modest. But Ricci was ambitious and cunning. In 1567, he had con-trived to be appointed the head of the papal committee overseeing Rome's water-works, including the not-yet-fully-restored Acqua Vergine beneath his property. Once restored, he leveraged his position, granting himself the right to tap down into the aqueduct channel. Both tedious and labor-intensive, his irrigation sys-tem relied on mules carrying water-filled barrels up from the aqueduct to the garden along a newly built ramp into the hill. He needed a more elegant solution. In 1574, Ricci hired Camillo Agrippa, a renowned Milanese hydraulic engineer, architect, and mathematician, to build an impressive waterwheel inside the aque-duct, which relied on the constant water current to supply kinetic energy to a hydraulic pump. It raised the water to the level of the garden.

Fig. 1.4. *View of Rome taken from the Pincian*. Gustave Eugène Chauffourier, ca. 1875–1900. Rijksmuseum. This shows the Fountain of the Brimming Bowl at Villa Medici.

Cardinal Ferdinando de' Medici purchased the property in 1576 and immediately rehired Agrippa to improve the waterworks and to create the "Parnassus," the garden's most prominent feature. This artificial hill is meant to recall Mount Parnassus, home of the Delphic oracle and the Muses, and hence home of poetry and literature in Greek mythology. The new hydraulic device lurked inside the hill, raising the water to a bubbling fountain standing nearly twenty meters above the garden—that is, about fifty meters above the aqueduct. An astounding feat.

Lust of any kind can be obsessive. Water lust is no different, as Medici's efforts at the Parnassus prove. Unfortunately, Camillo Agrippa's intricate and complicated mechanism was difficult and expensive to maintain. Apparently, it was dry before 1617. Today, a higher-pressure aqueduct, the Acqua Felice, supplies the villa fountains. It also feeds the so-called **Fontana della Palla di Canone (Cannonball Fountain)**—also known, more graciously, as the Fountain of the Brimming Bowl—which is spare and serene with its ancient basin at the villa entry (fig. 1.4). From here it is an inviting stroll to the Scalinata di Spagna (Spanish Steps).

If you don't want to climb the Pincian Hill, you can begin a Vergine pilgrimage by heading south from Piazza del Popolo along Via del Babuino, running along the bottom of the Pincian's slope. One of the whistling lions points the way with a bright ribbon of water and light. The street is named for a little drinking fountain (originally intended for people and horses) decorated with an ancient

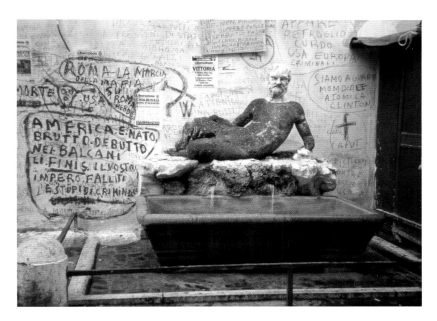

Fig. 1.5. Il Babuino surrounded by antigovernment graffiti, Via del Babuino. Artist unknown, 1577.

sculpture of a satyr, so bruised by time that he is called **Il Babuino,** which means "the baboon" (fig. 1.5). Built in the 1570s, this was the first privately financed Vergine drinking fountain. Rivulets still flow into the granite basin, but rather than Vergine water, a different aqueduct, the Pia Antica Marcia, provides drinking water today. Like many Roman fountains predating the city's nineteenth-century modernization, this one was peripatetic. Originally, Il Babuino stood against a palace wall across the street, but widening the road in the 1870s sent him into storage. In the 1950s, he returned from oblivion to reside in a spacious swath of sidewalk out of traffic's way.

Il Babuino is one of Rome's "talking statues"—the roster is completed by Pasquino at Palazzo Orsini in Piazza Navona, Marforio on the Capitoline Hill, and Madama Lucrezia, tucked into a corner of Piazza Venezia. Lacking a free press during the Renaissance, anonymous Romans penned *pasquinades,* barbed critiques typically directed at the seated pope (or his relatives), and hung the placards around Pasquino's neck. The practice began in 1501 when Cardinal Oliviero Carafa plopped him on a pedestal so that the public could read any comments. During the night, one of the other talking statues "responded" with an equally prickly anonymous reply, which might itself be answered by another pasquinade the following night, and on and on. Lucrezia and Marforio are heavily guarded today, but less so Il Babuino and Pasquino. Adorned with antigovernment placards and graffiti of every political stripe, they still have heated conversations

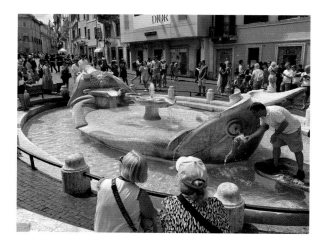

Fig. 1.6. Fontana della Barcaccia, Piazza di Spagna. Gian Lorenzo Bernini and Pietro Bernini, 1627–29.

across the kilometer or so that separates them, but at Il Babuino, even the most impassioned argument is cooled by water.

Whether taking the high or low road from Piazza del Popolo, the **Fontana della Barcaccia,** which means the "little, or worthless, boat," from 1627–29, awaits in Piazza di Spagna at the foot of the Spanish Steps. Unlike the hilltop Parnassus, the Barcaccia has no tricks, no mules, no devices; there is only gravity (fig. 1.6). Here is a tempting and beautiful place to pause; benches encircle the pool and stepping-stones lead to drinking spouts. While talking statues chatter away, the Barcaccia's voice is only for those who linger and deliberately engage with it, there, in Piazza di Spagna. Selfie-snapping, iPhone-chatting tourists won't hear its story.

The fountain commemorates the restoration by Pope Urban VIII (r. 1623–44) of the Acqua Vergine. Unveiled in 1629, it barely rises above the pavement, nestled there to compensate for very low pressure. Its distribution tank is hidden around the corner in the Metro station. Howard Hibbard and Irma Jaffe describe how the fountain's designers (Pietro Bernini and his son, Gian Lorenzo) "waved a wand over the mute creations of the past, transforming them into something new, allusive, and purely poetic."

The Barcaccia *is* different. Unlike earlier "mute" fountains, it is overloaded with explicit symbols—for one thing, there is no mistaking its papal sponsor— and the fountain is a storyteller. The narrative is a multiple-choice question: it is either a) a warship shooting life-giving water rather than cannon fire; b) Catholicism's resurgence during the Counter-Reformation; c) the physical representation of a poem by Urban VIII; d) a legend relating the most calamitous flood in Rome's history; or e) all of the above. While answer "e," all of the above, is correct, I am most interested in "d," the flood.

Fig. 1.7. Fontana degli Artisti, Via Margutta. Pietro Lombardi, 1927–29.

Nestled into a dip in the street, it looks like a boat washed ashore, nudged into a berth that, in some ways, appears to have always been there. An anecdote relates that a real boat was stranded there during a devastating 1598 flood. Although usually discounted (the story seems to have had an eighteenth-century debut), a small rivercraft could have come aground here; the flood did reach this far inland. Veracity is ultimately irrelevant. It is the bewitching water that seduces us as suave sheets fan out from the sinking boat and glide over the fountain's rim, making up in volume what it lacks in pressure.

The Piazza di Spagna district overflows with drinking water. The **Fontana degli Artisti** is nearby (fig. 1.7). Bigger than a palace barnacle, this *rione,* or neighborhood fountain, dates to 1929. Pietro Lombardi—who designed more Roman fountains than any other architect since antiquity—decorated it with painter's brushes and easels, sculptor's mallets and chisels, and architect's rules and calipers to represent its neighborhood, a warren of artists' studios. Few of Rome's barnacles remain (here or elsewhere). Now *nasoni* (big nose) drinking fountains from the 1870s are everywhere, freely dispensing cold water. It's easy to forget that when the nasoni were first built, most Romans remained without piped water. Then, as now, anyone could use them.

And don't worry about all that water streaming from a nasone. It isn't wasted; it's working hard. Water flowing through pipes is under pressure, so there must be opportunities to release excess pressure. Thus, each nasone works as a relief valve to keep the system working smoothly. A foolish attempt by a right-leaning government to appear sympathetic to conservation issues proposed removing many

(if not most) nasoni to "save water." Evidently there weren't any engineers on the committee, otherwise they would have realized the absurdity of the suggestion. Many members were staunch supporters of efforts to privatize water supplies throughout Italy. A 2009 referendum roundly defeated the initiative.

Walking around the Campo Marzio, at the heart of Rome's historic district, and the Borgo and Trastevere on the Tiber's right bank, you'll notice that the ground is relatively flat. Like Rome's gravity-driven water supply, much of the drainage and sewerage in the historic center is also gravity-driven. (Where do sewage-pumping stations go: next to the Pantheon?) The problems are obvious. So, the runoff from the nasoni helps to keep the street drains from stagnating (especially important during the summer) and flowing as freely as possible to pumping stations further south outside the historic center that link to a regional system.

Not only do fountains provide vessels where water seems to pause momentarily, providing a locus for political discourse, as at Il Babuino, or iconographic storytelling, as at the Barcaccia; they also allow the water to speak for itself. The pilgrimage of water is also one of sound. You don't only *look* at fountains, you *listen* to them as well. Each fountain has a voice: the Four Lions whistle; Il Babuino burbles; the Barcaccia whispers, and, at the Trevi, we hear Rome's heartbeat. For Romans, every fountain speaks, not just Il Babuino. Along the way there are more whispering and whistling fountains and ones that murmur, chatter, gurgle, chirp, and roar—the ear is as important as the eye. Describing a fountain as *muta* (mute) doesn't mean that it fails to tell a symbolic story like the Barcaccia; rather, it means that the fountain lacks water, life, its voice, and its soul: it is dead.

The actor Marcello Mastroianni died in 1996. To symbolize Rome's loss and to honor him, water ceased flowing in the Trevi; mourning draped the fountain. Like Marcello, the fountain passed into silence. The 2018 drought—and others that have come before and will come again—left Rome's fountains panting for water in the late summer. They are typically less rambunctious in August and September, but this was unusual. Everyone leaves town in August, not simply because of the heat, but because the fountains are quiet. Rome's soul is on vacation.

Almost a century after the Barcaccia's unveiling, the **Spanish Steps** (1717–26), which terminate near the fountain, were built to ease movement from the church and convent of Santa Maria della Trinità, under French patronage at the top of the Pincian, and the Spanish embassy at the bottom. With the steps in place, the French and Spanish were united physically and symbolically, and the steep, unstable slope was finally conquered.

Although it's nearly impossible to see when hundreds of people relax there, Francesco de Sanctis's stairs mimic water's flow: they are undulating in plan, with waves uniting church and piazza; fluid in section, with cascading stone steps; and in elevation, a rippling theatrical backdrop for contemporary life that can best be

seen emerging from Via dei Condotti (Conduit Street; see fig. 14.1), named in the late sixteenth century for the new water pipes running under the road.

The Trevi lies southward along Via di Propaganda Fide. Even before the 1570 Vergine restoration, this neighborhood held private gardens filled with sculpture and a few fountains. Their owners, some of Rome's most famous early sixteenth-century Humanists (the intellectual 1 percent), tapped directly into the aqueduct passing through their properties, and legally (or not) pulled water from the perilously low public supply to dignify their gardens. Antonio Colocci's garden was in a vineyard in this largely uninhabited part of town. The sleeping nymph sculpture that adorned its fountain—its accompanying inscription named her the *genio* (spirit) of the garden—was the subject of much discussion and the source of poetic inspiration among his guests, and, perhaps, grumbling from outside the garden gates.

Only garden scraps remain, hidden in courtyards, but there is a reminder of how the public's access to drinking water improved after 1570, and how water altered the social contract between the "haves" and the "have-nots." First, there is the sadly degraded **Fontana del Bufalo,** just past the church of Sant'Andrea delle Fratte. Like Il Babuino, it was part of a public/private partnership that developed after 1570 whereby some property owners were able to buy aqueduct water (or receive it as a gift from the seated pope), with the stipulation to provide a public drinking fountain on the street abutting their property wall. In this case, it was the small, exquisite urban villa owned by the Del Bufalo family that backed up to the aqueduct. They had most likely been stealing water for years. Sixteenth-century visitors described a bizarre fountain disguised as a rugged hill from which water poured forth as though it came from the ground. The artificial rock was strewn with glittering shells and supported trees of laurel, citron, and tamarisk under whose shade were statues of the Three Muses. The garden disappeared in the 1880s. Drinking water still flows to the Bufalo, but now from the Acqua Pia Antica Marcia aqueduct; and although Romans call the fountain *bruta* (ugly), the water is cold and fresh, and it's a welcome place to adjust one's bearings for the last leg of this water pilgrimage.

Imposing Vergine relics lay a few steps south on Via del Nazareno heading to Via del Tritone. To the left, set into a small arch, over which hovers the coat of arms of Pope Sixtus IV (r. 1471–84), there is an old wooden door, just the right size for Alice to enter Wonderland. A huge padlock tells us that something important is on the other side; it is a remnant of the ancient Aqua Virgo channel. Opposite it, imprisoned behind a fence by the municipality, stands a fragment of the aqueduct arches.

At this point, as the aqueduct headed to the Thermae Agrippae (Baths of Agrippa), a street passed through an arch large and high enough to ride under it on horseback. This is no longer possible because the ground level has risen many

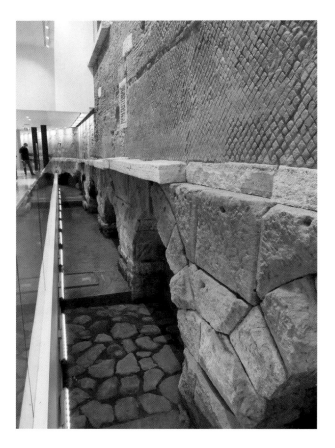

Fig. 1.8. Ruins of the Aqua Virgo in the Rinascente department store.

meters over the centuries, most notably from alluvial deposits left by recurring Tiber floods. But you can see an impressive stretch of **Aqua Virgo ruins** in the basement of the Rinascente department store (fig. 1.8). It's around the corner and worth a visit.

At the Via del Tritone corner, there is a glimpse of shimmering water to the left, up the street. It's Gian Lorenzo Bernini's Fontana del Tritone (Triton Fountain, 1642–43), but like the Medici fountains, it's fed by the Acqua Felice and thus is part of that water story. Our path instead leads us across the street, where, if you can arrive very early in the morning, it's possible to hear a low *rimbombare* (rumble)—not of traffic, but water. Like Anita Ekberg's nymphlike character, Sylvia, in Federico Fellini's *La Dolce Vita* (1960), the water pilgrim is drawn audibly into the orbit of the **Trevi Fountain.**

Following Via della Stamperia, the rumble intensifies. This is true even today, when the fountain's water ration has been drastically reduced. Our route is now adjacent to the aqueduct; it has lost elevation and we are almost

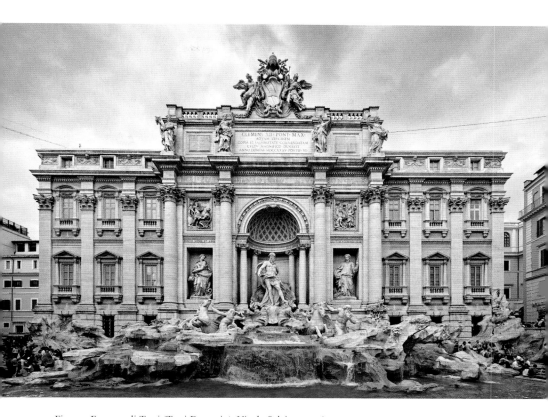

Fig. 1.9. Fontana di Trevi (Trevi Fountain). Nicola Salvi, 1732–62.

shoulder-to-shoulder with the channel. The ancient arches are sandwiched between addorsed palaces on our right. But, once past a slight bend in the street, the water's thunder overwhelms; there's no resistance, no restraint—only forward compulsion.

The Trevi is arguably the world's most famous fountain (fig. 1.9), noted for its gigantic scale, magnificent sculptures, complex iconography, embracing piazza, dramatic water display, and starring movie roles, most notably in *La Dolce Vita*. Like St. Peter's and the Colosseum, it epitomizes Rome. It also embodies all of Rome's fountains, symbolically feeding and absorbing them at the same time. Unlike Anita Ekberg and Marcello Mastroianni, we can't enter legally into the shimmering pool—this repository of dreams. There is now a twenty-four-hour webcam capturing every selfie, every coin toss, every soccer hooligan, and every Anita wannabe; but it is clear that this "welter of water" is more than a photo op and an oasis for weary tourists. Even in a dream state, it deserves sustained attention at many levels.

First is its subtle inhabitation of the piazza. Its architect, Nicola Salvi, took advantage of a reorganized piazza from an unfinished scheme for the Trevi that Gian Lorenzo Bernini had created for Urban VIII in the 1640s (see fig. 16.3). Salvi excavated more deeply into the sloping ground, creating a basin that almost fills its piazza, and he worked at a scale not seen since antiquity; its size is difficult to fathom—the fountain wall is fifty meters wide! Even while standing before it, it is nearly impossible to envision three American football field end zones fitting comfortably within it.

The Vergine terminates here, so water is abundant, although now, in place of an endless gravity-fed supply, a smaller quantity is mechanically recirculated. Salvi had little room to maneuver for a spectacular water display. With low pressure and the water level no higher than the street, an extraordinary sleight of hand was necessary. His mastery of the site is restrained and clever. A few steps lead down to the basin, giving it the feel of a grotto cave. He excavated the slope to the east nearly three meters to create space for this miniature ocean.

The Trevi is not only a seductive hybrid landscape of ragged stone cliffs and cascading water, mimicking a natural grotto at the edge of the sea with mythic characters traipsing around. Nor is it only an engaging sensual experience, nor simply an architectural statement of the political aspirations of its papal sponsors. The Trevi is about Rome—not only Rome in this piazza, but all of Rome.

As John Pinto points out, this fountain and piazza have made tangible the ancient ideal of *rus in urbe*—literally, the country in the city. Salvi brought water into Rome as an emollient to soothe the body, to calm the soul, and to quench our thirst, but he also turned this small piazza into a classroom, open to all. Hereward Lester Cooke understood the importance of Salvi's own notes about the Trevi. His translations clarify Salvi's intent that the fountain symbolically demonstrate "principles in natural science and physics which had been discovered in the early eighteenth century."

A curious polymath, Salvi studied medicine, architecture, hydraulics, botany, philosophy, and poetry. The Trevi is a tangible articulation of his cogent interpretations of then-current theories about water, moisture, plants, and air that were circulating among his erudite circle of friends at the prestigious Accademia degli Arcadi. As he makes clear in his competition notes, he used a mythic narrative to graphically represent eternal philosophical truths embodied in water's perpetual cycle.

The god Oceanus commands the center: above him, an allegory of a virgin leading Agrippa to the source springs unfolds; beneath his feet, water jets bubble, cascades foam from craggy rocks, and veils overflow each clamshell basin. Lesser beings populate the scene; plants and animals are deftly carved into the travertine stone. As Salvi explains, the ocean at the god's feet contains everything: the water forever reenacts the hydrological cycle as it circulates through the fountain's

interrelated parts. He demonstrates his belief that water "has no limit, and is not restricted in the material world. . . . It is completely free and always at work in even the smallest parts of the created Universe." Through water and stone, he articulated concepts that natural philosophers had theorized since antiquity. That is, the "essential mobility of water, which never ceases in its operation and is incapable of ever remaining still, even for the briefest moment; thus Oceanus is different from Earth which . . . is passive, and received the imprints which external forces, and particularly water, form upon her . . . which passes through her pores as rain."

In his competition entry, Salvi described Oceanus not as "the powerful operative forces of water gathered together in the sea so much as the actual working manifestation of these powers, which appear as moisture; in this form water permeates all material things, and winding through the veins of Earth, even into the most minute recesses, reveals itself as the everlasting source of that infinite production which we see in Nature, which water also is capable of perpetuating."

Salvi's interest in natural forces is also made clear on the far right, where we see broken and crumbling rocks and a cracked pilaster on the palace façade. The rocks are likely an homage to Gian Lorenzo Bernini's Fontana dei Quattro Fiumi (Four Rivers Fountain), and the dislocated pilaster might recall the Palazzo Montecitorio a few streets away. But it might also allude to the devastating 1703 earthquake (when part of the Colosseum collapsed) that Salvi experienced as a child.

His attention to nature is also made evident in his carved simulacrum of the Campagna landscape, represented by animals such as serpents, snails, and salamanders, and more than thirty species of native plants populating the Trevi's rocky crags and pools. Each plant grows as in nature; thirsty reeds such as the *Arundo donax,* which once grew wild in prehistoric Rome, sprout at the water's edge, while those plants that thrive in semi-aridity, such as *Opuntia, Quercus robur, Carduus,* and *Ficus ruminalis* (prickly pears, oaks, cardoons, and figs), cling near the top of the carved rock face. Cooke explains that, for Salvi, the plants represent the "new forms of life, which water can perpetuate, multiply and cause to grow." Before urbanization wiped away Rome's indigenous landscape, some of these plants grew around the crumbling heaps of history: prickly pears on the Palatine, cardoons on Monte Mario.

Nathaniel Hawthorne, seeing the "mossy, slimy, and green" stones in the 1850s, says, "Nature had adopted the Fountain of Trevi . . . as her own." Today, the fountain is better maintained. The fashion house Fendi paid for the 2016 restoration in exchange, it seems, for the right to hold fashion shows at (and in!) the fountain. Still, a few opportunistic plants, including flowering wild capers, *Capparis spinosa,* take root in the crevices beyond the reach of maintenance crews, making nature a simulacrum of the fountain's fictitious flora.

Two beautiful and apparently quite large bronze serpents once ornamented the Trevi. Long vanished, they slithered around a huge carved vase—still standing on the right-hand balustrade—and water spewed from each of their mouths into a drinking basin below. Eighteenth- and nineteenth-century couples came here, not to throw coins, but to drink Trevi water to ensure a safe return as the young man left home. Salvi seems not to have written directly about the meaning of the serpents within this narrative, so we are invited to speculate, like Pinto, who sees the snakes as "amplifying the metaphor of organic growth" that is evident throughout Salvi's design, and surely that is true. But there's more. Perhaps it's not incidental that drinking water flowed from the serpents' mouths, for to drink at the Trevi meant to engage directly with them. No one needs reminding that the serpent looms large in Christian narratives. It is the very symbol of what makes us human—our longing for knowledge and willingness to sacrifice everything to learn about and to be a part of the larger world outside the Garden of Eden. This search for truth led to what some persons call sin. Yet it was also true for those same believers that water could wash away their sins. Did Salvi intend for us to cleanse our souls by drinking at the Trevi? Perhaps. It seems clear to me that he provided a means for Romans to enter the perpetual cycle of rebirth and renewal in this theatrical Arcadian piazza, where myth and metaphor meet scientific investigations in an entirely new kind of urban environment.

Since 1946, once a week the Trevi is drained and cleaned, with its basin disinfected and its water recycled. The mechanism housed behind the fountain is now operated remotely. There are two chambers. Two hundred and twenty liters flow per second from a tank containing four hundred cubic meters that continually recirculates for eight hours; then, the second tank begins work for the next eight hours.

Every day and night since 1762, the *basso profundo* of roaring water has invited Romans and Rome's water pilgrims to step into a secular travertine and marble temple dedicated to the senses and the hydrological cycle. We arrive at the Trevi with new insights into the hidden workings of Rome's water supply, and it is here that this narrative reaches a crescendo. Now awakened to the complexity and subtlety of Salvi's iconographic program, we see how the Trevi was, and still is, an all-encompassing theatrical reenactment of the birth of life, made possible by the actions of water on the earth. Here, at the terminus of the Acqua Vergine, in a stage set of sacred springs and triumphal arches, we can watch the eternal drama of water's cycle of life and perhaps even glimpse the possibility of personal renewal.

We may not be any nearer to salvation when we arrive at Rome's most sacred water temple, but we will have the reward of a deep haptic experience of a portion of Rome—a knowledge of pulses and flows that alters our spatial sensibility of the city's topography. Water moving through subterranean conduits mimics water

flowing through Salvi's "veins of the Earth . . . into the most minute recesses," which are made manifest in Rome's public fountains. Through sight, sound, symbols, and steps, we can construct a new mental map hung on the armature of water infrastructure, one that tethers together the monuments, and indeed the entire city of Rome. Springs, streams, rivers, pools, marshes, aqueducts, floods, and fountains await the water pilgrim.

Bibliography

For fountains in general, see subject bibliography (especially D'Onofrio 1986) and Rinne 2010; for pilgrims and guides, see Birch 1998 and Nichols and Gardiner 1986; for the garden's soul, see Soderini 1904; for the Tiber River, its bridges, floods, and inscriptions, see subject bibliography (especially D'Onofrio 1980) and Virgil *Aeneid* 8:63–65; for springs, see Cicero *Republic* and Corazza and Lombardi 1995; for aqueducts (i.e., the Aqua Virgo/Acqua Vergine), see subject bibliography (especially Aicher 1995 and Ashby 1935) and Quilici 1968; for Villa Medici, see Andres 1976, Butters 1989–91, and Lombardi 2008; for talking statues, see Dennis 2005; for the Barcaccia, see Hibbard and Jaffe 1964; for Fontana degli Artisti and rioni fountains, see Matitti 1991; for Humanists and their gardens, see Bober 1977 and Rowland 2011; for the Trevi, see Cardilli 1991, Clark 1952, Cooke 1956, Hawthorne 1860, and Pinto 1986; for Trevi plants, see Gratani et al., 2014.

2

The "Floating City"

If you had stood in the Forum Romanum (Roman Forum) with Emperor Constantine, surrounded by gleaming marble buildings, you might not have realized that you occupied what archaeologist Rodolfo Lanciani called the "Floating City," meaning the beautifully paved and level public square beneath your feet concealed a complex hydrological history of environmental transformation. You, like many fourth-century Romans, were likely unaware of the subterranean world where streams once merged in a bowl-shaped valley—a wild and water-rich terrain that migratory peoples and their animals had inhabited seasonally for millennia. Instead of monumental buildings and paving stones in every direction, there were rugged plateaus and ravines, deeply carved by perennial streams. Their valley, now called the Forum Valley, is in the Tiber River floodplain, not much higher than the river itself. Why choose this saturated landscape to establish what would become the seat of an empire?

Rome's geology and hydrology are complex. During the Pliocene epoch (roughly 5 to 2.5 million years ago), the Mediterranean Sea submerged the entire area that would become Rome, including the plateaus and the surrounding Campagna (fig. 2.1). During the last glacial age, about ten thousand years ago, sea levels subsided dramatically, so that the marine, volcanic, and alluvial soils of Rome's stratigraphic profile emerged. At the time of Rome's mythic beginnings in 753 BC, steep ravines with densely vegetated valleys and flowing streams, and a broad alluvial plain through which the Tiber flowed, distinguished the area's topography and hydrography (fig. 2.2). The fabled "Seven Hills" could be distinguished as plateaus that hosted beech and oak groves. The plateaus each had small yet distinct summits: the Aventine, Caelian, and Viminal with one each; the Palatine and Capitoline with two each; and four on the Quirinal. The Caelian and Quirinal connected to the larger Esquiline Hill plateau, as did two minor hills

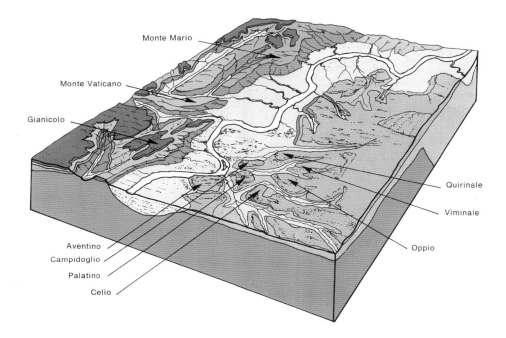

Fig. 2.1. "Geology of Rome around 8000 B.C." Published in Renato Funiciello, *La Geologia di Roma, il Centro Storico, Memoria, Carta Geologica d'Italia* (1995), fig. 13.

not counted among the seven, the Cispian and Oppian. (The Janiculum across the Tiber, so much a part of Rome today, was not counted.) Beneath the hills and valleys and out into the Campagna lies a stratum of water, varying in depth from five to nine meters, that still tends toward the Tiber.

Rome's foundation myth begins with a Tiber flood and the infant twins Romulus and Remus, who were the children of Rhea Silvia, the daughter of deposed King Numitor. Fearing that, once grown, the babes would displace him, the illegitimate king, Amulius, had them set adrift in a basket to drown in the Tiber. Luckily, the basket washed ashore at the mouth of a cave known as the Lupercal at the foot of the Palatine Hill, upon which Romulus eventually established his new city.

Rome's earliest history is rich with springs. According to the first-century BC statesman and scholar Cicero, Romulus chose this place because it abounded in springs. There are at least twenty-three of varying capacity known to have originated within the area now contained by Rome's Mura Aureliane (Aurelian Walls), including one at the Lupercal. Two of the springs still flowed beneath the paving where you and Constantine stood, and another, that of the goddess Juturna, had been a sacred fountain at the Forum's edge for centuries. All springs were holy, and once discovered, they were protected to maintain their purity.

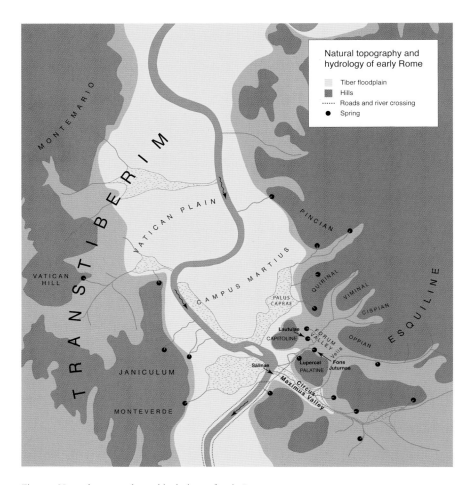

Fig. 2.2. Natural topography and hydrology of early Rome.

The springs fed streams—most were modest, but some were sizable—that served as territorial boundaries, creating defensible positions atop each plateau that connected to the broader Esquiline plateau through land spurs. Streams almost completely girded the Palatine, once connected to the Esquiline by the lower Velia land spur. One of the streams, now called the Forum Brook, originated at a spring on the Esquiline slope. Although relatively shallow, the brook had, over millennia, carved a deep channel through the tuff deposits that formed the Palatine plateau.

Nearby springs, including the Juturna, Tullianum, and Lautole (one that Ovid claims erupted with thermal waters during the Sabine War to overwhelm the invaders), emerged from the surrounding Quirinal, Viminal, Palatine, Capitoline, and Velia, feeding their own small streams to join the valley brook. United, their

combined flow continued west carving through the Velabrum, an alluvial plain connecting the Forum Valley to the Tiber River. The entire Velabrum rose less than two meters above the Tiber's level, and seasonal freshwater marshes formed from its frequent floods.

The area was originally settled during the Iron Age—long before Romulus and Remus—and each winter, shepherds and their flocks migrated from the Alban Hills and Apennine Mountains in the east to the lush meadows, seasonal marshes, alluvial plains of Central Italy, and the area that would become Rome. Simple mud and reed huts, duck blinds, and other temporary, perhaps portable, platforms for storing food were probably the only structures to be seen. In the harsh summers, the shepherds returned with their animals to the cooler hills and mountains. This kind of cyclic transhumance passage had probably continued uninterrupted for millennia. By the time the twins appeared, the shepherds had beaten paths through willows and osiers down to the Forum Brook, where they caught fishes, trapped birds with nets, foraged nettles and ferns, and collected basketry materials in this dynamic landscape. By the eighth century BC, modest permanent settlements already stood on the hilltops with altars and shrines on their slopes.

Louise Holland was among the first archaeologists to suggest that springs, streams, and marshes were essential components of archaic Roman city building. She wanted to discover for herself, as closely as possible, the Tiber's character in antiquity, including where and how it might be bridged. During the mid-twentieth century she studied brooks still flowing in analogous settings in Central Italy. She floated down the Tiber from Orte, at its junction with the Nera River, to Rome, camping each night along the way. She saw that perennial rivers and streams acted as natural territorial boundaries, and that they had been defensive barriers not only for Rome but also for scores of hill towns throughout the Italic peninsula. She discovered that the Tiber's wide bed and unstable banks along the entire stretch couldn't be bridged. There were no dams or villages either. The river could be easily spanned only at Rome; to do so required the approval of the gods.

Living water—perennial rivers and streams—was considered sacred throughout archaic Italy and Indo-European civilizations. In the Italic peninsula, perennial water boundaries could not be crossed without first conducting priestly rituals known as auguries (also conducted for warfare crossings). For example, priests might consult the flights of birds—their patterns and numbers—to determine an auspicious time. Even the Forum Brook, though not a particularly imposing physical obstacle, still held psychological importance that resonated long after Rome's foundation.

Gods ruled over rivers and streams, including the Tiber, while nymphs presided over springs. The gods and more important nymphs each had their devotions. Tiberinus, Father Tiber, was the most important water god in the construction of Rome's mythical water history, and the nymphs Juturna and Egeria contributed to

the foundation narrative. The poet Virgil relates that Jupiter, the most import-
ant god in the Roman pantheon, granted Juturna immortality and the honor of
ruling over lakes because he had stolen her virginity. According to tradition, she
became the wife of Janus (more about him later) and the mother of Fontus, the
god over all springs. Located in the damp Forum, Juturna's spring was sacred;
votive offerings were left there. According to legend, twin gods Castor and Pollux,
known as the Dioscuri, watered their horses here after a battle in 496 BC. After
this apparition, a monumental fountain was built at her spring.

Egeria, too, held cult status; tradition relates it was she, the consort of the
Sabine Numa Pompilius, Rome's second king (d. 673 BC), who brought religious
practice and law to the newly founded city. As the historian Livy recounts, her
authority guided Numa "in the establishment of such rites which were most
acceptable to the gods." She had the gift of prophecy and was the goddess of child-
birth. Considered especially pure, Egeria's spring, located outside the Forum near
the Porta Capena, wasn't allowed to flow through pipes. The Vestal Virgins tended
the eternal sacred flame brought to Rome by Aeneas. Each day they walked to
Egeria's spring to collect the purest water for their rites, although their temple
stood by the Juturna spring in the Forum.

It's difficult to know what Romulus, the crafty twin who killed his brother,
Remus, had in mind when he founded his Latin city on the Palatine. He built a
physically insignificant, yet powerful, symbolic boundary (*pomerium*) wall deflect-
ing evil and protecting its two small hills overlooking the Tiber and its island. In
any case, he avoided the saturated valley. But Romulus was not alone in this land-
scape. Etruscans controlled the Transtiberim (Trastevere) and the Janiculum to
the west across the Tiber, and the Sabines controlled the Quirinal across the val-
ley to the northeast. Relations between the Latins, Sabines, and Etruscans could
be volatile. But by the early sixth century, during the so-called Age of the Kings
(753–509 BC), they were so politically and culturally entwined—two Etruscans
and one Sabine (Numa) served as kings during the early seventh to mid-sixth cen-
tury BC—that fashioning a single shared public space may have been inevitable.

The Forum Valley seems an inauspicious site for that shared place. Experience
would have made evident the inherent difficulties in this soggy area, with its
low elevation and proximity to the Tiber. Yet, the disadvantages were apparently
ignored. The valley proved a convenient neutral ground to create what became
Rome's symbolic and political center—the Roman Forum. In exchange, the eco-
logical complexity of the native flora and fauna in this once vital and productive
area was now a nuisance. Only by obliterating the valley's watery identity could
the new Rome, fashioned from a cluster of villages, find a center around which
it could flourish.

Before the Forum Valley could become a civic space with monumental build-
ings, three things had to happen almost simultaneously: its ground level had to

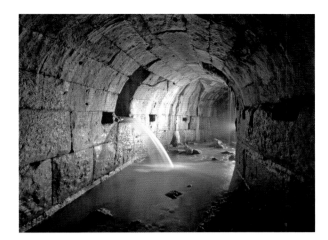

Fig. 2.3. The Cloaca Maxima beneath the Forum Nervae (Forum of Nerva), after it was vaulted in the late second century BC.

be raised by several meters to mitigate flooding; the streams flowing through the valley had to be channeled to desaturate the land; and bridges were needed to connect streets and pathways across the now-channeled streams. These public works required a centralized administration to coordinate a large workforce.

According to Livy and other historians, Tarquinius Priscus (r. 614–576 BC), an Etruscan king, had a drain built through the Forum Valley around the year 600 BC. Archaeological evidence meshes well with literary tradition, and this date is fairly secure. The complex details of the drainage project are now being revealed and correlated, providing fresh insights into the foundation—down to the native soil—of the Roman Forum, giving a clearer sense of the technologies and expertise that ancient Romans used to drain valleys and level hills to create a complex urban environment.

An undertaking of this scale took years to complete. Using core samples from the Forum and nearby Velabrum, archaeologist Albert Ammerman has proposed a compelling scenario. He describes a multiyear public works project that permanently altered the environment. It entailed filling the Forum Valley with imported debris, stone fragments, and soil to raise its level against flooding. The ground rose in stages. Ammerman estimates up to twenty thousand cubic meters of fill raised the level about three meters (to about nine meters above sea level in total), but still only slightly above the Tiber's normal height. Paved with gravel, the flat area proved stable enough for permanent buildings.

During the leveling stage, a permanent, monumental stone-lined drain, the Cloaca Maxima, controlled the brook flowing through the valley and prevented it from saturating the newly created level land (fig. 2.3). Its watershed ran from the ridge of the Quirinal Hill into the valleys between it and the Viminal, Cispian, and Oppian. Engineers typically carve the most direct and least costly route, but

this drain unfurled along the Forum Brook's winding course. This reflects the general reluctance to confront what classicist Lawrence Richardson describes as "a potentially hostile and dangerous power" residing within sacred flowing water.

The Cloaca used a complex new masonry technique. Fashioned without mortar from huge stone blocks, its remarkable size and strength were noteworthy. Tarquinius Priscus brought with him the Etruscans' already well-established city-building experience and their long history of building drains, called *cunicoli*. The Etruscans were engineers, par excellence, so it should come as no surprise that he would set the Romans to work with stone.

Natural fords, narrow chasms, or proximate paths along moving water like the Tiber River or the Forum Brook can, if the topographic conditions are right, become designated crossings over time, fashioned first of wood and later of stone. This was true long before the Cloaca Maxima. Holland points out that as Rome's population and influence grew, and the Forum Brook was traversed more frequently, permanently inaugurated bridges—no need to supplicate the gods for every crossing—were built at these important points. The guardian of gates and doors, the god Janus (married to Juturna), looked "forward and backward" and protected "coming and going," and as such the crossings are called Janus bridges. Four small, permanent spans along the brook continued to cross the Cloaca's open channel until the late second century BC, when the drain was finally vaulted and paved over. Not long afterward, Rome's public memory of the brook was erased, and the Cloaca Maxima effectively became a sewer. Only a small shrine to Venus Cloacina (Venus of the Cloaca) stood above it in the Forum, as a reminder of what lay below.

The Lacus Curtius was a small chasm not far from Juturna's spring. It "spontaneously" appeared in 362 BC. Here is the most common origin story. The chasm couldn't be closed until Rome's most precious thing was cast in. Marcus Curtius, a young patrician, leapt in fully armed on horseback, crying that arms and valor were most precious. The gulf then closed, and the area was subsequently paved and given a monument. The chasm must have been a remnant of the marsh below, perhaps where some poorly prepared earth gave way. With Rome's pockmarked geology, chasms—sinkholes, really—still open regularly.

Between the first century BC and second century AD, writers unanimously scorned the prehistoric Forum Valley. With little evidence, they projected back from contemporary conditions to reconstruct Rome's archaic topography. Ovid imagined a dank valley, but he didn't actually know the valley because, five hundred years earlier, the water had been drawn off, the ground was leveled and raised several meters, drains had become sewers, and much of the area was paved. Regardless, he and other authors portrayed a pestilential and malarial landscape without redeeming qualities that was a problem to be eliminated.

Perhaps this wasn't the case in the eighth century BC. Cicero wrote that

Fig. 2.4. "Fishes of the Tiber." Published in Strother Smith, *The Tiber and Its Tributaries, Their Natural History and Classical Associations* (1877), plate 1.

Romulus founded his city not *in,* but surrounded by, an area of dubious health-fulness, while the site itself was rich in clear and salubrious springs. Was this really an unhealthy place? Today, we know more about malarial anopheles mosquitoes than ancient historians did. Antonio Celli reports that if malaria existed before urbanization, it was mild and not a "hindrance to civilization." Bertha Tilly, Robert Sallares, and others argue that malaria might not have reached the Campagna until the second century BC, when Carthaginians arrived from North Africa. Sallares also points out that malaria survivors build up a genetic resistance, so that even if later generations encountered mosquitoes, their bouts, if they had them, would have been less severe.

The Forum (drained, raised, leveled, and paved) was malarial when later writers bemoaned its condition. Perhaps they didn't understand why the Cloaca Maxima—initially a drain—was built in the first place. Desaturating the land was essential for city-building (the Cloaca Maxima did just that), but if malaria only existed in a milder form or didn't arrive until several centuries later, the intention wasn't to rid the valley of malaria. It's likely that the Forum Valley, at least for the earliest settlers, was more an asset than a public health liability. The native reeds and willows and the clay beds provided building materials. Ducks, kingfisher, gulls, and herons were plentiful and were important components of their diet, along with wild onions, nettles, ferns, and other wild greens, and also the frogs, snails, and other small animals that called the wetland home. Some Tiber fish would have swum into the warm, shallow marsh to lay their eggs (fig. 2.4). This

ecologically rich and productive landscape was vital to the poorer people who foraged there for food. If a milder form of malaria existed before the second century BC, it might have become virulent when large drains, including the Cloaca Maxima, were built, that is, when the wholesale disturbance of the land quickly and permanently altered its ecology—banishing any dragonflies, lizards, newts, and frogs that feasted on mosquitoes and their larvae. With little to deter them, mosquitoes would naturally multiply and upset the organic equilibrium.

Outside the Forum Valley, other springs and streams flowed to the Tiber. Their names remain largely unknown, but ancient drains in the Circus Maximus and the Colosseum valleys, in the Campus Martius (Field of Mars), the Borgo, and the Transtiberim (Trastevere), confirm their existence. Another brook, fed by at least eight tributaries, flowed through the long valley running between the Palatine and Aventine hills. It was channeled in the sixth century BC (shortly after the Forum Brook), and its valley drained to build the Circus Maximus, where chariot races and other spectacles were staged. Its drain, the Cloaca Circus Maximus, was covered over in part to facilitate racing, but some of it remained open and served for many centuries as an ornamental median strip for the racetrack.

The scale of these public works required a well-developed civic administration that had at its command material resources including stone; the technology to quarry it into blocks and move them to the job site; and vast labor resources, in this case, slaves. This implies a level of control over peoples, landscapes, and resources that already hints at Rome's territorial reach even before the Republican period (509–27 BC). In fact, Livy remarks that Tarquin conscripted workmen from all of Etruria (his home base). Plebeians shared the work, a burden that was added to their military service. Ancient historians suggest that the workers felt it was easier to build temples than drains. Pliny the Elder relates that after beginning the drains (which by his time resembled sewers), and "set[ting] the lower classes to work upon them," for these workers, "the laboriousness and prolonged duration of the employment became equally an object of dread to them; and the consequence was, that suicide was a thing of common occurrence, the citizens adopting this method of escaping their troubles." But the plebians' displeasure didn't result solely from working underground or being more susceptible to malaria. As Nicholas Purcell and Louise Holland suggest, the work may also have challenged religious scruples.

Although a natural historian, Pliny, like Ovid, couldn't know how Rome's pre-urban ecology affected its inhabitants. He knew about the magnificent aqueducts bringing water from the Alban Hills. He might have bathed at the Thermae Agrippae (Baths of Agrippa) or the Thermae Neronis (Baths of Nero) in the Campus Martius. He looked at the city around him and marveled at all the sparkling fountains, hundreds of them built by Agrippa. He traveled widely and was acquainted with marshes and fens, but the ecology of well-watered Rome

was perhaps too environmentally altered to understand eight hundred years later.

The landscape was complex, and so too the plebeians' relationships to it. Although elite populations considered the valley and the people who relied on it for sustenance to be negligible and dispensable, those same "dispensible" people must have been angered at being forced to destroy close-at-hand productive landscapes that provided them with food and other resources. Bit by bit, a complex landscape of monumental temples, fora, palaces, and other new building types replaced Rome's original intricate, interwoven landscape of water, plants, and animals. This universal phenomenon continued into the nineteenth century, when former African American slaves were ejected from their homes to refashion the Manhattan landscape and build Central Park, or small English Midland farmers were evicted and their land drained by London bankers and speculators for agricultural estates.

Exploiting flood-prone areas like the Circus Valley for recreation or spectacles survived well into the Imperial period. Emperor Octavian (r. 27 BC–AD 14)—later called Augustus—drained the marshy Codeta, an area located across the Tiber in Transtiberim. He built a wholly new aqueduct, the Aqua Alsietina (2 BC), for his Naumachia Augusti, an enormous outdoor water theater for mock naval battles. Pulling dry land out of a wet hat for spectacles and sport, emperors Caligula (r. AD 37–41) and Nero (r. AD 54–68) drained and channeled another stream to build the Circus Gaius et Neronis in the valley that ran west–east from the Mons Vaticanus (where St. Peter's now stands) to the Tiber.

Alluvium filled the Colosseum Valley—its elevation about fourteen meters above sea level, much higher than the Velabrum, but still low enough to occasionally flood. This is where Nero built a vast artificial lake known as Nero's Stagnum as part of his palace complex, the Domus Aurea. Emperor Vespasian (r. AD 69–79) drained the lake to erase Nero's memory and replaced it with the Flavian amphitheater, the Colosseum.

The Campus Martius (now called Campo Marzio) occupies the bulging alluvial flood plain where the Tiber forms an arc. The Aqua Sallustiana and the Petronia Amnis streams flowed through the low-lying Campus, creating an expansive freshwater marsh known as the Palus Caprae (Field of Goats) that included the future Pantheon site. Still flowing strongly today, the Sallustiana, now underground, carved the valley between the Pincian and Quirinal hills. The Petronia Amnis originated at the Fons Cati spring on the western face of the Quirinal and fed the Palus Caprae before flowing to the river. Now called the Acqua di San Felice, the spring emerges inside the Palazzo del Quirinale grounds.

The campus remained largely unbuilt for centuries because it flooded frequently, and it was public land where people fished and trapped birds, as they once had in the Forum Valley. During the Early Republic (509–313 BC), part of it was a public pasture. Later, it became a military training ground (hence its name,

the Field of Mars, named after the god of war); its sodden environment simulated the extreme conditions that soldiers encountered during campaigns—you can practically hear the squelch of their boots in the mud.

As Rome expanded, the Campus Martius became a tempting target for large private and civic structures. The least-saturated areas were drained and built up first, most notably the Circus Flaminius in 221 BC, and the small temples (some ruins still stand) in the Largo Argentina area from the second and first centuries BC. The nearby Teatro di Pompeo (Theater of Pompey) of 55 BC perhaps seated as many as eleven thousand spectators. The impressive Porticus Pompeiana, Rome's first public park, was part of the complex. Its drains served two purposes: first, to dry out the land, then to handle runoff water from newly built fountains and pools. Its freshwater source remains a mystery (fig. 2.5). Propertius relates that those fountains, and an outdoor sculpture garden, made the garden a masterpiece. As Kathryn Gleason translates, there was an "avenue thickly planted with plane trees rising in trim rows . . . [with] the waters that flow from [the statue of] Maro's slumbering form and run babbling through their circuit until at last, with a sudden plunge, they vanish in the Triton's mouth."

Marcus Vipsanius Agrippa (son-in-law to Augustus) faced a major land reclamation project when he built the original Pantheon, Agrippa's baths, and an enormous outdoor Stagnum between 25 and 19 BC. The Aqua Virgo, Agrippa's new aqueduct (19 BC), supplied the baths and the Stagnum. Its overflow ran into the *eripus*, an open-air, ornamental swimming canal about one-and-a-half kilometers long. Crossed by small marble bridges, the eripus first headed west and then northwest to empty into the Tiber. Once these public buildings were in place, substantial residential buildings sprang up in the eastern Campus Martius.

The Virgo (now called the Acqua Vergine) was effectively a new stream, so before any Virgo water could enter the sodden Campus Martius, Agrippa drained the Palus Caprae. This perhaps best demonstrates the inherent contradiction that is Rome's urban history. To create dry land for building sites, massive drains withdrew water from marshy plains. Once dehydrated, aqueducts brought water in from great distances; this was the only way the city could thrive. Although Rome already had five aqueducts, the Virgo is emblematic of this contradiction because it brought water directly to the same low valley that had just been drained to accommodate it.

Throughout Rome's intensive, centuries-long land reclamation effort, the Tiber continued to flood. The relatively low and flat Campus Martius and the Ager Vaticanus (Vatican Field, or Plain) flooded first, and the long, straight Via Lata (now Via del Corso) provided a chute that sent water slamming into the land spur that once connected the Capitoline Hill to the Quirinal. This diverted floodwater to the southwest, scouring the foot of the Capitoline's north face. The Forum Boarium (Cattle Market) located along the Tiber in the Velabrum received

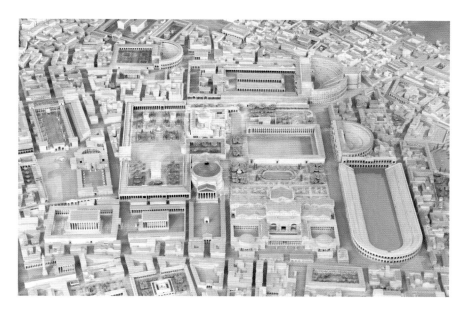

Fig. 2.5. *Model of Imperial Rome* (detail). Italo Gismondi, 1935–71. Museo della Civiltà Romana. From right to left: Stadio di Domiziano (Stadium of Domitian); Piazza Navona; Thermae Neronis (Baths of Nero); Pantheon (center), with Thermae Agrippae (Baths of Agrippa) and Stagnum (behind); Porticus Pompeiana (top center).

the brunt of the turbulence. Propelled along the Capitoline base, floodwaters turned toward the river proper and the Tiber Island, which helped push the water into the Roman Forum and Circus valley.

Rome's well-documented floods will appear in chapter 3. For the time being, it's important to know that not only did the floods destroy buildings and bridges, but they also carried alluvium and debris that clogged the drains. When the drains backed up, floodwater spewed into inland areas that might not otherwise have been affected. Alluvial deposits accumulated and ground levels rose. Streets, squares, and occupied buildings were cleaned as quickly as possible, but alluvium accumulated in abandoned buildings and unoccupied parts of the city.

Less than three hundred years after the first drains began to desaturate Rome—now girded with its first defensive barrier, the Mura Serviane (Servian Walls), completed in 353 BC—the city was running out of fresh water for its rapidly expanding population. Local springs could no longer provide the growing city with its expanding political and economic importance. This pivot is critical in Rome's urban history, but it didn't happen in a flash. There must have been a slow awakening over several decades as the population grew. In the late fourth century BC, Rome built its first aqueduct. Using technology similar to that of the drains, the Aqua Appia of 312 BC ran underground and brought water to

the Salinae (Salt Port) on the Tiber's left bank. Salt, a crucial commodity from coastal Ostia, was delivered to the Salinae, and from there distributed along the Via Salaria, the "Salt Road" that continued to the ridge of the Quirinal Hill, out to the Roman provinces. Concurrently, Appius Claudius Caecus, its sponsor, built Rome's first stone-paved military road. The Via Appia (now Via Appia Antica) connected Rome to Brindisi.

As the number of aqueducts increased, so too did Rome's population and the quantity of waste and debris. This called for dedicated sewer drains so that runoff water intended for a second life in industry, laundries, irrigation, animal fountains, or a swimming channel might remain clean. At the Thermae Caracalla (Baths of Caracalla, AD 212–217), for instance, runoff water from the various pools was reused (in one case, for grain mills in its basement), while others flushed through the latrines. Meanwhile, purpose-built drains collected rainwater from the streets and roofs. Open at street level, they quickly became sewers as unused runoff water, whether from streams or aqueducts, ultimately flowed into the Tiber, carrying waste and debris along with it. Rome's Tiber became an enormous sewer.

Expanding its reach beyond the Italic peninsula and the Mediterranean, Rome became a magnet for immigrants, all of whom needed water. As political, economic, and military control over Latium increased, access to springs in the Campagna increased. More water was diverted to the city, helping propel its phenomenal expansion. The history of Rome's fabled ancient aqueducts, their construction, the amount and quality of the waters they carried, their source springs, routes across the Campagna, points of entry into the city, and their impact on population growth and urban form are well known, and only need to be summarized here.

Between 312 BC and AD 226, eleven aqueducts served Rome, although not all operated at the same time (fig. 2.6). The source springs for the earliest of these, the Appia, were underground at a low elevation close to the city. The subterranean aqueduct only served the lowest zones of the city, which at that time included the area near the Salinae, the Circus Maximus, and perhaps the Velabrum. Most later aqueducts used higher, more distant springs in the Alban Hills southeast of Rome, to serve the city's higher elevations. Aqueduct arcades crossed open fields and valleys, and some ruins still stand in the Campagna. Several aqueducts arrived from the southeast, dictating in large part where they entered the city, and where water was distributed, enabling the city's growth.

Rome's earliest aqueducts, the Appia (312 BC), Anio Vetus (272 BC), Marcia (144 BC), Tepula (125 BC), and Julia (33 BC), served large public buildings and numerous public fountains at the port, in the fora, near temples, in the markets, and at street corners. The Aqua Virgo (19 BC) was a specialized line that Agrippa built specifically for his imperial bath. Next came the Aqua Alsietina (2 BC) for Augustus's naumachia in the Transtiberim—its inferior waters weren't fit for

drinking—and then the Aqua Claudia and Aqua Anio Novus (both AD 38–52). By the end of the first century AD, there were ninety-five ornamental fountains and 591 public basins for drinking and domestic uses. The Aqua Traiana (AD 109) and the Aqua Alexandrina (AD 226) came next. Only the Virgo, Alsietina, and Traiana entered Rome from the north. By the early fourth century, while you were chatting with Constantine, 1,352 public basins and hundreds of ornamental fountains served every part of the city. There were also public baths, the grandest sponsored by emperors.

Agrippa's baths were part of a larger urban complex in the Campus Martius: the Pantheon (27–25 BC), the Saepta Julia (a voting place planned by Caesar and completed by Agrippa in 26 BC), the Basilica Neptuni (its precise use unknown, but connected to the baths), and beautiful, spacious gardens with the Stagnum (see fig. 2.5). Because an aqueduct directly served his baths, water was abundant. Its larger scale meant that new functions—specifically those associated with the Greek gymnasium—could be added. According to Fikret Yegül, the gymnasium, a Greek invention, was "for the military and athletic training of young citizens as well as for their intellectual and artistic development. . . . By introducing extensive gardens, outdoor athletic facilities, and pools, [the Roman baths] embraced the full scope of the gymnasium idea." These amenities became even more important

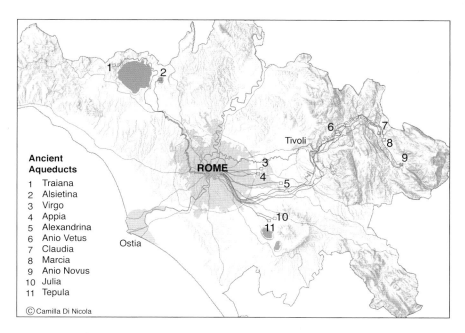

Ancient Aqueducts

1 Traiana
2 Alsietina
3 Virgo
4 Appia
5 Alexandrina
6 Anio Vetus
7 Claudia
8 Marcia
9 Anio Novus
10 Julia
11 Tepula

© Camilla Di Nicola

Fig. 2.6. Most of Rome's eleven ancient aqueducts entered from the east through Porta Maggiore (center right). The Aqua Alsietina and Traiana arrived from the northwest at Lake Bracciano (upper left). The Virgo entered from the north.

in later, much larger, imperial baths. At his death in 12 BC, Agrippa bequeathed his baths and their adjoining gardens to the Roman people to be enjoyed free of charge. This gave even Rome's poorest people the opportunity to bathe in opulent surroundings, perhaps on specific days, surrounded by verdant open space filled with fountains, trees, and statues.

Integrating baths with active exercise and intellectual pursuits, Agrippa's baths provided a new imperial model for bathing, copied and expanded in Rome (and throughout the empire) for more than three hundred years. The Baths of Nero, dedicated in AD 62, built close to Agrippa's, took advantage of the Stagnum. Dedicated in AD 80, the Thermae Titi (Baths of Titus) on the Oppian Hill, while larger than those of Agrippa, were still rather modest when compared with the better-known monumental Thermae Traianae (Baths of Trajan, AD 109), Baths of Caracalla (AD 212–17), and Thermae Diocletiani (Baths of Diocletian, completed AD 306). Their extravagances required large, purpose-built cisterns to collect water at night when the baths were closed, to ensure that the next day's supply wouldn't fail. Constantine also built a bath complex before he moved the capital of the Roman Empire to Constantinople in 330. His was the last imperial bath in Rome, now in ruins.

Portions of Rome's aqueducts rose on tall arcades as they crossed the relatively flat Campagna to the southeast. This made them vulnerable to attack, as happened in 537, when Visigoth armies tried to starve Rome into submission by cutting the aqueduct arcades. This will be discussed in detail in chapter 7, but for the moment, know that the Goth armies were routed, saving Rome at least temporarily. The Aqua Virgo and the Aqua Traiana were quickly repaired. Even so, some aqueducts remained useless for many years, and some were abandoned completely. The papacy then assumed control of Rome's water infrastructure, including the aqueducts. Popes Gregory I (r. 590–604), Honorius (r. 625–638), Hadrian I (r. 772–795), Gregory IV (r. 827–844), Sergius II (r. 844–847), and Nicholas I (r. 858–867) all repaired them. Excepting the Virgo, which continued sputtering along, the other lines had ceased flowing by about the year 1000. When the popes abandoned Rome for Avignon between 1309 and 1376, civic administrators established their right to oversee the Virgo, Rome's few remaining fountains, and the roads and bridges.

The history of Rome's aqueduct restorations intertwines with that of the drains, because even as less water flowed in, whatever drains remained still carried away rain and runoff water. But after the ninth century, ongoing strife between popes, nobles, and emperors meant that little was accomplished. The almost continual threat of invasion between the tenth and thirteenth centuries left little political will, money, or laborers to maintain the Virgo or drains.

Rome's civic administration and the papal government continued to be pawns in late medieval European power struggles. The city lacked any clear political

leadership that felt compelled to care for it, its citizens, or its public works. Parts of the Roman Forum were abandoned, and over time the ground level rose by several meters with accumulated alluvial soils and collapsed buildings; it came to be called Campo Vaccino, for the cows that pastured there. In the Campus Martius, many buildings were derelict due to structural damage from fires, earthquakes, and floods. In cases like this, why clean away debris? One simply built atop the ruins. As the ground became soggier without maintenance, Rome was less healthy overall, and malaria became endemic.

The collapse of Rome's infrastructure that began even before the sixth century meant that it no longer operated at an integrated urban scale but as fragments, perhaps at the neighborhood level. By the late tenth century, when most of the aqueducts had ceased functioning, there was little water to control at the civic scale. This caused spatial patterns to change, and Rome experienced profound urban contraction. Many people left entirely, and many who stayed moved down to the Campus Martius, soon to be called Campo Marzio, to be close to the Virgo and the Tiber River, while those living in the Borgo may have derived some benefit from a small fourth-century aqueduct, the Acqua Damasiana, that fed the Vatican immediately to the east. Some springs—buried underground for centuries—continued to flow (including the spring beneath the church of San Clemente near the Colosseum, still gushing today). They saturated the land, creating an unhealthy malarial landscape that further weakened the urban environment.

The popes abandoned Rome for Avignon in 1309, remaining there until 1376. This further exacerbated the city's centuries-long physical decline. Then, beginning in 1378, two competing popes—Urban VI (r. 1378–89), nominally in Rome (but usually resident elsewhere), and the antipope Clement VII (r. 1378–94), in Avignon—ushered in the Western Schism, which lasted until 1417. Finally, Martin V (r. 1417–31) returned the papacy to Rome in 1420. Architectural theorists, including Leon Battista Alberti, offered detailed plans to organize cities around sanitary measures, including sewers and fresh water. Some of these principles were practiced on a small scale, including cutting straight streets through Rome's contorted medieval neighborhoods. Martin V, Nicholas V (r. 1447–55), and Sixtus IV (r. 1471–84) attempted to regulate human waste, debris, and rubbish disposal. At the same time, their attention turned to restoring the still operational, but degraded, Aqua Virgo.

In 1452, Nicholas V partially restored the Virgo, by then called the Acqua Vergine, when he also replaced the fountain at the aqueduct's terminus, called the Trevi, which stood near the site of today's Fontana di Trevi (Trevi Fountain). Piecemeal repairs continued for the next one hundred years, but finally in 1570, popes Pius IV (r. 1559–65) and Pius V (r. 1565–72) completed a full restoration extending to the source springs, with some new springs added along the way. Sixtus V built the Acqua Felice (1585–87), which used ancient Aqua Marcia and Aqua

Alexandrina springs; then, Paul V (r. 1605–22) built the Acqua Paola (1607–12), tapping Aqua Traiana springs.

Not only were many original springs appropriated, the new aqueducts also followed nearly the same ancient courses, colonized some of the standing ancient ruins, served the same parts of the city as had their ancient counterparts, served the same uses, and followed the same law of gravity—flowing from higher to lower elevations. As in antiquity, the new water supply spurred urban growth and changed spatial patterns. Once again, water flowed to public fountains of all types, private palaces, and new villas and gardens on the hills that could compete in splendor with ancient ones.

Phenomenal amounts of water poured into Rome. The Vergine alone delivered 16,560 liters per minute—enough to fill ten three-meter-deep Olympic-size swimming pools every twenty-four hours. New drains carried away increased runoff water. Three areas received special attention: the Vatican and Borgo; the Campo Marzio; and an area that included the forums of Augustus and Trajan known at the Pantano (The Swamp, because of the huge amount of subterranean water that collected there), a part of the Forum Valley that flooded in antiquity. Open drains were covered over, and a few ancient ones—like those in the Pantano that linked to the Cloaca Maxima—were restored, the ground leveled (or raised), and new streets built or old ones repaved.

Still, water remained a problem. In 1880, Lanciani said that it was "impossible to conceptualize the volume of subterranean water" flowing beneath Rome. He reported that in 1875, when the city built the large drain down Via del Babuino, over a period of sixty days, 650,000 cubic meters of water were pumped out—nearly eleven thousand cubic meters a day. Some water leaked from the Vergine running under the Pincian Hill, some flowed from a nearby natural spring, and the rest from leaky pipes.

Rome remains Lanciani's "Floating City." The embankment walls create barriers that prevent underground water in the Campo Marzio, Trastevere, and the Borgo from flowing directly into the Tiber. Most of the streams are channelized, but pipes still leak and seeps still seep. Only a few meters below the Campo Marzio, Agrippa's swimming channel, the Euripus, still flows with water.

Maintaining urban order requires a central authority, whether an emperor, pope, dictator, or city council, to oversee the water supply and drainage systems. Thus, the system of linking together the new aqueducts, fountains, and drains was followed by succeeding generations of papal and civil administrators; this strategy is still employed today. The differences are few, but they are critical.

First, Rome has three mechanically pumped aqueducts built since 1870: the Acqua Pia Antica Marcia, the Acqua Vergine Nuova, and the Acqua Peschiera-Capore. The Pia Antica Marcia and Peschiera-Capore supply Rome's drinking water; their purity exceeds all European Union standards. As private residences

received their own water supply, public fountains began to disappear. Second, suburban and rural sprawl have compromised the once-pristine Acqua Vergine source springs. Third, Rome's population has increased dramatically, especially in the periphery. Those millions of persons (including illegal encampments called *borgate*) need water and sanitation services. Now, nearly five million individuals in Rome and its greater metropolitan region (5,363 square kilometers) claim the water supply and rely on the sanitary sewers, both of which are now administered by ACEA (Azienda Comunale Energia e Ambiente). Modern treatment plants process sewage generated in Rome's greater metropolitan region, but some areas still lack adequate sewerage, and the Tiber's pollution remains a serious problem.

Conservation efforts are in place. For example, much less water flows to ornamental fountains like the Trevi, and that water recirculates. But the stressed system still relies in part on its ancient and Renaissance roots and restorations. There are no simple solutions. Between private interests, sluggish entrenched bureaucracies, lack of political will, and lack of money for massive public works, Rome may begin to mirror its situation in the tenth century, when most of the aqueducts ceased working, water supplies failed, drains and sewers went without repair, and urban chaos prevailed. Since 2021, urban sanitation has deteriorated to a point that packs of wild boars roam through some Roman suburbs, scrounging through uncollected garbage. Recent health crises and continuing economic insecurity in Rome (and all of Italy) have placed even greater stress on this already fragile system, but Rome has fallen many times and been reborn. It can be hoped that today's troubles might provide the impetus for a much-needed urban overhaul, a true *renovatio Romae*—a rebirth of Rome, the eternal Floating City.

Bibliography

For geology and hydrology, see subject bibliography (especially Funiciello 1995), Cicero *Republic* 2:6, Coarelli 1988 and 1997, Holland 1961, Livy 1:39, 56, and Ovid *Fasti* 6:258, 401–2; for the Tiber River, its bridges, floods, and inscriptions, see subject bibliography (especially D'Onofrio 1980) and Cassius Dio 1987; for myths and deities, see Holland 1961, Livy 1:19–21, and Virgil *Aeneid;* for early settlements and kings, see Holland 1961 and Steinby 1996, vol. 3; for the Roman Campagna, its flora and fauna, and malaria, see subject bibliography, Meiggs 1982, Purcell 1996, Smith 1877, and Tilly 1947; for aqueducts, see subject bibliography (especially Ashby 1935); for naumachia, see Taylor 1997; for baths, see Yegül 1992; for land reclamation, construction projects, and clay beds, see Ammerman 1990 and 1998, Blake 1947, Gleason 1994, Lanciani 1880, and Richardson 1992; for drains, see Hopkins 2007, Narducci 1889, and Pliny the Elder *Nat. Hist.* 36:24; for Janus crossings, see Holland 1961; for urban administration from the sixth to twenty-first centuries, see Alberti 1988, Duchesne 1886–92, Fried 1973, Insolera 2002, Katz 2003, and Kostof 1973; for evictions, see Fried 1973; for wild boars, see Borgia 2021.

3
The Tiber's Seaward Rush

~~ Tiber River Pilgrimage I: Ponte Milvio to Piazza del Popolo,
 ~1.4 kilometers on the tram (walking is difficult in some sections);
 Piazza del Popolo to Ponte Sisto, ~2.6 kilometers

The Tiber's yellow-brown water, sometimes swirling and rushing or sluggish and stinking, still flows as it has for eons. Virgil relates that Father Tiber—the god Tiberinus, cloaked in a sky-blue mantle with a garland of reeds upon his head—was revered for his role in founding Rome. Although usually depicted reclining, Tiberinus wasn't passive. He could run savagely and swiftly, even in the summer, so that over millennia he relentlessly carved his channel and filled it with a sixty-meter-deep alluvium bed.

The Tiber is short—only 343 kilometers—but there are more than forty tributaries above Rome (its drainage basin exceeds seventeen thousand square kilometers), each with its own deities—minor gods and nymphs—vying for attention. The river originates at springs surrounded by beech trees at Monte Fumaiolo in the Apennines, springs so sacred that in 1927 the Fascist prime minister Benito Mussolini (who ruled as Il Duce 1919–45) redrew the boundary between Tuscany and his home province, Emilia-Romagna, to claim the source for his own mythology as the founder of a new Rome.

Shooting north from Piazza del Popolo, the arrow-straight Via Flaminia, built in 220 BC (and reconstructed several times), meets the Tiber at Pons Milvius—now called **Ponte Milvio** or Ponte Molle—where it crosses to join the ancient Via Cassia on the opposite shore. The Tiber is our goal. But, if we pause at the side of the road for a moment, we can step back in time and watch pilgrims, whether cardinal, queen, or humble folk from Northern Europe arriving in Rome. Two pilgrims catch our interest. In 1901, the historian Hilaire Belloc headed to Rome and found the Via Flaminia "bounded by factories, mean houses and distempered walls: a road littered with many scraps of paper, bones, dirt, and refuse."

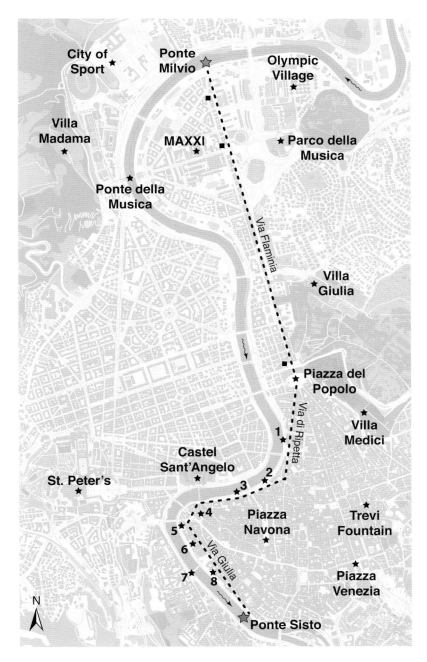

Fig. 3.1. TIBER RIVER PILGRIMAGE I: ■ = Tram stops. 1) Mausoleo di Augusto (Mausoleum of Augustus)/San Rocco flood markers, 2) Piazza Nicosia, 3) Porto degli Acquaroli (Water Carrier's Gate), 4) 1277 flood marker, 5) San Giovanni dei Fiorentini, 6) Il Puttino (The Putto), 7) Ponte Mazzini, 8) Piazza Padella (Frying Pan Piazza).

He failed to mention the richly decorated public fountain at the entry to Villa Giulia. Perhaps he wasn't thirsty, but I doubt it. It's a long walk to Rome.

Queen Christina of Sweden, Catholicism's most famous convert during the Counter-Reformation, came too. She had traveled to Rome many times, but in 1655 she came as a Catholic. Her arrival was strikingly different from Belloc's. First, she traveled by gilded barge, then in a sedan chair that Alexander VII (r. 1655–67) provided. For her state (rather than papal) arrival, senators, nobles, trumpeters, and a cavalry escort met her at Ponte Milvio. At the entry to Villa Giulia, her entourage turned at the fountain later ignored by Belloc. She took refreshment and was presented with a carriage and six horses, then continued to Porta del Popolo, for which Alexander had commissioned Gian Lorenzo Bernini to design a new façade. From there, she continued to St. Peter's.

While waiting for her cavalry escort to assemble, Queen Christina, well-educated and curious, might have used her time at Ponte Milvio observing how the bridge piers interrupt the Tiber's flow. Perhaps she noticed how caissons protected each pier by directing water around them. This created mini-streams flowing between each arch. Looking downstream, she may have noticed how they disappeared after they scoured the piers and caused increased turbulence until they reunited as one river. Perhaps she wondered what the impact of this turbulence might have on Tiber floods. Her concerns will soon be ours. Rather than wait for a cavalry escort, we can take the number 2 tram from Ponte Milvio.

Floods were a constant threat in Rome, and scholars and natural scientists sought to understand vexing questions about water's velocity, turbulence, and volume. In 1628, Benedetto Castelli, a student of Galileo and the hydraulic advisor to Urban VIII, published his treatise *Della Misura dell'Acque Correnti* (On the Measurement of Running Water). Using the Tiber as his laboratory, he introduces his velocity formula, explaining that it was a critical variable to calculate flow, whether in a pipe or open channel, and crucial for understanding flood dynamics. Castelli's treatise is considered the inaugural work of modern hydrodynamics.

Standing on Ponte Milvio, looking at the water, we are pulled metaphorically into the Tiber's seaward rush with a heightened awareness of pulses and flows, and our thoughts turn to the eternal hydrological cycle that began symbolically with cloudbursts over Monte Fumaiolo. Upstream are some rapids, and beyond them broad views where poplar trees apparently grow wild, as they once did here and in the Forum Valley. We imagine sailors navigating their skiffs filled with produce or lumber heading into Rome, or hear distant cries of an ancient battle, or perhaps a clamorous, onrushing Tiber flood.

Armies once rode north to battle from Ponte Milvio. Traditionally, although not in fact, Constantine changed the fortunes of the new Christian religion at this bridge in AD 312. Before he battled Maxentius (r. 306–312) for control of the

Western Empire, Constantine had a vision of a Christogram, the Chi-Rho. It came with a prediction: "*In hoc signo vinces*" (You shall conquer with this sign). He did in fact conquer, at the Battle of the Milvian Bridge, while Maxentius and many of his soldiers drowned in the Tiber. The Arco di Costantino (Arch of Constantine), built at the edge of the Forum Romanum (Roman Forum) in 313, commemorates this victory. Although Constantine didn't convert, he legalized Christian worship, irrevocably changing Rome's history.

Mussolini, eager to emulate and link himself with Rome's imperial past, dreamed of staging a Fascist Olympic Games north of Ponte Milvio in 1944. The games would take place at his Città dello Sport (City of Sport), the starkly haunting Foro Mussolini (now Foro Italico), a sports complex intended to transform young boys into good Fascists through rigorous physical programs. Located just beyond the bridgehead on the right bank, and built between 1928 and 1938, it opened in 1933 as an arena for spectacles exalting his regime.

At the other end of Rome's Tiber, Mussolini wanted to host an Olimpiadi delle Civiltà (Olympics of Civilization) in 1942. He vowed that the *Esposizione Universale di Roma,* or EUR '42, would become the nucleus of the ideal Fascist city and house its government—not a Roman suburb, but a new Rome. World War II canceled both dreams, yet the buildings survive. Immediately after the war, the Foro Mussolini became a recreation center for the Allied forces garrisoned in Rome and now, as the Foro Italico, it is Rome's foremost sporting venue. Meanwhile, EUR '42, despite Mussolini's rhetoric, is another Roman suburb, just one with exalted ambitions.

Rome hosted the 1960 Olympic Games, where Mussolini's Foro and EUR '42 became the principal sports venues. The Olympic Village for athletes was built in the Flaminian Field opposite the Foro. This was the first Olympics to house all athletes together in shared dormitory rooms. After the games, the buildings were reconfigured into apartments for state employees, with a town square and gardens.

Like much in Rome, there is a dark side. Mussolini built on former cultivated fields, but the Olympic Village site had housed a *baracca,* an unplanned encampment for hundreds of homeless Romans who came there after World War II. Displaced again, they were relocated to the periphery. Some of them occupied *intensivi* (intensive) apartments—newly built nine-story towers, sometimes without adequate infrastructure, including transit. Others created spontaneous encampments around Rome's tattered edges.

A different fantasy, Villa Madama, is tucked up into the hillside to the west. In 1518, Raphael Sanzio began designing one of Rome's first Renaissance villas for Cardinal Giulio de' Medici (later Clement VII, r. 1523–34), with fountains and manicured gardens and spectacular views up the Tiber, into Rome, and to the Vatican. It was both an *hospitium* (reception venue) to welcome and entertain

important visitors, especially foreign ambassadors and their retinue (often including hundreds of men and horses), before they entered the Vatican, and a *villa suburbana* where the cardinal could escape Rome. The Villa Giulia, where Queen Christina stopped, served the same purpose, on a smaller scale.

Villa Madama's eastern, and main, façade fronts the Ponte Milvio, and as Raphael related, it seemed that the villa was there first, and the bridge bowed to it. The visual connection also heightened the association between Constantine, who welcomed Christianity, and Clement, who thought he could save it from infidels. The site's topography and especially its water supply were equally, if not more, critical than sight lines, since no aqueduct served the area. Moving water for its greatest effect was a favorite topic between Medici and his engineer. Fortunately, a spring rose at the back of the property; otherwise, nothing significant could be built. Raphael's design for water flowing through the gardens came from his close examination of the topography.

A short channel delivers spring water to a fountain grotto (now greatly altered) that the seventeenth-century art historian Giorgio Vasari called *selvatica*—wild, yet natural. Embellished with artificial rocks, it resembled a real grotto—here art imitates nature—a leitmotif for fountains noted by Claudio Tolomei in 1543, as he marveled that in Rome, one couldn't discern which was which. This theme continues throughout the sixteenth and seventeenth centuries. A new term, "grotesque," was coined to describe cave-like and mysterious places. It derived from underground caves and grottoes discovered in the early 1500s. These were rooms in the Domus Aurea, Nero's "Golden House," long hidden beneath the ruins of the Thermae Traianae (Baths of Trajan) on the Oppian Hill. Once discovered, artists, including Raphael, had themselves lowered into them to record these mysterious, grotesque places. From the selvatica grotto, the water feeds fountains and pools, including an enormous fishpond, best seen, alas, via Google Earth. It's nearly impossible to enter the villa; today, its owner, the Italian government, hosts diplomatic visits there, not unlike its original owner.

Buoyed by beauty (even if only spied from Google Earth), from here you can saunter along the river to the Ponte della Musica, a new bridge meant to connect the Tiber's right bank to Rome's new arts district. Then, you can turn east on Via Guido Reni to drink a coffee; visit the modern art museum MAXXI—with a sonic installation of Rome's Acqua Vergine "heartbeat" that artist Bill Fontana created for the lobby; hear a concert at the Parco della Musica, with three auditoriums designed as glistening scarabs hiding in the foliage; or wander around the Olympic Village. Refreshed by coffee, music, art, architecture, or all four, you could walk back along the river, but if you take the number 2 tram to Porta del Popolo, you'll be following Hilaire Belloc and Queen Christina into Rome.

❦

For the Tiber, little changes. It flows faster or slower, higher or lower, wider or tighter, always flowing back to its bed. Whether the river nibbles away at the shore, or gnaws and spits it out downstream, the bed remains. Remember, Tiberinus was a god. Whether his river moseyed along or flooded, priests and common folk considered it his decision. Ordinarily this wasn't a concern; life along the river went on. Tiberinus chose where he flowed, returning to his own bed—although he might muss it up mightily. But humans dealt with the aftermath and had to interpret his actions, whether portents or punishments. If prophetic, what greater danger awaited Romans? Or should Tiberinus be appeased, and if so, how should sacrifices be performed?

Daily life along the riverbank was diverse and animated. It was Rome's life-blood; everything for survival, growth, and success came to its ports and shores and then into streets, warehouses, piazzas, and houses. When Rome still relied on the Tiber for commerce—that is, until the mid-nineteenth century, when trains usurped its rightful place in the city's life—its steady flow mattered. When slower and lower, ships carrying oil and wine couldn't travel up the Tiber from its Mediterranean port, or down from Umbria, where most produce was grown. And, with low water, life was difficult for fisherfolk who needed a constant water level and millers who needed a steady flow to propel their mill wheels. And when the water was low, the river stank!

When the Tiber ran faster and higher, it overflowed its low banks and surged through the Roman Campagna. Its bloated current ruined crops and killed animals before pushing into Rome, where it submerged the ports and battered palaces, churches, and houses of a still-unprotected city, often for days on end. Decade after decade, sometimes year after year, the Tiber, swollen by storms, or pride, as some suggested, terrorized Rome. Without the embankment wall (begun in 1877), water, urged on by its own mass, advanced through the streets, forcing everything out of its way: snaking under doors, then throwing them off their hinges; shoving against windows and blowing them wide open; and filling ground floors and basements with mud.

While the floods never lasted forty days and nights, weeklong storms, with the river rising and falling only to rise again, were not uncommon. When Tiberinus ceased hammering Rome, he paused, then slowly receded. Filthy walls topped by greasy black streaks were souvenirs of his prowess. Left behind were drowned animals, human corpses, waterlogged grain, the broken mills to grind it, whole trees with their branches and roots, chunks of marble, entire sculptures, alluvium (sometimes many meters deep), and backed-up sewers and drains. Now everything stank!

Without grain, starvation loomed. Homelessness and disease were rampant. Clearing the streets, basements, and drains took time and money, which were sometimes difficult to obtain. Cleaning the filthy walls devolved to property owners. The greasy streaks remained for years, but their presence sparked a tradition

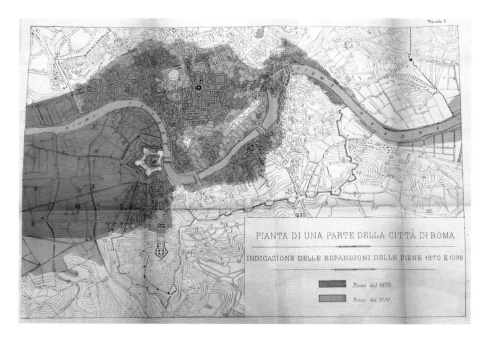

Fig. 3.2. This map shows the comparative levels of the 1870 flood (dark green) and 1598 flood (light green). Published in Raffaele Canevari, *Studi per la sistemazione del Tevere nel tronco entro Roma* (1875), plate x. North is to the left.

that survived into the twentieth century. Some building owners mounted an **inscribed plaque** to commemorate the level of the stain. The earliest surviving example (carved with elegant gothic letters) dates from 1277. Other plaques, sometimes with a little "Finger of God," pointed accusingly at the flood line, either praised Tiberinus for being audacious or lauded the Virgin Mary or the seated pope for interceding, causing the river to recede. Rome's last major flood occurred in 1870, shortly after Italian unification (fig. 3.2). Red lines marked the flood's height on Campo Marzio buildings and could be seen for many years. Fifty-two inscriptions commemorate that flood; none thank the Roman Council for their intercession.

The city reeled from the 1495 flood, as nine inscriptions attest. For the next 160 years, Tiberinus lashed out frequently and furiously. No one living near the river was safe. The 1530, 1557, and 1598 floods submerged the Pantheon floor under nearly six meters of water. One could row a boat through the doors. Flood markers commemorating Rome's worst recorded flood, in 1598, were everywhere: from Piazza del Popolo in the north, to Castel Sant'Angelo, the Borgo, Pantheon, Tiber Island, Santa Maria in Cosmedin, and the Ripa Grande, Rome's main port, in the south.

Eyewitness descriptions are rare. Rather, historians and diarists gave literary accounts, some fantastic, others, like that of Tacitus (ca. AD 56–120), one of ancient Rome's greatest historians, crisp enough for the *New York Times*. Although he didn't witness every event he describes, he avoids colorful embroidery. Regarding the AD 69 flood (preceded by a multitude of bad omens and followed by even more), he writes: "But an alarm greater than all, because it connected immediate loss with fears for the future, arose from a sudden inundation of the Tiber. The river became vastly swollen, broke down the wooden bridge [Pons Sublicius] . . . and overflowed not only the low and level districts of the capital, but also much that had been thought safe from such casualties. Many were swept away in the streets; many more were cut off in their shops and chambers. The want of employment and the scarcity of provisions caused a famine among the populace. The poorer class of houses had their foundations sapped by the stagnant waters, and fell when the river returned to its channel."

Hyperbole flourished; Paulus Diaconus (Paul the Deacon) reported snakes swimming in the streets in AD 555; most alarmingly, one resembled a "dragon." But Diaconus lived two centuries after the event. Snakes do wash ashore during floods, so it isn't surprising that they would do so in Rome—but a dragon! It's difficult to imagine what animal or fish gave impetus to his story. Tales of deformed human bodies with animal heads and cloven feet washing ashore continued long after, providing fodder to Protestant Reformation activists, who, eager to believe the worst of Rome, equated the "monsters" with the Catholic Church.

Flood reports make clear that the Tiber forced its way into the city like an invading army. Consider this elaborate and convincing eyewitness description of the 791 flood. On December 20, the Tiber, swollen by continued rains, surged through the city, scouring the streets and unhinging the doors on the Porta del Popolo, which were borne down Via Lata (now Via del Corso) to the Arco di Portogallo near San Lorenzo in Lucina, where the street narrowed blocking its progress. Water continued forcing its way down Via Lata, leaping over walls as far as San Marco, where the Capitoline slope halted the flood's southward progress, turning it toward the river to flow westward, submerging streets and piazzas until Ponte Sisto, where floodwaters returned to the Tiber's swollen bed. This account conveys real urgency: the water swells, surges, scours, unhinges, forces, leaps, turns, and submerges until finally abating.

An eyewitness describes the 1495 flood as causing incalculable damage, saying that boats, mills, and houses in the Campo Marzio were destroyed, and that the prisoners in Tor di Nona and stabled horses were drowned. He adds that because the mills were destroyed, there would be no bread, and "though we were surrounded with water . . . many are perishing with thirst." Goldsmith Benvenuto Cellini gives an eyewitness account of the 1530 flood, saying how the water rose at his house and shop on Via dei Banchi. He describes stuffing his pockets with the jewels

Fig. 3.3. Commemorative inscriptions in Piazza del Popolo: the 1598 flood (above, by Father Tiber) and 1530 flood (below).

entrusted to him, escaping out the back window, and heading to higher ground.

Filippo Bonini relates that during the 1557 flood, "The Tiber, which is wont to emulate the glories of distinguished men, and itself retains something of the Roman pride, did not fail ... to appear not only as the triumphant master, but as the tyrant of Rome." It destroyed nine Tiber mills, Ponte Santa Maria, and even cut a new course to the sea near Fiumicino, where Rome's Leonardo da Vinci Airport is located. Ports remained useless. Rubble was everywhere. Rampant disease followed and, without grain, famine, too. An *avviso* (a diplomatic report sent from Rome by ambassadors) relates that even before the flood, provisions were in such short supply "that no married man, and no one with a household of his own, was to take meals in an *osteria* [tavern], as otherwise those who had nowhere else to go for their food would suffer."

The worst was yet to come, in 1598, when a Christmas Eve flood "would have caused stones to weep." Now, Father Tiber's audacity is scolded; "raging with stormy winds," he thundered into the city on this holy day. Many of the plaques (nineteen in all) make clear that only the Virgin's intercession saved the city. Most impudently, Father Tiber himself composed a plaque for Piazza del Popolo. He tells us it is not enough to win, but that he is closer to heaven than earlier floods: "I will grab fame ... and I will be remembered in the New Year. The past age cannot recall anything like this. Oh Roman, put the sign here: here was I, Tiber on the ninth day before the calends of January 1599 [December 24, 1598] year VII of the Pontificate of Clement VIII [r. 1592–1605]. As soon as the river boldly touched the sign placed below, flooding evenly, but lower than the nearby source [the fountain in the piazza], the people who are inside said, it must be higher" (fig. 3.3).

Controlling the Tiber was crucial. Consider dictator Julius Caesar (r. 49–44 BC), who in 45 BC proposed to divert the Tiber from Ponte Milvio to flow

along the foot of the Vatican Hill (future site of St. Peter's), thus incorporating the alluvial Vatican plain into an expanded Campus Martius, ripe for development. But religious scruples were clearly compromised, and the plan didn't advance. It would surely anger Tiberinus.

Proposals to subjugate the river became an industry. After the 1598 flood, Clement VIII enlisted the most renowned architects, including Giacomo della Porta, Domenico Fontana, Giovanni Fontana, and Carlo Maderno, to offer solutions; all schemes were shelved. Taming the Tiber was simply too arduous. Aside from the prohibitive cost, sustaining momentum was nearly impossible. Unlike dynastic rulers, with no heir to continue his plans, each new pope brought his own agenda, and he and his supporters might see a way forward for their own projects, actively working against their predecessor.

Clement X (r. 1670–76) hired the Dutch engineer Cornelius Meijer to investigate flood management. In 1676, Meijer and the artist Gaspar van Wittel traveled to Perugia, making their way back to Rome by boat. They created a detailed illustrated technical report of the fluvial basin with proposals to counter erosion and improve navigability between Perugia and Rome. Only one section was tackled. The salient point is that the Tiber's challenge was too great. The popes could barely keep the bridges standing.

In 1743, the "Enlightenment Pope," Benedict XIV (r. 1740–58), hired Andrea Chiesa and Bernardo Gambarini to conduct a scientific survey of the Tiber from Malpasso, a town to the north, to Ostia, on the Mediterranean coast. They spent that summer traveling up and down the river with their assistants, including divers, to map the river's course (fig. 3.4). Their report included a map of the Tiber incorporating section cuts of the most difficult river stretches; beautiful, measured drawings of six Tiber bridges; and elevations of the 1742 flood along the route. Like the others, their plan was shelved.

In the late nineteenth century, the embankments were built; their unyielding walls yoked the river. Covered with grime and with trees sprouting everywhere, they have done their job. But they look about to buckle under pressure from the landmass behind them. Except for the bike path along the right bank, the pavements are often deserted and dirty, especially after annual high-water events that can leave them under as much as four meters of turgid, foul water.

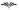

From Piazza del Popolo you can make your way slowly along the Tiber or Via di Ripetta toward the **Mausoleo di Augusto (Mausoleum of Augustus),** which after fourteen years and a major renovation finally reopened to the public in March 2021. Augustus's tomb is circular in plan. Built in layers like a cake and planted with a cypress crown, its summit was topped by an enormous bronze statue of Augustus. It stood in an open plain (drained before construction began)

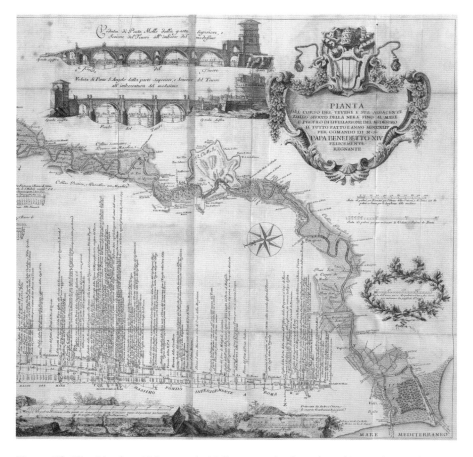

Fig. 3.4. *The Tiber River from Malpasso to the Mediterranean* (detail). Andrea Chiesa and Bernardo Gambarini, 1746. Vincent Buonanno Collection.

that stretched south toward the future site of Agrippa's Pantheon (not the round one seen today) and east to Via Lata. Filled with groves and walks, the area was open to the public.

Moving forward fifteen centuries, Cardinal Ferdinando de' Medici built a twenty-meter-tall, mounded hill, called a Parnassus, a home for the gods, in the gardens of his villa on the Pincian Hill in 1574. He built this above an amphitheater (destroying it in the process) in an ancient garden, the Horti Aciliorum. With an unobstructed view, his tall Parnassus, planted with cypresses, mimicked the tomb, which although in ruins at the time, remained symbolically potent. The allusion was so complete that, as Glenn Andres writes, it was erroneously labeled "Mausoleum" on most sixteenth-century engravings of the garden. His unobstructed view to the southwest includes the circular Pantheon, a temple to all

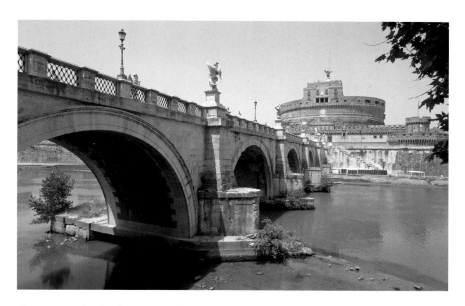

Fig. 3.5. Mausoleo di Adriano (Mausoleum of Hadrian), now Castel Sant'Angelo.

gods that also mimics Augustus's tomb. Visually and ideologically, the references were clear across the entire Campo Marzio.

When he built his tomb in 29 BC, forty years before his death, Augustus wasn't emperor. He built for the future and clearly had big plans for himself and his heirs. Why build along the river in the first place? Tombs were traditionally constructed along a cemetery road outside the city walls. Unlike roadside dynastic tombs, his strategic site could be seen from Rome's hilltops, from across the Campus Martius, and up and down the Tiber. Nothing stood in the way. He owned most of the land to the south, and what he didn't own was either the property of Agrippa or controlled by his allies. It isn't irrelevant that Augustus had spent time in Egypt, where he snatched up obelisks. In 30 BC, he acclaimed himself successor to the pharaohs whose mortuary pyramids stood along the Nile. Although his tomb is round and mounded rather than pointy, it's hard to miss the connection.

Emperor Hadrian (r. AD 117–138) admired Augustus. He built his own tomb to answer and honor Augustus's, which could then be seen just upriver on the opposite bank (fig. 3.5). Because of its superior concrete construction and defensive walls surrounding it, his tomb survives as the fortified Castel Sant'Angelo. His bridge, Pons Aelius, built in AD 134 and crossing from the Campus Martius to his mausoleum, survives as Ponte Sant'Angelo.

Hadrian's tie to Augustus goes deeper. Agrippa had built the first Pantheon (rectangular in plan and facing south, not north); it was part of a larger complex completed between 25 and 19 BC. Fire destroyed that temple in AD 80. Restored,

at least partially, by Emperor Domitian (r. AD 81–96), it burned again in AD 110. Trajan (r. AD 98–117) began rebuilding it, probably toward the end of his reign between AD 114 and 116, and turned it north to face Augustus's tomb. Hadrian completed it around AD 125.

The area between them became densely populated and remained so during the medieval period, when most Romans lived near the Tiber. During that time, Augustus's mausoleum, like many ancient ruins, was colonized. In this case, the noble Colonna family used it as a defensive Tiber outpost. Although a shambles, his mausoleum proved resilient even after the Colonna decamped. The area south of the mausoleum began to resemble its soggy, pre-urban landscape, becoming less and less desirable. Still, the important Ripetta port remained, as did churches and a hospital for syphilitics in the area called the Ortaccio (Orchard), best known in the Renaissance as a haunt for prostitutes, whom Pius V required to inhabit their own ghetto there. The restrictions didn't last long. The area retained this character even after the Soderini family reclaimed the mausoleum as a sculpture garden (fig. 3.6). Later, it became a bullring, then a circus, then, under Mussolini, a concert hall.

Across the river, the Colonna's archrivals, the Orsini family, fortified themselves inside Hadrian's tomb, which, because the Archangel Michael miraculously appeared there in 590 (ending a flood *and* a plague), was then called Castel Sant'Angelo. That's his statue at the top. The Orsini also snagged the defensive tower on the left bank at Tor di Nona (a quay for storing grain), giving them a stranglehold on southward Tiber access. By the mid-thirteenth century, they

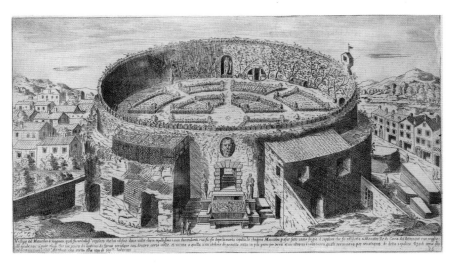

Fig. 3.6. *Mausoleum of Augustus with a Landscaped Garden in Rome.* Étienne DuPérac, 1575. Rijksmuseum. This area was reused as the Giardino Soderini.

Fig. 3.7. *View of the New Ripetta Port.* Alessandro Specchi, 1704. Vincent Buonanno Collection.

also fortified the nearby Monte Giordano. This was a period of intense rivalry between noble families, emperors, and popes, when factions divided all Europe. The Colonna supported the pro-imperial Ghibellines, while the Orsini supported the pro-papal Guelphs.

Linger a little longer in the area surrounding today's rather heartless piazza at Augustus's mausoleum. Step back to the late seventeenth century, when the *ripetta* (little bank) was nothing more than a muddy shore where produce and timber coming from the north were off-loaded. Between 1703 and 1705, Clement XI (r. 1700–21) transformed the port into the more functional Ripetta, which became one of Rome's most dreamlike and scenographic places (fig. 3.7). With beautiful, flowing steps to the water, nothing rivaled it architecturally until the Fontana di Trevi (Trevi Fountain), completed in 1762. Sacrificed for the embankment in the 1880s, the Ripetta's loss was wrenching for Romans. Although no longer a busy port, the Ripetta was treasured, and like the Spanish Steps, meant to be experienced through movement and viewed as a stage set seen from a distance, in this case from the Vigna Altoviti across the Tiber bank. Sadly, no amount of moaning will bring it back. The only reminder is a fountain from the port that was relocated across the street, now marooned in traffic.

Today's piazza, the blank river wall (under which a wisp of the Ripetta's ghost purportedly lurks), Mussolini's regimented building façades, and a pompous Fascist inscription all curdle hope. Even the new fountain at the Museo dell'Ara

Fig. 3.8. The Tiber River at the Museo dell'Ara Pacis.

Pacis is soulless—although seeing children playing there is exhilarating, perhaps because they are forbidden to do so (fig. 3.8). The restored mausoleum and beautiful Ara Pacis proper—Augustus's "Temple of Peace" hidden inside the museum—are the exceptions. Mussolini had the altar moved from its original location (closer to Via del Corso) to adorn his monument to himself at the mausoleum.

There is an enormous historic hydrometer attached to the sidewall of the San Rocco church (fig. 3.9). Stand next to it. Today, the ground level is 14.72 meters above sea level. The 1598 flood topped out at 19.56 meters above sea level, just above the sign at the top reading "Largo S. Rocco." Here it's possible to gain a visceral sense of the enormity of Rome's floods. Pay attention to the **flood markers;** by standing against them, you sense Rome's topography in ways that otherwise can't be easily understood.

A little further along is **Piazza Nicosia,** where the original Piazza del Popolo fountain now stands. This was Rome's first fountain after the Acqua Vergine's 1570 restoration. It bears a strong resemblance to medieval and Renaissance fountains and might be passed over as derivative. But there is nothing derivative about its profile. The undulating dialogue between positive and negative space is reminiscent of monumental ancient column bases. Like so many of Rome's fountains, it was moved—in this case, to make way for the Fontana dei Quattro Leoni (Four Lions Fountain), and then ended up in storage for years before moving here in 1950.

19.56 masl

18.95 masl

14.72 masl

Fig. 3.9. The hydrometer at the church of San Rocco. Flood levels: 19.56 meters above sea level (masl) in 1598; 18.95 masl in 1530.

From there, Vicolo degli Acquaroli (Water Carrier's Lane) led to **Porto degli Acquaroli (Water Carrier's Gate),** with steps down to the Tiber. This was one spot where the *acquaroli,* water sellers, worked. They then carried their barrels to storage spaces, where the water settled for a week before being decanted into smaller barrels to take to their customers. Beyond their gate is Santa Lucia della Tinta (St. Lucy of the Dye-Works). Wool makers had a purging basin at the Trevi. From there, they took their cleaned and spun wool to dye-works along the river. Like the tanners and butchers working along the Tiber, dyers disposed of their runoff in the Tiber. This neighborhood also has the Fontana dell'Orso (Bear Fountain), which recalls a Renaissance hostel with that name that stood nearby. Everyone important stayed there. While you're here, take a moment to notice the difference in elevation between the upper roadway along the Tiber and this much lower street. This is one of the easiest places along the river to gain a sense of the monumental effort to protect the Campo Marzio from flooding.

Death is nothing new on the Tiber. In 1204, some fishermen presented Innocent III (r. 1198–1216) with dead babies they had caught in their nets. Unwed

mothers had purportedly thrown them into the river to avoid shame. In response, Innocent converted part of the eighth-century English pilgrims' hostel, the Schola Saxorum, into a foundling hospital named Santa Maria in Sassia (now Santo Spirito). At night, unwanted babies were placed inside a turntable built into the hospital wall. Reinstituting this tradition—a safe place to leave babies— might have prevented another tragedy. A desperate mother clutching her twin four-month-old daughters might not have committed suicide and infanticide by jumping from Ponte Testaccio in 2018.

The mournful river was a convenient tomb for adult corpses. The body of Pope Formosus (r. 891–896) was exhumed and placed on St. Peter's throne to stand trial by Stephen VI (r. 896–897). Stripped of his papal vestments, he had three fingers (those used for benediction) severed from his right hand. He was reburied for a few days then re-exhumed and thrown into the Tiber, which then tossed him back on the shore further downstream. Another pope, this time the antipope, Clement III (r. 1080–1100), was also exhumed shortly after his death and flung into the Tiber.

Ingrid Rowland suggests that the Tiber canceled any evidence of wrongdoing. This practice was old: Cassius Dio (155–235) reports that after criminals had been garroted in jail, their bodies were exposed (often for several days) and then pitched into the Tiber for burial. Some people believed that Nero's bones were taken from his tomb and thrown into the river by Paschal II (r. 1099–1118), to exorcise the site. Murder victims were dumped here too. Juan Borgia, son of Pope Alexander VI (r. 1492–1503) and brother to Cesare and Lucrezia, was fished out in 1497 near the church of San Girolamo, a location frequented by scavengers. A witness reported that he hadn't spoken up immediately because "he had seen over a hundred bodies tossed into the Tiber without ever anybody troubling to know anything about them." But enough of this misery.

❧

Finally, walk by Ponte Sant'Angelo (originally Pons Aelius), where optimism is rekindled. Praising its proportions and composition in his *Trattato di Architettura* (Treatise on Architecture) of 1464, the theorist Filarete writes, "Truly, the ancient ones (like Ponte Sant'Angelo) are much more beautiful than the modern ones." This was before Clement VII had statues of saints Peter and Paul mounted on the left-bank entry, and before Bernini's ten angels alighted along the balustrades.

Here, as at Augustus's mausoleum, much has changed, but the big ideas, the ambitious buildings, and the grand ancient and Renaissance schemes are some-how more alive. When you turn to face south, you see a tripartite road system open before you. Modern roads have disturbed the original design, but straight ahead the street now called Via del Banco di Santo Spirito led to Via Papalis, along which the new pope made his ritual walk, called the *possesso*, from St. Peter's

to San Giovanni in Laterano, outside the Mura Aureliane (Aurelian Walls) to the south. This was the most important east–west street in medieval Rome.

Ponte Sant'Angelo is not only handsome; its design is intelligent because its four piers allow a central arch that doesn't impede the Tiber where it flows fastest, in the middle of the river. The bridge was restored after portions of the balustrade collapsed during the 1450 Jubilee, killing hundreds of pilgrims. Later, cars and buses became a problem, and now it is a splendid pedestrian bridge. An automobile bridge, Ponte Vittorio Emanuele II, stands downstream. If you pause halfway between the two, the ghost of Ponte degli Alari, a beautiful steel bow-string arch truss bridge, might appear. Completed in 1891 and modern in every sense, it spanned the Tiber until 1915, when it was demolished and replaced by Ponte Vittorio Emanuele II, which hides its modernity under a cloak of classical revival stone and ponderous sculptures.

Just downstream below a dangerous bend stood the ancient Pons Triumphalis, also called Pons Neronianus because it connected to Nero's Circus (the site of St. Peter's). It had probably collapsed before Hadrian built his bridge. This bend between Ponte Sant'Angelo and Pons Triumphalis was treacherous both on and below the water. Boats heading downriver needed to stay in the center of the river and pass safely between the second and third piers of the ruined ancient Pons Triumphalis, and avoid the mills on both banks. Although clearly a hazard, some ruined pylons near the right bank still lurk underwater; they remain for mysterious reasons.

Close to the river is the church of **San Giovanni dei Fiorentini,** built by Rome's Florentine population. Rich bankers, they controlled prime real estate that became more valuable when in 1504 Julius II (r. 1503–13) built Via Giulia, a straight street, leading almost, but not quite, to Ponte Sant'Angelo, "for the convenience and benefit of the public." That's what popes declared when they wanted the Roman Council to pay for the work (including fountains), all the while violently commandeering private properties and slicing through existing neighborhoods. At the same time, Julius built Via della Lungara, a parallel street on the right bank to link Trastevere to the Borgo. This project wasn't as rancorous. His goal was to build a new bridge at the Via Giulia terminus to link the riverbanks and to relieve congestion at Ponte Sant'Angelo.

The bridge wasn't built, but the church was. Its story is one of derring-do; the site is in absolutely the wrong location, at a major bend where the Tiber liked to chew up the bank. Formed millennia ago, the big oxbow was vulnerable as water gouged out the right bank, dumping its alluvium farther downstream, then flew around the curve to try the same on the left bank. A meander makes it appear that the river is taking its time, but it is actively seeking the shortest course to the sea: taking from one side and giving to another. The architects despaired, but finally the church was built. Everything that made this bend the wrong place for

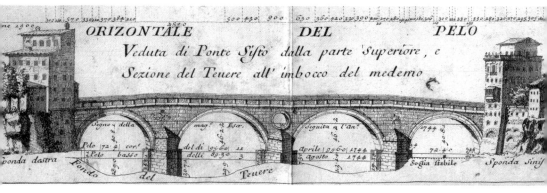

Fig. 3.10. *View of the Ponte Sisto* (detail of *The Tiber River from Malpasso*). Andrea Chiesa and Bernardo Gambarini, 1746. Vincent Buonanno Collection.

the church and a terrible spot for a bridge made it a perfect place for floating river mills.

A slow walk down Via Giulia to Vicolo della Moretta and Ponte Mazzini is next. It's a pleasant walk past sixteenth- and seventeenth-century palaces, but there aren't any elegant fountains. There is only one nasone and one defunct semipublic drinking fountain. You can see courtyard fountains by peeking through palace gates.

Palazzo Ricci-Sacchetti, further along on the left, offers a sad, vandalized façade fountain. **Il Puttino (The Putto)** must have been a strange sight even when new. There is a niche framed by caryatids. In the center, a boy rides two entwined dolphins. The fountain spigot attached where his genitalia would be is missing. The sixteenth-century palazzo has changed hands several times; its first owner was Antonio da Sangallo the Younger, then Cardinal Ricci da Montepulciano, then Tiberio Ceuli, whose coat of arms was hacked off the fountain frame.

Past the Carcere Nuove (New Jail) is Vicolo del Malpasso, which loosely translates to the "Street of the Bad Steps." It should have been named Vicolo Puzzolente (Smelly Street), because an open drain ran here for centuries. Considered an important feature in this neighborhood, the drain bore a lovely name, Chiavica di Santa Lucia. Poor St. Lucy. This area overlies the ancient stables of Augustus, and later, **Piazza Padella (Frying Pan Piazza),** and the church of San Nicola degli Incoronati. In the sixteenth century, the neighborhood's inhabitants—water sellers, washerwomen (they had their own large laundry house in the piazza), prostitutes, hostel owners, and their lodgers—were characterized as the "most vile" people.

Follow Vicolo della Scimia (Monkey Street) at the opposite corner of the Carcere to the Tiber, where you can cross to the right bank at **Ponte Mazzini.**

Looking downstream from the bridge is a good place to think about river dynamics. Agrippa built the Pons Agrippae south of here, probably before 19 BC. Restored in AD 147 and later abandoned, a new oxbow had already started to form. The current, battering the pier on the left bank, became turbulent, undermining the structure. His bridge was dismantled and rebuilt downstream as the Pons Antoninus at a more stable position. That site seemed safer. Alas, the bridge, with its statues and inscriptions, collapsed, probably during the 799 flood. Apparently, it was a humdinger. Father Tiber simply knocked the entire bridge over.

Just in time for the 1475 Jubilee, Sixtus IV (r. 1471–84) inaugurated **Ponte Sisto,** built upon its ruined foundations (fig. 3.10). Its design—sensible and happily beautiful—is strong. Although its plan breaks a cardinal rule of bridge design, that is, having an odd number of arches and an even number of piers as at Ponte Sant'Angelo to avoid turbulence in the center of the bridge, its architect opened the spandrel of the center pier with an oculus to allow floodwaters to swoosh through, relieving pressure. It has been damaged by floods but never to the point of collapse. Before you collapse, this is a good place to stop.

Bibliography

For the Tiber River, its bridges, floods, and inscriptions, see subject bibliography (especially Di Martino et al. 2017 and D'Onofrio 1980), Chiesa and Gambarini 1746, Filarete 1464, Liverani 1999, Long 2018, Richardson 1992, Rinne 2010, Tacitus *Histories* 1:86, and Virgil *The Aeneid*, 8:30–32; for pilgrims, see Belloc 1902 and Birch 1998; for hydrodynamics, see Castelli 1628; for twentieth-century planning in general and Mussolini, the City of Sport, and the Olympic Village, see Fried 1973, Insolera 1962, Katz 2003, and Kostof 1973; for Villa Madama, including Raphael, Tolomei, and Vasari, see Coffin 1979 and 1991 and Shearman 1983; for eyewitness reports, including Diaconus, see D'Onofrio 1980 and Villani 1846; for Benvenuto Cellini, see Cellini 1927; for ports and embankments, see Courtney 2003 and Marder 1980; for mausolea, see Blake 1947, Boatwright 1987, and Coarelli 1997; for the Colonna and Orsini, see Ajello Mahler 2012, Brentano 1991, and Carocci 2016; for prostitutes, see Cohen 1998; for Villa Medici, see Andres 1976, Butters 1989–91, and Coffin 1979 and 1991; for fountains, see subject bibliography (especially D'Onofrio 1986) and Lazzaro 1990; for trades, see Delumeau 1957 and 1959, Martini 1965, Rinne 2021, Sanfilippo 2001, and Segarra Lagunes 2004; for drowning, violence, and murders, see Cassius Dio 1987, Duchesne 1886–92, Evangilisti 2018, Katz 2003, and Rowland 2011; for Renaissance architecture and planning, see Ceccarius 1940, Ingersoll 1994, Insolera 2002, Rodocanachi 1912, and Salerno et al. 1975; for mills, see Mariotti Bianchi 1977; for Piazza Padella, see Rinne 2021.

4

Ponte Sisto, the Tiber Island, and Their Neighboring Shores

Tiber River Pilgrimage II: Piazza Trilussa to Pons Sublicius, ~3 kilometers

Piazza Trilussa, on the right bank, features another peripatetic fountain from 1613 that sits above a flight of stairs. It originally stood on the opposite bank, at the end of Via Giulia. Already a bit battered in the 1870s, with large portions eroded away by the water and constant abrasion from buckets and horses, the fountain was haphazardly dismantled for the embankment walls. What wasn't stolen during demolition was stored in warehouses around town. Fifteen years later, the pieces were reassembled here. Not a very elegant solution, this aloofness, but originally there was a little garden around back. That has disappeared, but as late as 1937 it was described as "one of the most delicious and frequented oases of Trastevere."

Threading forward and to the right you reach Via della Lungara. The road begins at **Porta Settimiana,** once a freestanding arch that is now part of the Mura Aureliane (Aurelian Walls). Beyond it lie two diversions for the end of a long morning. Either is a perfect finish, but to see both would be even better. Because **Villa Farnesina** closes at two o'clock p.m., it should be visited first. By 1505, Agostino Chigi, a Sienese banker and Rome's richest man at the time, owned property along the Tiber, where he built his villa and garden. Pope Paul III Farnese (r. 1534–49) purchased the adjacent property in 1537. Forty years later, the Farnese family bought the Chigi property, joined the two together, calling it the Farnesina (Little Farnese), because their palazzo was directly across the river. Michelangelo even designed a bridge (never built except as an art installation in July 2021) to link them.

No one comes here today for the fountains or the once-famous grotto that disappeared long ago. It was the most distinctive feature of Chigi's garden. Built underneath the garden's dining loggia at the river's edge and lit from above, the

64

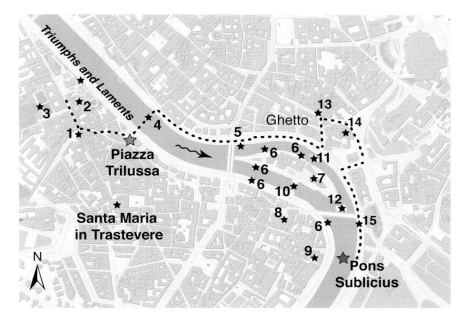

Fig. 4.1. TIBER RIVER PILGRIMAGE II: 1) Porta Settimiana, 2) Villa Farnesina, 3) Orto Botanico (Botanical Garden), 4) Ponte Sisto, 5) Cento Mole (One Hundred Mills), 6) mills, 7) San Bartolomeo all'Isola/Tempio di Esculapio (Temple of Aesculapius), 8) San Benedetto in Piscinula (Saint Benedict at the Little Pool), 9) Giardino di Donna Olimpia, 10) Ponte Cestio, 11) Ponte Fabricio (also called Quattro Capi), 12) Pons Aemilius/Ponte Rotto, 13) Sant'Angelo in Pescheria, 14) Teatro di Marcello, 15) Cloaca Maxima.

grotto was *in* the river—the Tiber literally washed into and through it to fill a pool surrounded by a bench. Obviously, the location was questionable, and perhaps a little daunting for the guests. The grotto and the loggia washed away in a Tiber flood, as things do, perhaps as early as 1530. At least half the villa property disappeared in the 1880s for the embankment, when one of ancient Rome's many Tiber wharves (this one for wine) and a villa (its rooms found filled with spring, not river water) were discovered here and then destroyed.

People come to the Farnesina for the sublime, perfectly proportioned villa building designed by Baldassarre Peruzzi, and for its transcendent frescoes, especially those in the loggias, *Cupid and Psyche* and *Galatea* by Raphael. Those frescoes, among the most handsome in Rome, are well described in the museum handout, so we'll dwell on a different one. The Sala delle Prospettive (Room of Perspective Views), where Chigi celebrated his wedding dinner in 1519, is pertinent to our aquatic agenda. Peruzzi painted the perspective views set between fictive columns that take in urban and rural landscapes. While *putti* fly overhead and gods and goddesses peer down, you look through real windows to a real garden, then turn to look through the fresco "windows" onto an illusory balcony

with views of countryside villages and Rome with the Tiber flowing outside, just as it did five hundred years ago.

Turning back to Porta Settimiana, Rome's **Orto Botanico (Botanical Garden)** is on the opposite side of the street next to Villa Corsini (formerly Villa Riario), begun in the sixteenth century. The gardens are quiet and shady, and there is plenty of water. Living springs along the Janiculum and Vatican slopes have existed since before Romulus. Their presence is one reason why elite ancient and Renaissance Romans built their gardens here along the unpredictable river. In the sixteenth century, Cardinal Raffaele Riario built a nymphaeum around one of the springs. Then, Cardinal Neri Corsini began creating a formal garden in 1736 with elaborate fountains and a *"teatro delle verdure"* (green amphitheater), now destroyed.

Many ancient *horti* are known only from inscriptions or vague references in letters. We know of one because the first-century AD poet Martial wrote an epigram lamenting his noisy neighborhood and his jealousy of a friend who owns a piece of *rus in urbe* (country in the city) where it's quiet and possible to sleep. There were fabled gardens like those of Julia Agrippina, mother of Nero, that started where St. Peter's now stands and continued down to the river; the Horti Getae, owned by Caracalla's brother (and later by Septimius Severus r. AD 193–211), where the Botanical Gardens now stand; the Horti Clodiae, where tales of debauchery kept gossipmongers busy (wealthy Clodia, its owner, entertained her many lovers here); and further south the Horti Caesaris, where Caesar purportedly hid Cleopatra while she resided in Rome.

Specimen trees of all varieties shade the weary in the gardens. Some, like the *Quercus suber,* are among the *monumenti centenari* (monumental centenarians), that is, trees known for their size and antiquity. This oak tree is about twenty-two meters tall. It isn't an ancient tree, but one of many meant to replicate the Janiculum's ancient forest. There is also a seed bank of native Italian flora and a *giardino dei semplici* (garden of medicinal herbs). Among the fountains is the Scalinata degli Undici Zampilli (Staircase of Eleven Jets) (fig. 4.2). This cascade fountain from 1741–44 is unfortunately often in disrepair. Shaded by trees on either side (one of which is four hundred years old and more than twenty-five meters tall), it is aqueduct-fed, but there are smaller ground-level pools and rivulets that are still spring-fed. One spring is thought to have fed the ancient Horti Clodiae fountains.

At the **Ponte Sisto** there are two fine vistas. Walking a few steps toward the east on Via dei Pettinari you reach Via Giulia, to stand in the Ponte Sisto fountain's original location. If you had walked down Via Giulia from the north, the fountain, with a six-meter-high gushing cascade, terminated your view and gave a final punctuation to the sentence of the street. All that is gone. Now there is only traffic. But the atmosphere brightens if you walk back toward the bridge, pause before the stoplight, and turn left to climb the short flight of stairs. Look across

Fig. 4.2. "Fontana della Scalinata degli Undici Zampilli (Staircase of Eleven Jets)." Orto Botanico (Botanical Garden). Ferdinando Fuga, 1741–44. Published in Giulio Magni, *Il barocco a Roma nell'architettura e nelle scultura decorativa* (1911–13), 3:56.

the river. First, you see the Piazza Trilussa fountain struggling to look important. But look up to the top of the hill behind it, where a triumphant fountain, Il Fontanone, marks the terminus of the Acqua Paola aqueduct completed in 1612 by Paul V (r. 1607–22). It's a glorious view—mother and child. The view looking down from the fountain is even better. It is a tantalizing prospect, and we will get there soon enough, just not today.

Lingering a little longer on Ponte Sisto, you can think about all the loot that was dredged from the river. Everything falls into the Tiber, from hair combs that never stay put to thousands of coins and sculpture. A life-size bronze Bacchus was pulled from the sixty meters of alluvium on the Tiber bed when building Ponte Garibaldi in the 1880s.

From the bridge, look upriver and down to the sidewalk, where South African artist William Kentridge translated the Tiber's version of Rome's history on this straight stretch of the river wall (fig. 4.3). Installed in 2016, his five-hundred-meter-long mural, *Triumphs and Laments,* developed over many years, with a team led by artist Kristin Jones. Water created the frieze. Power washing around ten-meter-high stencils revealed the figures hiding in the accumulated dirt. Rome's history—from the she-wolf suckling the twins to today's African immigrants—was stenciled here. It was magnificent. Meant to be temporary, the mural faded away, eroded by rain, floods, pollution, and graffiti. Now nothing remains.

❧

The Tiber's course between Ponte Milvio and San Paolo fuori Le Mura is circu-itous and long. The Tiber Island, just downstream, comes close to dividing the urban course down the middle, if not physically then at least symbolically. Livy, citing the authority of legend, deemed that the Tiber Island was created during Tarquinius Superbus's reign (535–509 BC), when grain from his fields in the Campus Martius was thrown into the river and stuck to its bed in the shallow water. Over time, the grain trapped and accumulated enough alluvium to create a small landmass stable enough to support buildings. Geological evidence, however, confirms that the island is part of the Capitoline ridge to the east.

The healing cult of Aesculapius was established on the island in 291 BC when a serpent, brought back from Epidaurus in Greece, the center of the god's cult, escaped the ship and slithered ashore. This serpent was good, unlike the bad ones swimming into Rome with the floods, bringing plagues. Isolated from the banks, the island is a logical site for a healing center and is currently home to the Fatebenefratelli and Jewish hospitals. If you're injured while in Rome, you could come to the Fatebenefratelli for treatment, where there is a sweet courtyard fountain with turtles, and in the basement there are ruins of the ancient temple. To the untrained eye (like mine when I began thinking about water in Rome), the island seems an obvious place to build a bridge. Wrong. The first bridge was further south. The island was off-limits, due in part to its role as a healing site.

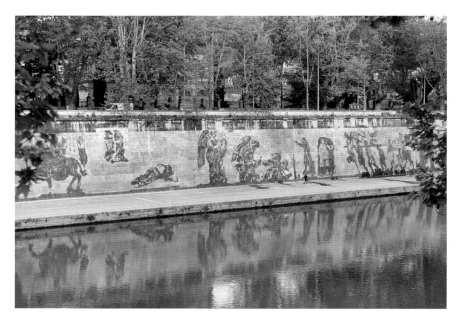

Fig. 4.3. *Triumphs and Laments.* William Kentridge, 2014. Photograph by Sebastiano Luciano, 2016.

Rapids near the island kept most boats from sailing upriver. As Procopius reports, "They do not use sails. . . . The river winds about exceedingly and does not follow a straight course, nor can oars be employed . . . since the force of the current is always against them. Instead . . . they fasten ropes from the barges to the necks of oxen, and so draw them . . . up to Rome. . . . On the other side of the river, as one goes from . . . Ostia to Rome, the road [left bank] is shut in by woods and . . . lies neglected, and is not even near the bank of the Tiber." You'll see the reengineered rapids as you cross the bridges.

Lionel Casson suggests that at least three hundred barges, called *naves codicariae,* plied between Portus (it replaced Ostia as the main port in AD 42) and Rome at the time of Tacitus. Their cargo delivered, they drifted downstream to start again. More nimble along the difficult course of the intra-urban Tiber, smaller flat-bottomed boats, called *sandalae,* served smaller docks upstream for local storage and distribution. Later, when the Aurelian Walls incorporated the Tiber's left bank during the 403–404 restoration, the defensive line included *posterule* (fortified gates) and towers.

Rapids impeded river traffic, but their strong currents proved ideal for water mills, especially at the island. After the Goth armies destroyed the Aqua Traiana in 537 and the Janiculum mills ceased working, Belisarius, Emperor Justinian's (r. 527–565) commander during the 537 Sack of Rome, had the mill's grindstones moved temporarily from the Janiculum and mounted on floating barges until the aqueducts were restored. When the Janiculum mills failed completely, river mills reappeared in the tenth century at the island and along the right and left banks (fig. 4.4). They soon multiplied all along the riverbanks.

In the late fifteenth century, with so many mills around the island, the area was called **Cento Mole (One Hundred Mills)** (fig. 4.5). Via della Mola led naturally enough to a mill, this one at the ghetto's edge, called La Mola della Regola, or alternately Molina della bella Giuditta. There were several small chapels near river mills in this area. They're easy to spot by their historic names. Most were lost in floods or sliced off for the embankment walls, including Santa Maria in Capite Molarum ("head of the mill"). Another, Sancti Thomae in Capite Molarum, survives as San Tommaso ai Cenci.

The Tiber's other industries included brickworks near Pons Agrippae, potteries in Via dei Vascellari in Trastevere, dye-works near Santa Lucia della Tinta, and catgut factories for violin strings on Via dei Cordari, all near the shore. The tanners clustered outside the ghetto on Via della Concia dei Vaccinari (Cow-Hide Tanners Street), which no longer exists. The butchers were close by. They depended on each other, and like the millers they relied on the river: a strong current to turn mill wheels also quickly flushed bloody waste.

In 1826, there were twenty-seven Tiber **mills,** many at the same site for centuries, as in Trastevere, with a "Via delle Mole" and "la contrada delle Mole"

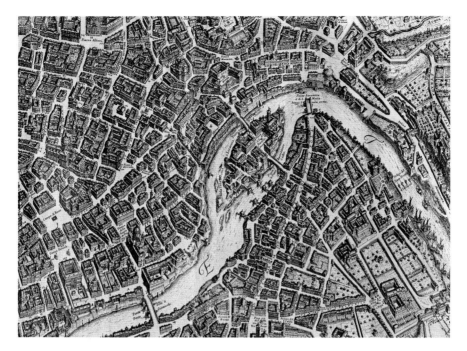

Fig. 4.4. *The New Map and Elevation of Rome* (detail). Giovanni Battista Falda, 1676. Vincent Buonanno Collection. From left to right: Ponte Sisto (bottom left), the Tiber Island, floating mills along the shores, the Jewish ghetto (top center-left along river), Ponte Rotto, and Trastevere (bottom). North is to the left.

Fig. 4.5. *View of Rome with the Tiber and Ponte Sisto*. At Cento Mole looking north to Ponte Sisto. Aegidius Sadeler, 1606(?). Rijksmuseum.

Fig. 4.6. Wellhead, San Bartolomeo all'Isola, 11th century.

(the neighborhood of mills), where many millers lived from the sixteenth century. Floating mills remained until the embankment was built, their picturesque image a favorite subject of landscape painters and printmakers. But they impeded traffic and aggravated flood damage, especially when the mills became unmoored and slammed into bridges, becoming stuck between piers, constricting the water's flow.

An eleventh-century wellhead stands inside the church of **San Bartolomeo all'Isola** on the island (fig. 4.6). The well is ancient, perhaps dating to the founding of the **Tempio di Esculapio (Temple of Aesculapius)** in 291 BC. Before that, a temple dedicated to our favorite river god, Tiberinus, stood here. His temple explains in part why the island remained sacred for centuries, despite continual flooding. The wellhead, carved with images of Christ and saints, has deep grooves cut into its lip by ropes drawing up water that attest to centuries of use and enhance its beauty.

The frescoed chapel of the Romanorum Molendinariorum, the Roman confraternity of millers, is indispensable, but most visitors never enter this quiet refuge, although it is only six steps up from the altar. Millers were hyperconscious of the Tiber's whims. Many of their mills ran at the island, a convenient spot for their confraternity, founded in 1497, to meet and worship. The island was especially vulnerable, and mill owners were in constant peril. Eyewitnesses describe floods repeatedly sweeping mills away, killing their operators, and destroying their

Fig. 4.7. Fresco to the left of the San Bartolomeo all'Isola altar showing a Tiber mill, ca. 1660.

supplies. The mills are now gone, but fragments of the frescoes, painted near the floor level of the chapel, remain (fig. 4.7). Framed by ribbons and garlands of roses, the frescos, rendered in the warm colors of the grain they ground, show the Tiber, a mill with a gangway between the millhouse and the shore, a millwheel, a miller, and a donkey with sacks of grain being led to the millhouse along the footbridge. The artist rendered the water's current flowing under the gangways and the water churning away from the millwheel; like Virgil's "tawny" Tiber, it is painted in golden-honey and cream colors.

Today, the island is a haven for weary Romans and travelers seeking a relatively quiet and somewhat "natural" (there are volunteer trees) spot to enjoy sun and the sound of rushing water. To get to the water, take the stairs on the west side of the island, facing upstream, to the "Tiber Beach," an encircling walkway at river level. The east side of the island is cool on hot afternoons. A first-century AD carving rendering the island as a ship is located here—literally at the prow of

the island heading downstream (it's under the staircase with the life preservers). Look carefully and you'll see a caduceus and snake carved onto the ship. But in the summer, an outdoor cinema blocks the view. There are other summer pleasures along the river. In the bend between the Ponte Vittorio Emanuele II and Ponte Principe Amedeo Savoia Aosta there is a temporary sand beach, and for a few weeks a grassy lawn with deck chairs might sprout at Piazza Tevere between Ponte Sisto and Ponte Cavour.

Notwithstanding a tradition of diving from bridges on New Year's Day, few people dare swim in the Tiber today. Unfortunately, early seventeenth-century Romans needed reminding that nude Tiber bathing was forbidden, particularly on the Trastevere side just below Ponte Sisto. Not only did people whose windows overlooked the beach, or those who walked by, object; so did the Trastevere women who did their laundry here. The male swimmers apparently swore like sailors (and perhaps they were) and engaged in "dishonest acts." Essentially, if they wanted to swim, they needed to keep their *mutande* (underpants) on and stop swearing! Seems sensible. The Tiber continued as a public plunge with plenty of regulations, including against swimming nude. Single-sex bathing sites were created along several sections of the beach farther north in the nineteenth century.

Pons Aelius, Pons Neronianus, Pons Agrippae/Antoninus, Pons Aurelius, Pons Cestius, Pons Fabricius, Pons Aemilius, Pons Sublicius, and Pons Probi: these were ancient Rome's Tiber bridges. By the late fourth century, the Pons Neronianus lay in ruins. Pons Probi survived as the medieval Pons Theodosi. It succumbed to a Tiber flood sometime before 1018, but its ruined piers remained until the 1880s. Petrarch saw the ruined masonry piers of Pons Sublicius, Rome's oldest bridge, when he visited Rome in 1337. Still visible in 1484, Sixtus IV ordered their destruction.

Petrarch might also have visited the little church of **San Benedetto in Piscinula (Saint Benedict at the Little Pool).** Because we're near the river, "*piscinula*" most likely refers to a pool to keep fish fresh for market. Don't let the façade fool you: this is an early twelfth-century church and an eloquent raconteur of water woes. Besides the restful quiet and subdued lighting, there are three things Petrarch, and you, would notice immediately: the spolia columns, the frescoes, and the *cosmatesque* floor (fig. 4.8). First are the columns: none match because they were scavenged from different ancient buildings. There are Corinthian, Ionic, and Composite capitals on columns of various heights and stone bases. Second are the twelfth-century frescoes. Only fragments remain, but they are striking even if you are tired of churches and religious subjects. They are beautiful but grim reminders that the Tiber's ferocious floods have worn away the fugitive colors of the fragile frescoes.

Then there is the original cosmatesque floor. It has shifted softly, creating an undulating, wavelike surface of swirling rondels that in turn reminds us that the

Fig. 4.8. San Benedetto in Piscinula, 12th century. Subsidence of the *cosmatesque* pavement is seen in the lower-right corner.

Tiber's soft, unstable alluvial shores are nearby. The *tesserae,* like the columns, are spolia, scavenged from ancient buildings. The stones are original to larger decorative panels from wall facings and floors found in palaces, temples, and baths; the deep wine-colored porphyry, for example, was only used for imperial projects. Look closely: see how the soft white marble, worn away after nine hundred years, creates shallows; the durable porphyry and granite are the crests of the swirling waves. You can feel the waves and troughs by drawing your foot slowly across the floor.

The cosmatesque style of inlay stonework became associated with the Cosmati family. Working between the twelfth and fourteenth centuries, the family became known for their patterns of checkerboards, snowflakes, stars, ribbons, circles, knots, and bands fashioned from small stone squares, triangles, parallelograms, rhomboids, hexagons, and circles. Four colors dominate: gray granite, white marble, red/purple porphyry, and green serpentine, with a smattering of golden-yellow *giallo antico* marble. The patterns sometimes surround larger

central stones. Interwoven white marble bands pull everything together. Quarried in Greece, Numidia, and elsewhere in the Roman Empire, the blocks were shipped across the Mediterranean and carried up the Tiber on barges, and then hauled upstream by oxen.

The Mattei, an influential family, held a compound in Trastevere near the church of San Benedetto in Piscinula by 1372. The Mattei produced a remarkable number of cardinals (eight in all) and at the same time were influential merchants. They also held a hereditary position, Guardiano de' Ponte e Ripe (Guardian of Bridges and Riverbanks), since at least 1271, and into the eighteenth century. Their private battalion controlled Ponte Quattro Capi, Ponte Santa Maria, the Ripa Grande, the Ripetta, and the Marmorata. One paid them to cross from Trastevere to the left bank. Soldiers—eleven at Ponte Quattro Capi alone—and wood gates barred the bridges. The private army's ability to maintain order was particularly important during the Sede Vacante, any time the papal throne was vacant, and codes of civil conduct were ignored.

The embankment completely refashioned this medieval and Renaissance neighborhood. At this bend of the Tiber, along Lungotevere Ripa, there once were fortified family strongholds with tall defensive towers stationed at the bridgehead; mills at the ruins of Ponte Santa Maria and the church of San Salvatore a Ponte Rotto; fishing sites; soap factories; and private gardens from antiquity through the late nineteenth century, such as the **Giardino di Donna Olimpia** with the Lumaca, Bernini's "Snail Shell Fountain." The church, also known as San Salvatore di Barilari, became the chapel of the confraternity of barrel-makers (both for wine and water) in 1540.

Only four bridges survived into the sixteenth century: Pons Aelius, now called Ponte Sant'Angelo, crossing to Castel Sant'Angelo; Pons Cestius and Pons Fabricius, now **Ponte Cestio** and **Ponte Fabricio** (also called **Quattro Capi**), at the Tiber Island; and **Pons Aemilius,** by then known as Ponte Maggiore (later as Ponte Senatorio, then Ponte Santa Maria, and now **Ponte Rotto**), which crossed from the Forum Boarium area to Via Aurelia on the right bank.

Like pilgrims and travelers, we will cross the bridges, alone or in groups, to thread our way through Rome's history as best we can. If you are still on the island, walk to the northern point of the "beach" encircling its base. Turning to face the island, Pons Fabricius (62 BC), the bridge to the Temple of Aesculapius, is to your left. It must have replaced a *traiectus* (ferry) poled by a ferryman along an overhead towline to transport patients to the island. Pons Cestius, completed by 27 BC, linked the island to the right bank. But when the embankment was built, it was disassembled and some parts salvaged, and then reassembled with new and ancient materials in a different design.

Built of wood in 615 BC, Rome's oldest bridge, Pons Sublicius, stood just below the island. In 598 BC, a momentous battle, one to rival Constantine's

Fig. 4.9. *Ponte Rotto over the Tiber.* Gerard ter Borch the Elder, 1609. Rijksmuseum. The center caisson is a fishing spot.

victory on Ponte Milvio, took place here when Horatius Cocles, with a small group of soldiers, routed the Etruscan army. As the Etruscans advanced from the right bank, Horatius and two defenders standing on the bridge halted their progress. He ordered his other soldiers to destroy the bridge behind them (on the Roman side) and his two aides to retreat. With the bridge crashing behind him, halting the enemy, at the last minute Horatius jumped into the river to safety (after praying to Tiberinus), while Etruscan soldiers, wearing armor, drowned.

Bridges, like everything along the river, are vulnerable to flood damage. Sometimes they were rendered impassable. Cassius Dio mentions that the flood of 32 BC "completely wrecked" Pons Sublicius, and that it washed away in 23 BC, when he reported the city navigable by boat for three days and again for seven days during 5 BC. Considered sacred, repairs were made whenever the bridge was damaged, a frequent occurrence. Although it may have ceded some importance to Pons Aemilius, Rome's first stone bridge of 179 BC, Pons Sublicius remained the primary link to Via Portuensis and the salt marshes near Ostia until the fifth century AD.

Pons Aemilius, linking Via Aurelia to the Forum Boarium, changed names over the years; it was called Ponte Maggiore in the twelfth century, then Ponte Senatorio for a time, then Ponte Santa Maria. Changing names didn't make it more resilient. After it was damaged by the 1422 flood, Martin V began to restore it in 1426, and Nicholas V completed it for the 1450 Jubilee. It collapsed in the

1557 flood, and Gregory XIII (r. 1572–85) oversaw its repair between 1573 and 1575. It was considered so successful that its restoration architect, Matteo Bartolani da Castello, earned the astounding sum of twenty-five hundred scudi and received Roman citizenship. It's impossible to give an "in today's dollars" figure, but that was a huge sum. Fortunately, Castello died before the bridge collapsed for the final time in the 1598 flood. A fragment of Ponte Santa Maria, now called Ponte Rotto (Broken Bridge), stands just below the Tiber Island (fig. 4.9). One remaining arch was demolished in the nineteenth century.

The location of Ponte Santa Maria, below the island where the two streams reunite to a single channel, preordained its destruction. Water flows faster in narrower streams. There is also more turbulence. As the streams comingle, their turbulence and velocity increase before returning to their normal flow. Ponte Santa Maria's central pier stood at that confluence and couldn't survive the continued pounding of the combined flow.

In 1594/95, Clement VIII had the Acqua Felice distribution pipes laid across Ponte Santa Maria as far as Piazza Santa Maria in Trastevere and the Ospedale di Santo Spirito in the Borgo. When the 1598 flood destroyed the bridge, water ceased flowing, as did the free flow of traffic between the right and left banks, which forced everyone to use the island bridges.

Ferries were once ubiquitous, until they were supplanted by bridges, as when Pons Fabricius took the place of an island ferry, and Pons Sublicius replaced a ferry where Via Salaria connected to the Salinae and salt traders paid their tolls. But as ancient bridges failed, ferries again crossed where the traffic warranted near the sites of former bridges—for example, where Pons Aurelius once stood and where Ponte Sisto now stands.

From the medieval period until the late nineteenth century, the *barcaroli* (ferrymen) typically leased their landings from the Church. Ferries were everywhere, including at river gates in the Aurelian Walls: at the Posterula Domitia, Tor di Nona, Posterula della Pila, and Arco di Parma. During the medieval period, ferries crossed at the Ripetta, Vicolo della Barchetta, San Leonardo in Trastevere, Porto di San Giovanni dei Fiorentini, Porto della Barchetta ai Cevoli, Sant'Anna dei Bresciani, Sant'Eligio, and the Marmorata. Pope Julius II had a private ferry to speed his visits from the Vatican to Villa Giulia.

Ponte Fabricio has been known since the sixteenth century as Ponte Quattro Capi (Bridge of the Four Heads), named for the pair of ancient four-headed "Janus" figures found nearby, where there had been a Janus bridge in the earliest days of the Roman republic. As the guardian of gates and doors, the god Janus looked "forward and backward" and protected "coming and going" at the Janus bridges, named for him. This was one of four permanently inaugurated bridges (no need to supplicate the gods) built at convenient locations across the Forum Brook, and later across the open channel of the Cloaca Maxima that replaced it.

They remained useful until the late second century BC, when the drain was finally vaulted and paved over.

Added to the Ponte Quattro Capi parapet in 1849, the battered heads have by now seen it all. With them as our guides, this is a perfect place to try to imagine the landscapes before the embankment walls irrevocably distorted the Jewish Ghetto on the east bank and Trastevere's west bank in the 1880s. Trastevere churches and half of the Villa Farnesina were lopped off. But the Jewish Ghetto experienced wholesale destruction under the guise of erasing diseases including malaria, typhoid, cholera, and tuberculosis—all chronic in Rome, especially near the river. To Raffaele Canevari, the embankments' engineer and designer, dismantling the ghetto, and building the embankments and the sewers and drains leading to them, was necessary for Rome to become a healthier, modern, European capital city. For him, these engineering "marvels" epitomized Rome as a city of reason and modernity that no pope had realized. Outdoing the popes was crucial to the new nation's identity.

Building the embankments altered the Tiber's intramural ecology in a manner not dissimilar to the Cloaca Maxima's wholesale destruction of the Forum Valley ecosystem. "Erasure" is the trendy word used to describe this kind of destruction. Trendy, but apt; this urban landscape was erased. Rome is still Rome, the Tiber is still the Tiber, but relationships between them have been erased and redrawn so often that their shared past is unrecognizable. Neighborhoods have been razored away, riverbanks filled in, bridges rebuilt, all surgically altering the river's profile (fig. 4.10). Excepting the island bulge, the embankment is one hundred meters wide for its entire length—engineered for efficiency. Huge swaths of both shores, together totaling more than five kilometers, were discarded. The litany of losses is mournful: the Tor di Nona wharf, where marble for Campus Martius projects was off-loaded; the Teatro di Apollo; nearly half of the Villa Farnesina; much of the ghetto; and more. The beautiful Ripetta had already been sacrificed for a new bridge (not the one you see today). So, we can't blame the embankments for that.

Canevari originally suggested linking the island with Trastevere and widening the left branch—that is, intruding into the Jewish Ghetto and eliminating Ponte Cestio. With a wider single stream, Ponte Fabricio would have to go too. For Romans, the island and its bridges are nearly as sacred as Romulus and Remus. With discontent growing, the plan was scrapped: the island and bridges were spared. Ponte Rotto was also on the chopping block, but as you can see, it's still there.

Jews had lived in Rome since the second century BC; many were emancipated Roman citizens. During the imperial period, so-called exotic Eastern religions, including Christianity, Mithraism, and Judaism, congregated in Trastevere. One building formerly used as a synagogue still stands on Vicolo dell'Atleta. During the later medieval period, many Jews moved to the area we now call the Jewish

Fig. 4.10. "Forma Urbis Romae." Published in Rodolfo Lanciani, *Forma Urbis Romae* (1893–1901), folio 28. The solid blue lines (proposed changes) show how the embankment walls altered the river's profile.

Ghetto, where a synagogue stood near Piazza Giudea by 1337. In 1555, Paul IV (r. 1555–59) irreversibly altered the ghetto when he built a gated wall (locked at night) to surround the area along the river where most Jews then lived (see fig. 4.4). When French magistrate Charles de Brosses visited Rome in 1739/40, he described the ghetto as "a perfect kennel." At that time, rhetoric focused on disease and filth as by-products of being Jewish. But the ghetto's maladies arose from its location, overcrowding, and the lack of adequate sanitation. These conditions were a direct result of prejudice and restrictions, placed by the papal government, that forced Jews to live, work, and socialize largely inside the ghetto.

After 1870, the papacy no longer controlled the ghetto, and Jews could live where they chose. Much of the ghetto was razed, its walls demolished between 1885 and 1888, and its population dispersed. More than three thousand persons were homeless; not many returned to the newly "sanitized" neighborhood. Mussolini and his Fascists also "cleansed" the ghetto. What they didn't complete, Hitler's Nazis tried to finish as they entered Rome toward the end of World War II. On the morning of October 16, 1943, the Nazis arrested 1,259 people in the ghetto at gunpoint and put them on trains to the Auschwitz-Birkenau death camps. Only sixteen returned.

The Nazis entered Rome like a triumphal army, with their prisoners on parade. But, as the Allied forces advanced northward, the Italian Resistance, including some Roman Jews, intensified its clandestine assaults. The Nazis cut the water supply (they blew up the Acqua Paola) and countered partisan attacks with indiscriminate massacres. On March 24, 1944, they seized 344 persons, mostly Jews, from around the city; herded them into the Campagna; executed them at Fosse Ardeatine; and left their corpses to rot in the cave where they were slain. It is possible to visit the beautiful and emotionally powerful memorial that marks the massacre site.

The **Teatro di Marcello** is difficult to miss. Built by Augustus to honor his nephew, it survived the long medieval period as a beehive of workshops and residences as people scrabbled into its abandoned spaces. Cardinal Giacomo Savelli (later Honorius IV, r. 1285–87) possessed and fortified the ruins in the late thirteenth century. The upper level became a palace, Monte Savelli, while individual shop owners remained on the ground level. Over time, alluvium from Tiber floods filled its ground level, and people moved to the second level. Mussolini removed its medieval accretions and Piazza Montanara (with its little fountain), which once fronted the theater, so that it could stand in isolation.

The Portico d'Ottavia is nearby, where a few columns remain near the pyramids of fresh artichokes on display at the restaurants. The artichokes change daily, but some of the columns have been here since Augustus built the porticus (around 27 BC), a covered colonnade enclosing a rectangular outdoor area, named for his sister. Temples dedicated to the gods Jupiter and Juno, a library, other civic buildings, and Greek sculpture stood here. A few of the Corinthian columns from the south temple remain in the façade of **Sant'Angelo in Pescheria.**

Rome's former open-air morning fish market stood beneath the temple columns since at least the twelfth century (fig. 4.11). On weekdays, fishermen could sell their catch anywhere, but on Saturdays all fish, whether from rivers, lakes, or the Mediterranean, were sold from here on rented stone slabs. Members of the *compagnia dei pescivendoli* (confraternity of fish sellers) could also sell birds, ducks, and game like rabbits.

Well into the nineteenth century, sewer drain mouths, especially the **Cloaca Maxima,** were the hot fishing spots. Various monasteries owned fishing platforms for their own use (following the tradition of fish every Friday). Like mills and the market stones, they could be rented out for income. There were platforms along the Marmorata (the ancient marble wharf) for northern pike; the Ripa Romea was the best spot for sturgeon; trapping eels took place between the pylons of Ponte Santa Maria; and for shad, with its prized roe, one used *giornelle,* nets that "turned all day" at Ponte Sisto. The best place to catch the delicate-tasting lupine, *perca labrax,* was "between the two bridges," that is, **Pons Sublicius** and Pons Aemilius.

Fig. 4.11. "Pescheria at Portico d'Ottavia in the Early Nineteenth Century." Published in Emmanuel Rodocanachi, *Rome au temps de Jules II e Léon X* (1912).

The confraternity was founded in 1571 or 1572, but the fishermen worked the Tiber long before that. They rented platforms, *peschiere,* along or in the river (attached to bridge pylons), especially between Ponte Santa Maria and Pons Probi at the Marmorata, where they placed their wooden fish traps below water. Trapped fish remained alive in complex woven trellis structures until they could be sold, often right along the river, but also, according to the statutes, "in any part of the city."

Much of Rome's early history unfolded where Pons Aemilius would later touch the left bank. Most famously, the twins washed ashore here and the she-wolf, as Ovid relates, licked them into shape with her tongue at the Lupercal Cave near the Palatine's base. In the nineteenth century, John Henry Parker describes the cave tucked in the bushes "with a gushing spring." Which cave was "the cave" is no longer certain, but it was on the northwest slope of the Palatine at the Tiber, where our next walk begins.

Bibliography

For Piazza Trilussa, see D'Onofrio 1986; for the Farnesina and Chigi, see Coffin 1979 and 1991 and Rowland 2005; for the Botanical Gardens, see De Vico Fallani, 1992; for horti, see Martial 1993, Purcell 2007, and Taylor et al. 2016; for Kentridge, see Eternal Tiber; for the Tiber River, its bridges, floods, and inscriptions, see subject bibliography (especially Di Martino et al. 2017), Cassius Dio 1987, Casson 1965, Ceen et al. 2015, Duchesne 1886–92, Holland 1961, Long 2018, and Petrarch 2005; for Tiber embankments specifically, see Canevari 1875, Courtney 2003, Insolera 2002, and Lanciani 1988; for Horatius Cocles, see Livy 2:10; for legends, including the Lupercal, see Livy 2.5, Ovid *Fasti* 3:285, and Parker 1876; for mills, millers, and San Bartolomeo, see Bevilacqua 1988, Mariotti Bianchi 1977, Procopius of Cesarea *History* 5.26:10–16 and Segarra Lagunes 2004; for ferries, see Delumeau 1957–59 and Lanciani 1988; for cosmatesque paving, see Severino 2012; for the Mattei, see Hüetter 1929; for Giardino di Donna Olimpia, see Gigli 1977–87; for the Jewish Ghetto and persecutions, see Benocci and Guidoni 1993, de Brosses 1897, San Juan 2001, and Stow 2001; for the Teatro di Marcello, see Ajello Mahler 2012 and Richardson 1992; for fish, see Smith 1877.

5
River of Fortune

Tiber River Pilgrimage III: San Nicola in Carcere to the Marmorata,
~1.3 kilometers (including the Aventine, ~3.3 kilometers); Marmorata to
Porta Ostiense, ~1.4 kilometers; Porta Ostiense to San Paolo fuori le Mura,
~2 kilometers (by foot or bus), not including the industrial district

The eleventh-century church of **San Nicola in Carcere,** with a fortified medieval tower as its campanile and a Renaissance façade, stands near the Teatro di Marcello. Hidden within it are the fossilized ruins of three ancient temples standing close together in what was the Forum Holitorium (Market Gardeners' Forum). The temples stood on high podia, no doubt to avoid flooding while exalting their respective gods. Their names are still disputed by scholars. To me, the most interesting of these is the northern temple from around 260 BC, most likely dedicated to Janus, our god of comings and goings. Some standing columns are to the right, and more are embedded in the northern wall. Of course, Janus would have a temple along the Tiber. He is closely related to Portunus, the god of ports, where ships, people, and goods come and go. Although third-century BC priests no longer consulted auguries before crossing a body of water, Janus was still honored at the port for his role as a god who looked up and down the river.

During the Republican period, the Tempio di Portuno (Temple of Portunus) stood close to the Janus temple and Pons Aemilius. Standing on a podium, it survived, most likely, as the Tempio di Fortuna Virilis. Then, in the ninth century, it became the church of Santa Maria Egiziaca. She was a patron saint of prostitutes who, in the sixteenth century, sometimes worked as laundresses at the nearby spring-fed Fonte di San Giorgio laundry, provided by Pius V in 1563 (fig. 5.2). A Janus crossing also stood here—much of it remains as the Janus Quadrifrons, the four-sided temple gate standing nearby.

The temple shares a small park with the fountain of **Santa Maria in Cosmedin** and a round temple dedicated to Hercules Victor. This was the ancient **Forum Boarium (Cattle Market),** so called not only because of a market, but

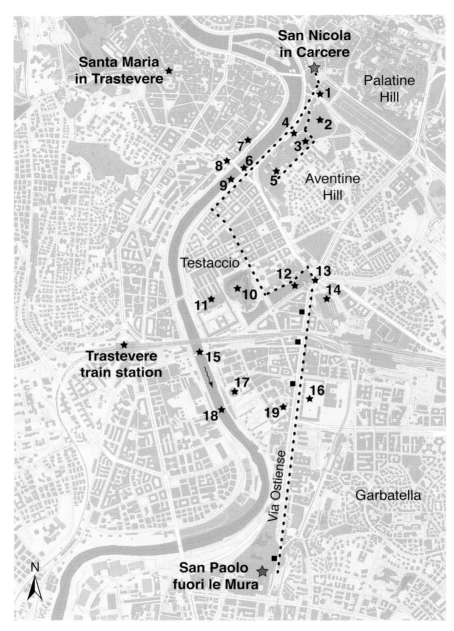

Fig. 5.1. TIBER RIVER PILGRIMAGE III: ■ = Tram stops. 1) Santa Maria in Cosmedin/Forum Boarium (Cattle Market), 2) Rocca Savella, 3) Giardino degli Aranci, 4) Fonte de Pico, 5) Santa Maria del Priorato, 6) plague chain, 7) Ripa Grande, 8) Porta Portese, 9) Marmorata/Emporium, 10) Monte Testaccio, 11) Mattatoio, 12) Cimitero dei Protestanti (Protestant Cemetery), 13) Porta Ostiense/Porta Ostiensis, 14) Ostiense train station, 15) Ponte dell'Industria, 16) Mercato Comunale, 17) Gazometro, 18) Ponte della Scienza, 19) Museo Centrale Montemartini.

Fig. 5.2. *View of the Temple of Janus Quadrifrons*. Étienne DuPérac, 1575. Vincent Buonanno Collection. The laundry fountain is at bottom center.

perhaps from the mythic cattle Hercules had stolen from Geryon and herded through this area, or from the bronze statue of an ox created around 400 BC by the Greek artist Myron and later brought to Rome. Purportedly, because of its beauty and perfection, people couldn't decide if it was real or a lifelike sculpture. Whether the ox was real or not, several roads met at the forum, making it incredibly busy.

Look to the west. You'll see the ground rising up about six meters toward the Lungotevere Aventino, the road paralleling the Tiber atop the embankment walls. Before the embankment, the land had sloped down to the river with mill landings, storage areas, and some gardens along the shore. The area flooded often. Yet the ground was lowered and leveled between Santa Maria in Cosmedin and the shore, and new drains were built when the fountain was erected in 1719. To lower the area seems irrational, but at that time Giovanni Crescimbeni reported that flooding had deposited alluvium to a height of "seven steps above the level of the nave." It isn't clear how seven steps measure up, but it could be about a meter and a half.

Santa Maria in Cosmedin, a ninth-century Byzantine Rite church, is glorious. The building's history is too complex to repeat here, but a mithraeum and remains of a second-century AD *annona* (grain-distribution center) lay beneath its foundations. When you step inside, in addition to eighth-century mosaics in the sacristy, you'll see beautiful cosmatesque floors like those at San Benedetto in Piscinula (see fig. 4.8). These were created by the Cosmati family between 1121 and 1124 and have been completely restored, more than once.

The Bocca della Verità (Mouth of Truth) is in the church's loggia. Its mask's form is intriguing: a huge marble disk carved with a face, its open mouth big enough to slip your hand into. Some people think it was a drain at an ancient villa—not in the street battered by cartwheels and horses hooves. Or, it might have been a wall fountain. Either way, it spent its ancient life with water—spewing it from a fountain or gulping dirty water as a drain.

We're standing above the Cloaca Maxima, one of fisherfolk's best angling spots along the Tiber. The Cloaca Maxima, Circus Maximus, and Acqua Marrana drains have their mouths just south of the island on the left bank, where, before the embankments, fish swarmed for the tasty morsels washing down. The Cloaca Maxima, now carrying rainwater, is just past Ponte Sublicio (the replacement of Pons Sublicius) beneath the large arch.

If you need a break, this might be the time. Coffee bars are infrequent along the river, but if you walk behind Santa Maria in Cosmedin you'll be on Via dell'Ara Massima di Ercole, where the starting gate of the Circus Maximus once stood. Farther along, the road becomes Via di San Teodoro, where there is a big public market. Or, you can burrow back into the neighborhood, where there are some coffee bars.

<div align="center">❧</div>

La Commare Secca (The Grim Reaper), *Accattone* (The Bum), *Ladri di Biciclette* (The Bicycle Thief), and *La Grande Bellezza* (The Great Beauty) are movies that depict the Tiber's banks as a sorry landscape, and in many ways it is: empty and yet filled with sadness; deserted, yet there is a prostitute's corpse along river. The smell at the *marciapiede,* the river-level sidewalk, can be overwhelming; often used as a urinal, it also offers other aromas: a pungent mix of garbage, mud, and dead fish. But the banks can't be discounted. This is a Rome that most visitors will never know.

People still fish the Tiber, usually on the right bank; it seems a relaxing way to spend the afternoon. Graffiti is everywhere, some written in English. "URBAN CARP-FISHING" is a favorite. Rome isn't the best place to find eels, but sometimes, using maggots as bait, they are caught near Ponte Sant'Angelo at the little sandy beach at the river wall (below the fake sandy summertime beach). But Cesare Bergamini, one of the last eelers on the Tiber (he works near the Grande Raccordo ring road), says it's better to fill your eel nets (he owns 250) with snails. Apparently eels love snails. Bream are sometimes caught as well. Many Romans rely on Tiber fish for protein, and apparently the carp, chub, common mullet, and eel were safe to eat in 2023. With a license, you can join in the fishing. Oh, and those animals that look like beavers or giant swimming rats are nutria, an invasive species native to South America. They love the Tiber, multiplying like rabbits, eating 25 percent of their weight each day, and destroying wetlands. If you have any ideas about how to get rid of them, the Roman authorities would like to know.

Along Via del Circo Massimo an animal trough stands to the left near Lungotevere Aventino. Originally located in the same park with the Santa Maria in Cosmedin fountain, it used the runoff water. Until the mid-nineteenth century, cowherds found this a convenient place to water cattle they brought to Rome for slaughter. They would have come into Rome along the Via Appia and through Porta San Sebastiano, passing medieval churches standing amid vineyards. Ruins of the Thermae Caracalla (Baths of Caracalla) loomed on their left, and the Acqua Marrana stream flowed on their right until they reached the Circus Maximus, which at the time was filled with market gardens. Finally, they reached Piazza Santa Maria in Cosmedin, near the cattle market.

You can decide for yourself about the next portion of this water walk. The Aventine Hill is a devil to get to; from Santa Maria in Cosmedin, there is only one way up and down—it happens to be quite enchanting. But backtracking is no longer necessary because a path connecting the Giardino degli Aranci, which means "garden of the oranges," to the Tiber River has finally opened.

Once covered with laurel and holm oaks, the ancient Aventine quickly became a prime residential district. Elite houses there, as elsewhere on Rome's hills, featured a peristyle court with a roof sloping toward the open *impluvium* (shallow basin) at the center of the home. Rain falling on the roof fell into the impluvium and then into an underground cistern accessed by a well. The Aqua Marcia branch line would have failed the Aventine—at the end of the line—long before the Caelian and Esquiline hills ran dry. Regardless, churches and monasteries popped up during the long, dry medieval years, drawing up water from deep wells like the one at Santa Sabina, founded in the 430s.

The powerful Savelli family dominated the largely abandoned Aventine by the thirteenth century. Honorius III (r. 1216–27) enlarged and fortified the family residence next to the church of Santa Sabina in 1216. Honorius IV (r. 1285–87) expanded the residence and added a fortified tower, since then called **Rocca Savella.** He encouraged others to build near the church, but without potable water, his effort failed.

Today, there is a welcoming nasone at the top of the Clivo di Rocca Savella, ascending from Santa Maria in Cosmedin. Drink up while you can. The water is delicious. There is another fountain with water spewing from the mouth of a marble mask like the Bocca della Verità. The Rocca Savella mask once provided water to cows in the Campo Vaccino, but more about that later (see fig. 9.7). It might be worth plunging your hands into the cold water before walking into the dusty but glorious **Giardino degli Aranci,** with its little fountain snug inside the Savelli wall. Fallen *aranci* (oranges) are everywhere, so make your way carefully to the terrace at the far end overlooking the Tiber and beyond. This is one of those sunset views where, if you haven't already done so, you might just fall in love, if not with another person, perhaps with Rome.

This is the best lookout to scan the horizon from the Aventine. St. Peter's is in the distance. The long building at the river's edge is the Ospizio Apostolico di San Michele, built in stages to house hundreds of orphans, abandoned elderly, and delinquent children. The once-vibrant Ripa Grande port stood in front until the embankment walls scraped it clean away. Porta Portese is further south, and after that you can just make out the roof of the former papal arsenal for ship repairs.

In a cave beneath the hill, along the Tiber, there is a spring, today called **Fonte de Pico.** (You won't see anything if you decide to walk along the river.) Ovid reports a spring with "a spirit . . . veiled by green moss . . . that trickled from a rock, a rill of never-failing water." The *Einsiedeln Itinerary* mentions a spring beneath the Aventine, and John Henry Parker describes it within "a grove black with the shade of holm-oaks." Tradition relates that Hercules hid the cattle he stole from Geryon here. It's a long story, but somehow Hercules drove the cattle from the garden of the Hesperides—rich with golden apple trees belonging to the goddess Hera—over the Aventine Hill. While he slept, a giant living there stole some of the cattle, making them walk backwards and leaving no trail, and hid them in a cave. Hercules found them when he drove his remaining cattle past the cave and heard the animals low.

Although you won't be able to see any of the fountains (or the azure swimming pool) at the church and monastery of **Santa Maria del Priorato,** I suggest you head there anyway. Giovanni Battista Piranesi designed the small piazza (now a car park) in front of the church in 1765. It is a handsome puzzle stuffed with references to ancient Rome. What you can see by waiting patiently in line at the gate is a keyhole telescope trained on the dome of St. Peter's. From here, you can return to Giardino degli Aranci and take the new shortcut path to the Tiber, if you like, or return along the road.

~~~

Wharves of all types huddled beside the banks along the Tiber; they dealt with wine, pottery, oil, lead, timber, fuel, and so forth. For example, clay arrived at, and then finished pottery shipped from, a wharf near the pottery workshops on Via dei Vascellari. And there had been a port at the Ripa Grande since late antiquity. It grew in importance during the early medieval period, eventually replacing a larger Testaccio port on the opposite bank.

When Leo IV (r. 847–855) built the Mura Leonine (Leonine Walls), he also restored the Mura Aureliane (Aurelian Walls) and built a tower, then attached a heavy chain that could span the river during times of siege and prevent ships entering from the south. The plague was another type of siege that could batter Rome. The best places to stop its spread were at the Aurelian gates, the Tiber gate at the Borgo that protected the northern flank, and the Tiber's southern gate near Porta Portese. By the seventeenth century, ropes replaced the **plague**

**chain** across the river. Laurie Nussdorfer explains that "gentlemen" checked the boatmen's health certificates "to keep out water borne traffic that might carry the disease."

As in antiquity, goods were off-loaded onto smaller boats closer to the river's mouth and towed upstream as far as the Marmorata by oxen—after the seventh century, by water buffalo—then off-loaded again for immediate sale or taken to storage. The teams consisted of eight to twelve animals yoked in pairs. Sometimes humans pulled the barges—which was legal until 1800. Oxen hauled ships and larger blocks of stone, including an obelisk from a port outside the Aurelian Walls through Porta Ostiense and eventually to the Circus Maximus in 10 BC. When Mussolini wanted an obelisk at his Foro Mussolini, his workers used eighty oxen to drag the largest piece of marble ever quarried at Carrara eleven kilometers to a ship waiting in the Mediterranean. Once it reached Rome, seven tugboats towed it up the Tiber—somehow making it past the rapids and the island—to Foro Mussolini.

Besides stone and timber, people were also towed up the river. While Queen Christina of Sweden and Hilaire Belloc entered Rome along Via Flaminia at Porta del Popolo, others arrived from the Tiber. Oxen pulled Charles of Anjou's ships up the Tiber in 1266 when he arrived to be crowned king of Sicily. He disembarked near San Paolo fuori le Mura and entered Rome at Porta Ostiense. At the same time, the **Ripa Grande** was the major port for pilgrims arriving by ship, who then walked to St. Peter's. Although much later, Giovanni Battista Piranesi's print from circa 1750 shows the chaos at the port, with small-oared craft and smaller skiffs off-loading and scores more either docked or waiting their turn (fig. 5.3).

Only a street name, a staircase to the river, and two drinking fountains recall the port's once formidable presence. One fountain is nearly impossible to reach across the busy road. The other, the Fontanella dei Timone (Ship's Wheel) of 1929, seems forlorn. At the end of the street is **Porta Portese,** the ancient Porta Portuensis. Step through the gate; there is Sunday hurly-burly that you shouldn't miss, although it has little to do with water except that you can expect to be thirsty. This is the Sunday flea market of legitimate goods and those that have "fallen off the truck."

When the embankments were completed in 1926, Mussolini claimed them as Fascist with a Latin inscription from the *Aeneid.* Carved at the Marmorata, and now neglected and covered with graffiti, it's best seen from the Ripa Grande. It translates as:

<div align="center">

I AM THAT RIVER IN FULL FLOW THAT YOU SEE
SWEEPING THESE BANKS AND CUTTING THROUGH RICH FARMLAND.
I AM THE BLUE TIBER, MOST FAVORED OF THE GODS.
HERE IS MY NOBLE HOME. MY SPRINGS RISE AMONG PROUD CITIES.

ANNO IV                                        MCMXXVI

</div>

Fig. 5.3. *Ripa Grande Port*. Giovanni Battista Piranesi, ca. 1750. Rijksmuseum.

The inscription has everything: it refers to the fourth year of Fascist rule, there are fasces, a Roman axe, the Fascist eagle (Imperial, really) at one end, and Romulus and Remus at the other. Romulus looks upstream to the river's source at Fumaiolo.

This long stretch of the left bank was known in antiquity as the **Emporium,** an area of wharves and warehouses. By the fourth century, the northern part was called the **Marmorata,** a site dear to stonecutters, artists, and Mussolini. That's a modern name for the ancient marble wharf where some ruins lurk down at the river's edge. The paving stones you saw beneath Constantine's feet in chapter 2 probably arrived here. When marble imports ceased to be important, before the seventh century, the area became a kind of wasteland.

Testaccio is further downstream in a part of the Emporium where oil-filled terra-cotta amphorae were unloaded in the southernmost reach. After decanting the oil into smaller amphorae for distribution, the larger ones, which could only be used once, were tossed into a heap, creating the thirty-five-meter-tall artificial hill that gives the neighborhood its name. Amphorae and potsherds accumulated here from the first century AD until around AD 268, when the port was moved northward beyond a bridge that could be defended from attack.

By the mid-thirteenth century, the Roman people used nearly the entire area for market gardens and for festivals during the summer, for the October harvest festivals, and for the eight-day Pre-Lenten Carnival. Bullfights, horse races, feasting, and games took place, and on the final Sunday of Carnival, carts with pigs

were rolled down **Monte Testaccio** (fig. 5.4). There was even a strange tournament, the "Game of the Ring," where men on horseback tried to hit a moving target that caused a tub filled with water to spill on the rider. Pope Paul II (r. 1464–71) moved the Carnival races to Via Lata (later the Corso) in 1466. After that, this Prati di Popolo Romano (Fields of the Roman People) became pasturelands. At nearby Porta San Paolo, the entry through the Aurelian Walls into Testaccio, you can see an inscription from 1720 that confirms their continuing rights to the pasture granted by "sacred edict of the SPQR," the Senate and People of Rome.

The **Mattatoio** slaughterhouse was moved here from a site along the Tiber outside Porta del Popolo in the 1890s. As a result, a new worker's neighborhood with small apartments, often without water lines and adequate sanitation, was built in Testaccio. By 1906, a large, unregulated, and unhealthy *borgata* (slum), often with entire families living in a single room, had developed. Some Testaccio apartment buildings remained without water piped directly to each unit until 1994. Rather, siphons pumped water to rooftop cisterns, where it sat under the sun, becoming insalubrious.

In the early 2000s, parts of the Mattatoio became a branch of the Università di Roma's architecture school and the core of an aspirational new arts district. All fine and dandy, you think, but sadly not for everyone. On the other side of the Mattatoio, where the oxen were once penned before slaughter, a Roma community known as the Kalderasha moved in peacefully to the long abandoned,

Fig. 5.4. *Carnival Games Held on the Monte Testaccio in Rome.* I. T. F., 1558.
Metropolitan Museum of Art.

but relatively safe, site in 1986, naming it Campo Boario. A group of Kurdish immigrants joined them in 1999.

The site already had water but no sanitary facilities. The residents leased portable toilets to supplement camper toilets, but, over time, sanitation became a critical issue. Even so, the group of about one hundred people lived there peacefully for twenty years, until everyone was forcibly expelled without adequate warning and the site dismantled in 2008. Today, small groups live along a dead-end stretch of the Lungotevere at Ponte Testaccio, outside the Mattatoio walls, remaining in the neighborhood so their children could stay in school. The nearest nasone is five hundred meters away! This isn't the only time Rome's water history will overlap with an intolerance that counters all the best intentions of a city with a free public water supply.

The Testaccio hill, already excavated at its base with small caves to store wine, became home to restaurants and wine bars catering to the workers. After World War II, it became home to themed al fresco summer nightclubs: a Hawaiian beach with imported sand, pyramids along the Nile, or Monte Carlo. Today, there are more clubs and trendy restaurants near the hill than bakeries and old-fashioned pizzerias. I lived at the opposite end of Testaccio for a while in 2002 and stuck close to my neighborhood piazza, park, outdoor market, bars, bakeries, pizza joints, and bus stop near its signature "Amphora" fountain, designed by Pietro Lombardi. My closest nasone stood at my corner.

The **Cimitero dei Protestanti (Protestant Cemetery)** is tucked inside the Aurelian Walls at the pyramid of Cestius at Porta di San Paolo (fig. 5.5). Percy Bysshe Shelley, who thought Rome's fountains magnificent enough "such as alone it were worth coming to [Rome to] see," is buried in this green and peaceful corner of Rome, as are Johann Wolfgang von Goethe, the American "Beat" poet Gregory Corso, the American abolitionist Sarah Parker Remond, Antonio Gramsci, leader of the Italian Communist Party, and Andrea Camilleri, author of the Inspector Montalbano mysteries, among scores of other poets, politicians, and novelists.

John Keats's grave is here too, and it is compelling. His epitaph reads, "Here Lies One Whose Name was writ in Water." What does it mean to write with water, or to have one's name writ in water? Is it something frivolous like writing with rain, or impermanent like a memory, or something that is ever-flowing, like the Tiber through Rome? While you're in the cemetery you might recall that Keats died in his room above Piazza di Spagna, where he could hear the Barcaccia until he took his last breath (see fig. 1.6).

Leaving the cemetery, you'll pass the Egyptian-style pyramid of Cestius and pass under Porta San Paolo, originally named **Porta Ostiensis,** for Via Ostiense, the road from Ostia. Here you can determine your next move. You can choose to follow the Tiber, or if you happen to have your swimsuit with you, you could take

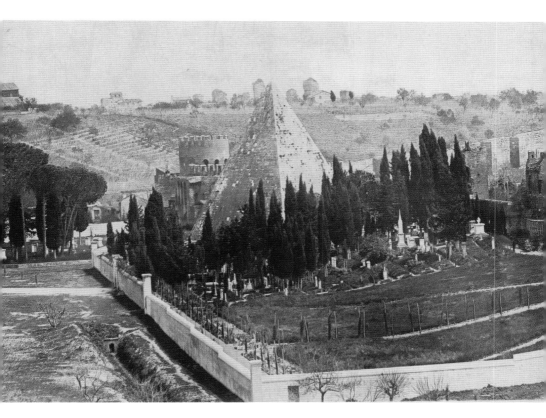

Fig. 5.5. *View of the Pyramid of Cestius.* Gustave Eugène Chauffourier (attributed), ca. 1857–75. Rijksmuseum. The Cimitero dei Protestanti (Protestant Cemetery) appears in the foreground.

the train to Ostia's beaches. The **Ostiense train station** is across the street, and the ticket is the same price as a bus ride in the city. If you decide to go, you can also visit the ruins of ancient Ostia, where you can see short runs of its aqueduct and its famous public latrines.

A sixth-century AD pilgrim could have walked from Porta Ostiensis to San Paolo fuori le Mura (St. Paul's Outside the Walls), under a colonnade extending the entire distance, about two-and-a-half kilometers. What the colonnade looked like we don't know, but it must have provided shade. At this point you can decide how much you want to see. If you feel up to it, you can, like early pilgrims, walk all the way to San Paolo fuori le Mura, through what was industrial Rome with gas tanks and a thermoelectric plant. On the way south are more bridges: Ponte Ferroviario di San Paolo (Railroad Bridge, from 1863), **Ponte dell'Industria,** Ponte della Scienza at the Gazometro—where earthen slopes and a riparian zone replace the walls on the right bank—and Ponte Guglielmo Marconi near San Paolo (fig. 5.6).

Fig. 5.6. Industrial Tiber. Ponte della Scienza spans the Tiber. The left bank is at the top of the image with warehouses to the left; the Gazometro is near the center; and the thermoelectric plant is to the top right.

The Lungotevere path along the river ends just after the Mattatoio and doesn't pick up again until after the river flows under Ponte dell'Industria. It's a bit of a slog to get there once you leave Porta Ostiense, but you can take the number 23 bus as far as the second stop at Ostiense/Matteucci, then follow Viale del Porto Fluviale to the river and pick up a short stub of the path on the left bank as far as Ponte della Scienza. Portions of the road are a bit dicey—there are no sidewalks in an isolated area. But it's important to see another side of Rome and the Tiber, and to hear another heartbeat in a part of Rome without glamorous fountains. This stretch of the river was once alive with the stevedores, ships, industries, and warehouses long missing from the historic center after constructing the embankment walls. Here you can gain some understanding of the engines of Rome's economic life in the early twentieth century. This was modern Rome's first zoned "industrial district," authorized in 1909. Rome's largest commercial market, the **Mercato Comunale,** once thrived here as well.

You'll see the abandoned **Gazometro**—a natural gas storage tower—a relic of Rome's industrial history in the gentrifying Ostiense neighborhood. Built between 1935 and 1937, the Gazometro doesn't have much to do with water except for its site near the river. A beautiful sculpture, its empty iron lattice once embraced a storage membrane. The scaffolding flying above you does relate to water: these are what remain of the loading and unloading cranes that connected to the warehouses at yet another Roman port.

Opposite is **Ponte della Scienza,** a good place to pause again and think about life along the river. From here you can look north toward the historic center. There is another bridge, with more scaffolds running overhead between the river and former warehouses, and the riparian growth at the water's edge. When you turn to face south, the view is much the same. In either direction, there is little to tell you that you are little more than three kilometers from the Circus Maximus.

The path along the river seems to continue from this point. It leads to other spontaneous encampments like that outside the Mattatoio that make clear the rise of urban inequalities in Rome, which intensified after 1870 and have only accelerated in the twenty-first century. In 2002, the United Nations affirmed that access to clean water is a basic human right that is "indispensable for leading a life in human dignity. It is a prerequisite for the realization of other human rights." There is no running water at these encampments, but the Tiber is outside the door. Of course, river water is filthy and shouldn't be used, but other than filling jerry cans at a public nasone—the nearest one is more than five hundred meters away—what is one to do if there is nowhere else to live? Meanwhile, directly across the river on the Tiber's right bank, on what was once the horti of Julius Caesar, the private tennis and swim clubs tell a different story.

If you decide not to take the river walk, you can take the bus from Porta Ostiense to its fourth stop at Ostiense/Garbatella. It's a short walk to the **Museo Centrale Montemartini** on Via Ostiense, a repurposed thermoelectric generating plant built between 1912 and 1917. Originally intended to generate electrical power through steam turbines and boilers, the plan shifted to diesel, but ultimately there was a hybrid solution of steam, an aspect of water we don't typically see in Rome's public realm, and diesel.

A museum since 1997, it displays the redundant diesel engines and a steam turbine as muscular backdrops for sculptures of muscular ancient gods standing sentinel. It is a superb juxtaposition and "worth a detour." The statues are magnificent, and the fluid drapery of so many female goddesses covers their bodies almost like waterfalls. Art that once filled ancient horti—lush aristocratic gardens of unimaginable treasures—is displayed in the boiler room. There are large fragments from an enormous mosaic floor from the early fourth-century AD Horti Liciniani, a garden on the Esquiline Hill that hosted numerous aqueduct-fed fountains and pools and luxurious plantings.

Our destination is **San Paolo fuori le Mura,** which, after St. Peter's and San Giovanni in Laterano, is Rome's third-most important basilica, and one of the seven foundational churches for religious pilgrims (fig. 5.7). To arrive there, you can either catch the bus or walk straight down Via Ostiense. At San Paolo and other ancient basilicas like San Lorenzo fuori le Mura, there were monasteries with baths, fountains, and provisions for pilgrims entering Rome. They could also receive baptism. A *cantharus* (pool) stood in the sanctuary's atrium for ablutions,

Fig. 5.7. *The Seven Churches of Rome.* Giovanni Brambilla (attributed), 1575. Metropolitan Museum of Art. San Paolo fuori le Mura is at the upper right, St. Peter's is at the bottom center, and San Lorenzo is at the far left.

as there once were at St. Peter's and Santa Cecilia. Leo I (r. 440–461) restored the pool, and Pope Symmachus (r. 498–514) built stairs to the atrium. We know nothing about the fountain's appearance—only that it was there by the fifth century, not so long after the church was dedicated in 390.

Being isolated outside the walls meant that the basilica lacked an extra layer of protection from marauding armies like the Saracens, who attacked in the ninth century. That's when San Paolo, San Lorenzo, and St. Peter's all built fortifications, creating small, self-sustaining monastic communities that encompassed the immediate environs. This one was called Iahannipolis (John's Enclave), named for John VIII (r. 872–882), its sponsor.

Little of the basilica and cloister are original because fire destroyed nearly everything in 1823 (although the baptistery survived). The fire sparked a fierce debate: whether to restore the church as the original or erect a completely new building to reflect contemporary design ideas. The traditionalists won. Today's church follows its predecessor as closely as possible, with, for example, thin alabaster clerestory windows that resemble sections cut from an amber stream (fig. 5.8). The copy of the early thirteenth-century monastery cloister by the

Vassaletti family is an oasis of green hedges and grass, roses, some spindly palm trees, graceful twisting colonnettes, and a mosaic frieze running on all four walls.

The Acqua Accia, a stream known by various names, including Almone, flowed immediately to the north. In antiquity, an important ritual was celebrated each year on March 27, as a statue of the goddess Cybele, Rome's "Great Mother," was carried from her temple, the Magna Mater on the Palatine, along Via Ostiense and bathed in the Almone, where it flowed into the Tiber. The stream still runs from the foot of the Alban Hills across the Campagna and into the Caffarella Valley, rich with springs. Fed by different springs, the Acqua Marrana runs nearby in the valley until it flows into the city, meandering toward the Circus Maximus and then to the Tiber. The Almone keeps outside the walls and heads toward the Tiber, now running underground near Montemartini. What remains of their waters flows to the Mediterranean Sea, where, through evaporation, it begins the long journey of renewing the hydrologic cycle. The Marrana also flows through chapter 7, along with some of Rome's aqueducts from the Alban Hills through the Campagna into the city at Porta Maggiore.

# Bibliography

For temples and fora in general, see Coarelli 1988, Holland 1961, and Richardson 1992; for prostitutes and laundresses, see Rinne 2021; for the Forum Boarium, see Krautheimer 2000; for Santa Maria in Cosmedin, see Krautheimer et al. 1964 and Crescimbeni 1719; for the Cosmati, see Severino 2012; for fish and fishing, see Brentano 1991 and Cerantola 2014; for drains, see Narducci 1889; for the Aventine and Rocca Savella, see Ajello Mahler 2012 and Krautheimer 2000; for springs, caves, and myths, see Corazza and Lombardi 1995, Ovid *Fasti* 3:285, and Parker 1876; for Tiber barges and trade, see Casson 1965; for embankment walls, see Courtney 2003 and Dey 2011; for the plague, see Nussdorfer 1992; for the Marmorata, its inscription, and wharves, see Lanciani 1988, Taylor et al. 2016, and Virgil *Aeneid* 8:62–68; for the Mattatoio and Testaccio, see Richardson 1992; for spontaneous housing and human rights, see Bermann and Clough Marinaro 2014, Insolera 2002, and UN Committee 2002; for the Protestant Cemetery, see Macadam 2020 and Shelley 1906; for the industrial district, see Insolera 1962 and 2002; for San Paolo fuori le Mura and Iahannipolis, see Camerlenghi 2018 and Duchesne 1886–92.

# 6

# Roman Aqueducts 101

Exhausted after walking nearly fourteen kilometers along the Tiber River, you'll need a break. Now you can pause without walking anywhere while tracing two of Rome's ancient, gravity-fed aqueducts from their source springs in the Roman Campagna: the Virgo (19 BC) and Traiana (AD 109); their modern iterations, the Vergine (1560–70) and Paola (1607–12); and two mechanically pumped modern ones, the Vergine Nuova (1930–37) and the Peschiera-Capore (1908–80). This chapter will, I hope, help prepare you for the next chapter, where you can walk among aqueducts—five ancient, one medieval, and two modern—that run alongside (and over and under) each other across a stretch of the Campagna southeast of Rome before flowing into the city (see fig. 2.6).

Difficult to visit, the springs are far outside the historic center, deep underground, heavily guarded, and on private land. There isn't much to see at the source of the Virgo; you would never guess that you're standing in the realm of myth above the Salone springs. With the springs bubbling away underground, how did surveyors and engineers chart a course, especially through difficult terrain, which sometimes required tunneling under hills, skirting around them, or crossing deep streambeds—all the while keeping the destination in focus, even when not in sight? It turns out to be relatively straightforward.

Late sixteenth-century surveyors used the same type of surveying instruments as the ancients, among them a *chorobates,* a type of plane table, and perhaps a *bussola,* an instrument with a magnetic compass. Unfortunately, imprecision increased over long expanses, and history bears ample testimony to surveying mistakes made as distances increased. As Michael Lewis explains, the plane table, perhaps two meters long, used weighted plumb lines, which, when they hung parallel to the supporting legs of the structure, established a level plane. The tabletop held a long, shallow trough. When the table appeared level, water was poured into

the trough as a test. The surveyors then sighted along the tabletop to establish the difference in level between the table and the next point on the survey. This task was repeated along the entire route, perhaps as often as every fifty meters. If plumb lines didn't align (a distinct possibility), errors occurred.

The Acqua Paola's route is over forty-six kilometers long (the ancient Traiana a few kilometers more), a distance that provided hundreds of opportunities, especially in the rough terrain around Lake Bracciano, to miscalculate the level. Even a half-centimeter error each time could mean as much as a nine-meter discrepancy between the source and the city. The Traiana/Paola source springs are a hundred meters higher than the Janiculum and Vatican hills, where the two modern distribution *castelli* now stand. But the Virgo/Vergine springs are little more than six meters higher than the Fontana di Trevi (where the aqueduct ends today); those kinds of errors could be catastrophic. The grade of the *specus* (channel) is only .05 percent between Salone and the Trevi—just enough to keep the water flowing.

The Salone springs are about ten kilometers outside the Mura Aureliane (Aurelian Walls) along Via Collatina, an ancient Roman highway, but the course is nineteen kilometers (mostly subterranean), winding for nearly the entire route. The aqueduct began life as the Aqua Virgo, built by Marcus Agrippa in 19 BC to serve his new public baths, the Thermae Agrippae, near the Pantheon, which he also built (see fig. 2.5). Running underground provided a level of protection from marauders and the elements. Because of this, and unlike the other ancient aqueducts, the Virgo flowed throughout the medieval period, although it no longer tapped its original sources and only provided a small fraction of its original capacity. You can see a stretch of its ruins in the basement of the Rinascente department store on Via del Tritone (see fig. 1.8).

The aqueduct needed constant maintenance to continue working for two thousand years. During the long medieval period, a dwindling population with meager resources found these responsibilities too onerous. Consequently, portions of the aqueduct collapsed and weren't repaired, and even the springs were forgotten. In 1453, Nicholas V restored the aqueduct sections closest to Rome, work that was continued by a string of popes over the next century.

Though noble, their efforts remained incomplete because the popes and their engineers didn't know that the Salone springs were the Vergine's source. Agostino Steuco, a sixteenth-century Vatican librarian, had read a recently rediscovered inventory of Rome's aqueducts, *De Aqueductibus Urbis Romae* (On the Water Supply of Rome), from AD 97/98 by Sextus Julius Frontinus, Rome's water commissioner under emperors Nerva (r. AD 96–98) and Trajan. Frontinus gives a short history of each aqueduct and its springs and describes the excruciating minutiae of Rome's water distribution: the length of each aqueduct and what percentage rode on arcades or was underground; the water's origin and its destination; how many settling tanks stood along the route; where and when the channels and

arcades were damaged; who repaired them; how much water was captured at the springs; how much arrived in Rome; and how much was stolen before arriving there.

In 1545, Steuco set out to confirm Frontinus's claim that the Salone springs supplied the Virgo and to convince Paul III (r. 1534–49) that the aqueduct could be restored, which would facilitate Rome's physical rebirth. Ingenious and resourceful, Steuco used Frontinus as his guide to read and interpret the landscape through firsthand observation. His team of workers looked for the aqueduct's airshaft capstones, which originally rose aboveground, where work crews could easily identify the access points. Built to facilitate underground construction, they permitted air to ventilate the channel and aerate the water, and the shafts allowed easier inspections and repairs. The capstones were removed as needed to enter the shafts.

Perhaps not as dashing as the legendary Indiana Jones, Steuco still must have cut an interesting figure as he and a team of surveyors scoured the Roman Campagna trying to trace the mostly underground aqueduct. They traversed rough and uneven ground with clods of earth, stones, grazing animals, and cultivated land. When they found any original airshafts, they used Frontinus's measurements (placed approximately every ninety-two meters) to look for the next. From Frontinus, Steuco also learned that a strip of five Roman feet, approximately one-and-a-half meters, remained uncultivated on both sides of an aqueduct, although the land would have been overgrown by the sixteenth century. A few *cippi* boundary markers (like those along the Tiber) remained to mark the route, and a road usually ran near aqueducts so that workers could follow along the line.

The water flowed continuously, but left behind calcium deposits, called cinter, that built up inside the channel and could slowly choke it, blocking the water's flow. Cinter—hard, crystalline layers—proved difficult to hack through but had to be removed at regular intervals to keep water moving along its shallow grade into Rome. Because the Virgo/Vergine springs arise in limestone (as do the other aqueducts apart from the Traiana/Paola, which is volcanic), the water is calcium-rich. Workers shimmied down the airshafts to remove the cinter.

By the mid-sixteenth century, when Steuco began his survey, the terrain had shifted after centuries of cultivation and grazing, leaving many of the shafts, capstones, and cippi broken, buried, overgrown, or missing. Portions of the road may have continued in use throughout the medieval period. Luckily, the ancient maintenance workers had left clues. Once they had removed the deposits, other workers hoisted chunks of cinter up the shaft in buckets and dumped them in nearby piles that continued to grow over several hundred years. Steuco's team might have identified some of them, because at least the tops of the mounds created by the crystalline residue might be visible, in stark contrast to everything that had changed around them over the previous centuries.

Calcium and debris had choked the channel farthest from Rome and closest to the springs, while other portions had collapsed. When water couldn't flow through the channel, it broke out to form its own streams, some of which led to the Aniene River. Closer to Rome, the collapsed channel didn't carry original spring water; rather, water from other springs and surface water flowed in.

Once the original springs and ancient conduit were fully restored between 1560 and 1570, Rome's urban history—not only its water history—changed dramatically. New fountains appeared in the most populous areas of the Campo Marzio—the only area the Vergine could serve because of its low elevation. Ornamental fountains, and fountains for drinking, animals, and laundry, began to appear.

The Vergine, the Virgin's aqueduct, once Rome's favorite drinking water, is no longer potable at the source, but it is treated nearby before running through distribution conduits. Even so, it carries its ancient legends into Rome as it fills many of the city's most famous display fountains—the Trevi, the Barcaccia, and those in Piazza Navona, among others—all in the low-lying Campo Marzio on the Tiber's left bank.

Acqua Paola springs arise much higher and can take water to nearly every part of Rome. Built between 1607 and 1612, the Paola's story begins in AD 109, when Emperor Trajan inaugurated his aqueduct, the Aqua Traiana (fig. 6.1). Trajan's engineers tapped abundant springs running in an arc along the northern rim of Lake Bracciano, a volcanic crater northwest of Rome. Emperor Domitian (r. AD 81–96) had already tapped a few springs for his villa and bath on the lake's north shore. Trajan requisitioned them and acquired more springs, taking his aqueduct into Rome, in part to serve his new imperial bath complex on the Caelian Hill, the Thermae Traianae. Among the newly tapped springs, one, the Santa Fiora, had a grand artificial nymphaeum, its high vault ornamented with "Egyptian blue" pigment, and probably populated with sculptures of water deities. It was a monumental structure unlike anything known in ancient Italy.

By the seventeenth century, the Traiana had been out of commission for centuries. Duke Paolo Giordano Orsini, who controlled vast swaths of land around the entire lake, including the town of Bracciano, its residents, and its castle, used the Santa Fiora water to power mills on his property. Paul V restored Trajan's aqueduct, renaming it the Acqua Paola. He wanted to use the Fiora spring—the most copious of all—for his aqueduct, but Duke Orsini declined Paul's offer. Instead, he sold him other springs. They still flow into Rome, but in the 1680s warm, slightly murky Bracciano water was added to increase water for St. Peter's and to power new grain mills on the Janiculum. Since then, Paola water has been disparaged and ranked last among Rome's waters for drinking and cooking, and although safe to drink, it is more often used for industry, for display fountains with no drinking apparatus, and as part of the emergency backup supply. A

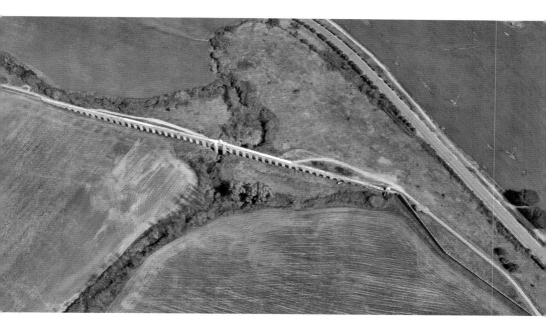

Fig. 6.1. The Aqua Traiana/Acqua Paola aboveground near Via Cassia. Water flowed from the upper left toward Rome (lower right).

Roman expression sums up this derisive attitude: "*Una cosa non serve a nulla e come l'acqua di Paola*" (Something utterly useless is like Acqua Paola).

Oddly, Paul and his engineers didn't know it as Trajan's project; rather, they thought they had reinstated a different aqueduct, the Alsietina built by Augustus in AD 2 to serve his naumachia in the Transtiberim. That's what the inscription over the fountain proclaims (see fig. 13.3). The Traiana hadn't been built when Frontinus published his treatise of AD 97/98. Fallen into ruin by the tenth century, the aqueduct had disappeared from memory. It wasn't until the late seventeenth century that Raffaello Fabretti confirmed the aqueduct's existence based on discoveries of ancient inscriptions and coins. Still, no one made the connection between Santa Fiora as the source of Trajan's aqueduct.

I've visited several Traiana/Paola springs and stretches of the aqueduct as a member of a research team of archaeologists, classicists, historians, and engineers brought together by Ted and Mike O'Neill in 2009. They became interested in the Traiana/Paola and hoped to discover the locations of the source springs. This was fantastically optimistic, since even the most famous late nineteenth- and early twentieth-century archaeologists, Thomas Ashby, Rodolfo Lanciani, and Esther Van Deman, had failed to find any trace of the Santa Fiora—although they did see a short section of the nearby defunct aqueduct. What makes their oversight

more bewildering is that the place-name has appeared on maps since the seventeenth century, some with drawings of a small chapel and a stream of water.

It happens that the nymphaeum is directly beneath the Santa Maria della Fiora chapel (fig. 6.2). It had made use of the ruins, and although the chapel didn't use water within the sanctuary, a nearby well tapped directly into the Traiana channel by using a surviving shaft, from the ancient aqueduct. Decommissioned in 1888, the chapel was in shambles by the early twenty-first century, hidden in a dense forest of fig trees and brush.

By the 1980s, the town of Bracciano had installed a pump to tap underground water because the Fiora was almost dry. Spelunkers knew of the nymphaeum, which had already been cleared out except for the now-useless pump. The specus of the Traiana (now nearly dry) opens directly into the ten-meter-high grotto. Clearly, people knew about the nymphaeum but hadn't made the connection. Finally, the aqueduct's headwater—its most important spring, depicted on Trajanic coins—had been identified.

We made reconnaissance surveys over a huge swath of land encompassing much of the northwest quadrant around the lake. With permission from property owners and local water districts, and guided by game wardens, water commissioners, and forest managers—all of whom had intimate knowledge of their land and the region—we learned of springs and possible aqueduct ruins, including those of a small underground Etruscan aqueduct that predated the Traiana by centuries. Searching in earnest for other traces of Rome's most mysterious ancient aqueduct, we surveyed as many springs and ruins as possible, including some springs missed by Ashby, Lanciani, and Van Deman.

Rome's twentieth-century aqueducts, the Vergine Nuova and Peschiera-Capore, are perhaps less interesting from an archaeological standpoint, and their fountains in Rome are disappointing when compared with those of the Vergine, Felice, and Paola. Benito Mussolini's project, the Acqua Vergine Nuova, draws water from a group of springs also at Salone that are part of the same aquifer originating in the Colli Albani, the Alban Hills east of Rome. Completed in 1937 (with new springs added in 1943), the Vergine Nuova is mechanically pumped to Rome's northwest quadrant—most notably to Villa Borghese and the Giardini del Pincio (Pincian Gardens)—and then another line heads across the Tiber to the neighborhoods north of Castel Sant'Angelo and the Borgo. Some even reaches the Giardini Vaticani (Vatican Gardens). The Vergine Nuova is treated and is part of the drinking-water supply. Its *mostra* fountain, which announces the water's arrival, is in the Pincian Gardens. It's the fountain waterfall that cascades down the Pincian Hill above Piazza del Popolo. It does a perfect job of aerating water that has been inside pipes for thirteen kilometers.

The Acqua Peschiera-Capore springs weren't tapped for ancient aqueducts. Surely, emperors and their engineers knew of the springs, only sixty kilometers outside the historic center. That's not far for Roman engineers, but they might not have needed the water, since there were so many springs nearer Rome in less rough and varied terrain. These springs originate from limestone karst formations in the Central Apennine Mountains northeast of Rieti, so like the other aqueducts (excepting the Paola), the water is calcium-rich.

Proposed in 1908, the Peschiera project began in 1938. Work halted during World War II, resuming in 1945, and the first line was complete in 1949. Its mostra fountain is in Piazza degli Eroi (fig. 6.3). A second branch began in 1966, and then in 1975 the Capore springs combined with Peschiera water, and work was concluded in 1980. A long wait, but worthwhile. The Peschiera-Capore makes Rome's other modern aqueducts look puny; it pumps fourteen thousand liters per second, suppling 80 percent of greater metropolitan Rome's population with water and electricity, as well as other towns and cities in Lazio.

More interesting than its mostra fountains are the tall water towers, like one on the Janiculum Hill, Rome's highest hill, near Porta San Pancrazio. Unlike the bulbous water towers that once dotted small towns across the United States, these are hidden inside on the top floors of mid-twentieth-century, mid-rise buildings. Water is pumped to towers to create pressure so that it can be distributed by gravity throughout the city. Most people are unaware of them, except that the twelve-story buildings seem out of place in neighborhoods of four- to six-story apartment blocks.

Rome's drinking water—aside from the Salone springs—is potable at the source, but is treated to meet a European Union requirement. The huge takeaway is that you don't need to buy bottled water in Rome. The exception is dining in

Fig. 6.3. Piazza degli Eroi fountain. Artist unknown, 1949.

a restaurant where the custom of buying sparkling water dates to the nineteenth century. If you want to drink water while at a bar, simply ask for "*l'acqua al rubinetto*," water from the tap. As long as you buy something else, you'll be fine. To save confusion, ask for it at the counter, not at the register (you pay first). Some bars will give you a small glass of tap water or even sparkling water alongside your coffee, a long-standing tradition that sadly is disappearing.

Refreshed with coffee and water, I hope you're ready to continue. Meet at the Termini train station, the entry to the Metropolitana, Rome's subway system. Be there early; depending on your stamina, this could be an all-day jaunt.

## Bibliography

For the Roman Campagna, see Tomassetti et al. 1979–80; for aqueducts, see subject bibliography, Coates-Stephens 1998 and 2004, and Quilici 1968; for Renaissance aqueducts, see Long 2018 and Rinne 2010; for Santa Fiora, see Taylor et al. 2010; for nineteenth- and twentieth-century aqueducts, see Coppa et al. 1984; for Agostino Steuco, see Bariviera and Long 2020; for surveying, see Lewis 1999, Long 2018, and Maier 2016.

# 7
# Romavecchia

✣ Romavecchia Pilgrimage: Cinecittà Metro stop along Via delle Capannelle to the park entry, ~2 kilometers; Cinecittà Metro stop along the path to the Aqua Claudia at the Casale del Sellaretto entry, ~1 kilometer; Subaugusta Metro stop to the Casale Romavecchia, ~600 meters. The path along the aqueduct, from entry to exit, is ~3 kilometers.

Sometimes taking a ride on Rome's Metropolitana is worth the hassle—the confusion, stale air, unreliability, and crowds—if only to experience the contrasts between departure and arrival. This is especially so when you start at Termini, the transit hub beneath the central train station, and head out on the Red "A" line to Subaugusta or Cinecittà. Either stop is fine. The ride from urban chaos into the Roman Campagna to Romavecchia, "Old Rome," is short. Romavecchia is a romantic name given to Parco degli Acquedotti (Aqueduct Park) and the countryside around it; its ancient name was Pagus Lemonius. It's here that you step into a dreamscape of ruined aqueduct arcades, crumbling villa walls and cisterns, a fragment of the ancient Roman road Via Latina, umbrella pines, and open ground strewn with wildflowers in the spring, prickly bristles in the summer and fall, mud in the winter, and sometimes even snow.

You've seen this dreamscape before: in the opening sequence of Federico Fellini's *La Dolce Vita,* as two helicopters fly into Rome, one transporting a giant sculpture of Jesus. They appear to linger over the Campagna as though they're lost, but then decide to follow the aqueducts into Rome. Or perhaps you saw Paolo Sorrentino's *La Grande Bellezza* (The Great Beauty), where the protagonist, Jep Gambardella, ambles beside the ruins in his impeccable white linen suit as he comes to terms with his ruined career and failed life. But Romavecchia isn't only about movies and nostalgia. This is where it's possible to surround yourself with the heady reality of ancient and modern Rome's water supply, to momentarily calm the rippling fountains, silence the marble lions, and get down to cold, hard

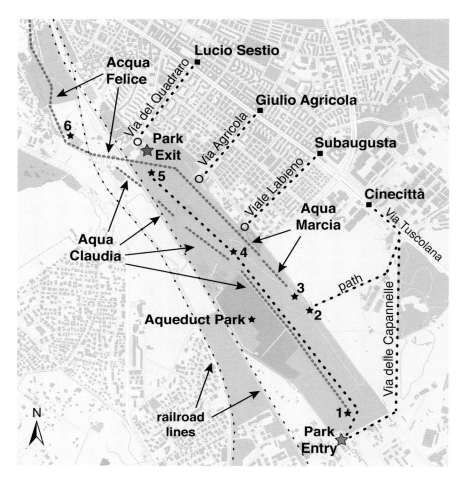

Fig. 7.1. ROMAVECCHIA PILGRIMAGE: ■ = Metropolitana stops. ○ = park entry points. 1) Aqua Claudia specus, 2) Casale del Sellaretto, 3) Via Latina ruins, 4) Casale Romavecchia, 5) Villa delle Vignacce, 6) Tor Fiscale. You may also enter or leave the park at any of the points marked with a circle.

facts. Here you can gain a rudimentary sense of the system's workings and what the Roman Campagna might once have been.

Eleven aqueducts built between 312 BC and AD 226 served ancient Rome. Five of them crossed this plain: the Aqua Marcia, with the Tepula and Julia riding on top of each other, and the Aqua Claudia, with the Anio Novus riding on top of it (see fig. 2.6). The medieval Acqua Marrana runs as a small brook near the arcades. Six more aqueducts serve modern Rome, and two of these, the Acqua Felice and Acqua Pia Antica Marcia, snake across and under these fields too. You won't see the Pia Antica Marcia. Sponsored by Pius IX (r. 1846–78) and completed in 1870, it was Rome's first mechanically pumped aqueduct. It is

completely underground. But the Anio Novus rode above the Claudia, the Julia rode the Tepula, which in turn rode the Marcia, and then when most of the Julia and Tepula had disappeared, the Felice took their place in 1587.

Excepting the Anio Novus—fed directly from the Aniene River, the last Tiber tributary before Ponte Milvio—the source springs lie eastward in the Alban Hills. We know of them from Sextus Julius Frontinus's *De Aqueductibus Urbis Romae* (On the Water Supply of Rome) of AD 97/98. The Renaissance Humanist Poggio Bracciolini discovered a medieval transcription of the treatise in the Monte Cassino monastery library in 1429 and quickly had it copied and distributed. This was an exhilarating find at a propitious moment, as new interest arose to restore the long-dormant aqueduct system. Rarely has a technical report (even including pipe diameters) been so warmly embraced.

Because of geological movement over more than two thousand years, the ancient springs are difficult to find. But Frontinus gives directions. He says the Aqua Marcia begins "where numberless springs gush forth from caves in the rocks . . . like unto a pool, and of a deep-green hue." The "cold and clear springs" lie along Via Sublacense, the road to Subiaco built by Nero two hundred years after the Marcia. The first-century AD natural philosopher Pliny the Elder said the Marcia was Rome's glory and a "divine bounty" given to the city. He calls the springs the most famous waters in the world for "coldness and wholesomeness." These are the modern Rosoline springs, "from veins deep in the mountain." Aqua Claudia's springs were also legendary: the "copious and beautiful" Caerulian and Curtian (now called the Serena springs), the "pure" Albudinus, and the Augusta, added later.

Closer to Rome lie the Sorgente di Squarciarelli of the Aqua Julia and Acqua Marrana, and the Sorgente Preziosa, where "a most abundant spring gushing forth" fed the Aqua Tepula. More springs emerge on the Alban slopes. The Santa Lucia and Fiumetto springs join the Pia Antica Marcia. There are more springs that once served ancient and baroque villas, and others that now supply small towns and monasteries. Most notable are the springs near Tivoli that watered Villa Adriana (Hadrian's Villa) and the Villa d'Este (see fig. 0.2).

It would be a wonder to follow the aqueducts from their springs in the Alban Hills out through the open Campagna: to visit the ruins near Tivoli and those at Ponte Lupo, or at Ponte San Pietro. But that's for another water walk, one you would take with an archaeologist who could drive you there. You might want to carry sturdy clippers and a machete to hack through the vines, underbrush, and brambles blocking your path. And wear knee-high boots, just in case there are snakes.

Back to Romavecchia. Rome, the aqueducts' ultimate destination about ten kilometers away, lies north-northwest. All but the Marrana passed over, under, or alongside Porta Maggiore, Rome's main gate from the southeast in the Mura

Aureliane (Aurelian Walls), begun in AD 271. Excepting the Felice and Pia Antica Marcia, the others predate construction of the walls, which took advantage of the aqueduct arches—filled in and reinforced as needed—saving time, materials, and money as the defensive walls were hurriedly built. The Acqua Felice, sometimes called a parasite riding the Aqua Marcia, now runs atop a portion of the wall, while the Pia Antica Marcia runs underground to its distribution station just inside Porta Maggiore.

Although the Acqua Marrana looks like any little countryside brook, it, too, is an aqueduct, one built at grade in 1122 by Pope Callixtus II (r. 1119–24). It also taps ancient springs, but without money or engineering skill, nothing grander was attempted. From Romavecchia it flows through the Caffarella Valley in the Parco Regionale dell'Appia Antica. After that, it runs underground, skipping Porta Maggiore entirely, and passes close to Porta Asinaria to enter Rome farther west at Porta Metronia.

The longest and loftiest surviving arcade marching across Romavecchia is the main attraction: 153 arches run for 1,375 meters (fig. 7.2). They are what make the park so evocative: here you can follow, touch, investigate, smell, even taste the stone used to build them. It's still possible to follow long segments of arcades by foot, indeed, to walk from Aqueduct Park to Porta Maggiore, keeping them close by much of the time. To do this, two things are necessary: you must begin early in the morning, and you need to plan for a long day—so, sturdy shoes, a broad hat, sunglasses, sunscreen, a camera, pens or pencils, a notebook, lots of water, some food, a little money, and, in the interests of conviviality, a friend or two to share

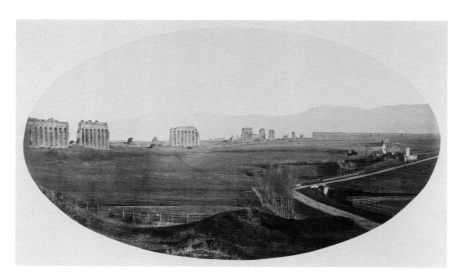

Fig. 7.2. *The Campagna near Rome.* Robert Macpherson, 1850s. Getty Museum. The longest aqueduct stretch enters from the Alban Hills to the far right.

the adventure. If you don't relish walking over long stretches of uneven ground, you can enter the park at Via Lemonia at the end of Viale Labieno, a short distance from the Subaugusta station, where you'll see the aqueducts advancing from the southeast. The park is large, but there are several places along Via Lemonia where you can opt out and take the subway back to Rome.

But for the full experience, you should exit the Metropolitana at the Cinecittà station and walk southeast along Via Tuscolana for about one hundred meters and turn left on Via delle Capannelle, a two-lane road than runs for about two kilometers. It allows you to enter at the park's farthest (southeast) end, where some ramshackle ruins of a second-century AD villa, called Sette Bassi, remain. This was once one of Rome's largest *ville suburbane* (suburban villas). Some of the grandest ancient sepulchers and villas arose along Via Latina (some traces of the road are visible further inside the park), and later many Christian cemeteries and churches. A larger villa, the Quintili, lies in ruins about three kilometers away along Via Appia Nuova. The two villas were the heart of what came to be known as Romavecchia.

Starting here, you'll have the morning sun at your back. Following gravity allows you to "go with the flow," along with the aqueducts, and to enter the city as they once did. Straight ahead is the point where the Aqua Claudia emerged from underground. It's possible to look inside its **specus** to see its peperino stone lined with waterproof cement that prevented leaks and reduced friction on internal surfaces. The channel was nearly two meters high and over one meter wide, big enough for maintenance crews to stand up and turn around.

But it isn't necessary to go all the way to the end. It can be a bit of a slog to get there, and if you didn't start early, you will already be looking for a coffee bar, but there isn't one anywhere nearby. Instead of taking the left-hand fork at Via delle Capannelle, you could take the other path directly in front of you through the fields toward the **Casale del Sellaretto.** The Aqua Claudia arcades will be immediately ahead, and no amount of willpower can keep you from walking straight to them. Their physical attraction overwhelms. Once you reach them, you have little to do but walk along the path on whichever side suits you and begin accompanying them to Rome. There will be much to think about: how and by whom were they built, the flora and fauna in the surrounding fields, the distant springs, or the little brook running nearby. But first, you might wonder why they were built, and why here. The first is obvious: Rome's swelling population needed water.

The Aqua Marcia of 144 BC came at a time of tremendous urban expansion in Rome. The defensive Mura Serviane (Servian Walls), already two centuries old, couldn't contain the growing city. By 270 BC, there were already two old aqueducts, incapable of satisfying the booming population. Immigrants had begun pouring into Rome—for instance, from North Africa, where the Punic Wars, most notably the Battle of Carthage, concluded in 146 BC. The number of captured

slaves moving to Rome further swelled the population, which by the end of the century might have been half a million persons, all of whom were thirsty.

Thousands of slaves maintained the aqueducts both outside and inside the city. Rome's first *curator aquarum* (water commissioner), Agrippa, owned 240 slaves dedicated to this task. Frontinus relates that collectively they were known as *aquarii,* and that Agrippa bestowed them to Augustus, who in turn gave them to the state, to be retained as a workforce known as the *familia publica.* In AD 52, as the Aqua Claudia was completed (and Rome's population neared a million), Claudius (r. AD 41–54) created a new office of *procurator aquarum* and added 460 slaves to the staff. This was the *familia Caesaris,* with "overseers, reservoir-keepers, line-walkers, pavers, plasters, and other workmen." We know that independent laborers built the Acqua Felice between 1585 and 1587. They worked at a feverish pace in teams assembled by craft—usually two thousand men worked at a time, and sometimes as many as four thousand. This was probably the case for the ancient aqueducts, too.

Slaves stationed outside the city attended to immediate problems, while inside the city they were posted at distribution points and maintained the pipes and fountains. There were nonslave workers: architects, freedmen who worked as deputy commissioners (that is, perhaps payroll clerks), and plumbers. Contractors carried out heavy maintenance and restorations. To help future water commissioners make informed decisions, Frontinus insists that they "be armed with self-acquired practical experience."

Once an engineer discovered good springs, the aqueduct's course had to be laid out as directly as possible, and at the same time maintain a uniform slope, because everything worked through gravity. This sometimes resulted in circuitous paths. The gradient couldn't be too shallow or the water would stagnate, nor could it be too steep because swiftly flowing water could damage the aqueduct and threaten its stability. Sometimes the aqueduct channel ran underground, or along the side of a slope, or across open ground, as at Romavecchia. Arcades were a necessary evil in order to maintain a constant grade.

The long valley that includes Romavecchia separates the lower slopes of the Alban Hills from Rome. The change in elevation dictated lofty arches—certainly dramatic, but plagued with problems. Arcades are costly. They require more materials and labor; load calculations are more delicate because there is no earth to protect the channel; and when built outside the city in sparsely populated areas of the Campagna, as Romavecchia was in antiquity, they were vulnerable to attack. Standing here next to the ruins of the Aqua Claudia, the loftiest of the arcades heading to Rome, it is easy to see how often they were repaired, failed, repaired again, and then failed altogether.

An historian, Procopius, accompanied Belisarius, Emperor Justinian's commander, on his campaigns. His careful records inform us that in AD 537, the

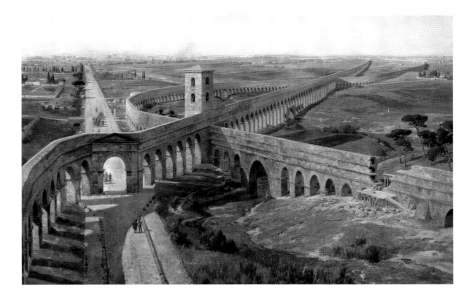

Fig. 7.3. *Tor Fiscale Where It Meets the Two Aqueducts.* Michael Zeno Diemer, 1914. Deutsches Museum, Munich. This is a reconstruction of the Campus Barbaricus landscape.

invading Visigoths hacked the aqueducts open "so that no water . . . might enter the city," and that they used a nearby field now called **Tor Fiscale** (slightly closer to Rome) as a temporary fortification from which they sent armies to attack Rome. Because the Visigoths camped here, the area was called Campus Barbaricus (Field of the Barbarians, fig. 7.3).

Procopius describes two exceedingly high aqueducts running on arches for long distances between Via Latina and Via Appia (the Aqua Claudia/Anio Novus and the Aqua Marcia/Tepula/Julia). They crossed each other "so that for a little space they reverse their relative position. For the one which previously lay to the right from then on continues on the left side. And coming together again, they resume their former places, and thereafter remain apart. Consequently, the space between them, enclosed, as it is, by the aqueducts, comes to be a fortress. And the barbarians walled up the lower arches of the aqueducts . . . with stones and mud and . . . gave it the form of a fort and encamping there to the number of no fewer than seven thousand men, they kept guard that no provisions should thereafter be brought into the city."

Procopius relates that in an earlier battle in Naples, Belisarius and his troops had entered that city by sneaking through one of its aqueducts. With that successful strategy in mind, Belisarius closed each of the aqueducts inside Rome's walls "by filling their channels with masonry for a considerable distance, to prevent anyone from entering through them . . . to do mischief."

Cutting Rome's aqueducts stopped water from flowing, dried up fountains, closed the public baths, and shut down the grain mills on the Janiculum. Starvation loomed because the mills, once driven by the motive force of the Aqua Traiana, ceased working. Had Belisarius not been so resourceful, the Visigoths might have won the battle right then. As a temporary measure, a stroke of genius, really, Belisarius had the mill's grindstones moved to floating barges on the Tiber River, inventing a new milling process (see fig. 4.5).

Belisarius quickly restored the Traiana (to revive the mills), the Marcia, and the Claudia. They again needed major repairs in the eighth century. Pope Hadrian I (r. 772–795) restored them (using agricultural workers for his labor force), but after the tenth century, no repairs are mentioned. Only the Aqua Virgo continued to babble along to the Campo Marzio, but no longer to the Thermae Agrippae (Baths of Agrippa).

What about the land itself, which has been farmed for millennia? You saw plowed fields to the right and left if you entered from Via delle Capannelle, and you'll see them again beyond the golf course (not ancient). The Church had owned much of this land since the fifth century: this was the *domus cultae* (cultivated land) that fed the Early Christian city. Before that, the land, then known as *latifundia,* had fed ancient Rome. Vast villas and large, efficient farms owned by emperors, their families, retainers, and senators swept across the arable land.

Ruins of **Villa delle Vignacce** lie at the west end of the park, just off Via Latina. Like Sette Bassi, it dates from the early second century AD. Owners brought palatial pleasures with them to their agricultural hubs, including elaborate bathing complexes. Quinto Servilio Pudente, an extremely rich brick producer linked to Emperor Hadrian's court, owned the Vignacce. Hadrian used bricks everywhere during his reign, both in Rome and at his Villa Adriana. The Vignacce was reoccupied and fortified during the sixth century when the Visigoths created their Campus Barbaricus nearby.

Emperor Constantine's family owned extensive territories, portions of which he gave directly to the Church, most notably the land where San Giovanni in Laterano stands on the Esquiline Hill. Some members of the Roman aristocracy also donated land to the Church, making it a rich and powerful owner. And, when endowed, the land included everything on it, including the *contadini* who worked the fields. Things hadn't changed much by the seventeenth century. The Church still had large holdings, but noble Roman families (some founded in medieval times) and individual churches (such as Santa Maria Maggiore and San Giovanni) or monasteries (such as San Gregorio) controlled most of the Campagna, using it for grazing and agriculture. Landowners didn't live here. They hired tenant farmers as overseers and subcontracted land to peasants, shepherds, and foreigners to farm. With few villages in this part of the Campagna, sheep outnumbered people.

The Campagna was left to the contadini, who had no choice but to stay.

Poor and tired from working long days (up to twelve hours), they had little to show for their efforts. They didn't even own the food they produced. Fed first, the land-owner usually received 50 percent of the harvest. The feudal sharecropping system kept many peasants tied to unproductive land and on the threshold of starvation. But, to artists and other visitors to the aqueducts, they were picturesque accents to plop into landscape paintings.

Originally, malaria was thought to result from *mal aria* (bad air)—that is, damp air, not marsh mosquitoes. Both damp air and mosquitoes are plentiful in the Campagna. Malaria seems to have become a particular terror as a result of feudal land tenure practices, in this case, the large swathes of cultivated land that stretched over vast territories. When aqueduct water arrived in the sixteenth century, trough basins for cattle were located all along the route. Surely the cattle and contadini appreciated them, but they exacerbated the ambient dampness, as their runoff water created undrained pools. Fever was rampant in the Campagna, and especially further south in the Pontine marshes, but particularly so in the autumn. The jaundiced faces of contadini advertised the endemic fever.

Visitors to Rome inevitably crossed some part of the Campagna. It couldn't be avoided: open fields and streams surrounded the city well into the twentieth century. Even Romans feared crossing, and some people deemed it suicidal. Malaria wasn't the only concern. Bandits pounced on travelers, and Italian wolves, *canis lupus italicus,* came down from the Apennines during extreme winters. Perhaps that explains why a wolf awaited Romulus and Remus on the flooded Tiber shore. Sixtus V tried unsuccessfully to do away with the bandits in 1586, and urban expansion eliminated the wolves.

Still, the "Roman fever" didn't keep people away. Romavecchia and all the Campagna became infested with excursionists on their Grand European Tour, an essential experience for upper-class men and some women from the seventeenth to nineteenth centuries. They contracted a different Roman fever, one for collecting. The Campagna—its ruins, the land, the atmosphere—were collected in poetry, paintings, and antiquities carried back home. Travelers not only took away marble chunks and sweeping landscape paintings. For many of them, another memento, malaria, now lurked in their blood, also reminding them of their Grand Tour.

The aqueduct ruins were on every artist's itinerary. This poignant landscape rarely escaped the eye of painters coming to Rome from France, England, Germany, the United States, and elsewhere. Claude Lorrain, Camille Corot, Thomas Cole, and George Inness all found their muse residing here. Whether they painted what they saw or created an imaginary scene was less important than the euphoria of an inspirational landscape. Johann Wolfgang von Goethe, among the most famous poets to rhapsodize the ruins, saw the aqueducts in 1786 and found them "highly venerable. How beautiful and grand a design, to supply a whole people

Fig. 7.4. *Goethe in the Roman Campagna.* Johann Tischbein. 1787. Städel Museum, Frankfurt am Main.

with water by so vast a structure!" Perhaps the most romantic portrait of the Campagna landscape was Johann Tischbein's painting of Goethe lounging among ruins, with the aqueducts in the background (fig. 7.4).

For sculptors traipsing through Romavecchia, there was always something to twitch their creativity. And any scoundrel or someone just needing easy cash could loot the ruins. That wasn't hard to do in the eighteenth century during this phase of "marble mania." Rodolfo Lanciani lamented how even the San Salvatore hospital administrators at the Lateran would "auction off arcades of the Claudian, which unfortunately crossed their farm of Arco di Travertino on the Via Latina. . . . [They sold] a monumental arch over which the Claudian spanned the highroad; and again the sale of four piers." Romavecchia remained a quarry until the early twentieth century.

After Giovanni Torlonia, a wealthy private banker, loaned Pius VI (r. 1775–99) some much-needed cash, he became the most important private banker for the Papal States. In March 1797, Torlonia purchased the Romavecchia estate, its thirteenth-century farmhouse, the land (about one thousand hectares), its ruins, and its tenants from the confraternity of the Sancta Sanctorum (associated with San Giovanni in Laterano). Then in September 1797, Pius, with some reciprocal back-scratching, named him the marquess of Romavecchia, his family's first royal title.

Approached by Via Latina, his land had a fantastic ancient pedigree. At the discretion of Pius, excavations took place there in 1789. Thomas Jenkins and Gavin Hamilton, artists working in Rome who had discovered the lucrative antiquities trade, directed the work and the sale of as much as two-thirds of the finds. Jenkins and Hamilton sold most of their loot to English clients. One-third went directly to Pius, who had first pick. He decided whether any finds

were too important to leave the Papal States; those went to the new Museo Pio-Clementino.

Archaeologists and antiquarians with scientific agendas, rather than an antiquities-exporting business model, also roamed the Campagna, and some of them, like Vatican librarian Agostino Steuco, looked for proof that could corroborate the evidence of Frontinus. The most important aqueduct hunter was Raffaello Fabretti, among whose interests were the source springs for the Aqua Marcia and Aqua Claudia in the Anio Valley near Tivoli. In 1680, he published his findings in a systematic topographic study of Rome's aqueducts and the Roman Campagna.

Naturalists arrived in droves. They probed the earth with sticks, zoomed in with magnifying glasses, sketched every plant's petals, roots, and leaves, or captured salamanders to study with members of a cultural and scientific society. A fellow at the Accademia degli Arcadi, Nicola Salvi, studied botany and might have come here collecting and drawing plants to "grow" on his Fontana di Trevi (Trevi Fountain). There were birds galore, especially sparrows, and a quite rare species, a particular dark-colored skylark seen in the Campagna but nowhere else in Italy. Birdsong is fast disappearing as their populations diminish. This is especially so for migratory birds, victims of illegal hunting in Italy's forested regions.

Looking down at the furrowed earth, you may think you see nothing but weeds, but these opportunists are glorious, displaced plants that thrive in disturbed landscapes throughout the Campagna (fig. 7.5). In May and June, there is *Vicia narbonensis* (perhaps a wild ancestor of the fava bean). There's buckhorn, willow herb, and wild licorice, and from November to February, there are cardoons. Milk thistle is everywhere, as are clover and dandelions. There is always a

| Feine Rauke, Crucifera tenuifolia. | Ross-Malve, Malva silvestris. | Akanthusblättrige Distel, Carduus acanthoides. |

Fig. 7.5. "Flora of Romavecchia: Wild Arugula, Field Mallow, and Common Thistle." Published in Johann Georg Sturm, *Deutschlands Flora in Abbildungen nach der Natur* (1796), pl. 32, 63, and 9. Biodiversity Heritage Library.

fig tree, sprouting on the shady side of ruins, perhaps the variety *Ficus ruminalis* that sheltered Romulus and Remus as babies. There is *Diplotaxis tenuifolia* galore, the marble-mouth name for spicy wild arugula. If you arrive in the morning, you'll see Romans picking it, and you too can harvest some to add to your lunch.

Looking up, you'll see little gardens in the sky. Capers grow on the aqueduct piers and in spring and early summer, there's wild fennel waving like flags from the pinnacle of the Aqua Claudia. Sometimes there is a stumpy *Quercus robur,* the common oak, perched up there too. Like the capers and fennel, oaks love dry places.

The farmhouse, once owned by Giovanni Torlonia and now called the **Casale Romavecchia,** is a good place to pause, if only because there is shade from the double rows of umbrella pines. Planted in the nineteenth century, they head south to Via Appia Nuova, at the time the main entry to the *casale.* The longest Claudian arcade terminates here, but to your right are Aqua Marcia ruins, running alongside the Acqua Felice. Here you can look closely at their construction and climb over the ruins. It is even encouraged with bridges and signs. In front, there is a small pool filled with cold water that you can see gushing from the side of the aqueduct. This was one of several locations where water was "let out" of the aqueduct, perhaps for repair, or as part of a rationing scheme with allotments to individual landowners at staggered times, as was the case in antiquity. Now a small quantity keeps the pond fresh. Its overflow water joins the Marrana channel.

But the ruins! In front of you are eighteen Aqua Marcia arches that continue to run northward behind the farmhouse. You can draw close enough to see inside the channel; you can see how carefully the tuff (erroneously called tufa) stone blocks were cut and laid, and how little mortar was used. You can also look through its specus (fig. 7.6). The Tepula and Julia that once rode on top have mostly disappeared, perhaps because they were built with cement, not with tuff stone. The lumpish Acqua Felice has abandoned its earlier perch on the Marcia and now runs alongside it. **Via Latina** once ran there too; you can see some of its cobbles to the south. A row of umbrella pines has been planted to recall those that once lined consular roads, like Via Latina.

Another kilometer along is the Via del Quadraro entrance to the park. To get there, just follow beside the Acqua Felice (the Marcia has now disappeared) or head into the shade of the oak and pine trees on the farmhouse side and walk for a while along the Acqua Marrana, where willows grow. Either way, you'll arrive at an ancient two-story cistern once fed by the Aqua Marcia. It belonged to the Villa delle Vignacce—only shreds survive—opposite the cistern. Owned by Quinto Servilio Pudente, the villa needed a lot of water for his brick factory.

Unfortunately, this is the end of the park, and a place of uncertainty: to stay longer to eat lunch, draw, take a nap, or simply sit and think by the little Marrana pool; to head to the Metro and return home; or to continue following

Fig. 7.6. Ruins of the Aqua Marcia at Romavecchia.

the aqueducts to Tor Fiscale and the Campus Barbaricus. The walk there is long, about two kilometers down a roundabout and poorly maintained path, and the Metro is so close.

After all, you have what you came for. You've looked toward the Alban Hills, rich with springs, and back to Rome's skyline in the distance. You've crossed some of the same territory as pilgrims, armies, contadini, archaeologists, artists, and naturalists, and smelled the same turned earth, mowed fields, and wildflowers. You've spent an entire morning, or more, in one of Rome's biggest museums, without an admission charge. Because it's free and relatively green and open to the sky, many Romans come here too. On a Sunday, there will be scores of families basking on picnic blankets on the uneven earth.

❧

Although the Aqua Claudia ruins continue to the northwest, they lie beyond two sets of railroad tracks and they're difficult to reach. If you choose to walk, follow the path to Tor Fiscale along the south side of the Acqua Felice ruins, which will cross over the train tracks. Or you could exit the park at Via Alessandro Viviani and take Via del Quadraro to the Metro. It will be to your right, straight along Via Lucio Sestio (also the station name), for four blocks. From here, you can catch a cab if you want to head to Tor Fiscale. Or since the Claudia and Marcia no longer

Fig. 7.7. Tor Fiscale at the crossing of the Aqua Marcia (below) and the higher Aqua Claudia/Anio Vetus (above).

flow at all, and the Felice will soon be underground, you might want to head into Rome, via the Metro.

Tor Fiscale marks where the Aqua Claudia/Anio Novus veered a bit to cross over the Aqua Marcia/Tepula/Julia at a ninety-degree angle (see fig. 7.3). The Marcia was about to describe a big arc that forced the Claudia to cross it again, before they both took sweeping turns to the left to head into Rome on high arcades. You are in the Campus Barbaricus, from which Vitiges's army, of perhaps seven thousand troops, swept across the Campagna to cut Rome's aqueducts. You can still see a bit of the intersection at the tower base (fig. 7.7). Built in the thirteenth century, Tor Fiscale was a watchtower, perhaps related to the Romavecchia farmhouse, also built then. Standing here, you feel a sense of enclosure; the aqueducts are no longer marching in straight lines, but bending to the will of water that determines its preferred path.

~~≫~~

Now begins the more arduous task of returning to the other side of the railroad tracks to reach Porta Furba, about two kilometers away. But, if you don't need to see Tor Fiscale and the Campus Barbaricus (it can eat up a huge part of the day), leave the park at Villa delle Vignacce and take the Metro from Lucio Sestio station for three stops to Arco di Travertino. Once there, turn right along Via dell'Arco di Travertino and then right again on Via Tuscolana. The walk to Porta Furba takes about ten minutes, but it's worth it. At Porta Furba, the Felice crosses over Via Tuscolana, a medieval road, where Sixtus V built the Fontana Mandrione in 1586 (fig. 7.8). An inscription above the monumental arch reminds everyone that Sixtus restored water brought to Rome's "desolate" hills from ancient sources.

Fig. 7.9. Rome's homeless residents built spontaneous houses (now destroyed) in this stretch between two aqueducts, the Aqua Claudia and the Aqua Marcia, and elsewhere along their routes.

If you haven't done so already, you really need to fuel up at this point before you decide what to do next. You can either walk a lot more or call it a day after seeing Porta Furba and return to the Arco di Travertino Metro stop. Whatever you decide, walk a little bit further along Via del Mandrione, heading toward Rome. You will soon come to a complicated space (fig. 7.9). The Aqua Claudia runs almost parallel to the Aqua Marcia (only a few meters apart). The Felice, after having ridden the Claudia for a while, hops back over to the Marcia for a short stretch before returning to the Claudia. Everything is squeezed together in part because the now nearly imperceptible ridge they follow into Rome is narrow, and the water must remain elevated.

This is also a good place to pause to imagine a different and decidedly unromantic Rome where hundreds of homeless Romans built a spontaneous encampment along the aqueduct arcades. A critical housing shortage developed as soon as Rome became Italy's capital in 1871. Homes for laborers and their families who arrived to build the new Rome weren't considered during planning, only those for the bourgeoisie who would run the new Italian government. Frankly, Rome has never caught up.

As in every major city, there are thousands of homeless people in Rome. Until evictions occurred between the 1960s and 1980s, destitute families still colonized the Acqua Felice and Aqua Claudia/Anio Novus ruins, taking advantage of standing stone and brick piers and infill to build "temporary" homes (you can see remnants of paint and even wallpaper), small businesses, and workshops and

create small vegetable gardens. There was even an elementary school attached to the wall. The most desirable location was along the Felice (here and in Roma-vecchia), where illegal taps into the specus supplied residents with water. Many families became permanent residents, as their children and grandchildren continued living here until they were evicted. Romavecchia was the boys' playground in *Mamma Roma,* Pier Paolo Pasolini's 1962 portrait of the desolation of postwar Rome, where the new suburbs met the Campagna: a very different dream from those of Fellini and Sorrentino.

From here, you make a little jump to the parallel street and continue to the next road, Via di Porta Furba, which becomes Via dell'Arco di Travertino and takes you right back to the Metro. Let's face it: you really don't want to walk the rest of the way back, even though you can see in Google Earth that the arcades continue almost uninterrupted to the Aurelian Walls. What's difficult to see are the long stretches of private property. In any case, you're tired by now. So, take the Metro to the San Giovanni station (five stops), transfer one stop to the Lodi station, and save a three-kilometer walk.

You can't imagine how much I hate "giving directions," but there is one last leg: it's short and sweet. Exit the Lodi station and turn right on Via la Spezia until you come to Piazza Lodi, a roundabout. You'll see the aqueduct crossing over the road. Pass under it and take Via Casalina to your left, and it will deliver you directly to Porta Maggiore, with its tangle of aqueducts surrounded by constant traffic. Here is one of Rome's thrilling complex intersections where threads of history—not only water history—unite in unexpected and seemingly serendipitous ways (fig. 7.10).

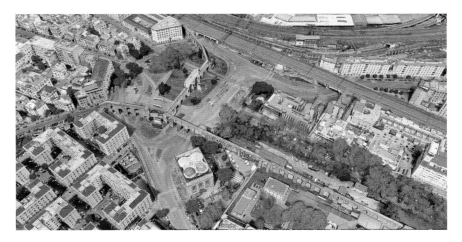

Fig. 7.10. Moving from the lower-right corner, the Aqua Claudia/Anio Novus/Acqua Felice makes a sharp turn toward the Quirinal Hill at Porta Maggiore (center top). A second Felice branch (middle left) rides atop the Aqua Neroniana toward the Caelian Hill.

It's always chaotic here. This is a treacherous corner with exhaust fumes wafting continually from the elevated highway to the right and dirt constantly swirling through the air. But if you stand outside the gate away from the traffic, there's a lot to think about. It's difficult to remember that the aqueducts were here first. The Aqua Claudia/Anio Novus runs along your left side and then makes that sharp turn to the right, before turning again just where you now see the train tracks streaking into Termini station. Although the wall wasn't begun until AD 271, Claudius, the aqueduct's sponsor, built an honorary gate where the arcade crossed over two roads leading out of Rome: Via Praenestina and Via Labicana.

When the Acqua Felice reached Porta Maggiore in 1586, it made use of the walls, with its main branch riding on top as it turned sharply north at Porta Maggiore and headed to the Quirinal Hill. A second branch, built thirty years later, headed to San Giovanni in Laterano. While Sixtus intended water to flow to urban fountains, he also intended that he and his friends with hilltop villas would have first dibs. And that is what happened. He handed out huge water gifts to them and to himself for his Villa Montalto. Only then could Felice water head out to the city from the Quirinal. We'll be going there next to follow the Acqua Felice and Aqua Marcia along the Quirinal's ridge, then down into the heart of Rome. When you're ready, head to the main entry at Termini station.

# Bibliography

For aqueducts, see subject bibliography (especially Evans 2000) and Coates-Stephens 1998; for their administration and construction, see Ashby 1935, Blake 1947, and Herschel 1913; for Poggio Bracciolini, see Ghisalberti, vol. 13; for springs, see Ashby 1935 and Pliny the Elder 1861; for Renaissance and contemporary aqueducts, see Cassio 1756–57, Coppa et al. 1984, Long 2018, and Rinne 2010; for aqueduct hunters, see Bariviera and Long 2015 and Evans 2002; for Belisarius, Goth wars, and Campus Babaricus, see Procopius *History,* 5:1.19 and 5:2.3; for city walls, see Dey 2011 and Richmond 1930; for the Roman Campagna, its flora and fauna, and malaria, see subject bibliography (especially Tomassetti et al. 1979–80), Goethe 1870, Sanguinetti 1864, Tilly 1947, and Wrigley 2013; for the Acqua Marrana, see Alessio Angeli and Berti 2007, Ashby 1935, and Duchesne 1886–92; for bandits, see Wrigley 2013; for latifundia, domus cultae, and suburban villas, see Duchesne 1886–92 and Tomassetti et al. 1979–80; for land tenure, see Carocci 2016; for Fontana Mandrione, see D'Onofrio 1986; for spontaneous encampments along aqueducts, see Insolera 2002; for the Grand Tour, marble mania, and Giovanni Torlonia, see Lanciani 1909 and Wrigley 2013; for Porta Maggiore, see Coates-Stephens 2004.

# 8

# Emperors, Popes, and Wealthy Women

🌿 Quirinal Hill Pilgrimage: Termini train station to Piazza del Quirinale, ~2.3 kilometers

My love affair with Rome began on my honeymoon, while standing with my husband at Rome's central train station. We arrived in the early morning and stumbled out to Piazza dei Cinquecento. We needed coffee and we needed to walk. This water walk, less than three kilometers long but thousands of years deep, recreates that first day in Rome. If you decide to follow along, I urge you to do so in the morning, when the sun will be at your back most of the way and there will be long swathes of shade to accompany you through time. Also, if you decide to visit the three small churches along the way, they might only open in the morning.

My husband was the perfect tour guide. He had lived in Italy for three years, and Rome was his favorite city; it was about to become mine. Standing outside the coffee bar, he helped me imagine this spot as it looked in the late sixteenth century. The **Termini train station,** with its tentacles of tracks, stands above ruins of the Mura Serviane (Servian Wall, Rome's fourth-century BC defensive line), but only a small piece remains over in the far corner of the piazza. The station also stands above a portion of Villa Montalto, Pope Sixtus V's luxurious Esquiline Hill retreat designed by his favorite architect, Domenico Fontana, and created from property he and his widowed sister began acquiring in 1576. The villa entry stood opposite Santa Maria Maggiore, where Sixtus was the titular cardinal until his election. He hunkered down in his villa in earnest when on the outs with his predecessor, Gregory XIII, for spending too much money.

Sixtus built the Acqua Felice that you followed through Romavecchia into Rome. He owned the aqueduct, gave it his name (Felice), and gave himself first dibs on the new water supply; he needed it for the scores of fountains, towering cypresses, oaks, plane trees, and acres of flowers and lawns he wanted for his villa.

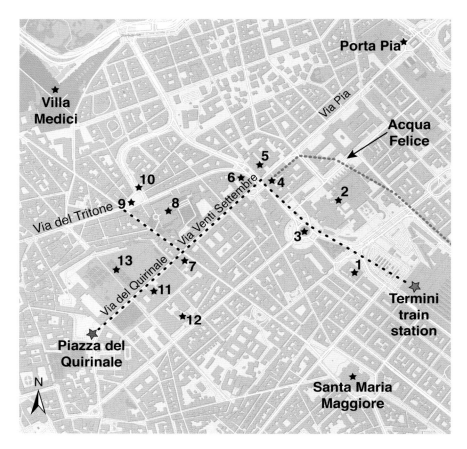

Fig. 8.1. QUIRINAL HILL PILGRIMAGE: 1) Villa of Livia Drusilla murals, 2) Thermae Diocletiani (Baths of Diocletian)/Santa Maria degli Angeli, 3) Fontana delle Naiadi (Naiad Fountain), 4) Fontana del Mosè (Moses Fountain)/Lavatoio Felice, 5) Santa Maria della Vittoria, 6) Santa Susanna, 7) San Carlo alle Quattro Fontane, 8) Palazzo Barberini, 9) Fontana del Tritone (Triton Fountain), 10) Fontana delle Api (Bee Fountain), 11) Sant'Andrea al Quirinale, 12) San Vitale, 13) Palazzo del Quirinale.

Here, as at Villa Madama on Monte Mario overlooking the Tiber, water became the focus of the garden, only now it was aqueduct water (fig. 8.2). There was a fishpond (with a dramatic *Neptune and Triton* by Gian Lorenzo Bernini added in 1623, but now at the Victoria and Albert Museum) and the obligatory *giochi d'acqua* (water games), designed to drench unsuspecting guests. One fountain, designed by Antonio Negroni (perhaps never built), had forty-nine water jets placed among singing birds, swimming fish, and a Siren. The gardens were also stuffed with antiquities—a necessary complement without which a villa would be incomplete. But water was the focus. Sixtus wanted to revitalize Rome's long-dry hills with aristocratic villa gardens, vineyards, orchards, and fountains like those

VEDVTA DEL GIARDINO DELL' EMINT.º SIG. CARDINALE PAOLO SAVELLI PERETTI VERSO SANTA MARIA MAGGIORE
1.Aspetto del Palazzeto felice.    2. Giardini secreti.    Architettura del Caual.º Domenico Fontana    3.Teatro è fontane auanti il Palazzo felice.    4. Fontane de leoni.

Fig. 8.2. *Villa Massimo.* Giovanni Battista Falda, 1665. Vincent Buonanno Collection. The garden entry for the villa, originally known as Villa Montalto, is at center right.

that had flourished here in antiquity. Set above the miasmic "Floating City," with its mosquitoes and heat, he made these prized hills flourish once again.

Sixtus retained his affection for Santa Maria Maggiore. He provided it with a drinking fountain for people and horses, and he erected an obelisk to face northwest toward a new road he built for pilgrims traveling to Santa Maria del Popolo. In 1614, another fountain was built at the main entry, facing southeast toward Santa Croce in Gerusalemme and San Giovanni in Laterano. Relatively modest, this one survives.

Gregory XIII had wanted to restore an ancient aqueduct, but money was short. Sixtus eagerly picked up his predecessor's project and called it his own, the Acqua Felice. In any case, a nearby aqueduct arch over Via Tiburtina, built by Augustus, no doubt goaded Sixtus's resolve to build the Felice. The Thermae Diocletiani (Baths of Diocletian) loomed next door, and their enormous reservoir— seventy-one meters long—still stood at the villa's property line. Aqueduct ruins ran across his property, seventy-seven arches in all, beginning at eleven meters tall, until dying into the hillside. Equally enticing were the ruins of an ancient terminal fountain known as the Trofei di Mario (Trophies of Marius), one of only two surviving monumental fountains in Rome.

The "trophies" loomed rather ominously over nearby fields in what would become Piazza Vittorio Emanuele II, a bastion of bourgeois housing built at the end of the nineteenth century for government functionaries arriving from Northern Italy. But sumptuous ancient gardens, the Horti Maecenatis and Horti

Lamiani, had flourished long before. The ancient *agger* (an earthen wall) inside the Servian Wall ran beneath them. They also stood above a *fossa,* the defensive ditch just outside the wall that had been excavated to build the agger. The wall disappeared centuries earlier and the ditch was filled in, but not before being used as a grave for hundreds of thousands of Rome's plebeians.

Sixtus's villa vanished in 1871, when Rome became the capital of the newly minted Italian state. His wasn't the only distinguished villa, vineyard, or garden on Rome's hills to go extinct. The litany is a dirge, and some, like the legendary Horti Bellaiani, had vanished earlier. These were Cardinal Jean du Bellay's gardens, nestled inside the exedra of Diocletian's baths, and described in 1597 by Jean-Jacques Boissard as "planted with pomegranates, oranges, citrons, cypress, myrtle, and laurel like a coverlet."

Tragic for the loss of green and airy spaces alone (even though the gardens were private), the vacuum would be easier to bear had more attention been paid to planning a real national capital, not an idealized neoclassical city meant to recall its ancient past or a beaux-arts European city of grand boulevards and ponderous government temples. Rome struggled to be a modern Risorgimento capital of the unified Italian peninsula, but change happened too rapidly; nothing could stop its momentum. Leaders of the fledgling government dreamed of urban reorganization sweeping from the hilltops to the Tiber and out to the periphery of the Campagna. Their urban strategy began to fail almost immediately.

During the rapacious 1870s and 1880s, developers and the new Italian government swallowed up prime hilltop real estate from cash-strapped owners to

Fig. 8.3a–b. Villa of Livia Drusilla, Prima Porta, frescoes (including detail), first century AD.

build behemoth government buildings and new housing blocks. As today, developers built "luxury" housing for desirable tenants, but nothing "affordable" for the workers who, left to fend for themselves, created makeshift housing at Rome's edges, as at Romavecchia. This wave of destruction only slowed with the worldwide economic depression that began in 1887.

Since Rome's ancient villa gardens no longer exist, visiting the illusion of one, now housed in Palazzo Massimo (formerly a part of Villa Montalto) by the Termini train station, is in order. There you'll find frescoed murals retrieved from an underground room at the **villa of Livia Drusilla** (wife of Emperor Augustus), located at Prima Porta, about twelve kilometers to the north, near the Tiber (fig. 8.3a–b). Frescoes are always fragile, but especially so in damp conditions. Despite the underground humidity, and the fact that German troops used the rooms as a hideout as they retreated north in 1944, they are remarkably intact. Removed from the site, the murals were restored in 1951. Their fourth-floor museum haven is peaceful; few people venture there. It's also mysterious—a strange and secret place, like Alice's Wonderland.

Painted with luscious garden scenes on all four walls, the room might have been used for dining during Rome's blazing hot summers. A small aqueduct watered the real Prima Porta gardens. Some of the painted birds, fountains, plants, and decorations might have mirrored the gardens outside, or portions of the nymphaeum also found there. The illusionistic murals depict cypresses, laurels, oaks, palms, pomegranates, and the fabled umbrella pines. There are flowers and flowering bushes: irises, oleanders, periwinkles, roses, violas, and quince, with chamomile, ferns, and ivy in profusion along little wickerwork borders. Blackbirds, jays, orioles, partridges, sparrows, thrushes, and what look to be doves perch everywhere. Oddly, there are no mural fountains, although a live fountain probably burbled within the room. With or without a fountain, none of the real garden would have been possible without aqueduct water and the slave labor that built and kept everything in order.

Aside from Villa Montalto, there were other villas (also gobbled up) and gardens planted with artichokes, olive trees, and vines—in 1581, Michel de Montaigne extolled eating grapes all year long and artichokes in mid-March. Ruins galore sprouted everywhere, many with wildflowers flourishing within the crevices of broken stones. Consider the **Baths of Diocletian,** the biggest ruin of them all, standing on the Quirinal opposite Termini (fig. 8.4). Completed in AD 306, it was a shambles by the 1870s. Drenched in shadows, covered with opportunistic plants, it was also a haven for birds. Fortunately, much of the 120,000-square-meter precinct (about twelve hectares) was beyond the well-greased palms of even the most aggressive developers and planning commissioners. Pius IV set in motion the building's salvation when he revived Giuliano da Sangallo and Baldassarre Peruzzi's 1515 idea to build a church in one of its vast halls. Pius

Fig. 8.4. *Baths of Diocletian.* Giovanni Battista Piranesi, no date. Vincent Buonanno Collection.

consecrated the ruins in 1561 and hired Michelangelo to slot **Santa Maria degli Angeli** into the enormous *frigidarium,* the cold pool area. Other parts became a monastery (today housing the Museo Nazionale Romano) or gardens such as the Horti Bellaiani, where Cardinal du Bellay entertained François Rabelais. Gregory XIII put another area of the precinct to use as a granary.

For me, the Baths of Diocletian (r. 284–305) rather than those of Caracalla (r. 211–217), make it possible to comprehend the scale of the ancient baths. This was one of the biggest; no records exist, but one estimate suggests that three thousand people could be there at a time. The baths constituted a social center, with gymnasia, libraries, classrooms, cult shrines, and gardens where you could *also* bathe. You could race on the *palestra* (an outside athletic field), then bathe, read poetry, and talk politics amid the roses, all in one extraordinary domain. The baths were public. For a small fee, men and women, rich and poor, senator and slave, bathed there, on different days or at different times.

Diocletian's baths gulped enormous quantities of water each day and had a dedicated water line from the Aqua Marcia. A massive holding tank stood at the edge of what later became the Villa Montalto, and a *piscina* (filtering tank) was not far away. With the baths closed at night, water filled the tank for the next day's bathers. All baths used wood to heat water: in doing so, they played a major role in deforestation in the hills and mountains north and east of Rome. This in turn led to increasingly destructive Tiber River floods.

You can sit quietly in the church and imagine yourself as one of those early fourth-century bathers with hot, warm, and cold pools available to you. Acres of sumptuous marble covered the floors. Granite and porphyry abounded in massive slabs of decorative green and maroon panels fixed to the walls. Michelangelo reused eight red granite columns that still support the original cross-vaulted ceilings twenty-eight meters above the floor. In his plan, worshippers entered from the south rather than the west (the shift occurred in 1749). Some of the grandeur of entering—with a longer vista unfolding before you—has been lost. Still, it is numinous.

Rome's last imperial bath, that of Constantine (the Thermae Constantinia-nae), built around AD 315, stood at the Quirinal's opposite end. The Via Salaria (by then called Alta Semita and now Via del Quirinale to the west and Via Venti Settembre to the east) connected the baths with vineyards and villa gardens featuring pools, fountains, and lush plantings on both sides. Rodolfo Lanciani relates that from the time of the dictator Sulla (r. 82–79 BC), for another five centuries "every inch of ground had been eagerly sought for by the leading patricians." Oddly, not everyone had water. Martial, a first-century AD poet who lived on the hill, was tantalized by the sound of the Aqua Marcia running nearby, but miffed that he couldn't claim some for his home. In 537, when Vitiges hacked through the aqueducts in the Campagna, water ceased flowing to all the baths and villas.

The **Fontana delle Naiadi (Naiad Fountain)** confronts you as you leave the church (fig. 8.5). There is nothing like it in Rome. It's a whizbang affair: the central jet is a fire-hose explosion that can shoot eleven meters into the air. The juxtaposition of sacred and profane couldn't be more pronounced, and fun! Not even ancient bathers were as naked as the Naiads; they at least wore modest coverings. Like all our fountains, the Naiads have a voice, and, in this case, they whoop with joy as they shimmy under the shower.

Perhaps this is the fountain that excited William Faulkner when he visited Rome in the 1950s. These are the most likely candidates for those "naked girls wrestling with horses and swans and tons of water cascading over them" that he admired. That is one sybarite's take on naked beauty. Others were appalled, and the Naiads were hidden and the inauguration postponed until someone anonymously stripped them of their temporary enclosure one night in 1901. Naked gods and goddesses or not, the fountain holds a special place in Rome's water story. Like the Trevi, it is the terminal fountain (mostra) for its aqueduct, in this case the Acqua Pia Antica Marcia. In what turned out to be his last public appearance, Pius IX, its sponsor, inaugurated the aqueduct on September 10, 1870. Ten days later, soldiers of the new kingdom of Italy breached the Mura Aureliane (Aurelian Walls) near Porta Pia. Rome was no longer a papal domain. Pius retreated to the Vatican, where he spent the rest of his life. In 1871, Rome became the new Italian capital.

Fig. 8.5. Fontana delle Naiadi (Naiad Fountain), Piazza della Repubblica. Alessandro Guerrieri (basin), 1888; Mario Rutelli (bronzes), 1909.

When Via Nazionale was cut through to connect the Termini station to the city, it punctured the embracing exedra hemicycle, once used as spectator seating in the palestra of the baths. Doing so created Piazza dell'Esedra; the now-surrounding buildings are meant to recall its sweep and scale. Every piazza needs a fountain, so one was placed here. Because the mechanically pumped Pia Antica Marcia arrives under great pressure, there's a spectacular water display: one befitting an emperor. The Naiads replaced the 1870 iteration that stood closer to Piazza dei Cinquecento, where the station had been recently completed. A tepid affair, the original fountain was thrown together quickly with stucco lions that must have melted away from the water's force. To replace the lions, Mario Rutelli designed the naiads, with their assorted beasts, for a larger basin and added the central male figure, "Glauco," in 1911. The water seems thrilled to arrive here and dazzle us all. After the silence of the church, the roar of water is an enticing counterpoint.

The **Fontana del Mosè (Moses Fountain)**, the Felice's mostra, is to the northwest (fig. 8.6). Ignore the scathing criticism that the Moses is "*la più brutta scultura di Mosè,*" that is, his most unattractive likeness. That's unimportant. The water is important, not his ungainly proportions. We've made it to Moses's bully pulpit in Piazza di San Bernardo so that we might listen as he points to the craggy rocks from which Felice water gushes into huge basins. He is doing so at Sixtus V's bidding. The huge laudatory inscription tells us that, as Moses once brought water to the Sinai Desert, Sixtus brought water to Rome. The meaning is obvious: Sixtus was a new Moses.

Fig. 8.6. *Moses Fountain.* Giovanni Battista Piranesi, 1748–78. Rijksmuseum. The Lavatoio Felice was to the right of the fountain.

The fountain, standing at the top of the Quirinal, faces toward Rome along a major road, at this point now called Via Pia. Its inscription hovers over the tableau like a billboard, proclaiming Sixtus as protagonist of Rome's revival. Bringing water to Rome's eastern hills meant he could once again see them covered with gardens, as they had been in antiquity. Domenico Fontana, the fountain's designer, might have been inspired by the Trophies of Marius. While Moses is a pale comparison to the Naiads and the Trevi, he was the first to celebrate Rome's new water supply. In this conflation of a triumphal arch (recalling ancient imperial power) with the biblical Moses, Sixtus is clear: he inherited both the Catholic and imperial traditions. While still the pope, he was Moses and an emperor.

It's good to have Moses parting waters and letting people drink at his fountain, from the mouths of whistling lions, as you begin following the Felice through Rome. But before leaving his chaotic piazza, this is a good place to do a 360-degree turn. Looking back along the road to the Naiad Fountain, where the hotel now stands to your left, Sixtus built the **Lavatoio Felice,** an enormous public laundry for three hundred women, using Felice water. The Cistercian nuns at Santa Susanna sponsored the walled compound that Sixtus commemorated in a fresco painting. A porter protected the women—prostitutes often worked as laundresses alongside female servants and other women doing the household wash—from being molested and taunted by men on the prowl. Its large size and noisiness made it difficult to manage. It closed within two decades.

Looking beyond Moses to the northeast, down Via Venti Settembre (formerly Via Pia, Alta Semita, and Via Salaria), Porta Pia, designed by Michelangelo for Pius IV, lies at the far end. Closer by, opposite the fountain, is the church of **Santa Maria della Vittoria,** home of Bernini's intense portrayal of St. Teresa. If you stay in Piazza di San Bernardo, but pivot to face northwest, you will see the handsome façade of **Santa Susanna,** designed by Carlo Maderno and completed in 1603. Camilla Peretti, Sixtus V's sister, founded a monastery for cloistered Cistercian nuns there, the same nuns who sponsored the laundry. The biblical Susanna bathed at a pool and ran into trouble from the leering elders. Susanna reminds us that access to water and the vulnerability of women and girls are persistent problems. According to UNICEF, today "girls around the world spend a collective two hundred million hours a day gathering water." Without piped water at home, they must fetch it and bathe or do laundry at a stream. It seems like a small thing, but protecting women while they washed linens was critical, even if the details didn't work out at the scale Sixtus had hoped.

Camilla knew firsthand about laundresses' work and how vulnerable the women could be. She worked as one for many years before her brother became a cardinal and she moved with him to Rome. She soon became wealthy enough to buy the property that became Villa Montalto. She was the victim of a

Fig. 8.7. Fontana di Juno (Juno Fountain), Via delle Quattro Fontane. Pietro da Cortona or Domenico Fontana, 1589.

pasquinade begun by Marforio (you'll meet him in the next chapter) and bandied across town—nearly everyone in Rome could have identified her as the intended target.

> MARFORIO: "How you've neglected yourself, Pasquino! Your shirt is as filthy as a coal miner's!"
>
> PASQUINO: "What can I say? My laundress [Camilla] has become a princess!"

If you turn 180 degrees from Santa Susanna's façade, you will see the little round church of San Bernardo. It's worth peeking inside. This building marked the northwest corner of Diocletian's baths. It's interesting because it provides another opportunity to consider scale. This was just one of many rooms dedicated to reading and pursuits other than athletics.

Back in the piazza, continue following Via Venti Settembre toward the west, where a trunk line of the ancient Aqua Marcia ran under this street, and later the Acqua Felice and Pia Antica Marcia. From here, you can follow gravity down the crest of the hill. It's about a three-hundred-meter walk to an intersection with four fountains, the Quattro Fontane. You have four choices to slake your thirst when you arrive: Father Tiber, the Aniene River, Juno (fig. 8.7), or Diana. I recommend Father Tiber, since we spent three chapters following him through Rome, but anyone will do. Anyway, you'll return here, so you can patronize them all. The water, once Felice but now Pia Antica Marcia, is cold (ten degrees Celsius) and

delicious. Sixtus persuaded his wealthy friends to pay for the fountains by prom-ising aqueduct water for their private villas located here. These are semipublic fountains like Il Babuino. Unlike him, they are not outspoken about politics, but given this prime location in a vociferous city, I imagine them gossiping like crazy late at night.

Sixtus wanted the fountains at the intersection where Via Venti Settembre becomes Via del Quirinale and crosses Via delle Quattro Fontane—a new street that he had built and originally named Via Felice. This was intended to be a convenient and welcoming pause for religious pilgrims who walked from Santa Maria Maggiore to Santa Maria del Popolo when they visited the seven pilgrimage churches. This part of their journey, about two-and-a-half kilometers, involved crossing over one of Rome's highest hills, the Quirinal. The fountains are still a pilgrim's destination. Regardless of creed, it's the perfect place to take a drink.

There is so much to see and do, at and beyond this corner, all of it magnifi-cent and storied beyond any expectations. There is enough to dumbfound any-one: there is the church of **San Carlo alle Quattro Fontane** (nicknamed San Carlino, Little St. Carlo Borromeo) on the corner. Palazzo Barberini lies to the northwest, Palazzo del Quirinale to the southwest, and Santa Maria Maggiore to the southeast. But before going anywhere, pause another moment. From here, it's possible to see three of Rome's six obelisks. Looking beyond Piazza Barbe-rini, there is one at the top of the Spanish Steps; a second anchors Santa Maria Maggiore; the third awaits you in Piazza del Quirinale. Roman emperors brought them from Egypt as part of their conquering loot. Sixtus began uprooting them, baptizing them as Christian, and re-erecting them at important intersections as signposts for navigation and urban domination.

At this point you can choose to walk down the hill to Piazza Barberini or perhaps pause inside San Carlo alle Quattro Fontane. If you decide to walk down-hill, it's about 250 meters each way. Not far to see one of Rome's most important fountains and to learn what it can teach us about water and gravity.

<center>⚜</center>

When Cardinal Francesco Barberini built **Palazzo Barberini** (now a museum), he had a famous collection of exotic plants overseen by the eminent botanist Giovanni Battista Ferrari, who dedicated his 1633 treatise, *De Florum Cultura* (On the Cultivation of Flowers), to the cardinal. The palazzo, designed by Carlo Maderno, Francesco Borromini, and Bernini, is still glorious, with its sublime Borromini staircase and Pietro da Cortona ceiling fresco, but the rear garden is sadly diminished.

Heading downhill past the palazzo is the best way to keep the narrative alive and to rouse the water pilgrim's spirit. To the right is Bernini's **Fontana del Tritone (Triton Fountain)** commissioned by Urban VIII, a Barberini (fig. 8.8).

Fig. 8.8. Fontana del Tritone (Triton Fountain), Piazza Barberini. Gian Lorenzo Bernini, 1642.

While waiting at the stoplight to cross to the fountain, you can think about the invisible torrent of water rushing beneath the street. It emerges from ancient springs to the east to become the Acqua Sallustiana that originally flowed into the Palus Caprae in the Campus Martius. Channelized in antiquity, it still flows under the hill. Until the late nineteenth century, nearby houses drew water from wells along the upstream portions.

The geology is striking: this is still a wet valley between the Pincian and Quirinal hills where little springs flow along the Quirinal face. Enrico Gigli wrote that the entire Quirinal is "*inzuppato,*" drenched in water. The springs at the head and on both sides of the Valle Sallustiana were buried when the hill was leveled for Diocletian's baths; the earth filled the valley to a depth of several meters. There are also the Sallustiana springs further up the hill, where Caesar had another horti, later owned by the historian Sallust in the late first century BC, and then by Emperor Tiberius (r. AD 14–37), and after a long gap acquired by the Ludovisi family in the seventeenth century.

Not only is the Triton Fountain stunning, until recently it was one of the most instructive places to understand how gravity distribution works. Today, with water conservation in full force, Triton is lucky to have his meter-high jet, and his voice—once a proud bellow—is today little more than a gurgle, not at all what Bernini intended, acoustically, spatially, environmentally, or dynamically. Together,

the dolphin pedestal, conch shell, and Triton are nearly six meters high, and as originally designed the water jet added eight more meters. With a papal sponsor, the fountain received an enormous supply of water, and pressure is high because the piazza is about twenty meters lower than its source at the Moses Fountain. But all twenty meters couldn't be used. The principle is easy—water seeks its own level—but the practice is more subtle. To lower the pressure and protect the pipes, the water flowed into a cistern at the Quattro Fontane (a few meters lower than the Moses). There also needs to be some wiggle room—for example, during droughts there is less water, hence less pressure. Designers need to ensure their clients' fountains won't lack a beautiful water display, even when water is scarce; thus, the jet had to be a few meters lower than the Quattro Fontane *castello*.

Myth and poetry are never far from Rome's fountains, and the Triton is no exception. Bernini's Barcaccia told multiple stories about a flood, a warship, the Counter-Reformation, and poetry. But the Triton expresses a specific, overarching reference about harmonious accord created out of chaos. The allusion is from Ovid's *Metamorphoses* (as translated here by Ian Johnston), and it would have been familiar to Rome's elites, distinguished visitors, and to his patron Urban VIII, who was a poet. Where Sixtus saw himself as Moses, Urban might have envisioned himself as Triton:

> The lord of the ocean
> sets down his three-pronged weapon, calms the seas,
> and summons dark-blue Triton standing there
> above the ocean depths, his shoulders covered
> by native shells, and orders him to blow
> his echoing horn and with that signal
> summon back the flooding waters and the sea.
> Triton raised his hollow shell, whose spirals
> grow as they curl up from the base
> that horn, when filled with air in the middle of the waves,
> makes coastlines under east and western suns
> echo its voice—and thus, once the god's lips,
> dew dripping from his soaking beard, touched it,
> and, by blowing, sounded out the order
> to retreat, all the waters heard the call,
> on land and in the sea. They listened to it,
> and all of them pulled back. And so the sea
> had a shore once more, full-flowing rivers
> remained within their banks, floods subsided,
> hills appeared, land rose up, and dry places
> grew in size as the waters ebbed away.

The Triton's close neighbor, a drinking basin called the **Fontana delle Api (Bee Fountain),** originally stood where Via delle Quattro Fontane meets Via Sistina at the northwest corner of the piazza. The Bee, like Il Babuino, was removed during the nineteenth-century road-widening program. But it, too, returned to its old neighborhood and is worth a visit, if only because you might be thirsty again. Three clever and obliging bees perch on an open scalloped shell protecting the water (now the Acqua Pia Antica Marcia) as it streams into the basin. It now stands at the north corner of the piazza near the Capuchin church, with its famous crypt filled with the bones of 3,700 long-forgotten brothers, artfully displayed to remind us of our mortality.

Heading back up the hill is San Carlo's church, a breathtaking example of baroque architecture designed by Francesco Borromini between 1634 and 1662. Rome is a city of baroque buildings and piazzas. Fluidity, dramatic spaces, and contrasts between light and dark are some defining characteristics of the style. An underlying premise of the baroque is that stone can follow and imitate water's flow. The baroque movement began in Rome, where aqueduct water spurred creativity—first with fountains, and then buildings, sculpture, painting, and entire piazzas, with its apotheosis at the Porto di Ripetta and the Trevi.

All you need do at San Carlo is sit and look toward the ceiling. Everything undulates as it moves upward; the space is elastic, musical, and fluid. The walls drift forward and backward seamlessly in balletic adagio. Although movement pauses at the entablature—the horizontal element between the walls and the dome—your eye won't stop moving until your head becomes too heavy to keep staring upward.

From inside the church, you are washed ashore out onto the narrow sidewalk. The real clincher for understanding baroque architecture's fluidity is the entry façade. If you didn't take time to look at it on your way in (the traffic is always horrendous), try doing so now. It is lyrical and sinuous (technically a sinusoidal wave), pushing vertically, with the undulating entablature dividing the façade horizontally. It was revolutionary and had a profound influence on architecture and urban design in Rome and elsewhere.

The plan is to continue along Via del Quirinale to the fountain at the end of the ridge at **Palazzo del Quirinale.** But other things interrupt: if you need to rest for a moment there are two public gardens with dripping fountains (one has a little lake). There is also a slice of a view into the Giardini del Quirinale (Quirinal Gardens). This was a hot property that cardinals and popes lusted after for centuries. It now houses the president of Italy. So, the guards won't let you get too close, but we will return for a "flyover" in chapter 12. There are scores of fountains—some predate the Acqua Felice—and a famous water organ.

There is Bernini's church of **Sant'Andrea al Quirinale,** completed in 1670. Knowing the sublimity of Bernini's fountain designs, it stands to reason the

church will also be sublime. It doesn't disappoint. It's more straightforward at first glance than San Carlo. Bigger, but only slightly, the sanctuary plan is a "St. Andrew's Cross," an *X* centered on an oval, crossed by another, flatter *X,* each end terminating in one of eight chapels. But what about those marble walls and columns? Only now do you realize how San Carlo's interior—a study in white and gray—is entirely calm, despite its constant current. At Sant'Andrea there is a riot of color that allows us to more easily visualize the marbles that once covered ancient Roman interiors in temples, fora, libraries, baths, and palaces. The stones speak. In ancient Rome, they told of trade and conquest: mottled red porphyry from Egypt, honey-golden *giallo antico* from Tunisia (ancient Numidia), gray-streaked marble from Proconnesus (ancient Greece, now Turkey). Here they tell of newly opened quarries that had been shuttered for centuries.

An earlier Sant'Andrea church stood on this site. The Jesuit order was relatively new when Giovanna d'Aragona Colonna donated land to found their original novitiate at Sant'Andrea a Monte Cavallo in 1566 on land that she owned. Her family, the Colonna, had controlled a huge chunk of the hill since the twelfth century. Wealthy, influential, and devout, she was lauded for her interest in reforms—hence the Jesuits—and for donating land within the Quirinal pleasure gardens. She was one of several influential women to establish a convent, monastery, or church on the Quirinal. Another we have already seen: Santa Susanna at the Moses Fountain, with a Cistercian nunnery installed by Camilla Peretti. Portia Massimi Salviati founded a new convent at Santa Caterina di Siena behind the Mercati Traiani (Markets of Trajan), and Maddalena Orsini founded Santa Maddalena a Monte Cavallo. The Quirinal trifecta of wealth and power is complete: emperors, popes, and influential women dominating the hill with baths, fountains, and monasteries.

In 1595, Clement VIII gave the church of **San Vitale**—built in AD 400 and founded by the widow Vestina—to the Jesuits. This property adjoined the back of Sant'Andrea. The Jesuits now controlled a swath of garden land from the crest of the hill down to the floor of the Viminal Valley. This is when their serious garden- and fountain-making began. In a view from 1611, we see a luxuriant garden and an upper terrace connected by stairs (fig. 8.9). A wooded slope separates them. Citron and lemon trees, lilies, violets, poppies, carnations, roses, and grass parterres surrounded by low wicker fences (as in Livia's garden murals) fill the terraces. There are also two sundials, a biblical inscription from the Song of Songs, an obelisk, and what appear to be beehives. There is a wellhead for drawing water and eight fountains of various types, including one where water seems to fall like rain. It is altogether a beautiful garden, where Felice water fed the fountains and the well tapped into a living spring.

Also called Monte Cavallo (Horse Hill), the Quirinal earned that name for two colossal marble statues of horse tamers that stand at its far western edge. Known

Fig. 8.9. "Les Jardins." Published in Louis Richeome, *La peinture spirituelle, ou L'art d'admirer aimer et louer Dieu* (1611), 472. Folger Shakespeare Library.

as the Dioscuri, these are the healing gods Castor and Pollux. Roman copies of Greek originals, they are clearly ancient and probably part of Constantine's baths that once covered the Quirinal slope in this area. They are among the few ancient sculptures that remained in their original location at the end of the sixteenth century. When Sixtus V had them turned to the northeast to face Porta Pia, he placed a new fountain (now lost) at their feet. It signaled the completion of his papal dominion of the hill. Early views show a basin with a scalloped edge nestled between the tamed horses (fig. 8.10). But the panorama depicts a completely untamed landscape of fallen columns and marble chunks littering a potholed road and the clearing. There is no piazza, just dirt! How optimistic to place a gorgeous fountain in this ramshackle environment.

You have come this far—to the Quirinal's edge. Now there is the crisp, paved **Piazza del Quirinale** and a fountain that, like the Piazza Barberini's Triton, provides another hydraulics lesson (fig. 8.11). This jet also looks to be scarcely trying, but when built, the fountain displayed a plume of water, high enough for

Fig. 8.10. "Monte Cavallo." Anonymous, ca. 1590. Published in Christian Hülsen and Hermann Egger, eds., *Die Römischen Skizzenbücher von Marten van Heemskerck* (1913–16), 2:82.

Fig. 8.11. "Piazza del Quirinale fountain." Raffaele Stern, 1816. Published in Giulio Magni, *Il barocco a Roma nell'architettura e nelle scultura decorativa* (1911–13), 3:39.

the horses to drink. It's a bit of a trick of the eye because when you look back toward Porta Pia, you have the impression that you are still on the same level as the Moses Fountain, nine hundred meters away. In fact, you are nine meters lower. Before the anonymous drawing of 1590 (see fig. 8.10), the Piazza del Quirinale stood several meters higher than today. The top of Rome's tallest original hill was scrapped away before water conduits could be laid along Sixtus's liquid highway to feed the fountains. The crest of the hill had been carted away and dumped into the valley between the Quirinal and Pincian, further burying the Acqua Sallustiana.

The Quirinal's edge is a place to pause. It's also the point where aqueduct water flowed into receiving tanks to regain some elevation before ramifying out to the southwest and south: up to the Capitoline summit and into the Suburra, Fora, and the Velabrum. The Botte di Monte Cavallo (decommissioned in 2009) is to the left of the entry to the Scuderie museum; you can still see the plaque above the door.

This is also the point where Sixtus V turned a portion of Felice water over to the Roman Council, the city government, to manage, distribute, and regulate.

The story shifts then from the papal tiara to the she-wolf and Romulus and Remus. The main branch heads down the hill and back up the Capitoline, and then flows back down again. Remember, you're following gravity, so when the water heads up to the Capitoline, it is under pressure inside pipes and will return almost to its level at the Quirinal.

Although you've walked less than three kilometers, the time to stop, think, look, discuss, and take some photos will exhaust the entire morning. But in those hours, you've built another armature for a mental map of Rome and its water infrastructure. This is hard work. You'll need another coffee and perhaps lunch. In any case, it's wise to start the next leg refreshed. That said, the high altar of fountain art, the Trevi, lies less than three hundred meters away, at the bottom of the hill to the northwest across the open piazza. I'm heading there now. Whenever you decide to continue following the Aqua Marcia, both old and new, and the Acqua Felice, meet me here in Piazza del Quirinale.

# Bibliography

For aqueducts, see subject bibliography (especially Cassio 1756–57), Fontana 1590, Lanciani 1880, Long 2018, Martial *Epigrams* 2:9.18, and Rinne 2010; for horti see, Purcell 2007; for Sixtus V, see subject bibliography (especially Gamrath 1987 and Simoncini 1990) and Massimo 1836; for Antonio Negroni, see Tchikine 2010; for Quirinal Hill gardens, see Coffin 1979 and 1991, and Montaigne 1903; for nineteenth- and twentieth-century urban planning and spontaneous encampments, see Insolera 2002; for Livia Drusilla's villa, see Caneva and Bohuny 2003; for imperial baths, see Yegül 1992; for deforestation, see Meiggs 1982; for the Naiad Fountain, see D'Onofrio 1986; for Faulkner, see Varriano 1991; for the Moses Fountain and Lavatoio Felice, see Fontana 1590 and Rinne 2021; for Camilla Peretti and pasquinades, see Dennis 2005; for pious women, see Valone 1994; for Borromini, see Portoghesi 1968; for the Quattro Fontane, see Benedetti 1992; for obelisks, see Collins 2004 and Curran et al. 2009; for geology and hydrology in general, see Corazza and Lombardi, 1995, De Angelis d'Ossat 1938, and Gigli 1970; for Palazzo Barberini and Giovanni Battista Ferrari, see Waddy 1990; for Bernini, see Averett 2014, Ovid *Metam.* 1, and Schama 1995; for Palazzo del Quirinale, see Frommel 1999 and Wasserman 1963.

# 9
# Acqua Felice and the Roman Council

🌿 Aqua Marcia and Acqua Felice Pilgrimage: Piazza del Quirinale to
the Capitoline, ~2 kilometers; the Capitoline to the Forum overlook,
~2.3 kilometers

Pope Sixtus V staked his claim to the Quirinal Hill with the Acqua Felice. At
**Piazza del Quirinale,** on the hill's western edge, the Roman Council took over
the job of moving their portion of water to the Capitoline. This was the ancient
Capitolium, the Campidoglio, the seat of the Roman civic government—*Senatus
populusque romanorum* (SPQR), the Senate and the people of Rome. The council
would manage and regulate public and private fountains.

The Botte di Monte Cavallo, a large cistern located at Piazza del Quirinale
in the Scuderie, was the primary SPQR distribution point. The thick sidewalls
were fitted with conduits placed at the same level to ensure consistent pressure.
Water then swooshed out to fill new council-built cisterns and fountains in the Su-
burra, the Forum Romanum (Roman Forum), the Capitoline, the Palatine, and the
southernmost Campo Marzio. For a short time, the Felice crossed in the roadbed
of Ponte Santa Maria to the Tiber Island and into Trastevere.

Before descending the Quirinal, turn around and look back to Porta Pia,
about one-and-a-half kilometers away. You are standing on what was, according
to legend, Sabine territory (think Numa Pompilius, Rome's second king). The
highest of Rome's original seven hills, its strategic location gives views to the other
hills and up and down the Tiber. Temples and sanctuaries stood everywhere, and
it became a desirable residential neighborhood, especially after aqueduct water
arrived in 144 BC, and because cool summer breezes blew in from several direc-
tions. The Quirinal flourished with gardens, vineyards, and villas in antiquity and
again from the sixteenth through nineteenth centuries.

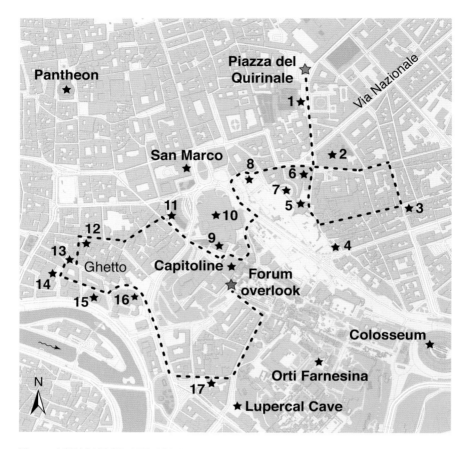

Fig. 9.1. AQUA MARCIA AND ACQUA FELICE PILGRIMAGE: 1) Casa Colonna, 2) Villa Aldobrandini, 3) Madonna dei Monti, 4) Torre dei Conti, 5) Torre del Grillo, 6) Torre delle Milizie, 7) Mercati Traiani (Markets of Trajan), 8) Colonna Traiana (Column of Trajan), 9) Santa Maria in Aracoeli/Marforio, 10) Monumento Nazionale a Vittorio Emanuele II, 11) Aracoeli fountain, 12) Fontana delle Tartarughe (Turtle Fountain), 13) Piazza Giudea, 14) Piazza delle Cinque Scole, 15) Tempio Maggiore di Roma (Great Synagogue of Rome), 16) Teatro di Marcello, 17) Janus Quadrifrons.

You're standing on the hill's crest. As the land drops away on each side, so, too, does any water falling on the hill. To the north is the Sallustiana watershed, and to the south, the Viminalis. By the twelfth century, when most of Europe was a political bedlam, the pro-imperial Colonna family began increasing its holdings on the Sallustiana slope, where they occupied ruins of an ancient temple to Serapis (near the Scuderie). Meanwhile the pro-papal Conti family already held the Viminal slope in its iron grip. The families were rivals. The Conti held the upper hand, with their own pope, Innocent III (r. 1198–1216), soon followed by his relatives Gregory IX (r. 1227–42) and Alexander IV (r. 1254–61). When Martin V

Fig. 9.2. *View of the Quirnal Hill*. Aegidius Sadeler, after Étienne DuPérac, 1624–50. Rijksmuseum. This image shows the ruins with the Tempio di Serapide (Temple of Serapis) and Casa Colonna. See fig. 8.10 to view the tower from the opposite side (center top).

(r. 1417–31), a Colonna, became pope, his presence in Rome signaled the beginning of a long-awaited rebuilding of a fractured city. He built his modest palace, the **Casa Colonna,** lower down the Quirinal's slope, leaving the ancient ruins as a fortified tower at the top of the hill (fig. 9.2). As the Colonna family took this pro-papal turn, it increased its urban authority and cemented control of their hillside, as the Conti still clung to theirs.

Turning to follow the Aqua Marcia and the Acqua Felice down the steep road—this portion is called Via Ventiquattro Maggio—keep the lie of the land in mind. Each family commanded at least one reliable perennial spring. The Colonna controlled the Cati Fons (Acqua di San Felice) that fed the Petronia Amnis. This may be the same sacred spring at Porta Fontinalis in the Mura Serviane (Servian Walls) that was sacred to Fons (or Fontus), the god of wells and son of Juturna and Janus. The Conti held the Fonte del Grillo—it might not have a similar pedigree, but it was a "healing spring" that flowed into the Forum Brook. Both springs still gurgle along today.

What did it mean to control a spring? Control assured water during siege and a better chance of outlasting enemies. Small-scale gardens were also possible, like those that took hold in the Fori Imperiali beginning in the ninth century, after the gleaming marble pavement had been spoliated, stripped for reuse, most likely to ornament new churches. The Roman Forum and those of Julius Caesar, Augustus, Trajan, and Nerva once boasted scores of fountains among their temples and colonnades, but now they hosted clusters of small domiciles and working gardens

Fig. 9.3. Fora of Trajan (top, bound by Mercati Traiani [Markets of Trajan]), Augustus (center), and Nerva (bottom) during the 10th century, with houses and irrigated truck gardens.

in the abandoned theaters of government (fig. 9.3). Far from being hardscrabble, apple, fig, cherry, plum, and nut trees grew in the irrigated gardens as well as small vineyards, and lettuces, coriander, mint, and mustard in rows. Fresh water was nearby with wells, some only three meters deep, and springs.

Within an area called Campus Kaloleonis in the Forum Traiani (Forum of Trajan), there was a garden of about fifty-five hundred square meters covered with one thousand cubic meters of imported topsoil. Another one-thousand-square-meter garden flourished in the Forum Iulium (Forum of Caesar). This, during the eleventh century, when much of Rome lay in shambles and the aqueducts that once served this area ceased flowing. By the year 1030, there was even a corporation, the *schola hortulanorum,* with its own binding authority over its members who grew and sold produce. Further south toward the Oppian and Caelian hills, the ground was damper; underground streams still flowed through ruined ancient drains. On the lower slopes of the Oppian, near the Velia land spur that once connected it to the Palatine, the ground was drier. By the thirteenth century, that area was called Campo Torrecchiano (Field of Towers), for the bristling defensive towers occupied by baronial families, among them the Torre dei Conti.

The area you'll traverse was radically altered in the late 1800s when Via Nazionale was created to link the Termini train station at the top of the Esquiline Hill—cutting through the exedra of the Thermae Diocletiani (Baths of Diocletian)—with Piazza Venezia at the foot of the Capitoline Hill. Ancient springs that fed the Forum Brook are now buried beneath the earth dumped from Via Nazionale into the valley. The amount of earth moved to keep the road at a constant grade was prodigious. Look at the church of San Vitale (closer to the exedra, and backing up to Sant'Andrea al Quirinale), now six meters below street level (see fig. 8.9). At the opposite end, as the hill descends into the Campo Marzio, **Cardinal Pietro Aldobrandini's villa** stands marooned several meters above the street. A third of the villa was sliced off for Via Nazionale, but there's still a little garden up there, a dusty ghost of its former self. Across the street is the Torre delle Milizie, another Conti stronghold.

Hug the Villa Aldobrandini wall and turn left at Via Panisperna, past the villa entry and fountain and tattered ruins of the Thermae Constantinianae (Baths of Constantine), and you're following one branch of the Felice as it heads into the Suburra. You're in an ancient neighborhood—one of the poorest in Rome and pretty rough-and-tumble at the time. It stretched, then as now, through the valley behind the Fori Imperiali where the Forum Brook originated. This is approximately where the sodden Forum Valley ended, and the drier foothills began.

You're moving toward the **Madonna dei Monti** neighborhood, with its unpretentious fountain built by the Roman Council between 1588 and 1589 (fig. 9.4). Follow Via Panisperna one more block and turn right on Via dei Serpenti—one long block into the heart of Madonna dei Monti. It may be difficult to tell

Fig. 9.4. Madonna dei Monti fountain, Piazza di Madonna dei Monti. Giacomo della Porta, 1588–89.

because this area has gentrified so quickly, but once this was a modest district that received the simplest of all Rome's new fountains. Its humble octagonal basin and central chalices reflect the relative poverty of its neighborhood—this isn't the fountain you take out-of-town guests to see. Still, the symbolism of the chalice offering water to the neighborhood is beautiful beyond its modesty. A drinking fountain originally clung to the basin where water jugs could be filled to carry home, further highlighting its utility to residents, and there was once a public laundry on the corner of the piazza.

It's tempting to remain here—the church of Madonna dei Monti is at the corner and the small church of San Lorenzo in Fonte, where a miraculous spring appeared when St. Lorenzo was imprisoned there, is not far away. Instead, head toward the Mercati Traiani (Markets of Trajan). Turning west on Via Baccina—or if you stopped at the church, head west along Via della Madonna dei Monti—it's a straight shot to the colossal firewall separating the Suburra—filled with poorly constructed wooden buildings—from the Forum Augustum (Forum of Augustus) and the once-lustrous marble city floating above marshes and streams.

I suggest taking Via Baccina because of the "wow" factor as you slam into the firewall at the end of the street. On the other side you'll see columns: they are what little remains of Augustus's temple. Later, a monastery and a hospital—using a nearby spring, probably the Fonte del Grillo—occupied it, neatly tucked into protective ruins (you can see restored medieval windows in the wall).

This is Conti territory. At the end of the street to the left is one of their towers, the **Torre dei Conti**—with a well, but no spring. You must noodle behind the fora and head up the hill to the right to reach their other towers and their healing spring in the Palazzo del Grillo. This spring hasn't been hidden under meters of debris and landfill, so it still flows into three fountains on private property. From the sixteenth through the eighteenth centuries, people in the neighborhood could

Fig. 9.5. Torre delle Milizie. Architect unknown, early 13th century.

use it. From there, you can walk out onto a balcony for an expansive view over the Forum of Trajan and the **Monumento Nazionale a Vittorio Emanuele II.** The street continues up the hill under the archway.

A second Conti tower is here on the corner, **Torre del Grillo,** and their third tower, **Torre delle Milizie,** is at the top of Salita del Grillo, where you turned away from the retaining wall of Villa Aldobrandini. Originally more than fifty-one meters high, Torre delle Milizie was among the most imposing features of Rome's medieval landscape; it was a tall building on a high hill and could be seen from far across the city (fig. 9.5).

The rear wall of the **Markets of Trajan** are to the left. To me, these are the most interesting ruins in all the fora because they are well preserved, making it easier to grasp the immensity of the entire area and to fit oneself into it. Also, the **Colonna Traiana (Column of Trajan)** is right there (fig. 9.6). Unlike the obelisks that have fallen or been moved around the city like chess pieces, it stands where it was erected.

At the top, back at Via Nazionale, turn left and hug the wall until you reach the entry to the Markets of Trajan. Today, this is a museum with a separate entrance and fees. Since you're here, you should visit it if you've never been. Once inside, you can enter the Torre delle Milizie and see its medieval cistern (it's gigantic), its deep well, and a permanent exhibit of ancient olive oil amphorae in a modest, yet stunning, exhibition space. Once you're outside, the steep staircase leads down

Fig. 9.6. Colonna Traiana (Column of Trajan). Dedicated in AD 113.

to the Column of Trajan. Here is a spectacular opportunity to think about scale, altered topography, and water.

Guidebooks will tell you that the column—dedicated in AD 113 by his successor, Hadrian, to commemorate Trajan's conquest of the Dacians—is a masterwork of Roman sculptural art. You'll also learn that the Basilica Ulpia surrounded it, and that one could probably see the extraordinary carvings by standing on the upper levels of the building, and that the column is one hundred Roman feet tall (29.7 meters), excluding the statue. And no doubt you'll discover that its height is equal to the original land spur that connected the hills before Trajan built his forum. But what does that mean? You've just walked from the top of what remains of the Quirinal Hill, and even then, you stood several meters below its height in the sixteenth century. If you climb to the top of Villa Aldobrandini, or better yet the Torre delle Milizie, you could see the column at eye level. Then you would have some sense of *those* one hundred Roman feet.

Classicist Harry Evans suggests that the Aqua Marcia channel might have crossed between the hills on top of the Servian Wall to reach the Capitoline in 144 BC. Regrettably, that section of the wall would have been destroyed when Trajan built his forum. It's unclear how water continued to the Capitoline, unless a siphon was built behind the Basilica Ulpia. This has never been adequately explained. Too much has disappeared.

Romulus claimed the Capitoline as a place of asylum where he rounded up the men—reportedly hooligans and criminals—who would join him in the new city. By the late sixth century BC, it was Rome's sacred center. The Capitolium (Temple of Jupiter, Juno, and Minerva), Rome's most hallowed site, stood here. The early fourth-century Servian Wall encompassed it and the other hills.

After the emperors decamped in the sixth century AD, only **Santa Maria in Aracoeli,** its monastery, some temple ruins, various fruit trees and oaks, and a few houses stood there. By the twelfth century, it was the seat of the SPQR. By the early 1300s, influential noble families with deep connections to civic administration built and ornamented chapels in the Aracoeli. Today, Piazza del Campidoglio is Rome's most transcendent and potent political space, with Michelangelo's piazza approached by its grand staircase, the Cordonata, surrounded by three palaces of government, and centered with the statue of Marcus Aurelius (r. AD 161–180). Within the ambit of the Roman Council, the Aracoeli is their sacred space.

Excepting small seeps, and the Tullianum spring at the bottom of the slope, the medieval Capitoline lacked both aqueduct water and spring water. But there were large cisterns, one from the Republican period, built before the Aqua Marcia. There was also a medieval cistern, built perhaps after 1143, when a group of "dissatisfied Romans" seized the hill from papal forces and reclaimed it for the Senate. In 1151, they built themselves a new headquarters, where they remain today.

While Paul III reorganized the Capitoline—moving the statue of Marcus Aurelius to the center of the piazza in 1538—he also built himself a summer palace, known as the Torre di Paolo III, on the northeast point of the hill. Very strategic, this, with a clear view up Via Lata (the Corso) and perhaps a view that took in everything on the horizon from the Colosseum (possibly even as far as San Giovanni) to St. Peter's and the Janiculum's slope. The church remains, but everything else—the tower, monastery cloisters, and garden—was demolished for the monument to Vittorio Emanuele II.

Bringing Felice water to the Capitoline created technical challenges for the Roman Council. Piazza del Quirinale rose about forty-three meters above sea level in the late sixteenth century, while the top of the Capitoline, where its fountain now stands at the back of the piazza, was, as today, nearly thirty-nine meters above sea level. Add three more meters for the height of the water in the fountain, and you have forty-two meters above sea level, only a meter lower than the Quirinal distribution chamber. In between stood the remains of the Fori Imperiali, about twenty-five meters below and covered with meters of debris and fill over ten centuries. To make the leap, a siphon carried water to the Palazzo dei Conservatori (Palace of the Conservators) on the Capitoline summit. The success of the entire distribution plan to reach neighborhoods on the other side of the hill depended on this.

Archival records describe workers digging deep trenches to lay the siphon between the hills. This was a major undertaking, with 5,180 terra-cotta pipes laid in the relatively flatter areas, that is, across the Fori Imperiali, and lead pipes used on slopes where the pressure was greatest. The image of fabricating the terra-cotta pipes is fascinating to conjure. There was the potter *mastro* de Ubelilli, whose employees made four thousand of the pipes, perhaps in the Valle dell'Inferno north of St. Peter's. Then, Giovanni Maria's team fired them at his *forno* in the San Lazzaro neighborhood. Someone else transported the pipes back and forth, but that name hasn't survived. By the time the pipes were ready, Antonio Larione and his crew had dug the ditches from hill to hill, into which another team laid and joined them. The pipes tapered—one end with a slightly narrower throat to slot into the larger throat of the next pipe. The pipes had been rubbed with olive oil inside and out and then sealed. They connected to the lead pipes at each end of the slope.

Like the Acqua Felice that crossed the Fori Imperiali from the Quirinal and then headed up to the Capitoline, you, too, should ascend from the east. You'll walk along the edge of the Forum of Caesar. Follow Via di San Pietro in Carcere uphill until you reach a terrace overlooking the Roman Forum, with the Colosseum in the distance and the Palatine Hill to the right. The conduits kept going, but you might pause here.

First is the Carcere Mamertino (Mamertine Prison), entered through San Pietro in Carcere with the Tullianum spring (now in the basement) that St. Peter

purportedly used to baptize his fellow prisoners. Or you might recall that Edward Gibbon conceived his idea to write *The Decline and Fall of the Roman Empire* on the Capitoline. Or that it was here that Petrarch, arriving in Rome for the first time in 1337, when the city was a shambles, was "overwhelmed . . . by the wonder of so many things and by the greatness of my astonishment." Four years later, he returned to be crowned poet laureate on the Capitoline—the hill of his astonishment. You may never be crowned with laurel on the Capitoline, but you can, on a blisteringly hot day, take a drink from the little Acqua Pia Antica Marcia fountain behind you.

<center>⚜</center>

When the Acqua Felice was built, the Roman Forum lay hidden under many meters of earth, some of it alluvium left behind after Tiber floods. Also, with gradual desertion of the fora, some buildings simply collapsed, and scavengers pillaged for marble and gold, leaving other, less valuable, materials behind. As a result of abandonment, dirt and debris blew in and accumulated: a thousand years of dust bunnies.

What stood above the Forum was the Campo Vaccino (Cow Pasture), with random columns and half-buried buildings popping up (fig. 9.7). This was Rome's cattle market that included a monumental fountain newly provided for the cows

Fig. 9.7. *View of Campo Vaccino*. Giovanni Battista Piranesi, no date (ca. 1750–78). Vincent Buonanno Collection. A view of the Forum Romanum (Roman Forum) can be seen looking south. The fountain appears at the bottom center.

(it's now on the Aventine Hill at Santa Sabina). But the greatest delight was the Orti Farnesina, the new gardens for Cardinal Alessandro Farnese atop the northern corner of the Palatine, above ruins of emperor Tiberius's palace. The orti were famous; there was a rare plant collection, and it must have been very beautiful. Portions of the Farnese gardens remain (as do bits of Tiberius's palace), and they can be visited.

Excepting the Teatro del Fontanone set below the two aviaries and the Ninfeo della Pioggia (Rain Nymphaeum), both on the eastern slope overlooking the Forum, today there are some pretty, though unremarkable, fountains. To me, the most interesting was the eight-lobed, scalloped basin with a central jet that once stood in a grove of plane trees. The Accademia degli Arcadi met here between 1693 and 1699—the same academy that Nicola Salvi would later join. The grove no longer exists, but from there, a stair once led down to the Fontana degli Specchi (Fountain of Mirrors), a semi-hidden, opulent nymphaeum used for water games that today stands only partially restored. Some surprise water jets now function, but the colored marbles, mirrors, statuary, and enameled lilies (a Farnese symbol) are all missing.

What about the rest of the Palatine Hill? After all, this was the ancient hill of palaces, and it would be expected that Tiberius and other emperors would want luxuriant gardens filled with fountains. Not much is known about water on the Palatine before the Aqua Marcia arrived in 144 BC, and even so, it isn't clear where the aqueduct terminated. Like Rome's other hills, living springs flowed at the bottom of the slope—in this case, about forty meters below the crest—so rainwater cisterns were essential. The oldest Palatine inhabitation overlooked the Tiber on the hill's western corner, where a complex system of underground rainwater cisterns, fed by a series of channels and accessed from the surface by wells, has been discovered. One cistern was 5.3 meters deep.

Nero completed his branch line of the Aqua Claudia to the Caelian Hill in AD 54, and from there Domitian tagged on a new stretch of tributary arches to the Palatine. He and his successors expanded the palace to cover the hill to the south and southeast with new fountains, fishponds, and gardens. Remains of impressive pools and nymphaea survive at the Domus Augustea, the hilltop palace of Rome's emperors, also known as the Palace of Domitian. Without much pressure, water displays lacked spectacular jets, but there were broad pools and fishponds.

At the Domus Flavia—a portion of the Domus Augustea typically used for receptions—a ruined octagonal island, rather like a maze, floats in the center of the main peristyle, where two elaborate fountains (each in its own courtyard) flanked the dining hall. Elliptical in shape, each had a tall center island surrounded by niches and set in a deep pool. Today, only one brick core remains, but it and its twin would have been covered with marble and perhaps contained sculpture.

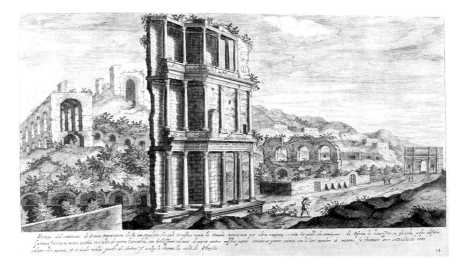

*Vestigia del considerato di Severo Imperatore che fu un sepolchro che esso si edifico sopra la strada. Aprio un per altra cagione, in non che quali che semivano di Africa, lo haurissero su gli orchi, parte edifitio fatiana faceta a mezzo giorno, et sotto di questo Corintia, con tre ordine colonne, a vario pietre, nostre parti striate et parte senza con li loro membri di marmo, si chiamale anco esterata da onte colore che curua, et si vede molta perte di dietro, si volge la chiama la scola di Vergilio.* 14.

Fig. 9.8. *Ruins of the Septizodium.* Aegidius Sadeler, after Étienne DuPérac, 1606. Vincent Buonanno Collection. This image shows the Arco di Costantino (Arch of Constantine, far right) and the Palatine Hill (behind).

Practically nothing is known about how water played in the fountain—whether there were thin sprays or trickles, rivulets or bubblers is unknown. Whether or not the emperor and his guests could hear the play of water in the fountains— something to be desired—they could see them as they dined.

Septimius Severus was a master builder. Among his many projects, the Septizodium, an enormous fountain built in AD 202, stood along a triumphal route, at the foot of the Palatine adjacent to the curved wall of the Circus Maximus (fig. 9.8). It resembled a stage front, with three levels lined with colonnades broken into bays. And, because this fountain was at the bottom of the hill, it could have had gushing cascades and vaulting jets that any Las Vegas casino with outrageous fountains might envy.

The fountain was part of a larger urban scheme that included a palace complex on the Palatine and extended to the Thermae Caracalla (Baths of Caracalla), on one's left approaching from Via Appia. To make this happen, Severus restored the Aqua Claudia for the Palatine and Septizodium, and the Aqua Marcia for the baths. As Susann Lusnia describes it, the Septizodium was a vibrant and innovative "billboard for the new Severan Dynasty in Rome." Anyone entering from Via Appia saw the Septizodium, proclaiming control of an entire swath of the city, in this case the Palatine Hill and Circus Valley. Thirteen centuries later, Sixtus V (who carefully assessed its travertine and peperino stone and then dismantled it as a building quarry) made a similar announcement on the Quirinal with his Fontana del Mosè (Moses Fountain) billboard.

A handful of popes and powerful medieval families resided on the Palatine long after aqueduct water ceased flowing. They defended portions of the hill and relied on rainwater cisterns and wells. Pro-papal baronial families controlled fortifications surrounding the Palatine base where springs flowed. Beginning around the year 1000, one family, the Frangipane, fortified ancient buildings on the lower slopes. They created a circuit of defensive positions, most related to springs (and later to the Acqua Marrana), that they dominated for nearly 150 years.

<center>⁓</center>

On the Capitoline, the pivot is key. The Capitoline embodies both ancient and modern Rome, and, like the Roman god Janus, looks forward and back. In one direction lies the heart of ancient Rome: the fora, the Palatine, the Colosseum. Turn around. Cross Michelangelo's piazza to the balustrade facing northwest. Apart from buildings like the Pantheon and Castel Sant'Angelo that have been "exorcized" of their ancient spirits, nearly everything on the horizon is Christian Rome, most notably, St. Peter's.

Since you're here, this would be a good opportunity to break off to visit the Musei Capitolini. (You can come back to the piazza later.) But if you go, you should plan to spend the rest of the day. There is so much to see, and nearly everything in the museum is exceptional, so my blatant disregard seems almost criminal—but water is our focus. A few displays relate directly to Rome's water history. First is Constantine, whose colossal and fragmented likeness waits in the entry to the Palazzo dei Conservatori. It seems fitting to say hello, since you spent so much time together in chapter 2 in the Roman Forum.

Next, the she-wolf who nurtured Romulus and Remus, and hence nurtured Rome's birth, is one floor up. Her foundational companion, Father Tiber, is here in the piazza where Michelangelo moved the ancient sculpture along with the Nile, forty years before the fountain arrived. It almost seems that he anticipated the water, although there were only cisterns at the time. Paul III, Michelangelo's sponsor for the Campidoglio project, did try to restore the Acqua Vergine, but was sidetracked when Holy Roman Emperor Charles V (r. 1519–56) decided to visit in 1536. He didn't want a replay of the emperor's last visit in 1527, when Charles's troops sacked the city. Even if Paul had successfully restored the Vergine, its low pressure meant that it couldn't have reached the Capitoline.

Back to the museum. After you visit the beautifully restored statue of Marcus Aurelius in the basement, you will encounter several small galleries to the left that display finds from ancient villa gardens, most notably the Horti Maecenatis and Horti Lamiani on the Esquiline. Both gardens probably had frescoes like those from Livia's villa that made us swoon. Horti Lamiani remained almost incognito until early twenty-first-century excavations revealed fountains and orchards that included apricot and citron trees and an animal park. To gain a sense of

Fig. 9.9. Marforio, a "talking statue." Artist unknown, 1st century AD.

water's play in the luxuriant nymphaeum, you can visit the new underground Museo Ninfeo (Nymphaeum Museum) nearby in Piazza Vittorio Emanuele II, on the Esquiline.

From the galleries, you can head to the tunnel that connects along the back of the Tabularium to the Palazzo Nuovo, with its mesmerizing view across the Roman Forum. Finally, the palazzo courtyard houses **Marforio,** one of Rome's four "talking statues" (fig. 9.9). Marforio was one of very few ancient sculptures to survive in situ until the sixteenth century—in his case, near the Tempio di Marte Ultore (Temple of Mars Ultor) in the Forum of Augustus, where he kept house for fifteen hundred years. He is clearly a river god. Whether he presided over a fountain in his original location or not, he hosted pasquinades by the late sixteenth century. Marforio was moved to what is now Piazza Venezia for seven years, and then came here in 1595 to reign over this new horse trough. Although Marforio, buff and beautiful and lounging like a lizard in the sun, has plenty of water, today he is mute. He can no longer signal across the Campo Marzio to his pals Pasquino, Madama Lucrezia, and Il Babuino, which means "the baboon." He is too heavily guarded to even open his mouth.

The elegant fountain in front of the Palazzo Senatorio is a mostra because it terminates the Capitoline branch of the Acqua Felice. There must have been something similar (although its presence seems to be completely lost) for the terminus of the Aqua Marcia. Set below the river gods placed there by Michelangelo earlier, when no water was present, the huge, tiered basin was designed to overflow with nearly transparent curtains of water. Designed by Matteo Bartolani da

Castello, its scale is impressive and its elegance profoundly satisfying; it embodies *magnificenza* (magnificence), exceeding that of almost any other Roman fountain at the time. That validated the council's role in bringing water to dry neighborhoods, and perhaps suggested that it quietly outshine the ponderous papal Moses Fountain on the Quirinal.

Standing guard at the top of the Cordonata ramp is another sculptural pair of Castor and Pollux, the Dioscuri who, in an apparition, watered their horses at Juturna's spring in the Forum. Their temple stood near the pool, but these twins arrived from the Campus Flaminius, near the Teatro di Marcello. They face northwest, gazing at a spot somewhere between Castel Sant'Angelo and the obelisk at St. Peter's that Sixtus V placed there in 1586.

We don't know if the ancient Aqua Marcia distributed water beyond the Capitoline. At the time, the Campus Martius, on the other side of the hill below the Capitoline slope, remained damp and uninhabited. Felice water is a different story. We know a great deal about how and where the Roman Council distributed water. We also know that a grand extravaganza took place when the spigots of all the Felice fountains opened almost simultaneously on September 8, 1589. To do this—whether on this special day, or any other day—the water's flow must be choreographed across the entire distribution area.

The SPQR conduits begin at the Capitoline mostra fountain and snake under the piazza. The first line headed to Marforio. Another went to a medieval rainwater cistern under the piazza that Michelangelo restored when he reorganized the hill for Paul III (the Republican-period cistern wasn't discovered until 1940). The restored cistern became the Felice distribution castello. From here, subterranean pipes ramified down the hill to public fountains in the densest and oldest neighborhoods, to a hospital, and to some private fountains.

The first conduit shuttled water to the regal black basalt lions at the foot of the Cordonata, where they whistled water into urns and ground-level basins, again for horses. Unfortunately, they are often dry without apparent reason. Other conduits headed west to Campo Marzio neighborhoods. You'll be there in a few minutes. But first, is the **Aracoeli fountain,** across from the lions (fig. 9.10). As it is often trapped in traffic, hidden by buses, abused by pollution, overgrown with moss, silenced by horns, and its basin often filled with trash, it can be difficult to see its inherent beauty. But beautiful it is. There are times, when the early morning light hits it "just so," that you can glimpse its original radiance. Unfortunately, it's too noisy to stand here very long, so you might head to Piazza Mattei.

The Mattei fountain, now called the **Fontana delle Tartarughe (Turtle Fountain),** is a hybrid, both of design and water supply. Giacomo della Porta designed it in 1581. Taddeo Landini created the handsome bronze boys. The fountain has a complicated history, and its placement in this piazza was the result of impressive palm-greasing on the part of Muzio Mattei, a member of the

Fig. 9.10. Aracoeli fountain, Piazza Aracoeli. Giacomo della Porta, 1593.

powerful clan you met in chapter 5 when you paid a toll to cross Ponte Quattro Capi in the thirteenth century.

Come hell or high water (literally, if he had only known), Mattei wanted a fountain in front of his palace. So, a private Acqua Vergine conduit was laid, but this low-pressure line could only reach the lower basins. For the high water, he waited for the Felice's arrival in 1588. The boys each grasp a dolphin's tail with one hand while holding down the head with one foot, perhaps to ensure that water spewing from the dolphins' mouths cascades into the basins. Their opposing hands reach up to the turtles, added, perhaps by Bernini, during a restoration project between 1658 and 1659. Even without the turtles, it was an immediate success. In 1588, Girolamo Ferrucci thought the subtle intimacy of the Mattei fountain made it the finest and most perfect one in Rome.

Everyone loves the boys and the turtles, but they rarely notice the veined marble pedestal; the slender jet of water; or how water dribbles from four putti busts, stationed on the basin rim, into the ground-level pool, where water drops flow out in concentric then intersecting circles. The geometry is mesmerizing. Nor do people typically notice how water slips from the dolphin's mouths and slides down white marble scrolls into voluptuous, pink-veined, gray marble shells, and that from there the water trickles over their rims into the ground-level pool to disrupt the geometry of transecting circles, creating a subtle commotion. Like the Barcaccia, it reveals itself slowly.

A third Felice branch headed to **Piazza Giudea.** This is where the Acqua Vergine should have arrived in 1580, before Mattei exercised his persuasive

financial arguments ensuring that he received water first. The Giudea fountain was built almost a decade later outside the main gate into the Jewish Ghetto. The walls encircling the ghetto finally came down in the nineteenth century. When the ghetto was euphemistically "sanitized," that is, destroyed for the embankment walls, the fountain was eventually relocated to **Piazza delle Cinque Scole.** You can see the footprint, newly planted as a memento near where the fountain once stood. What you can't see is the life of the Jewish Ghetto as it was lived in the late sixteenth century. Jews waited a long time for water to arrive inside their ghetto. They received the tiniest amount from the Felice to be used primarily by their five synagogues (all housed in one building) and for the ritual *mikvah* bath. They waited until 1614 for their own multipurpose public fountains with drinking water for people and animals and a laundry basin. Everything disappeared with the arrival of the embankment.

I suggest returning to the **Teatro di Marcello.** To do so, you'll walk past the **Tempio Maggiore di Roma (Great Synagogue of Rome),** completed in 1904, which houses the Museo Ebraico di Roma (Jewish Museum of Rome). Near the theater, temple ruins became an eighth-century hostel for pilgrims where they could rest, eat, and bathe. Later, this became Piazza Montanara, where itinerant workers arriving from the Campagna waited for daily work. The piazza was not unlike the casual work corners in many cities today where gardeners and carpenters wait each morning for a ride to a job site. One difference was a welcome Felice fountain in Piazza Montanara by 1592. Like the Madonna dei Monti fountain, only much smaller, there weren't any bells and whistles, just refreshing water. It remained until 1932, when Mussolini ransacked the entire area to build Via del Mare, his "Road to the Sea"—part of his empire-building for an anticipated New Rome. The fountain is now in Piazza di San Simeone.

Continue south until you pass the Fascist-era buildings. Cross here and head to the **Janus Quadrifrons** around the corner. Louise Holland wrote about the sacred rites required to cross living water during the archaic period. Once approved by the presiding god, passage might entail wading through low water or building a temporary structure, probably of wood. But as particular crossings became more useful, permanent bridges rose. Although it has been much altered from its original form, this Janus Quadrifrons, faced entirely in marble, is on the site of one of four crossings. It stands above the Cloaca Maxima, in which the Forum Brook flowed, now hidden far beneath your feet. It replaced an earlier stone bridge. In the twelfth century, the Frangipane family took it over—even adding rooms on top, now missing—as part of their strategy to control water sources surrounding the Palatine Hill.

The ancient Fons Juturna from the Roman Forum, covered over by centuries of debris and alluvium, found its way out, as flowing water always will, to emerge nearby as Fonte di San Giorgio, named for the nearby church. In 1562, the spring

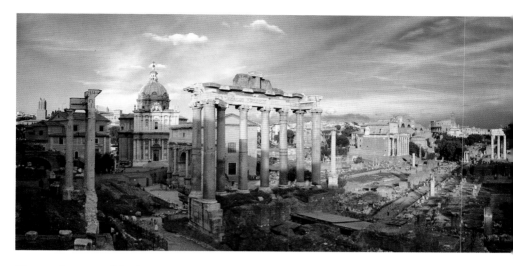

Fig. 9.11. Panorama of the Forum Romanum (Roman Forum).

was given a public laundry basin built of stone (see fig. 5.2). This was perhaps Rome's first official laundry in many hundreds of years. It wasn't a success. This was a marginal part of town where current and former prostitutes lived and where men trolled for trade. Still, ordinary women needed to do the wash, but they too were harassed. This was exactly the kind of situation that Sixtus V and Camilla Peretti reacted against when building the Lavatoio Felice on the Quirinal Hill.

Return to the back slope of the Capitoline. As you have ambled slowly up to its summit, the walk has allowed you to construct another map built on the armature of water infrastructure that links the Quirinal Hill to the Capitoline, and from there to the Roman Forum, the Palatine, the Velabrum, and the Campo Marzio. Standing here at the **Forum overlook,** you see ruins popping out from what Eleanor Clark calls "that lovely lake of time" (fig. 9.11). The Alban Hills, the source of so much of Rome's water, arise in the distance, while the aqueducts you followed in from Romavecchia lie closer in. This water map comes together on the Capitoline.

Beyond the edge of the Forum is the Colosseum. Just out of view is the Caelian Hill, and beyond that San Giovanni in Laterano and Porta Asinaria in the Mura Aureliane (Aurelian Walls). From there you can follow the Aqua Marcia, Claudia, Neroniana (yet another branch), and Acqua Felice as they flow across the Caelian. Along the way, there are ancient ruins, villa gardens, underground springs and streams, a lake even, ancient temples, fountains, and glorious church cloisters with wells and much more.

# Bibliography

For Sixtus V, see subject bibliography and Marder 1978; for the Colonna, see Brentano 1991 and Carocci 2016; for the Conti, see Keyvanian 2016; for towers, see Bianchi 1998; for geology and hydrology in general, see subject bibliography, De Angelis D'Ossat 1956, and E. Gigli 1970; for Madonna dei Monti, see Rinne 2010; for the Suburra, see Richardson 1992; for medieval inhabitations, including Campus Kaloleonis, see Hubert and Carbonetti Vendittelli 1993, Meneghini 2009, Meneghini and Santangeli Valenzani 2004, and Santangeli Valenzani 1999 and 2007; for the Markets of Trajan, see MacDonald 1982; for Aqua Marcia, see Evans 2000; for Paul III, see Delumeau 1957–59; for the Capitoline Hill, see subject bibliography (especially Pecchiai 1950), Hülsen and Egger 1913–16, and Sinisi 1991; for Santa Maria in Aracoeli, see Brancia di Apricena 2000 and Krautheimer 2000; for terra-cotta pipes, see Rinne 2010; for Petrarch, see Petrarch 2005; for Ferrucci, see D'Onofrio 1986; for the Palatine Hill, see subject bibliography (especially Augenti 1996), Coffin 1976 and 1991, and Higginbotham 1997; for Septimius Severus, see Lusnia 2014; for fountains, see subject bibliography (especially Rinne 2010); for Janus Quadrifrons, see Holland 1961; for the Jewish Ghetto, see Benocci and Guidoni 1993, San Juan 2001, and Stow 2001; for pilgrims, see Dey 2008; for Forum overlook, see Clark 1952.

# 10

# The Caelian, Esquiline, and Oppian Hills

🍃 Caelian, Esquiline, and Oppian Pilgrimage: Porta Maggiore to Porta
   Asinaria, ~1 kilometer; Porta Asinaria to Santi Quattro Coronati,
   ~3 kilometers

Querquetulanus Mons (Oak Tree Hill) is the earliest name for the Caelian, so
called, Tacitus says, for its groves of native oaks. The hill was well populated
during the Republic (509–27 BC), especially after the Aqua Marcia arrived in
144 BC. There were military barracks pinned to the hill's far-western crest and
to its eastern plateau, where it joined the Esquiline. A big market and brothels
hugged the western slope. Much on the hill burned in AD 27, but after the AD 64
fire, when Nero extended the Aqua Claudia there, it again became a fashionable
address for Rome's elites, such as the Horti Domitiae Lucillae, owned by Emperor
Marcus Aurelius's mother.

By the seventh century AD, two Christian basilicas and several nascent mon-
asteries and churches occupied ancient villa gardens. They took advantage of
aqueduct water, but now instead of nymphaea and topiary around every garden
corner there were orchards, vineyards, and vegetables. The residents were tena-
cious. Even after the aqueducts failed around AD 1000, they clung to the with-
ering hill. Because springs still bubbled out on the lower slopes, deep wells were
dug to reach the aquifer.

Among the springs were Acqua di San Clemente, Acqua di Mercurio (*"fons
mirabilis immo saluberrimus,"* or "indeed, a miraculous healthy spring," accord-
ing to John the Deacon), the Fons Apollinis, and the sacred spring of Egeria,
called Fonte delle Camene, from which a "pebbly brook" flowed (now inside an
underground conduit). And there is what geologists call an "underground lake"
beneath the Tempio del Divino Claudio (Temple to the Deified Claudius) on the

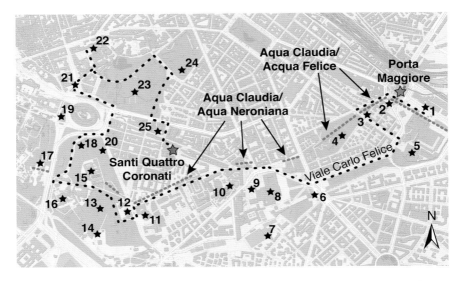

Fig. 10.1. CAELIAN, ESQUILINE, AND OPPIAN PILGRIMAGE: 1) Acqua Felice/Aqua Claudia, 2) inscription/Thermae Heleniani (Baths of Helena), 3) Acqua Felice siphons, 4) Villa Wolkonsky, 5) Santa Croce in Gerusalemme, 6) Porta Asinaria, 7) cistern at the Acqua Marrana, 8) San Giovanni in Laterano, 9) obelisk, 10) Ospedale del Salvatore (San Giovanni in Laterano), 11) Santo Stefano Rotondo, 12) Santa Maria in Domnica, 13) Villa Mattei Celimontana, 14) Fons Egeria, 15) Tempio del Divino Claudio (Temple to the Deified Claudius)/aqueduct castellum, 16) San Gregorio Magno al Celio, 17) Aqua Claudia ruins, 18) Colosseum overlook, 19) Meta Sudans, 20) Neronian nymphaeum, 21) Colosseum Metro station, 22) San Pietro in Vincoli, 23) Thermae Traianae (Baths of Trajan)/ Domus Aurea/Parco del Colle Oppio, 24) Sette Sale, 25) San Clemente.

north-facing slope. Sited near springs, there were two Mithraic temples that used living water for their rituals dedicated to the god Mithras.

There are two ways to begin this walk, depending on your interest and stamina. One path is slightly over three kilometers long, and the second adds one more. Either way, the walk is easy, although there is always traffic. The shorter walk begins at the new San Giovanni Metro "C" station just outside Porta Asinaria at the Mura Aureliane (Aurelian Walls). But, if you long to see more aqueduct ruins, then begin at **Porta Maggiore,** where our Romavecchia walk ended. You could ask the priests to read the flights of birds to tell you which way to go, but that could take forever. I suggest the longer walk.

Porta Maggiore: the ancient Aqua Marcia, Tepula, Julia, Claudia, and Anio Novus, the Renaissance **Acqua Felice,** and the modern Acqua Pia Antica Marcia come together here like tangled threads (see fig. 7.10). We picked up the Marcia and Felice when we walked along the Quirinal and Capitoline hills. Now turning west and southwest along the Esquiline and Caelian, we follow the **Aqua Claudia,** and two other lines, the Aqua Neroniana and the Rivus Herculaneus (an

Aqua Marcia branch), which began underground and then crossed the low valley on arches to the Aventine Hill.

Whether you are inside or outside Porta Maggiore, turn to the west and walk beneath the aqueduct arches. There's Mussolini's 1923 commemorative **inscription** for his restoration of the Pia Antica Marcia, and that awkward, heavily rusticated building to the right is its pumping station. Peter Aicher translates the inscription as: "Introduced to Rome by the praetor Quintus Marcius three years after the destruction of Carthage, then restored a few days before the city of [the new Republic of] Italy was liberated, now in the fifth year after the overthrow of the Austrian empire [the end of World War I] the increased supply flows alongside the ancient channel for the splendor, health, and perpetual growth of the city, a partner joined to the prospering affairs of Italy."

The Claudia, Anio Novus, and Felice lines march in from the south and make a sharp turn to the east. The Aqua Neroniana arches run alongside Via Statilia to the west. This was Nero's private line, which tapped the Claudia ostensibly to take water to the Aventine Hill. Along the way, it detoured to fill the Stagnum, an artificial lake at his spectacular palace, the Domus Aurea. We'll follow that line in a moment, but first, the paltry ruins of a cistern from the so-called **Thermae Heleniani** (**Baths of Helena,** the mother of Constantine) are nearby. In the sixteenth century, they were impressive enough for Andrea Palladio—an Italian architect who visited Rome several times in the 1540s—to measure and draw.

Look up. In the first two arches on the upper level of the arcade, you'll see a slapdash brick addition to the left. That's the second line of the Acqua Felice built in 1614 to reach San Giovanni in Laterano. Like the main branch, it used existing arches to maintain height. Along the way are what remains of Nero's arches and the Felice conduit. Heading west on Via Statilia, the arcade will be on the left until Via di Santa Croce in Gerusalemme. For construction buffs, the most interesting things to see are the restorations—many and frequent—of the tall, slender Neronian piers built using brick facing over a concrete core (a new idea at the time). They are flashy but were simply too tall and slender to carry water's heavy load. The arcade was restored four times before the fourth century. The final effort seems to have worked until 1004, the last time the Marcia was mentioned. The arcades are now inside a little park, entered on Via di Santa Croce in Gerusalemme, where you can take a closer look. Standing under the arches near the entry, you can see **terra-cotta siphons** emerging from Acqua Felice brickwork nearer your feet.

From here, the arches are inside the private **Villa Wolkonsky** grounds, so I suggest turning left toward **Santa Croce in Gerusalemme.** If you are interested in Helena's life or are on a pilgrimage to all seven churches, Santa Croce is on the official itinerary. Helena purportedly brought a fragment of the True Cross from Jerusalem, for which she built a chapel into the grand audience hall of an imperial

palace complex called the Sessorium. Benedict VII (r. 974–83) built a monastery for the church in the year 975, just as aqueduct water disappeared on the Caelian.

Essentially abandoned and in ruins while the popes were in Avignon (1309–76), the church is a mishmash of architectural styles, but four features stand out. First is the twelfth-century bell tower. Second are the thirteenth-century cosmatesque floors (heavily restored between the sixteenth and eighteenth centuries), with distinctive zigzag, circle, and box-frame patterns; huge fields of geometric panels that resemble quilts, and others that recall Chinese checkers game boards; and interwoven connective tissue, called *guilloche,* of white marble. Third are the late fifteenth-century holy water fonts, with carved fish (often representing the community of believers) swimming in their basins. And fourth there is a monastic garden of compelling simplicity and charm. Rather than being tucked in a cloister, it is off to the side of the church embraced by a portion of the Aurelian Walls called the Anfiteatro Castrense. At the lattice gate filled with shards of colored glass, you can peer into the garden, with its pergola walks and planting beds.

Walking through the linear park inside the Aurelian Walls, along Viale Carlo Felice, leads to Porta San Giovanni. Once you cross the street, the basilica of San Giovanni in Laterano fills your field of vision. Here is the Mother Church of Catholicism and the cathedral of the diocese of Rome. The reigning pope is its bishop. We'll return to San Giovanni, but since we are at **Porta Asinaria,** we should walk under the wall, then across the street to the Coin department store. The second, shorter, walk begins here.

Unlike most gates in the Aurelian Walls, Porta Asinaria (Donkey Gate) didn't link to a major road; this was simply a *posterula* (postern), literally a back door into the city, built exactly where it was needed for the farmers moving through this area long before the walls were begun in AD 271. But, as traffic increased to the newly created San Giovanni (consecrated in 318), Emperor Honorius (r. 395–423) enlarged the posterula, covered it with travertine, and fortified it with towers.

Recent excavations for the Metro "C" revealed that before Rome's founding, the entire area was much lower and flooded often. Streams, including what became the Acqua Marrana, flowed here. Some archaeologists speculate that before inhabitation, lush meadows, flowing water, and low forests of water-tolerant trees including willows flourished in the deep valley. By the first century AD, agriculture was fully established. Bucketloads of peach pits were found, indicating that the fruit, newly arrived from the Middle East, might have grown here in orchards. A **cistern** about thirty-five by seventy meters, discovered nearly twenty meters belowground, might have held as much as four million liters and probably stored water for irrigation during dry summers.

Ground levels rose over the next thousand years, and the valley filled with silt or was artificially raised. Streams continued running southwest and then south

through the valley, to an area known as the Decennia, just past Porta Metronia, where there were irrigated gardens as late as the fourth century AD—what historian Ian Richmond calls a "market gardener's paradise." The Decennia was such an impressive obstacle that the walls were built at its edge. By the ninth century, when the *Einsiedeln Itinerary* strolls this way, the area is still described with flowing water, but also as swampy. In the nineteenth century, it was pestilential and stagnant; in 1912, excavated earth from the Thermae Caracalla (Baths of Caracalla) was dumped here to dry out the land.

In 1122, the Marrana filled a natural bowl, creating a pool for watering animals outside Porta Asinaria, then entered the city through Porta Metronia. A mill stood along its banks near a nunnery at San Sisto Vecchio. Some Marrana water was diverted to create a laundry site for the nuns; they were seen working there in 1451. The stream changed course to flow northwest to join water from the valley of the Camene—where the Fons Egeria, her sacred spring, emerged. From there it continued into the Circus Maximus and joined another stream to power mills and irrigate orchards, rows of artichokes, and, of course, vines, into the nineteenth century.

By 1597, the Marrana powered twelve mills "without equal in Rome," including one near the nunnery (controlled by San Giovanni). The mills were especially important after floods destroyed those on the Tiber River. This stream was clearly vital. To control it meant revenues for the church; to impede it meant steep fines. Today, water flows in an underground conduit, but as late as the 1910s, there were still rustic bridges crossing it within the walls. It enters the Tiber just below the Cloaca Maxima.

※

Constantine founded the basilica of **San Giovanni in Laterano** on family-owned land just inside the Aurelian Walls where military barracks, the Castra Equitum Singularium, once stood. When he suppressed the army, the barracks were torn down, and he donated the land to the newly validated Christian religion. This was a wildly daring move—to build a Christian church inside the walls (St. Peter's was outside)—and it radically altered the area, which became a ritual and administrative center of the Church.

This is the bishopric of Rome and, as such, is the pope's by right. But he also possesses St. Peter's at the opposite end of Rome, and the two sacred magnets altered patterns of movement across Rome. One example is the *possesso*, a ritual procession where the pope, newly anointed at St. Peter's, crossed the city to the Lateran to claim his bishopric. Along the way, his entourage passed the Capitoline Hill, the Colosseum, and other important sites. This ceremony created a physical and spiritual tension flowing between complementary, but sometimes competing, symbols of the Church.

Little of the fourth-century church and its associated buildings remain, but much else invites close attention that deepens our understanding of Rome's water history on the hill. These are the ruins of Nero's branch of the Aqua Claudia; San Giovanni's baptistery and cloister; the ruins of the Lateran baths; its hospital, founded by the guild of water-carriers in the fourteenth century; its ancient **obelisk** (floated down the Nile, across the Mediterranean, and up the Tiber River); its seventeenth-century fountain; and the springs that once flowed down the valley to the southwest where, tradition relates, Egeria resided.

First, the baptistery: Sixtus III (r. 432–440) rebuilt an early fourth-century octagonal structure. The purity of the Early Christian architecture still sings out, even after restorations by Sixtus V and Urban VIII. Simultaneous full-immersion baptisms were practiced here in an octagonal pool eight-and-one-half meters in diameter. Eight purple-red porphyry columns (porphyry was reserved for imperial use) surround the baptismal area. A gigantic green basalt baptismal font with a bronze lid fills the center. Outside, Pope Symmachus built a fountain, which no longer exists. Ruins of the Lateran baths are next door on Via dell'Amba Aradam. The *Liber Pontificalis* (Book of the Popes) relates that Pope Hadrian I restored the Aqua Claudia, in part, to revive the baths.

San Giovanni's cloister garden is exceptional. As with most monasteries and convents in Rome, there was at least one (if not two) cloister garden, in addition to vegetable gardens and fruit trees. Sometimes there were grassy plots surrounded by borders, and sometimes there were trees. Regardless, they usually had either a well or fountain at the center. To visit the cloister, you must reenter the church and head to the far left-hand aisle to buy a ticket. With simple grass parterres, an olive tree, a few cypresses, and roses, this is among the most deeply reflective places in Rome, where calmness reigns and birdsong can be heard.

The cloister walk is encircled with some plain, but for the most part delicate, twisted columns decorated with mosaics topped by acanthus-leaf capitals (or some with mythological beasts) created between 1222 and 1232. A frieze of porphyry and green basalt fragments with inscriptions hovers over the entire space. Gargoyles and beasts hide the rainspouts that send water to an underground cistern beneath the cloister. This was the work of Jacopo and Pietro Vassalletto, master sculptors and mosaic artists who were members of the extended Cosmati family, whose work we saw at San Benedetto in Piscinula. There isn't a fountain, but there is a handsome central wellhead that tells a great deal about the relationship between this building and its water supply (fig. 10.2). This late ninth- or very early tenth-century wellhead suggests that the once water-rich hill, where so many ancient aqueducts flourished, was struggling to remain hydrated—that aqueduct water was either severely diminished or completely exhausted.

Outside, the ancient obelisk and fountain are located where the statue of Marcus Aurelius stood until Paul III moved it to the Capitoline Hill in 1538. Emperor

Fig. 10.2. Medieval wellhead, San Giovanni in Laterano cloister. Jacopo and Pietro Vassalletto, late 9th or early 10th century.

Constantius II (r. 337–361) brought the fifteenth-century BC obelisk from Karnak, Egypt, in AD 337 to Rome, where it stood in the Circus Maximus. Its broken shaft was found under the fallen stadium and alluvium that had washed down from the Acqua Marrana and Circus Maximus Brook. Sixtus V had the obelisk re-erected here in 1588. The obelisk is magnificent; the fountain, not so much.

Sixtus offered the canons of San Giovanni some Felice water if (and only if) they built a public fountain. They were reluctant, and the promised fountain wasn't built until 1614. It's overloaded with papal symbols: Sixtus V, Clement VIII, and Paul V are represented with lions, a dragon, a griffin, stars, and so on. The emblems appear to have been slapped onto the fountain's surface, rather than intended to narrate a story. When clean, which isn't often because of the horrendous traffic, it is handsome enough, but compared with nearly any other papal fountain, it fails to lift the heart and spirit. Its most important feature, a statue of St. Giovanni, was so corroded it disappeared ages ago. In an eighteenth-century print, the contemplative saint perches above the various animals all busily spouting water into the lower basin. Much has been lost, but you can drink the water.

If you began at Porta Maggiore, you may want to catch your breath before continuing. You could return to the basilica. Sitting in a pew, you can recuperate among the swirling cosmatesque floors or head to a coffee bar to drink caffeinated water supplied by either Acqua Pia Antica Marcia or Acqua Peschiera-Capore. Once you are revived, return to the obelisk and gird your loins for an imminent battle with Roman traffic. It isn't quite as daring as crossing the Rubicon, but even Julius Caesar might build a bridge.

꧁

Fig. 10.3. Ruins of the Aqua Neroniana. The castellum, with its holding and distribution tank, is near the back; the second arch (at the center) has been restored.

Standing with the obelisk behind you, you can see a remnant of Nero's aqueduct to the right; it's the line we followed along Via Statilia. Looking to the north you can see Via Merulana, and just to its left there is another tattered arcade fragment (two arches peek from behind the second building). From here, there are several ways down the hill. Via Merulana connects San Giovanni to Santa Maria Maggiore as part of the pilgrimage route across Rome. Take this road if you want to look more closely at the basilica's sparkling chapels, the baptismal font, a handsome well in the courtyard, and, of course, the Acqua Felice fountain in its piazza.

A straight street, Via dei Santi Quattro passes between the seventeenth-century men's ward (to the left) and women's ward (to the right) of the **Ospedale del Salvatore (San Giovanni in Laterano).** But Via di Santo Stefano Rotondo to the left is the preferred route; it's the longest but the most interesting, instructive, and, when not dodging traffic, beautiful itinerary. Getting there is tricky. From the obelisk it's easiest to take the crosswalk on your left to the traffic island across Piazza di San Giovanni to the bus stop. Keeping left, make a hard left turn and follow Via di Santo Stefano. Soon there will be ruins of the Aqua Neroniana (fig. 10.3). Walking along the top of the ridge following the aqueduct increases your own awareness of Caelian topography.

As you continue along Via di Santo Stefano, a military post is on the right. A thirteen-meter-high ruin of an ancient castellum, a holding and distribution tank of the Aqua Neroniana (Claudia), and eight arches run along its boundary. By dodging the oncoming cars, you can draw closer. Though not as handsome and tall as those at Romavecchia, the brick arches are still striking and instructive, especially the *bipedales* (bricks) seen in the arches that are two Roman feet long. Their presence marks ancient construction, rather than medieval or Renaissance restorations. Modern restorations have recreated the original-size brick but rendered them differently, to easily draw a comparison.

It's probably wisest to keep to the street's shady side because the sidewalk, skinny as it is, continues all the way to the end of the road. There isn't much to see until then, but finally there are some heavily restored arches on the left side of the road, leading to the entry of the round church of **Santo Stefano Rotondo,** with its gory seventeenth-century frescoes portraying scenes of Early Christian martyrdoms. They're famous, and it's worth going in if you are into that sort of thing; but I warn you, it's grizzly. Even Charles Dickens, an ace at conjuring the horrors of humanity, was disgusted. There is a second-century AD Mithraic temple under the church.

Popping up above everything else in Piazza della Navicella are the ruins of the "Arco di Dolabella," another fragment of Nero's aqueduct, this one considerably taller as the ground falls away. Across the street is the fifth-century church of **Santa Maria in Domnica,** with its fountain, the Navicella, in front. The model boat, carved in marble, is ancient but was only moved here in 1513 by Leo X (r. 1513–21). It became a fountain in 1931.

If it is open, it is worth stepping inside the church to see the early ninth-century apse mosaic of Christ with apostles, angels, and prophets. Although its subject doesn't involve water—although I think the haloes recall bubbles on the surface of a pool, and the drapery resembles waves—sitting inside a cool church on hot summer days is always pleasant. The church does have a simple, yet elegant, holy water font. Fonts were popular gifts among cardinals. Cardinal Giovanni di Lorenzo de' Medici donated this one before he became Pope Leo X. His coat of arms is at the bottom.

Whether visiting the church or not, you can slip around to the left and enter **Villa Mattei Celimontana,** a public garden (fig. 10.4). The villa is welcoming with fountains and umbrella pines and quiet spots to rest, read, or simply look at swimming goldfish. This was Cardinal Ciriaco Mattei's once-spectacular garden begun in the 1580s where, Elisabeth MacDougall reports, he was happy to entertain visitors, both Romans and foreigners, if they loved truth and were famous yet without pride.

Gabriel Faure (not to be confused with Gabriel Fauré the composer) found the garden "hardly important enough to detain us." Perhaps his interest encompassed only what he could see. Rather, our interest includes what we sense—the garden's watery underpinnings. Although there were springs at the bottom of the slope, there wasn't water at the top until Mattei purchased a dose of Acqua Felice in 1592 from the San Salvatore hospital (which received free water from Clement VIII). He continually added ancient sculptures set in an allegorical narrative sequence for his fortunate guests to follow along as actors in the storytelling. A symbolic hierarchy organized everything, with various gods and goddesses sequentially placed to create an ambulatory lesson in mythology.

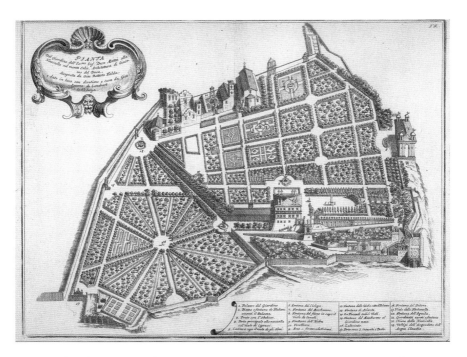

Fig. 10.4. *Plan of the Mattei Gardens*. Giovanni Battista Falda, 1675. Vincent Buonanno Collection. The water stair runs diagonally, with the high point near San Tommaso in Formis in line with the upper-left corner. Santa Maria in Domnica is at the center top.

After his death in 1614, his heirs continued to maintain the gardens. By the mid-seventeenth century, there was a long water allée that followed the steep declivity from the back of the little church of San Tommaso in Formis two-thirds of the way downhill (fig. 10.5). There was a Fontana del Tritone by Bernini at the top and a Fontane di Atlante at the bottom. And between them was a water stair with fountain bowls, each with central jets set atop retaining walls along each side. If you strolled slowly from the upper to lower garden, the water would have tumbled alongside and cooled the air. Perhaps attendants would have held parasols above your head for shade. The Mattei garden still declines, but the Triton Fountain and its water stair have disappeared, with the cleft partially filled and its gradient softened. There were other fountains that gurgled, whistled, plinked, plopped, and murmured. Most are gone.

For a dramatic *scala d'acqua* (stair with water on both sides) or a *catena d'acqua* (water chain, with stairs on either side of the water), a sloping site and abundant water are necessary. The water needs to boil and churn and act like a river with braided streams within its own stream. Among the most famous were those at Villa d'Este in Tivoli, Villa Lante at Bagnaia, and Villa Farnese at Caprarola.

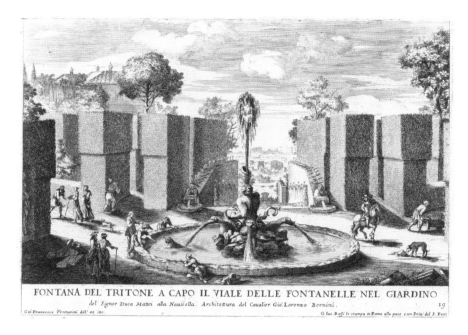

FONTANA DEL TRITONE A CAPO IL VIALE DELLE FONTANELLE NEL GIARDINO
*del Signor Duca Mattei alla Nauicella*: *Architettura del Caualier Gio. Lorenzo Bernini*.　　　19
*Gio. Francesco Venturini del.' et inc.*　　　　　　　　　　　　　G. Iac. Rossi le stampa in Roma alla pace con Priu'del S. Pont.

Fig. 10.5. *Bernini's Triton Fountain at the Top of the Water Stair.* Giovanni Francesco Venturini,
1676–89. Rijksmuseum. The water stairs—on either side of the walkway—ran in two directions.

Private aqueducts supplied those gardens and the adjoining towns. Within Rome's walls, a water stair was uncommon.

Continuing right is San Tommaso in Formis—"in formis" refers to the aqueduct. John Henry Parker claims the building foundations are part of the aqueduct that headed to the Aventine Hill. An enormous cistern stood next door. At the far end of the park, an exit leads to Santi Giovanni e Paolo, featuring a twelfth-century portico with eight reused ancient columns, delightfully mismatched with Corinthian and Ionic orders and a handsome twelfth-century campanile built on the foundation of the **Temple to the Deified Claudius** on the north side of the small piazza. Beneath the sanctuary there are ruins of a domus with nymphaeum and bath that you can visit.

Behind the monastery wall are a few aqueduct arches and the remains of the Claudian temple whose construction Nero interrupted to transform it into a distribution **castellum** for his aqueduct. From here, water cascaded down an expansive wall fountain into pools that fed Nero's Stagnum, and perhaps other fountains too; there were scores of them in this area. Under the temple and church there is an "underground lake," one of two still existing in Rome's caves.

As part of an initiative to erase Nero's memory, Emperor Vespasian completed the temple to Claudius (which may later have served as the office for the

*curator aquarum,* the director of the water works), drained the Stagnum, and built the Flavian amphitheater, the Colosseum. Water flowing to the wall fountain on the Caelian slope was decreased; the large eastern façade survived for a while, but the fountains on the north side (overlooking the amphitheater) were altered or destroyed.

To the left of the church is the Clivus Scauri, one of the few ancient streets still following its original route and carrying the same name. Seven buttresses, supporting the church, span the road. Reaching the bottom, the Palatine is directly in front (hidden behind trees), and the road swings to the left to reach **San Gregorio Magno al Celio,** founded as a monastery by Pope Gregory I (r. 590–604) on his family's property. The complex is located above one of Rome's most illustrious springs, the Acqua di Mercurio, which Ovid mentions was near Porta Capena. He claims there was "divinity in the water." When aqueduct water ceased flowing, the monks built a deep well.

An inscription commemorating the Acqua di Mercurio lies further along the street. Another spring, the Fons Apollinis, flowed to the southeast, and after that the **Fons Egeria** flowed in an area so rich in springs it was known as the "field of springs." That also means that it was damp. Their waters flowed to the Marrana.

The route to Via di San Gregorio is inelegant, but there's a little path back where the road swung around to the front of the church, and after that a short flight of stairs across the street, slightly to the right and then to the left. **Ruins** of Domitian's branch of the Aqua Claudia to the Palatine Hill are right there. Only a bit remains. It has been restored and its channel is missing, but at least you can form an idea of the scale and grandeur, and what it took to get water to the top of the Palatine.

You can stay on this loud, dusty, and shadeless road, but it is better to walk back up the stairs and turn left along a street that's used by the number 3 tram line but still above the hubbub. You'll walk through the Antiquarium archaeological park and pass the new Museo della Forma Urbis (which you should visit if you can), to reach an **overlook** above the Colosseum and Arco di Costantino (Arch of Constantine). The Colosseum was described in the twelfth-century *Mirabilia Urbis Romae* (Marvels of the City of Rome) as the "Temple of the Sun," where "rain was shed through slender tubes." Here was Rome's symbol of its own greatness, as a quote attributed to St. Bede in the seventh century, "as long as the Colosseum stands, Rome stands; when the Colosseum falls, so falls Rome; when Rome falls, so too the world," makes clear. With earthquakes and stone-robbers dismantling it right and left, it wasn't always clear that it would stand.

Sixtus V wanted to reclaim a portion of the Colosseum for a wool factory with worker housing in the upper stories. Wool merchants would be given shops. To create a factory, he needed to introduce Acqua Felice water with a new line

coming down from the Caelian Hill. He hoped to support the wool industry and to "sanitize" the ruin that Benvenuto Cellini described as a hideout of bandits, where it was risky to pass by alone at night. None of this happened.

The Arch of Constantine is to the left, and the pathetic ghost of the **Meta Sudans,** which means "sweating goal," fountain is marked on the ground between them (fig. 10.6). Standing just outside the Colosseum, victorious gladiators purportedly cleansed their faces and hands there. The name might relate to the water that "dripped" from the top down the sides of the nine-meter-tall conical structure. Built in AD 80, this was one of the few ancient fountains to survive to the twentieth century. Destroyed in 1936, it impeded Mussolini's ambition to build Via dei Monti. In its place there is a sad, usually dry, Fascist-era fountain across the street from the Palatine's entry.

A few things at the Colosseum spark our aqueous interests. There is the underground stream flowing beneath it from the Labicana Valley; the gentle San Clemente spring arising just a short way up the hill; the framework of water distribution—from the pipes inside the walls taking drinking water to spectators on the upper levels and to flush the latrines; the "slender tubes" shedding rain; and, most notably, Nero's Stagnum.

Fig. 10.6. *Arch of Constantine.* Robert Macpherson, 1857 or earlier. Clark Art Institute. The Meta Sudans can be seen at far right.

After the AD 64 fire, Nero built his Domus Aurea (Golden House) to span portions of the Esquiline, Palatine, and Caelian hills. There were three hundred rooms, many with pools, fountains, and waterfalls. It replaced his smaller palace destroyed by the fire. The ground level was raised by about four meters, perhaps with earth excavated for the Stagnum, the artificial lake. The Aqua Claudia and perhaps the Labicana Brook, flowing through the Esquiline Valley, supplied the water.

First-century AD historians Tacitus and Suetonius are our best sources for the palace and garden. What they report about Nero's hubris was certainly still being talked about. Tacitus first: "But Nero profited by his country's ruin to build a new palace. Its wonders were not so much customary and commonplace luxuries like gold and jewels, but lawns and lakes and faked rusticity—woods here, open spaces and views there. With their cunning, impudent artificialities, Nero's architects and engineers, Severus and Celer, did not balk at effects which Nature herself had ruled out as impossible." Suetonius goes further when he describes what has come to be called "*rus in urbe*," the countryside in the city: "An enormous pool, like a sea, was surrounded by buildings made to resemble cities, and by a landscape garden consisting of ploughed fields, vineyards, pastures, and woodlands—where every variety of domestic and wild animal roamed about."

Exaggerating? Perhaps not, as the area was immense. The Colosseum footprint alone is nearly two and a half hectares, and its surrounding valley would add many more. Vespasian and his successors set about erasing Nero's impudent artificialities from the valley and hill. To do so, they needed to move earth, both to fill the Stagnum, which was several meters deep, and to fill in the Domus Aurea rooms and create stable building platforms for the baths of Titus (r. AD 79–81) and of Trajan on the Oppian Hill.

A fantastic variety of plants once grew over the walls and inside the arena and caused eighteenth- and nineteenth-century tourists to swoon with romantic delight. Richard Deakin, who saw a "wild and solemn grandeur," published 420 species in *Flora of the Colosseum in Rome* in 1855. The variety of plants, he explains, is due to the varied wall surfaces, diversity of soils, and moisture; the lower north side is damp, while the upper walls are warmer and dryer, and the south side is hot and dry. Each micro-zone encourages different plants. The dampest areas weren't only along the north side, but also on the arena's south side, where the Labicana Brook, although in a drain, still seeped.

Bees and butterflies must have feasted here on some of the same species we saw at Romavecchia, like wild arugula and mallow. Three of the most common species throughout the Campagna, capers, so-called English ivy, and edible figs, were seen at the Colosseum, at Romavecchia, and as simulacra on the Trevi. Elm trees grew in the arena. Like many beautiful and good things, the plants were further eroding the already compromised building; with each restoration and

cleaning, they are further scrubbed from the walls and from memory. What today's designers and horticulturalist wouldn't give for vegetated walls like those for their vertical gardens.

If you're still admiring the Colosseum from the number 3 tram route, remains of the great cascading **Neronian nymphaeum** that was part of the Stagnum are to your right and around the corner on Via Claudia (taking a hard right). The ruins continue for nearly 167 meters. (To compare: the Trevi is fifty meters wide.) The sound of rushing and falling water must have been deafening, the air brisk, and the display exhilarating.

<div align="center">⚬</div>

Rather than visit the overcrowded Colosseum, I suggest a walk to the Oppian Hill, where there are breezes, fountains, and views, and the ruins of the Thermae Traianae (Baths of Trajan) crowning the hill. Before heading there, side-step over to San Pietro in Vincoli (St. Peter in Chains), the fifth-century basilica church best known for Michelangelo's 1515 sculpture of Moses for a funerary monument for Julius II. The statue is famous for its beauty and the controversial horns growing from his head, but for me, the most powerful features are the elegant, fluid drapery and his swirling beard, which resembles a tumultuous river.

You can take a taxi if you prefer not to walk. But it isn't far. To get there, the easiest thing to do is head to the **Colosseum Metro station,** where there is not only a nasone, but also one of the new "Water Houses" where you can fill your water bottles with either *liscia* or *frizzante,* still or sparkling water. Of course, like all public fountains in Rome, the water is free. Once inside, instead of heading toward the trains, take the escalator at the far left to the top, where you'll exit into a small piazza. Take the staircase straight ahead to a bridge that crosses over Via degli Annibaldi and leads to Via della Polveriera, and then left on Via Eudossiana to Piazza San Pietro in Vincoli. Beneath the church are excavations that revealed walls related to baths, with a hypocaust (heating system) and cistern that date from the reign of Marcus Aurelius, and remnants of a *cryptoporticus* that likely surrounded an ornamental garden that contained fountains and water tanks, like those at Villa Adriana (Hadrian's Villa). All are signs that an important villa once stood here.

The real reason I dragged you here is to visit the former **San Pietro in Vincoli** monastery, now housing the Università di Roma engineering faculty. You passed it on Via della Polveriera. The Viminal Hill was almost abandoned after the aqueducts failed, but there was a well when Augustinian monks arrived in 1480 and a cistern by 1510, now beneath a pebble-paved cloister that Giuliano da Sangallo designed. You can still see the drainage holes around the edge of the court.

Today, there is a central wellhead and a little fountain. Begun under Julius II but completed by Cardinal Leonardo della Rovere, this is one of the best-preserved

Renaissance wellheads in Rome and is worth a patient look. It has everything: there are sea monster masks, inscriptions, Cardinal della Rovere's stemma, big loopy handles like a giant sippycup, and four columns supporting the apparatus to haul water up in a bucket. There is also a simple, serene fountain—an iconic chalice—from 1624. Water drips over the rim into an octagonal ground-level basin. No fountain could be more straightforward, but in the late afternoon, it reflects the creamy-pink portico fractured by shots of green, pewter, and gold as the drops agitate the water. So modest, yet one of Rome's most rewarding water displays.

Only scraps of the Thermae Titi (Baths of Titus, AD 80) remain, but fortunately Palladio, like many other sixteenth-century artists, drew what remained, while scavengers grabbed what they could, including a magnificent granite fountain basin that Julius II moved to the Vatican Belvedere. There was originally a broad flight of stairs down to the Colosseum. The **Baths of Trajan,** built over Titus's baths and portions of the Domus Aurea, fared better (fig. 10.7). What's left of them are on the Oppian Hill opposite the Colosseum where ruins (now underground) of the **Domus Aurea** still astound visitors as they did during Nero's time.

The public park, **Parco del Colle Oppio,** was created in 1871. As so often happens in Rome, a spring was discovered when it was redesigned between 1928 and 1932 by Raffaele de Vico. It became the organizing principle for the new fountains, including one to the residing nymph. Maintenance is sometimes spotty here, but fortunately the travertine drinking fountains still work.

Walking among the standing ruins of the Baths of Trajan, you realize that (as at all imperial baths) water was everywhere. A bather was always in the presence of glistening pools, while the sounds from swooshing cascades and tinkling fountains permeated the atmosphere. It might simply be easiest to think of each bath complex as a single giant fountain that a person could enter and inhabit for a while. Walk about the ruins to gain a sense of their size. Completed in AD 109, they covered 11.3 hectares, slightly less than the Thermae Diocletiani (Baths of Diocletian). A few of the larger exedra remain, including the library off to the far left as you enter the park.

The Baths of Trajan hid portions of the Domus Aurea until a worker fell through its roof in the 1400s. After that, artists including Michelangelo, Bramante, and Raphael were let down on ropes into rooms they called "caves" and "grottoes," from which the term "grotesque" was coined to describe mysterious, cave-like spaces. An anonymous poet—Ingrid Rowland calls him "Mr. Perspective" and suggests it was Bramante—wrote that in 1499/1500, the rooms were "full of artists" crawling through "crumbling grottoes . . . along the dirt upon our bellies" drawing plans and copying frescoes.

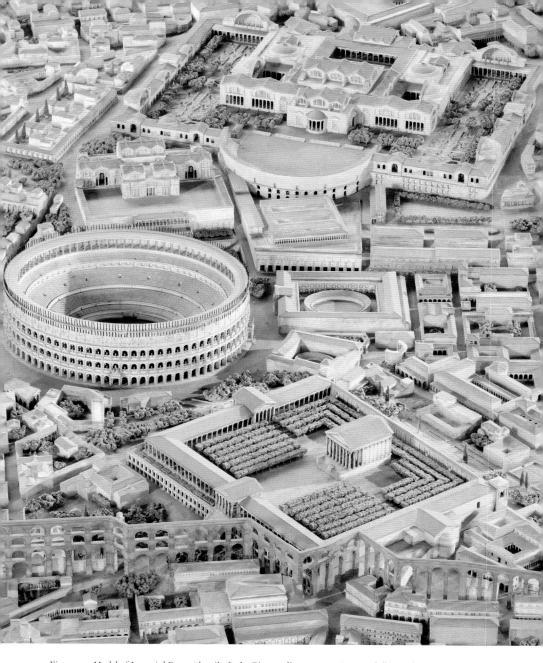

Fig. 10.7. *Model of Imperial Rome* (detail). Italo Gismondi, 1935–71. Museo della Civiltà Romana. Reconstruction of early fourth-century AD Rome, showing the Thermae Traianae (Baths of Trajan) (top third), with the Thermae Titi (Baths of Titus) and the Colosseum (center). See also the Tempio del Divino Claudio (Temple to the Deified Claudius) (bottom center), with the Aqua Claudia/Neroniana heading to the Palatine Hill below it.

As Fikret Yegül points out, the Baths of Trajan were innovative. Most notably, they introduced an enormous open-air swimming pool, and the baths were surrounded with a precinct wall embracing libraries, clubrooms, lecture halls, and so on. Oriented to the southwest—another innovation—bathers could enjoy the late afternoon sun. Trajan built a new aqueduct, the Aqua Traiana, to serve the baths. Arriving on the Tiber's right bank and dedicated in AD 109, it crossed the river (quite how isn't clear) and then ascended to the top of the Oppian Hill. He built an enormous cistern now called **Sette Sale** (Seven Rooms, although there are nine) that held eight million liters. It's in the far-right corner at the opposite end of the park across Via delle Terme di Traiano. Prodigious quantities of water were necessary, and so the cistern was filled each night for the next day.

During World War II, the park became one of Rome's *orti di guerra* (war gardens); it was plowed by water buffalo and watered by hand by *dopolavori,* afterwork groups of mostly men, but also women and children. Pausing from their labor, they had a spectacular view of the Colosseum. There were dozens of wartime *orti* around the city—some in schoolyards or set among ancient ruins. They were on the San Giovanni lawn, within Villa Borghese, at Caracalla's baths, and on the Aventine Hill. Some gardens grew everything; others specialized. Wheat grew within the Mercati Traiani (Markets of Trajan); lettuces at San Giovanni; and potatoes along Via dell'Impero. Today, the former victory garden at Parco del Colle Oppio hosts a skate park overlooking the Colosseum.

Nearby are two churches, San Clemente and Santi Quattro Coronati, that will steal your heart and revive your spirit, which is fitting, since they mark the end of this water walk. But first, both churches close for lunch, so plan accordingly. Although widely visited by tourists, both are still active monasteries: Dominican monks at San Clemente and Poor Clare nuns at Quattro Coronati.

First is **San Clemente,** with layer upon layer of history, where Rome's seduction is complete. You enter a twelfth-century sanctuary where the mosaics in the apse shimmer with swirling green tendrils against a golden sky, and tender white sheep parade before a turquoise ribbon. Deer drink at the Four Rivers of Paradise that emerge beneath the cross. You are standing in the third level of the church, built upon the ruined fourth-century basilica, badly damaged in the 1084 Sack of Rome by the mercenary Robert Guiscard. It, in turn, stands upon first-century AD buildings that include a Mithraic temple. That's where we're headed.

Heading down to the lowest level there is the sound of rushing water—you can hear it long before you see it—from a subterranean stream: the Acqua di San Clemente, once used for religious rituals at the Mithraic temple. Springs can go missing, sometimes for millennia—buried alive, as it were, by alluvium and debris. Gravity being what it is, the water continues to flow until it emerges, sometimes several kilometers away. "Lost" for centuries, even as it continued flowing and saturating the ground, Acqua di San Clemente caused some of the

dampness surrounding the Colosseum where Deakin counted all those ferns and mosses. The spring was rediscovered during scientific excavations at the church that began in 1857 and then again in 1912–14. Good thing, too. As Allied forces moved up the Italian boot in 1944, the retreating German army retaliated and destroyed portions of the Acqua Paola (like the Goth army of AD 537, except with bombs). Water pumped up from the spring led to public spigots that were a reliable source for the neighborhood.

The castle-like church of **Santi Quattro Coronati,** the four crowned martyrs (their identities are debated), is only a block away. It's up the hill a short way above a stair set into the retaining wall. Built over ruins of a late imperial villa, and a late sixth-century church (restored in the ninth century), it burned in the 1084 Sack, at a time when much of the Caelian was desolate and the monastery especially vulnerable. After that, it was rebuilt on a smaller footprint and fortified. Cardinal Stefano Conti (that Conti family whose three fortified towers suggest familiarity with the form), nephew of Innocent III, sponsored the defense works in the thirteenth century. The eleventh through thirteenth centuries were cataclysmic for all of Rome, and the Santi Quattro Coronati wasn't the only Roman church or monastery that needed fortifications.

The water situation on the Caelian was also dire. San Gregorio Magno al Celio had a spring, as did San Clemente, but theirs lay hidden under meters of rubble and fill. Aqueduct water ceased flowing at least a century before, so Santi Quattro Coronati, San Giovanni, and Santa Croce in Gerusalemme relied on wells, as did San Giovanni a Porta Latina. Its eighth-century wellhead bears an inscription from the donor Stefanus that, in translation, invites us: "In the name of the Father, of the Son, and of the Holy Ghost. All you who are thirsty come to the water." There were other public wells, but only this one and another at San Marco survive with inscriptions inviting us to drink.

Passing through the two entry courts, you are inside one of the smallest and most serene of all Rome's churches. It is quiet and timeless. The frescoes are difficult to see, but the thirteenth-century cosmatesque floors rippling beneath your feet are welcoming. Your eyes will adjust while your heartbeat and breathing become calm. The cloister is to the left. Once there was a well, but now there is a fountain assembled from ninth- and eleventh-century fragments discovered here during 1920s excavations. This is one of the most delightful fountains in Rome; there are little lions (yes, more lions) gently blowing water from their puckered lips. There are also fat blue and red raindrops painted on the cloister arches— perhaps as reminders of the water collected in the cistern. There are still catchment areas around the cloister for a cistern under the gravel court.

You can remain in the cloister for hours, thinking about some of the ways in which water connects the Esquiline plateau, the Caelian and Oppian hills, and the Colosseum Valley to Romavecchia and source springs in the Alban Hills. With

the solace and refreshment of blue and red raindrops and the whistling lions, you can think about the underground branches and tendrils of water's Tree of Life—a fitting end to a long day's water pilgrimage.

# Bibliography

For Porta Maggiore, see Adinolfi 1857 and Coates-Stephens 2004; for the Acqua Felice, the Aqua Claudia, and Aqua Neroniana, see Aicher 1995 and Ashby 1935; for San Giovanni in Laterano, see Krautheimer 2000 and Krautheimer et al. 1977, vol. 5; for the Cosmati and Vassalletto, see Severino 2012; for the *possesso*, see Cafà 2010 and Ceen 2022; for the obelisk, see Curran et al. 2009; for imperial baths, see Yegül 1992; for Porta Asinaria, see Richardson 1992; for the Decennia, see Richmond 1930; for the *Einsiedeln Itinerary,* see Lanciani 1891; for the Acqua Marrana and mills, see Alessio Angeli and Berti 2007 and Mariotti Bianchi 1977; for laundries, see Rinne 2021; for bipedales, see Blake 1947; for Santo Stefano Rotondo, see Dickens 1846, Krautheimer 2000, and Vermaseren 1956–60; for Arco di Dolabella, see Richardson 1992; for Villa Mattei Celimontana, see Faure 1926 and MacDougall 1978 and 1983; for San Tommaso in Formis, see Parker 1876; for Temple to the Deified Claudius, see Colini 1944 and Richardson 1992; for monasteries, see Dey 2008; for Acqua di Mercurio, see Ovid *Fasti* 5:674–77; for John the Deacon, see Lanciani 1897; for Domitian, see Schmölder-Veit 2011; for the Meta Sudans, see Richardson 1992 and Steinby 1996, vol. 3; for the Colosseum, see Deakin 1914, Fontana 1590, and Rea 2002 and 2019; for the Domus Aurea and Stagnum, see MacDonald 1982, Suetonius 6:31, and Tacitus *Annals* 15.42; for nymphaea, see Neuerburg 1960; for San Pietro in Vincoli, see Krautheimer et al. 1967, vol. 3; for Parco del Colle Oppio and *orti di guerra,* see Campitelli 2019; for artists and the grotesque, see Rowland 2011; for the 1084 Sack of Rome, see Gregorovius *History* vol. 4, pt. 1, ch. 6, and Krautheimer 2000; for San Clemente, see Krautheimer et al. 1937, vol. 1 for Santi Quattro Coronati, see Krautheimer et al. 1970, vol. 4; for individual popes, see Duchesne 1886–92.

# 11

# Imperial Playground and Papal Domain

🌱 Vatican Plain Pilgrimage: Guided walk of the Vatican Gardens,
~800 meters; St. Peter's to Castel Sant'Angelo, ~1.6 kilometers

Pope Leo IV (r. 847–855) created the Civitas Leonina (Città Leonina, or Leonine City) when he built the Mura Leonine (Leonine Walls) surrounding St. Peter's Basilica, the Vatican, the Borgo, and Castel Sant'Angelo, to defend them against marauding Saracen invaders who had looted and burned St. Peter's in the year 846. To begin to understand the area's topography, let's tear those fortifications down and drop back to the early first century AD, before Gaius (Caligula) built his racetrack in the southern reaches of the alluvial plain, then known as the Ager Vaticanus.

The ager extends north to Ponte della Musica (see fig. 3.1). It's a bottleneck, but once south of the bridge, the alluvial plain broadens out. The Tiber hugs its eastern bank. Its western edge extends to the foot of the Vatican Hill and farther south to the Janiculum Hill, where the plain narrows again (see fig. 2.1). Both the Vatican and Janiculum hills are relatively steep and ripe candidates for accelerated runoff. East of St. Peter's, a *palus* (marsh) fed by that runoff, Tiber floods, rainwater, and underground springs from the Vatican Hill had formed. A local spring, the Damasiana, served a small Vatican aqueduct. Tapped by Pope Damasus I (r. AD 366–384), it still flows with one liter of water per second, or 86,400 liters per day.

Streams had deeply incised the valleys along the Vatican Hill, including the Valle dell'Inferno (Valley of Hell), so called for the brick kilns located there. Monte della Creta (Clay Hill), the source of the Inferno's wealth, is to the west. Except during the medieval centuries, brick manufacturing was among Rome's most important industries since antiquity, and one of its most prodigious smog producers. Fornace Veschi—now an industrial archaeology site open to

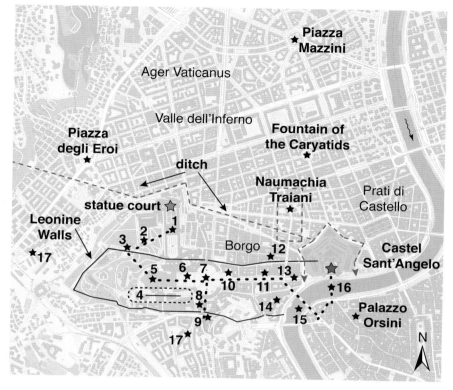

Fig. 11.1. VATICAN PLAIN PILGRIMAGE: 1) Belvedere, 2) Casina Pio IV (Casino of Pius IV), 3) Fontana dello Scoglio (Fountain of the Rock), 4) Circus Gai, 5) St. Peter's Basilica, 6) *paradiso*/ bronze pine cone, 7) obelisk/colonnades, 8) Schola Saxorum, 9) Porta Cavalleggeri, 10) Santa Caterina fountain, 11) Piazza Scossacavalli, 12) Porta di Castello, 13) Mascherone di Borgo, 14) Ospedale di Santo Spirito, 15) Pons Neronianus, 16) Ponte Sant'Angelo, 17) brick kilns.

the public—operated until the 1960s in the Borghetto dei Fornaciari, the kiln-workers neighborhood, next to the Valle Aurelia Metro stop. The Acqua Valle dell'Inferno stream flows to the Tiber across the Prati di Castello, the alluvial plain east and north of Castel Sant'Angelo. Today, it is a dense neighborhood of, for the most part, late nineteenth- to early twentieth-century apartment buildings. Another large palus formed to the north.

Gaius channeled the Vatican stream and drained the soggy plain for the **Circus Gai** (later Circus Gai et Neronis), his private chariot-racing arena begun in AD 37 and completed under Nero. It included an obelisk along its median strip. Nero is more commonly associated with the circus, perhaps because of the games he staged there after the AD 64 fire, and for the Christians slaughtered there in AD 65. Built alongside a pagan cemetery on the Vatican slope, the circus ran

east–west through the Horti Agrippinae (the garden of Nero's mother, which he inherited). It extended to the Tiber with porticos and promenades.

It's possible that Nero also built Pons Triumphalis—a bridge also called Pons Neronianus—intended to reach the Horti Agrippinae and only later the circus. Regardless, it was built in absolutely the wrong place—at a sharp bend in the river where increased turbulence at the western pylon chewed up the right bank. Pons Neronianus may have been decommissioned before Hadrian built Pons Aelius, now called Ponte Sant'Angelo.

Emperors continued to busy themselves here with construction projects. Nero built temporary housing for victims of the AD 64 fire. Later Domitia, wife of Domitian, created the Horti Domitiae. Trajan built his water theater, the Naumachia Traiani, where reenacted historic naval battles continued to their bloody end. Although much smaller than that of Augustus (with fewer ships and combatants), his theater was a water hog. Perhaps water came from a branch of the Aqua Traiana, or from the Tiber River or the Acqua Valle dell'Inferno. Trajan also proposed a "Fossa Traiana," a deep ditch to swing from Ponte Milvio, far to the west, returning to the river where Hadrian would build his mausoleum. He wanted the fossa to divert a portion of the water when the Tiber flooded. But a shorter fossa might have begun where Ponte della Musica now spans the river and headed due south to the naumachia. Perhaps he filled his water theater in this manner. A drainage channel could have returned post-spectacle water directly to the river. Trajan's naumachia could have mitigated flooding when empty, as Rabun Taylor has conjectured the Naumachia Augusti might have done.

We already know something about Hadrian's mausoleum and bridge, but it's important to envision how they, and later building projects, transformed the life of the Vatican plain and the Tiber. First, the new bridge facilitated river crossings (the Circus Gai et Neronis needed to connect across the river). Second, the plain remained outside the ancient city. When Emperor Aurelian (r. AD 270–275) built his wall, begun in AD 271, he didn't enclose any part of it. Third, St. Peter was buried at the pagan and Christian cemetery north of the circus, and it became a pilgrimage destination. Christians increasingly desired burial there too. Fourth, Constantine began building Old St. Peter's in AD 320 over the consecrated ground at the still-active cemetery.

You might begin exploring by buying a ticket to the Giardini Vaticani (Vatican Gardens). They lie at the highest point on the far western edge of the plain—along the ridge of the watershed—where aqueduct water first arrived; it's all downhill from here. The gardens brim with fountains (fig. 11.2). Today, they display Acqua Paola water—there is a dedicated branch line from the aqueduct—but earlier fountains received water from the smaller Damasiana aqueduct, fed by a spring just outside the Vatican walls. Because spring water infiltrated the saints' graves,

Fig. 11.2. Fontana della Galera (Fountain of the Galleon), Giardini Vaticani (Vatican Gardens). Giovanni van Sanzio and Martino Ferrabosco, 1622.

Damasus I had a channel bored into the Vatican Hill in the late fourth century to divert water away from St. Peter's.

Nicholas III (r. 1277–80) was the first pope to extend the gardens beyond the Leonine Walls. He owned vineyards on Mons Geretulus, where the Cortile del Belvedere (Belvedere Court) now stands. He made a new enclosed garden with a meadow, trees, and a fountain. Leaping the defensive walls for beauty was a bold gesture, even if this garden needed walls of its own. Not much changed until Urban V (r. 1362–70) returned to Rome in 1367 from exile in Avignon. He rebuilt and enlarged the garden; nearly seven hundred men worked to plant vineyards and trees, probably laurels, cypresses, and bitter oranges. (Pliny the Elder thought that an ancient holm oak growing there was older than Rome.) Later, there were huge groves: in 1537, Paul III purchased fifteen hundred orange and other citrus trees (probably irrigated by hand).

Urban V also built a fishpond. A rainwater-filled cistern might have fed Nicholas's fountain, but fishponds need fresh water. To ensure that the fish survived, the

water couldn't become stagnant. Since the Aqua Traiana, which brought water to the Vatican and Janiculum hills, hadn't worked for nearly four centuries, a nearby spring might have provided the water, perhaps the Acqua Damasiana.

During the Western Schism (1378–1417), when two popes reigned—one in Rome, the other in Avignon—the garden languished. But when Giovanni Rucellai visited Nicholas V in 1449, he described small and large gardens with fountains and a fishpond. Enclosed, the small garden would be closer to the palace, while the large garden might resemble a wood used for bird hunting. Apparently, Nicholas envisioned enlarging the gardens and irrigating them with living water from subterranean conduits, that is, from the Damasiana. But more pressing needs impinged, including building a drainage system to protect the basilica from stormwater rushing down the Vatican Hill. It's unfortunate that he didn't build a diversion because, as Sarah McPhee explains, when it came time to build Paul V's south tower on St. Peter's façade, the workers bailed water day and night.

Copious underground water meant that it was relatively easy to dig wells after the Traiana was damaged in 537. Over the next thousand years, water for most fountains ceased, and the number of wells increased. You can see fifteenth-century wellheads at Castel Sant'Angelo and at Palazzo della Rovere. In 1490, Pope Innocent VIII (r. 1484–92) replaced a well in Piazza San Pietro with a fountain named for St. Caterina. It must have been a beauty; an eyewitness described it as "*nobilissima,*" with nothing like it in all of Italy.

Donato Bramante restored the Acqua Damasiana to the Vatican and the Santa Caterina fountain in 1504, where, because the piazza is several meters lower than the garden, there was a spritely jet and slender streams of water falling into a chalice. That runoff went to an animal trough. Maarten van Heemskerck created a drawing around 1536 that shows a chalice raised three steps above the ground, with an acorn-shaped finial set into a basin. A feathery water jet shoots from the acorn, with four figures beneath, each squirting a thin stream into the basin. Disassembled in 1612, its parts were scattered, some to create Maderno's fountain in Piazza San Pietro. Today, a rione drinking fountain, Fontanella delle Tiare (Fountain of the Papal Tiaras), stands in the approximate area of the Santa Caterina fountain (fig. 11.3).

Bramante also began designing the Belvedere and its **statue court**—an enclosed sculpture garden with several fountains—for Pope Julius II (fig. 11.4). The Belvedere statue court is on the crest of Monte Egidio, across a valley from the Palazzo Apostolico (Vatican Palace). The **Belvedere,** composed of three large terraces enclosed by long, arcaded loggias and corridors on both sides, connect Monte Egidio to the palace. A 1510 guide to Rome describes how a great deal of earth was moved to level the hills and fill the valleys.

Julius's garden was among the earliest in Rome to display antique sculpture. This became the rage by mid-century, and here as elsewhere, ancient

Fig. 11.3. Fontanella delle Tiare (Fountain of the Papal Tiaras), at the territorial boundary between the Vatican and Rome. Pietro Lombardi, 1927–29.

sculptures—not newly commissioned ones—became a focus of garden fountains. Bramante extended the Acqua Damasiana to the Cortile del Belvedere for new fountains, including a sculpture of Ariadne set into a niche with water "dripping" or "oozing" into an ancient marble sarcophagus. Of course, "dripping" and "oozing" tell us there wasn't too much water, yet by the 1530s the Vatican Gardens and the Belvedere were soon called a "Parnassus." Soon the Tiber, Nile, and Tigris joined Ariadne, each lolling above their respective fountain.

Like Ariadne, the Tigris sprawled seductively in a niche—above a rocky outcrop with two rivulets. Meanwhile, the Tiber and Nile adorned a central courtyard fountain. None of the fountains flaunted water, because the modest Damasiana probably fed them. A large *peschiera* built for Pope Julius III (r. 1550–55) also stood along the exterior Belvedere wall. With Acqua Paola available, Paul V had it remodeled as an inventive and whimsical galleon ship with water shooting from cannons (see fig. 11.2).

Bramante placed an enormous fountain in the lower level of the Cortile del Belvedere (below the statue court). Its huge basin—6.8 meters in diameter—came originally from the Thermae Titi (Baths of Titus) and was the largest surviving ancient monolithic basin in Rome. Yet, even at this imposing size, it was peripatetic, like so many of Rome's fountains, including the Piazza del Popolo

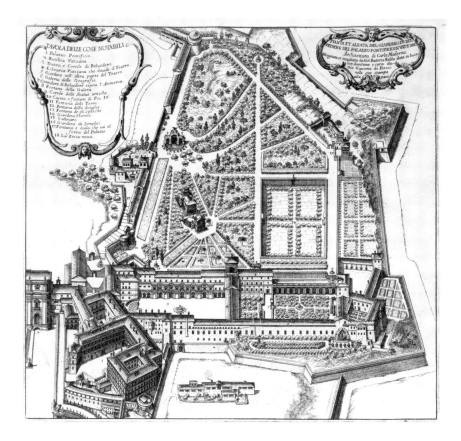

Fig. 11.4. *Plan and Elevation of the Vatican Gardens and the Belvedere.* Giovanni Battista Falda, 1675. Vincent Buonanno Collection.

fountain and fountain sculptures of Marforio and the Babuino, not to mention bathtubs carted from ancient thermae to Piazza Farnese. All were relocated, some, several times.

When Pius IV redesigned the *cortile* in 1565, he buried the Belvedere basin under several meters of earth to create a space for jousting and bullfights in the courtyard. The fountain wasn't reinstalled after the tournament. With plenty of water, Paul V returned it to the Belvedere in 1614 and placed it on a new pedestal designed by Carlo Maderno. All this moving makes one lightheaded.

Close to the Belvedere, the **Casina Pio IV (Casino of Pius IV),** begun in 1558, nestles into a hillside. Originally, a *bosco* (wooded area) stood adjacent to it. The *casina* is best known for its ancient inscriptions, sculpture collection, and architecture created by Pirro Ligorio, the most famous antiquarian of his time, who also held a deep interest in water. (He studied the Acqua Vergine meticulously

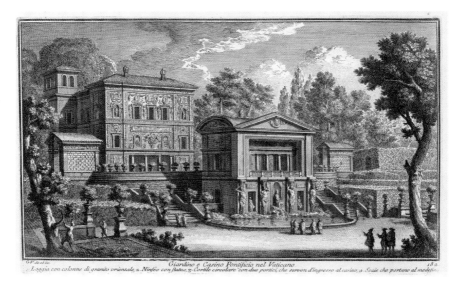

Fig. 11.5. "Casina Pio IV." Published in Giuseppe Vasi, *Itinerario istruttivo diviso in otto giornate* (1763), plate 182. Vincent Buonanno Collection. The nymphaeum is in the center with a *peschiera*.

when Pius IV hired him to restore it.) Our interest lies in the nymphaeum—a fountain house, really—dedicated to and overseen by the Muses (fig. 11.5). Set below grade, slightly below the more formal areas, the nymphaeum has small cascades rushing into a peschiera. Leaving the Belvedere, the pope and his visitors saw the nymphaeum first, and only after that, they entered the casina through a side door and hidden staircases.

Serious fountain building—with gushing jets and crashing cascades—arrived with Paul V's Acqua Paola, completed in 1612. The **Fontana dello Scoglio (Fountain of the Rock)** is a grotto meant to recall the source springs at Lake Bracciano (fig. 11.6). It stands where the Paola terminates inside the gardens. It was the primary distribution center for the gardens, the Palazzo Apostolico, Piazza San Pietro, and the Borgo. This grotto-type fountain resembles a monster vomiting water as it emerges from the primal ooze. From here, water flowed to the other fountains, the lush lawns, and acres of flowers and trees.

Unless you buy a ticket to visit the gardens, a water walk probably begins outside the Vatican walls: so, let's head to **St. Peter's Basilica** and think about topography along the way. So much has changed since Constantine founded his church over a cemetery and alongside the racetrack. He would recognize little other than the obelisk, and even that has been moved.

St. Peter's sits on a raised platform because a stream flows through the valley. Problems with running water and seeps occurred early on (even the racetrack of Gaius and Nero flooded). Although the ground had been raised several meters to build the basilica, water still caused problems, sometimes flooding the now underground tombs. Seeps continued after Pope Damasus I built the Acqua Damasiana conduit in the late fourth century.

Nothing remains inside the basilica to indicate that water was ever a problem. But water is present in the several *acquasantiere* (holy water fonts). While the two eighteenth-century fonts grab your attention—they are spectacular, with putti the size of football linebackers—there are others. Most notably, there is a white marble chalice font, nearly one-and-a-half meters tall (its basin more than a meter wide), that stands to the right of Michelangelo's *Pietà,* hidden in plain sight. Probably created by a Florentine sculptor around 1450, it is one of a pair; its companion is missing. Everything about it is sublime: its pie-crust basin rim; the floral scroll rustling under the lip; a deeply scalloped bowl; the fluted column shaft; and its concave, fish-scale molding above a convex floral molding.

An ablution fountain once stood in the atrium, known as a *paradiso.* By the fourth century, a pool surrounded by porphyry columns stood at the center of the courtyard in front of the church. Pope Symmachus provided mosaic decorations for the pool in the early sixth century. By the mid-eighth century, the Pigna, an

Fig. 11.6. The Fontana dello Scoglio (Fountain of the Rock), Giardini Vaticani (Vatican Gardens). Martino Ferrabosco and Giovanni van Sanzio, 1611–13.

LA PINA NEL CORTILE DI S PIETRO'

*Molti credono che questa Pina fuse l'alta dala mole di Adriano Imp.; la quale S.mmaco Papa, ne fece fare una fontana, dentro il Cortile di S. Pietro; doue hoggi risiede; detto il Paradiso facendola ... questa opera antica, et questo fece per comodità de foresteri, et peregrini che in quel tempo ... d'uisitare quella sacro santa Basilica.*

Fig. 11.7. "The Pigna in St. Peter's Courtyard." Published in Bartolomeo Rossi Fiorentino, *Ornamenti di Fabriche Antiche et Moderne dell'Alma Città di Roma* (1600), plate 2. Vincent Buonanno Collection.

enormous ancient **bronze pine cone** (probably from a fountain), stood in the center of the pool (fig. 11.7). Described in the twelfth-century *Mirabilia Urbis Romae* (Marvels of the City of Rome), the fountain had porphyry columns joined together by marble slabs with carved griffins and a brass canopy with gilt flowers and dolphins. A bronze pine cone, a symbol of rejuvenation, stood in the middle and "poured water through the holes in the nuts to all who wanted it." It was removed to the Belvedere by the early sixteenth century, where it remains.

Rome's first Holy Year occurred in 1300. Eyewitnesses report that two hundred thousand pilgrims came to Rome throughout the year to be absolved of sin by Boniface VIII (r. 1294–1303). The painter Giotto was already there, creating a fresco for the Jubilee. Little remains of this work. He returned in 1313, probably finishing a spectacular mosaic called the *Navicella* (Little Boat), placed in the colonnade that fronted Old St. Peter's façade. Leaving the sanctuary, congregants saw it when crossing the atrium and passing by the "Pigna." Most of the enormous mosaic (about nine by thirteen meters) disappeared when New St. Peter's was built in the seventeenth century. Fortunately, there is a painted copy from 1628. It portrayed Christ walking on water and calling Peter to join him. As Christ rescues Peter from a violent storm, he taps him gently with his right hand, the hand of baptism. The scene symbolizes Peter's authority to steer the "Ship of the Church."

The Holy Years of 1300 and 1350 gave Rome brief economic boosts. Those two hundred thousand pilgrims slept and ate somewhere. In the year 1350, there were 1,022 establishments advertised as hostels. An eyewitness, Matteo Villani, reported, "All Romans ran hostels, giving their homes to pilgrims." Some hostels had small bathing rooms provided with cistern water, and while most people didn't drink water—wine was preferred—their horses certainly did.

In a ruinous state in the fourteenth century, the basilica stood over the tomb of St. Peter and was held too sacred to replace. Only when Julius II decided that the Constantinian building needed to come down did a completely new basilica replace it. The plan was controversial—apparently Julius, enormously ambitious, was the only person who liked it—but he held a competition, won by Bramante, and laid the foundation stone in 1506.

This isn't the place to provide details of its long and complicated evolution, but between 1506 and 1612, Rome's most esteemed architects, including Bramante, Giuliano da Sangallo, Raphael, Baldassarre Peruzzi, Michelangelo, Giacomo della Porta, and Carlo Maderno, participated in its design. The basilica still stood open to the sky in 1536, when Heemskerck drew it and Johann Fichard described it with grass growing in the nave. Della Porta completed the cupola in 1603, and Maderno completed the façade in 1612.

Through an heroic effort, Domenico Fontana, with a team of eight hundred men and 140 horses, moved the **obelisk** 275 yards from the *spina* of the ancient racetrack to stand before the basilica—almost but not quite on axis with the church. The alluvial soil was saturated, but Fontana didn't discover that until he started digging a seven-and-a-half-meter-deep hole for the foundation. He drove six-meter-long oak piles into the soil before the foundation stones could be laid. The effort was sophisticated, complex, successful, and financially rewarding for Fontana. Sixtus V charged Fontana, a bold engineer but mediocre architect, with erecting ancient obelisks around the city at important crossroads and prominent piazzas like Santa Maria Maggiore. They became granite beacons that helped orient people across long distances. If there wasn't already a fountain, as in Piazza del Popolo, he or a successor added one.

Then, Gian Lorenzo Bernini swept in, creating an entirely new piazza with **colonnades** and a second fountain near the obelisk (fig. 11.8). Building the colonnades destroyed some properties adjoining the old piazza, including parcels from Cardinal Federico Cesi's garden on the rising slope of the Janiculum, standing atop the Horti Agrippinae. Bernini aggressively hacked into the garden, loping off a huge chunk of the Janiculum slope to accommodate the oval symmetry of St. Peter's colonnades.

Today's water fanfare in Piazza di San Pietro can be disappointing; frankly, one expects more than the relatively modest jets from two of Rome's most illustrious fountains (fig. 11.9). In 1664, with still only one fountain, Gasparo Alveri

Fig. 11.8. *View of the Basilica and Piazza San Pietro in Vaticano.* Giovanni Battista Piranesi, ca. 1748. Metropolitan Museum of Art.

described "a huge jet of water in the form of a fleur-de-lis . . . that reflected the sun especially in winter . . . and created a rainbow in front of the church." To fashion the fleur-de-lis, Maderno designed a finial with three large-diameter central nozzles pointed upward (one capable of launching a seven-meter-high jet), surrounded by two rows of small diameter outlets, all slightly angled outward. Maderno reused the granite basin from the dismantled Santa Caterina fountain. Howard Hibbard explains that the 4.5-meter-diameter basin was raised and kept "supported in air while the new pedestal was being installed underneath; a guard was posted night and day, workdays and holidays, until this work was complete." His workmen probably used winches to perform this levitation.

When Bernini rearranged the piazza around the obelisk in 1667, he doubled the razzle-dazzle display with a second fountain (on the left). Alexander VII wanted to tap more cold-water springs around Lake Bracciano, but negotiations took forever, and by the 1690s, with Innocent XI in charge, the water came instead from the tepid lake. That's fine for flamboyant jets, but lousy for drinking water.

Eleanor Clark describes the water shooting from the fountains as "two high waving flags of Catholicism." The castello (in the Scoglio fountain) stands at about sixty meters above sea level; the piazza at the seven-meter-tall fountain is about twenty meters above sea level. The water supply fluctuated seasonally, but

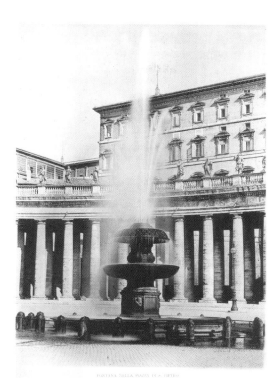

Fig. 11.9. "Fountain at Piazza di San Pietro." Carlo Maderno, 1614. Gian Lorenzo Bernini created a nearly matching fountain in 1676. Published in Giulio Magni, *Il barocco a Roma nell'architettura e nelle scultura decorativa* (1911–13), 3:20.

theoretically the jets could rise thirty-three meters. There are reports that they rose twenty meters above the fountains, but nine meters is more realistic. From the vantage of earthbound beings, they give the impression of reaching high enough to wash the sandaled feet of admiring saints atop the balustrade (see fig. 0.1).

Water conservation began hesitantly at the Vatican in the 1930s, then revved up in the 1960s. But it seems John Paul II (r. 1978–2005) found that the fountain's racket made sleeping difficult, so it was lowered again. That saves water and avoids drenching people when the wind blows; now the water falls as veils. But a breeze helps to fashion those rainbows and to subtly change the environment as it cools and calms the often-hectic piazza. During the 2018 drought, with Lake Bracciano water levels significantly lower, the fountains were turned off completely in the piazza and the Vatican Gardens.

Before walking away, notice the basins stained with mineral deposits—blue-green, sometimes even coppery—that are surprisingly cool and warm, refreshing and soothing. There is a kind of sadness for the first year or so after Roman fountains are cleaned to a scorching whiteness, erasing their time-honored stains. A fountain's patina, deposited on receptive stone surfaces as water flows, recalls the mineral environment of its water source. No ancient descriptions of

the Acqua Paola springs survive, but we know from Frontinus that the Aqua Marcia springs, for example, were "a deep-green hue."

<center>❦</center>

Enough pretty fountains and gardens at the Vatican and Piazza San Pietro. What about life in the Borgo and Prati, outside that rarified enclave? We have already spent some time at the Castel Sant'Angelo, but there is always more to say about what Spiro Kostof calls a "defanged but noble beast on a leash" still connected to the Vatican by the fifteenth-century *passetto,* a hidden escape route for the pope built atop the Leonine Walls. We'll return there soon, but for now, let's look at the Borgo—both old and new—that lies between and connects them. It has changed radically—first as the Early Christian neighborhood consumed the ancient pleasure ground, then when Renaissance buildings transformed much of the medieval fabric, and again when the Fascist regime devoured Renaissance buildings in the twentieth century.

When St. Peter's became the most important site of Christian pilgrimage, the Traiana served it and the Acqua Damasiana supplemented it. By the late seventh century, the Traiana served *diaconiae* (charitable hostels for pilgrims and the poor), monasteries, and national houses like the **Schola Saxorum,** or English hostel, for Saxon pilgrims clustered around St. Peter's. There, pilgrims received food, lodging, and baths. Three pilgrims' baths huddled near St. Peter's. When Hadrian I restored the Traiana, he directed water to them, the baptistery, and the Pigna fountain, where worshippers washed their hands before entering the church. After the Traiana failed completely, the small Damasiana spring, rainwater cisterns, and wells sufficed until Paul V completed the Paola in 1612.

Pope Francis I (r. 2013–), known as the "slum bishop" in Buenos Aires, didn't restore an aqueduct like Pope Hadrian, but he did return water to "homeless pilgrims." Understanding that homeless people today, like Early Christian pilgrims, need to bathe, he revived the practice in 2015 with free showers (and a barbershop) installed in the public bathrooms at St. Peter's. Going further, in 2017 he opened the Lavanderia di Papa Francesco, a free laundry open to the poor and homeless. Providing showers, toilets, and laundries was especially important during Covid-19 lockdowns, when homeless people clustered at St. Peter's to avoid being arrested for curfew violations. Popes Pius V, Gregory XIII, Sixtus V, and Pius IX (r. 1846–78) all sponsored public laundries for "poor women to do their wash," but none of them provided Whirlpool washers and dryers!

Water workers would have scrambled around the palace. Fish-sellers delivered their catch to a pescheria, to be kept alive until eaten. Ornamental fish swam in separate pools. There were also laundry basins, and we know how much the laundresses were paid. In 1572, Joanna de Ferrarijs received four ducats each month and a Christmas gift of ten ducats. At least one acquarolo, Bartolomeo Cometo,

served the papal palace and received three ducats each month and five ducats at Christmas. The water barrels waited in a storage room, perhaps near the kitchen. The anonymous person who maintained the plumbing at Santa Caterina's fountain received ten ducats at Christmas.

Fire was always a threat in the Borgo, as it was throughout Rome. Gruesome reminders were an 817 fire and another of 847 that began in the Schola Saxorum, east of St. Peter's along Via Cornelia. Like most hostels and diaconiae, it was a group of flammable timber buildings. We don't know the water source used to extinguish fires; the Tiber was three to five hundred meters away, and the Aqua Traiana may have been in disrepair. While legend says that Leo IV miraculously halted the fire of 847 with a benediction—Raphael depicted him calming the flames in his *Fire in the Borgo* of 1514—it's more likely that if the Traiana failed, bucket brigades commandeered Tiber water and cisterns and fountains in the area. Remember that the Acqua Damasiana continued to flow, and even though the amount of water might be modest, it was unfailing. Likewise, water could be pumped from community or private wells.

In the 1560s, Pius IV developed a plan to integrate the freshwater supply, public and garden fountains, street drains, and wastewater sewers from the Vatican through the Borgo to Castel Sant'Angelo and the river. He also dredged the moat around Castel Sant'Angelo in an unsuccessful effort to control Tiber floods. Here is an outline of his strategy. He began by having the rainwater cisterns and the conduits leading to existing fountains in the Palazzo Apostolico, gardens, and Belvedere cleaned and repaired. Then came a new, spring-fed public drinking fountain at **Porta Cavalleggeri** for the guards and their horses; its runoff water flushed their new latrine. Some Damasiana water went to the **Santa Caterina fountain,** which in turn sent its runoff to an animal trough. This and other runoff water flowed to a restored underground drain, called Chiavica Grande (big drain), that passed through the Borgo to the Tiber.

Concerned with overcrowding in the Borgo, Pius IV built a new residential area known as Borgo Pio north of the Leonine Walls' passetto (fig. 11.10). He gave it a new defensive wall with two gates. Pilgrims arriving from the north entered through Porta Angelica leading to Piazza San Pietro, and at the opposite end, soldiers passed through **Porta di Castello.** Both gates had bridges across the moat. Pius also added a street, Borgo Pio, and several cross streets all laid out with drains linking to the Chiavica Grande.

The earthwork moat around Castel Sant'Angelo reshaped the landscape outside the Vatican walls. The scheme involved more than simply digging a wide ditch. Banked-earth defensive walls were built, the Acqua Valle dell'Inferno was diverted, and all the irrigation ditches in the orchards and vineyards flanking the length of the stream were reconfigured. Intended to protect the Borgo from flooding, Pius also envisioned that the flowing water would eliminate mal aria (bad

Fig. 11.10. *New Plan and Elevation of Rome* (detail). Giovanni Battista Falda, 1676. Vincent Buonanno Collection. Castel Sant'Angelo is at the top; the Borgo (with Borgo Pio along the far left) stretches between it and St. Peter's, with the Giardini Vaticani (Vatican Gardens) at center bottom. The brick kilns are to the right. North is to the left.

air), thus rendering the entire area more salubrious and habitable. So, defense, irrigation, public health, and flood control were joined at Castel Sant'Angelo. Yet even with this enlightened plan, the Borgo flooded as often as the Campo Marzio, in part because when floodwaters, rushing across the Prati fields, reached the Leonine Walls, the water's force simply tore the gates open. The flood markers proving it are displayed in Castel Sant'Angelo.

Bridges tethered the Vatican plain to the Campus Martius: first **Pons Neronianus,** then Pons Aelius. Once Constantine founded St. Peter's Basilica at the pagan and Christian tombs, his bridge grew in importance. New roads appeared as traffic to St. Peter's increased during the medieval period, especially perhaps after the 1300 Jubilee, when Rome swarmed with pilgrims. Via Cornelia survived for centuries under different names. For a long time, it was simply "the street that goes from the pontifical palace to the castello." Alexander VI (r. 1492–1503) built a new formal street, Via Alessandrina, to welcome pilgrims to the 1500 Jubilee. It cut through existing urban fabric; some medieval buildings were torn down and replaced by Renaissance ones.

Churches and elegant palaces soon flanked Via Alessandrina, and once Acqua Paola arrived, fountains did too. Later known as Via Borgo Novo, it, and Via Borgo Vecchio, formed the edges of what became known as the Spina di Borgo (Spine of the Borgo). Smaller streets crossed them, and **Piazza Scossacavalli,** with its church and early sixteenth-century palace, provided open space. The spine blocked views heading toward St. Peter's. Bernini used this obstruction brilliantly when he designed Piazza San Pietro. He created a breathtaking surprise that left dark, narrow streets behind and a piazza of colonnades, light, water, and, of course, the basilica ahead. Don't expect that surprise. Via della Conciliazione, the Street of Reconciliation, took its place.

If you're looking for an architectural topic about which opposing opinions still rage, look no further than Via della Conciliazione. Completed in 1950, the street ironically commemorates the 1929 Lateran Pact that reconciled church and state; but like Mussolini's other streets, this one ripped out a medieval and Renaissance neighborhood, that although dark and crowded, housed nearly five thousand people. Mussolini wielded the first pickax in 1936. The former residents never returned because the entire street was given over to pilgrims and tourists.

There weren't many fountains in the Borgo (or Trastevere) before 1612. There was the Pigna fountain in the atrium and the pretty Santa Caterina fountain, with its horse trough. But these fountains all stood close to St. Peter's and the Vatican and received Acqua Damasiana water. There were wells inside some monasteries, like Santa Maria in Traspontina, and in some Borgo palaces (as at the Palazzo della Rovere), and Castel Sant'Angelo had at least two wells in the early sixteenth century. Most Borgo residents relied on the Tiber or the acquaroli.

While most sixteenth-century Romans took baths infrequently, Julius II had an opulent *stufetta* (small heated bathing room) at Castel Sant'Angelo. Now called Bagno di Clemente VII, it's near the *cortile del pozzo* (courtyard of the well). A stone tub stood in a small room that an eyewitness, Johann Fichard, describes in 1536 as decorated with shells and gilt paintings. Here, seated in the tub, His Holiness washed with hot water that flowed from a bronze spigot of a female nude. Fichard continues, describing other nudes that he was certain His Holiness "*Ex quibus non dubito quin magna devotione tangatur*"—meaning he touched them with great devotion. What does that signify, exactly?

Among the frescoes are putti riding dolphins and another putto adoring himself mirrored in the water. There is a painted border of little fish and mythological figures near rocky cascades and pools, including Venus gazing at her reflection in a mirror. Mirrors and water have been linked from time immemorial, most notably the myth of Narcissus enamored with his reflection in a still pool. Up another level there was a room fitted with pipes, a cauldron to heat water, and another area with a cistern for cold water. This was the top floor of a building more than forty-five meters tall, and water barrels were probably carried on donkeys' backs as they trudged up the internal ramp.

Acqua Paola fountains sprouted up throughout the Borgo. In 1614, there was a beautiful one (with lots of high-pressure water) fashioned for Piazza Scossaca-valli. The piazza, church, and fountain are gone, and the palace now faces Via della Conciliazione. Giovanni Battista Falda shows us an athletic water display of jets vaulting from the lower basin and then tumbling in graceful arcs into the upper basin. In his fountain prints, Falda typically exaggerated scale, but the details are right. It became another peripatetic fountain, but there are no graceful arcs in its new location in Piazza Sant'Andrea della Valle.

Several drinking fountains from Paul V's reign ornamented Piazza Scossaca-valli. Two of these—one with an eagle, the other with an eagle and dragon—still flow in their new location on the south side of the street, while the others have disappeared. At the end of the spina, closest to **Castel Sant'Angelo,** Paul V placed a tall fountain, the **Mascherone di Borgo,** which means "big borgo mask," designed by Carlo Maderno. It filled the entire wall. Everyone crossing from **Ponte Sant'Angelo** saw it as they turned left toward St. Peter's. This was an ornamental drinking fountain writ large that also played an important technical role. Water flowed to the fountain under pressure (in a siphon) to an upper-level castello basin. Some water cascaded to a lower basin, and its runoff was used in the neighborhood. The remaining water—still at a high elevation—flowed in a second siphon across Ponte Sant'Angelo to Rome's left bank, where the Orsini (who sold Paul V their water rights) received a "donation" from the pope for their palace. *Quid pro quo!*

The lucky few had private fountains, while some new housing blocks in the

expanding Borgo Pio received courtyard basins. The basins no longer exist, but Acqua Pia Antica Marcia fountains in Piazza delle Vaschette and Piazza del Catalone have taken their place. Porta Angelica and Porta di Castello had Acqua Paola animal troughs. Porta Angelica also had a drinking fountain at the church of Santa Maria delle Grazie, fed by a spring inside the Vatican grounds.

Several fountains served the **Ospedale di Santo Spirito,** including basins for drinking, cooking, attending to the ill, and laundry, and two ornamental fountains, one centered in each of the men's and women's wards and, added later, the Fontana del Cupido (Cupid Fountain), with an eagle and dragon and a sea monster gushing water into three shell basins. This tall mural fountain first stood in the Vatican Gardens and then at the Palazzo Apostolico (before landing in the hospital's entry courtyard in 1669).

Springs including the Acqua Pia, Acqua delle Api, and Acqua Angelica were frequently "discovered" (rediscovered, more likely). A particularly salubrious spring, Acqua Lancisiana, was mentioned in 1581. Its *fontanella* stood closer to the Tiber with very low pressure. In 1717, a new public fountain, the Lancisiana, was built along the Tiber's bank at the ferry that connected the Ospedale di Santo Spirito with San Giovanni dei Fiorentini. However, it was decommissioned in 1828, and a new Lancisiana fountain replaced it at nearby Porto Leonino, but local citizens insisted it be reinstated in its original location. Rebuilt on Via del Fondamento in 1830, it disappeared when the Tiber embankment was built in the 1880s. In 1925, two drinking fountains, now dry and forlorn, struggled to take its place down along the water.

<center>❧</center>

Outside the Leonine Walls, there are brickyards in Valle dell'Inferno, one surviving into the twentieth century. Brickyards were located at clay beds and near water, first to add water to the clay so it could be molded, and then to quench the **brick kilns** at the end of firing. There were also brickyards outside Porta Cavalleggeri in the Valle delle Fornaci (Furnace Valley) that continued into the nineteenth century (see fig. 11.10). The Porta Cavalleggeri spring was discovered in 1562 when digging clay, and then Pius IV installed a drinking fountain for soldiers garrisoned nearby. Now provided with Acqua Peschiera-Capore water, it is near its original location, but sadly, aside from a few nasoni, the pleasant Fornaci neighborhood has never received it share of neighborhood fountains.

Well into the nineteenth century, vineyards, orchards, and vegetable gardens flourished in the Prati fields that Pius IV had reconfigured for his drainage system (fig. 11.11). Small landholders, churches, and monasteries leased or owned parcels, but wealthy families controlled larger areas. The Altoviti family, fabulously influential Florentine bankers, related by blood to popes Innocent VIII, Clement XI, and Clement XII (r. 1730–40), owned a villa along the Tiber. Their boat

Fig. 11.11. *Roads Originating outside Porta Angelica* (detail). Catasto Alessandrino, 1661. Archivio di Stato di Roma.

landing provided the best view of the Ripetta port across the Tiber. Later a papal property, it became the pope's marina.

Although proposed in 1908, work only began on the Acqua Peschiera-Capore in 1938 but was then halted by World War II. Its first section terminates outside the Vatican walls in Piazza degli Eroi, where its mostra fountain is stranded in a traffic island (see fig. 6.3). The fountain, built quickly to be ready for the 1950 Jubilee, is pleasant when it's working properly, with several fat jets leaping from the central bowl. But it can't compete against the traffic. Frequently there are only little rivulets falling from basin to basin. Unless you're in the neighborhood, to visit the Fornace Veschi museum in the Valle dell'Inferno, for example, there isn't any compelling reason to seek it out.

A branch of the Acqua Vergine Nuova made it across the Tiber at the behest of Mussolini, who sponsored its construction between 1931 and 1934. In the Prati, it flowed to new housing blocks and to an enormous fountain in Piazza Mazzini. Designed by Raffaele de Vico, it is larded with Fascist eagles and *fasces* bundles, but also with inventive rills, drinking fountains, and a pebble mosaic

basin floor decorated with zodiac signs. Piazza Mazzini forms the heart of a large new neighborhood, and this was the water's symbolic terminus. The fountain, and its necklace of laurels and four enormous cypress trees, is marooned in a traffic island. So, if you make it across the street (of course there aren't any stoplights), you may as well sit for a spell in the shade.

As you leave the Prati neighborhood, you might want to head south and see the Mussolini-era Fontana delle Cariatidi (Fountain of the Caryatids), in Piazza dei Quiriti. There are four gigantic nude women, and for a moment they were scandalous. But once you've seen the Fontana delle Naiadi (Fountain of the Naiads) in Piazza della Repubblica, you'll wonder why anyone bothered to be upset. It's nice that the neighborhood has its own traffic island fountain, but frankly, it's rather clumsy.

The Tiber is five blocks to the east. This might be a good time to recall Father Tiber's fickle temper, and how he could change course at whim. Just as there are inscriptions that record Tiber floods, there are also ancient cippi inscriptions. These regard jurisdiction of the river and record the shifting boundaries found here and elsewhere along the bank. Because the river shifted course often, new markers registered the changes. Many cippi were discovered during the embankment work when the entire urban river edge was reshaped for what is hoped will be the final time.

A cippus was a legal and liminal threshold between land and water. In chapter 12, we'll cross another threshold, this time between earth and sky, when we head toward the clouds to fly over, and peek into, Rome's villa gardens, like playful putti looking for fountains to populate. Prepare to don your wings.

## Bibliography

For Leonine Walls, see Coates-Stevens 1998; for brick kilns, see Giustini 1997; for geology and hydrology in general, see subject bibliography (especially Corrazza and Lombardi 1995) and De Angelis d'Ossat 1953; for the circus and obelisk, see Curran et al. 2009 and Long 2018; for the naumachia and fossa, see Taylor 1997; for aqueducts, see subject bibliography (especially Ashby 1935 for springs); for Palazzo Apostolico, Belvedere, and gardens, see subject bibliography (especially Ackerman 1953), Coffin 1979 and 1991, Habel 2013, Müntz 1878, and Pliny the Elder *Nat. Hist.* 16.237; for St. Peter's, see Krautheimer 2000 and Krautheimer et al. 1977, vol. 5; for Boniface VIII, see Brentano 1974; for Maarten van Heemskerck, see Hülsen and Egger 1913–16; for the Tiber River, its bridges, floods, and inscriptions, see subject bibliography (especially D'Onofrio 1980); for Casina Pio IV, see Cellauro 1995; for fountains, see subject bibliography, Alveri 1664, and Hibbard 1971; for Holy Years, see Krautheimer 2000 and Villani 1846; for the Schola Saxorum, see Dey 2008 and Krautheimer 2000; for Pope Francis I, see Estevez 2017; for the Borgo and spina, see Ceccarius 1938, Guidoni and Petrucci 1997, Insolera 2002, and Kirk 2006; for Pius IV and urban planning, see Rinne 2012; for Castel Sant'Angelo, see D'Onofrio 1978, Gibson and Ward-Perkins 1983, and Taylor et al. 2016; for the Bagno di Clemente VII, see Edwards 1982.

# 12

# The Source of the Soul
## Water for Rome's Villas and Gardens

Lazio's most spectacular gardens, at Villa Adriana, Villa d'Este, Villa Lante, Capra-rola, and Bomarzo, all lie outside Rome, nestled into or dominating hills in the surrounding Campagna. They are breathtaking, expansive, restorative, dramatic, voluptuous, intellectually engaging, sometimes shocking, always magnificent—and they all rely on prodigious quantities of water. But other celebrated gardens are closer to home. To visit them, we'll waft skyward, somewhat like putti in Renaissance frescoes, flying over Rome. After that, you can decide where you would like to touch down.

Magnificent villas sprouted up all over Tuscany beginning in the mid-fifteenth century, but like the Renaissance, such beauty came late to Lazio. With few exceptions (Villa Giulia, for example, with a direct line to the Acqua Vergine), lavish gardens weren't feasible until 1587. Then, with aqueducts entering the city along the city's hilltops, water gushed everywhere, and Rome's gardens outshone most others in Italy for a century. These gardens fill Rome with their rampant beauty—their trees and flowers, fountains and sculpture, grass and pebbled paths, shade and sun, and rustles and sighs.

A late sixteenth-century horticulturalist, Giovanvittorio Soderini, wrote that "water is the soul of villas . . . and pleasure gardens," and that it needed to be used abundantly, as in ancient Rome. We saw this at **Villa Madama,** where water structures the garden, providing the *anima* (soul) that animates everything. Without water, there would be only sculpture and meager plantings.

Most guides to Rome's gardens fail to consider the water's source and how its flow, pressure, and other qualities made possible fountain displays—did water drip or flutter, gush or cascade, run or amble, tumble or slide, ripple or roil?—or indeed, how the source might underlie the garden's conceptual design and

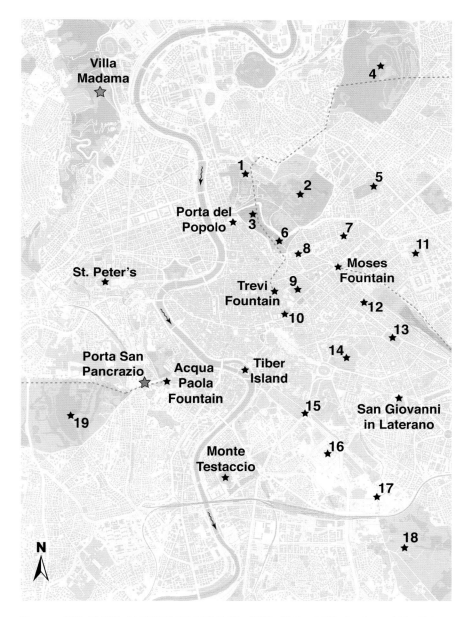

Villa
Madama

4

1

2

5

Porta del
Popolo    3    6    7

8    11

St. Peter's    Moses
Fountain

Trevi    9    12
Fountain

10    13

14

Porta San
Pancrazio    Acqua    Tiber
Paola    Island
Fountain

15    San Giovanni
in Laterano

19    16

Monte
Testaccio    17

N    18

Fig. 12.1. VILLAS AND GARDENS PILGRIMAGE: 1) Villa Giulia, 2) Villa Borghese, 3) Giardini del Pincio (Pincian Gardens), 4) Villa Ada, 5) Villa Albani, 6) Villa Medici/Horti Aciliorum/Horti Luculliani, 7) Horti Sallustiani, 8) Villa Ludovisi, 9) Palazzo del Quirinale, 10) Giardino Colonna, 11) Villa Olgiati, 12) Horti Maecenatis/Villa Montalto, 13) Piazza Vittorio Emanuele II, 14) Colle Oppio (Oppian Hill), 15) Parco Archeologico, 16) Thermae Caracalla (Baths of Caracalla), 17) Porta San Sebastiano, 18) Via Appia Antica/Parco Regionale, 19) Villa Pamphilij. Three contemporary aqueduct routes are shown as schematics.

structure. Really? As if the garden would have been possible without water! Yes, emperors, senators, popes, cardinals, and royalty could command, "Make me a garden with fifty fountains," but the water must come from somewhere, and its origin could profoundly affect the evolving design ideas and final plans. We'll try to rectify this lacuna as we travel along with Rome's elite citizens to visit their glorious gardens.

We'll fly in a clockwise arc from Villa Giulia, outside the Mura Aureliane (Aurelian Walls), to the northeast, to the Pincian Hill—known in antiquity as Collis Hortulorum (Hill of Gardens)—to the Janiculum Hill in the west. Several gardens are open to the public. You can simply walk in and spend the day. Many of Rome's historic gardens have been altered to reflect changes in taste. That isn't necessarily a bad thing; English-style rambles with murmuring brooks or pool table–flat French parterres with sheets of mirroring water can steal the heart as easily as Italian umbrella pines and cascading fountains. Still other Roman gardens were hacked to bits to accommodate unbridled development, and some, like the Villa Montalto, disappeared completely. In 1923, the poet Gabriel Faure lamented that "something of the soul of things past" still survived in only three or four of Rome's gardens.

Before we start, a few general comments. Using water as a lens, we see that three types of gardens evolved in late sixteenth-century Rome: spring-fed, aqueduct-fed, and spring/aqueduct hybrids (or sometimes aqueducts pretending to be springs). Without aqueduct water, a spring organized the sequence of water displays. As at Villa Madama, the spring itself might be artfully designed to resemble a grotto nymphaeum—a symbolic home for the Muses and retreat for poetic creativity in the antique mode. Their settings were bucolic, like Egeria's sacred grove; in the late first century BC, Livy relates that it stood in "a certain little copse watered summer and winter by a stream of which the spring was in a dark grotto" (fig. 12.2).

Even with gushing sources, spring-fed gardens were often more compact, while aqueduct-fed gardens like Villa Borghese and hybrid gardens like Villa Pamphilij could sprawl. Regardless, there was typically a nymphaeum intended to imitate a natural grotto; they were everywhere in Rome's gardens and estates. Ancient remains of one were even discovered within the thickness of the Aurelian Walls, with standing statues still in their niches; another was sixteen meters underneath the Palatine Hill, with its vaulted ceiling covered with mosaics still in place when it was found in 2007. Nymphaea were abundant on the Quirinal, in part because several springs emerged on its slopes.

Some nymphaea were architectural, including the Casina Pio IV and Bramante's nymphaeum for Julius II at the Belvedere (both at the Vatican). Others occupied real, although enhanced, rocky outcrops, as at Villa Madama, or artificial grottoes made to "imitate" caves, as at the Palazzo del Quirinale. "Sleeping

Fig. 12.2. Grotto of Egeria, Caffarella Valley, 2nd century AD. Egeria's statue stood in the niche, and green porphyry and mosaics covered the walls.

nymph" statues inhabited grottoes at Villa Cesi and Villa Giulia. Built before the aqueducts' restoration, these nymphaea grottoes never had much water. After 1587, garden fountains will gush, not dribble, and fewer nymphs and mythological figures will populate them. As Elisabeth MacDougall comments, genre figures like dragons, dwarves, and dogs now took prominence.

Renaissance theory often dictated that gardens, whether at a villa or urban palace, imitate nature through a dialogue between art and technology. When applied to fountain design, the artist shapes water into a beautiful fountain through technical means. Ideally, art and nature shared equally in the design of something called "a third nature." The grotto nymphaeum, crafted carefully to imitate a real grotto cave, fit the bill.

At the Trevi Fountain we saw how Nicola Salvi's microcosm provided Romans with front-row seats to attend his ongoing seminar, which made manifest his understanding of natural laws. A garden is much the same. It is a miniature cosmos that could, in the hands of a talented designer and patron, reveal natural order, typically a divine order during the Renaissance. That is a lot to ask of a garden. If possible, they were divided into formal spaces with orderly walks, walls, and plantings, countered by a rustic garden (*bosco*), often much larger and dense,

Fig. 12.3. Frontispiece of Giovanni Battista Ferrari, *Hesperides sive de Malorum Aureorum cultura et usu: Libri Quator* (1646). Metropolitan Museum of Art.

with trees and sometimes used as hunting grounds. Romans were never shy about moving earth to create the flat formal surfaces that disregarded topography. But the bosco was enhanced by varied topography.

Trees grew profusely, especially cypresses, holm oaks, and umbrella pines, and also ornamentals, such as the bitter orange (Seville), perhaps the most popular ornamental tree in Renaissance gardens, in part because it linked to the myth of the golden apples of the Hesperides (fig. 12.3). The Hesperides were nymphs (daughters of Atlantis) who guarded the golden apples in Hera's garden, located at some unspecified place in the "West" or "North." Symbols of knowledge and immortality, the golden apples were perfect talismans for Humanist gardens.

Elite Romans participated in *villeggiatura,* relaxing travel outside the city. Pliny the Younger (AD 61–112), an aristocratic lawyer with a long and successful political career in Rome, designed and enjoyed two gardens. He wrote in detail about his villas, one south of Rome—close enough, he says, that he could ride out after a day's work. His goal: to leave the public world of *negotium* (business) and retreat to his private world of *otium* (leisure). Emperor Hadrian built Villa Adriana, perhaps Rome's most famous ancient garden, where pools surrounded

rooms built like islands. From his vast estate outside modern Tivoli, Hadrian looked across the Campagna toward Rome, the center of his empire. But it wasn't necessary to travel far to enjoy a lush villa garden, either then or now. Many gardens are at the edges of the historic core, within or just without the walls.

In his quest for otium, Julius III built close to Porta del Popolo. His **Villa Giulia** and other sixteenth- and seventeenth-century gardens emulated ancient ones (which, without extant garden remains, they only read about, as with Pliny's letters) and recreated ancient environments with real antique sculpture, architectural fragments, and inscriptions. The gardens themselves were rich archaeological sites; treasures emerged as the earth was turned.

Each garden displayed the owner's taste, wealth, cultivation, and influence— tempting invitations to the Muses (often water deities like nymphs) to visit and offer poetic inspiration to the owners and their Humanist friends, all tutored in Greek and Latin, who would write in those languages. A grove of trees, statuary of nymphs, and benches were necessary, but water, the garden's soul, was essential.

Where was Villa Giulia's soul? Even with several perennial springs all along the Pincian slope, architects Bartolomeo Ammannati and Giacomo Barozzi da Vignola ignored them. Instead, they burrowed into a concavity in the hillside, where they tapped into the Acqua Vergine's underground channel as it passes under the Pincian Hill before entering the city from the north. Here, they built a grotto nymphaeum, a rustic recess meant to look natural but with an architectural framework. The fountain is about fifty meters from the hidden aqueduct, and that proximity determined the villa's siting and that of the nymphaeum. The inscription *Fons Virginis Villae Juliae* stamped on the commemorative foundation medal suggests that the nymphaeum is the conceptual focus of the entire villa complex.

The shady and cool grotto is set belowground. Being here is like returning to ancient Rome, where sculptures of river gods—Tiber and Arno—adorn the fountain, and mosses and ferns create a numinous environment. Once, plane trees on the second level shaded the nymphaeum, in conscious imitation of the antique. The gods really could visit this fountain and feel at home; its design emulated the temple that Frontinus tells us stood at the Aqua Virgo's spring. Although gods might have felt at home here, sixteenth-century Romans groused, rightfully, about the lack of water at the Trevi. This wasn't the only example of papal greed at the expense of public good, but in this case the Trevi was the Vergine's primary distribution point. Diverting so much water meant there was little left for residents, and in 1559 water flowing to the Trevi ceased almost entirely.

Water still drips softly at the Villa Giulia nymphaeum. The gardens are inviting, putti gambol among frescoed pergola vines, and the Museo Nazionale Etrusco is glorious and must be visited. But where once apricot, plum, pomegranate, and quince trees abounded, now there are mostly umbrella pines. And, while

Villa Madama remained half-complete, leaving us longing for a whole garden, Villa Giulia was sliced up when Viale delle Belle Arti was cut through to create what became a new arts district for the 1911 Universal Exposition. Much of Villa Giulia disappeared.

Flying above Rome, **Villa Borghese** is only a few flutters of our wings to the southeast. Made a public park in 1903, it features monumental chalice fountains, and parterres with rustic fountains at the top of the stairs. You'll pass under a miniature triumphal arch and through the oak and pine tree ramble, and shortly reach a little artificial lake added in the nineteenth century with its own temple to Asclepius, a healing god.

Beginning in 1608, Cardinal Scipione Borghese, nephew of Urban VIII, began transforming family vineyards and farms outside Porta Pinciana into his villa suburbana retreat and to create a home for his art collection. Like Sixtus V, Urban VIII's family snapped up prime adjoining properties with plans to build a villa. Among the parcels was the sixteenth-century Villa Giustiniani, entered outside Porta del Popolo, with its fountains (fed by the Acqua Vergine, like Villa Giulia). Without perpetual attention, time, and money, gardens won't survive, let alone flourish. Villa Giustiniani fell into ruin after its owner's death in 1621, making it

Fig. 12.4. *Plan of the Borghese Gardens.* Giovanni Battista Falda, before 1695. Vincent Buonanno Collection. Note the galleria and private gardens (right) and main entries (bottom).

a tempting bonbon for acquisition. Now only a street name recalls the villa and its garden.

As with Sixtus, it was election to papal office that got things going at Villa Borghese (fig. 12.4). Since popes couldn't own property in their names, they transferred holdings to a relative, typically the papal nephew, like Scipione, or a sibling, like Camilla Peretti. Once Paul V began his Acqua Paola project (1607–12), he turned to providing his nephew's villa with Felice water. Between 1609 and 1611, a private line was laid from the Fontana del Mosè (Moses Fountain) to the property's far eastern corner. From there, the water flowed to new fountains and irrigated the garden. It was here that Scipione also built his museum, the Galleria Borghese, for ancient and contemporary art. With excellent taste, he commissioned work by Bernini and Caravaggio; the best of both are here.

The grounds closest to the galleria, about a quarter of the site, were originally laid out with formal parterres (fashionable at the time), each square surrounded by trees. The area behind the galleria was private, with smaller orange and myrtle trees. The remaining land was densely planted with laurel, umbrella pines, a meager one thousand fir trees, a glade of elms, and a rectangular lake surrounded by plane trees. The host and his guests could shoot birds and animals kept in the rustic bosco. There was an aviary, a lion enclosure, another for gazelles, and a "serraglio delle tartaruche," an enclosure for turtles.

There were fountains galore, including the enormous Fontana del Mascherone (Fountain of the Mask), an artificial grotto overseen by a giant mask gushing water (fig. 12.5). A dragon (a Borghese insignia), an eagle, and ten smaller masks spewed bubbles and plumes of water, and 180 jets could be adjusted for giochi d'acqua (water games), whereby the host drenched the guests unexpectedly. Apparently getting sopping wet was something of a treat and became an important part of villa garden entertainments. The inventive secrets used by *fontanieri* to create fountain mechanisms were closely guarded to "amaze" guests and keep them guessing about the clever devices. The fontanieri also designed stones that could suddenly gush water beneath the visitors' feet, benches that suddenly spouted geysers as guests seated themselves, and gates that activated waterspouts inside a grotto.

Astounding visitors was essential for an elite villa garden. But who visited? A type of inscription posted at garden gates known as the *Lex hortulorum* (law of gardens) invited people to enter and enjoy its beauties. But this didn't mean that any country bumpkin could amble in for an afternoon. Rather, Rome's elite citizens invited their equals to stroll through their gardens. As Katherine Bentz notes, the inscriptions, like one at Villa Medici, are placed inside the gate, not outside, where anyone could see them.

Unlike the clear organization at Villa Madama, today there is little sense of water's arrangement at Villa Borghese. A gravity-flow watering plan must be

FONTANONE RVSTICO NEL GIARDINO DEL SIGNOR PRENCIPE BORGHESE.14
fuori di Porta Pinciana detto il funtanone del mascherone in faccia il Portone à capo il Viale de gli Olmi Architettura di Gio Antonio Vansantio

Fig. 12.5. *Rustic Fountain at the Borghese Gardens.* Giovanni Francesco Venturini, 1676–89.
Rijksmuseum.

logical; neither the landscape designers nor the fontanieri could forget that water
flows downhill. Symbolic fountain hierarchies structured many gardens, with var-
ious gods and goddesses placed sequentially to create an ambulatory lesson in
mythology, walking from one statue and fountain to the next, as at Villa Mattei.
But that wasn't the case here. As Elisabeth MacDougall explains, there was no
"unifying allegory"; this garden wasn't a "book in which one learned lessons of
mythology and morality."

Villa Borghese was transformed into an English-style garden in the eighteenth
century, erasing the original scheme. The rectangular lake disappeared within rus-
tic plantings. So today, we know where the water system ends topographically—in
a lake near the far western edge of the garden—but there is no sense of an order-
ing principle designed around water. Perhaps that only matters to me.

Conceptually, the villa extends across the Aurelian Walls to the **Giardini
del Pincio (Pincian Gardens),** with Via delle Magnolie (Magnolia Street), a
landscaped bridge flying over the horrendously busy road below to land on top
of the walls, then going through the park to visually connect with Piazza del
Popolo and St. Peter's beyond. Created between 1809 and 1814, at the direction
of Napoléon Bonaparte while the French controlled Rome, but not completed for
many more years, the Pincian Gardens were Rome's first public park. And the park

was glorious. Anyone, properly dressed and well behaved, could visit and share one of Rome's most stupendous views from Piazza Napoleone: a scenic sweep of the city with St. Peter's dome shimmering in the distance (see fig. 1.4).

When aqueduct water ceased flowing, ancient villas were abandoned. In the sixth century AD, Vitiges, a commander of the Goth army, built a camp outside Porta Pinciana (within the future Villa Borghese), while Belisarius, the commander of the Roman forces, huddled with his troops on the Pincian Hill inside the Aurelian Walls (begun in AD 271), in what is now Villa Medici and the Pincian Gardens. Over the next one thousand years (between the sixth and sixteenth centuries) the ground remained largely undeveloped, with a few vineyards and orchards owned by monasteries. The gardens suffered during the short-lived Repubblica Romana in 1849 when papal troops, supported by the French, fought republican battalions for control of Rome. The republicans transformed the strategic Pincian Hill into a fortress, cutting down trees, ripping apart the water lines, overturning lawns, and pulling out rose beds to create cannon mounts and a defensive ditch. The victorious French soldiers then bivouacked in the garden. During World War II, lawns were again ripped up for victory gardens.

One doesn't come here for the fountains; they are rather languid pools. The Acqua Vergine Nuova doesn't have much pressure up here, and neither does the Acqua Felice. Frenchmen, including François-René de Chateaubriand, André Gide, and Gabriel Faure, liked to visit in the late afternoon for the "magic of light," with its "azure mist . . . pouring down like rain." The light is still amazing. Now one also comes for the shady trees planted in the 1850s—some are enormous—especially the plane trees. When sitting and reading isn't enough, visitors also play "Name That Italian Hero" among the 228 mostly mutilated, mute statuary busts dotting the garden.

Leaving from the opposite end of Villa Borghese on Viale Gioacchino Rossini, you can walk to **Villa Ada** in about fifteen minutes, but it's easier to fly there on imaginary wings. The park is huge, about 160 hectares. Created for the Pallavicini family in the eighteenth century, it became a royal residence of the House of Savoy (the Italian monarchy was only abolished in 1946) in the late nineteenth century. The villa followed a traditional plan, with a relatively small formal garden surrounded by a larger rustic bosco. The fountains are beyond our reach, within the small area of villa buildings, which is now the Egyptian embassy. Nineteenth-century photographs make clear there was a water stair, a large peschiera, and the obligatory nymphaeum in the formal garden. Its most beautiful water feature is an artificial lake at the far end of the park. Between 1872 and 1878, more than twenty-five thousand cubic meters of earth were excavated to create two lakes and to amplify surrounding hills.

The bosco is famous for its sixty-four hectares of cork oaks (*Quercus ilex),* covering 40 percent of the park's area. This is more than all the planted areas of

Fig. 12.6. *The Gardens of Villa Albani.* Edward Lear, 1840. Yale Center for British Art.

Villa Borghese combined. The ilex grove is nearly sacred in Rome, in part because it harks back to a primordial Campagna landscape when cork oaks were plentiful. There is also a seven-hectare cedar grove. Together, these seventy-one hectares are the most effective plot of land in central Rome for carbon sequestration. The park also sequesters military remnants: Forte Antenne, built in 1872, and a bunker built to protect the royal family during World War II. Even older are the ruins of Antemnae, an important town more ancient than Rome built on a small hill that overlooked the Aniene River.

**Villa Albani** lies only six hundred meters east of the Galleria Borghese, but it's about a sixteen-hundred-meter walk to the front gate. Begun in 1747, the estate created garden settings for Cardinal Alessandro Albani's stupendous antiquities collection. Topographic surprises are few because ground swells were leveled and hollows were filled to create sheets of land with clipped parterres in the French manner (fig. 12.6). As historian Hippolyte Taine remarked in 1868, "Nature has no freedom. Everything is factitious"; and in 1889 the poet Gabriele D'Annunzio called it "cold and mute." That doesn't mean that beauty doesn't reside here; the parterres are among the most beautiful in Rome, with French broderie designs. Today, the fountains are unexceptional, but at one time a 125-meter-long cascade with seven levels (shallow, I presume) flowed down a gentle slope. There was a small grotto tucked at the back of the property—the only bit of romanticism. Factitious or not, a great deal has disappeared. Urban development gobbled up much of the villa.

<div align="center">⌇</div>

The pedigree of the site of **Villa Medici** is impressive. Ruins of the ancient **Horti Aciliorum** and **Horti Luculliani** lie underground. Determining where one began and the other ended on the Pincian and Quirinal hills is a bewildering exercise. The horti probably extended into today's Villa Borghese. First was the Horti Luculliani of 60 BC, which began on the lower Pincian and swept back to the north and east across the plateau. The owner, Licinius Lucullus, was filthy rich. He laid out his garden, considered exotic by Roman standards, in a new luxurious Persian style—enclosed, with fruit trees, flowers, deep shade, and pools. But how and where water flowed is conjectural, since so few remains have been discovered. We know water arrived in 52 BC, so there must have been fountains as well. The Regionary Catalogue (a fourth-century AD urban inventory) includes a *nymphaeum Iovis* (Jupiter's fountain) on the hill, but it might have belonged to the Horti Aciliorum from the second century AD.

Slightly to the north, a portion of the Horti Aciliorum lies under the Pincian Gardens. Its steep retaining walls on the north and east were merged into the Aurelian Walls (giving an idea of the hill's precipitous slope). Rodolfo Lanciani explains that a "reservoir with a labyrinth of small galleries hewn in the rock" fed a pool with eighty-meter-long tunnels. Another portion lies under Villa Medici, with a huge amphitheater carved into the west-facing Pincian slope and ruins of a temple behind. Still occupied in the fourth century, the gardens were probably derelict in AD 537, when Belisarius camped inside the walls and built a cistern (now partially below Villa Medici). His encampment extended into Villa Borghese. These were dark days, when the Visigoths hammered Rome and cut its water supply. Without aqueduct water, the Pincian and Quirinal summits remained essentially dry and sparsely occupied throughout the medieval period. As late as 1551, vineyards, pockmarked with scattered antiquities, filled the area.

Here, Cardinal Ricci da Montepulciano built his villa. Because he administered Rome's waterworks—including restoration of the Acqua Vergine that ran beneath his property—he easily acquired water for his garden. Cardinal Ferdinando de' Medici bought the property in 1576, and immediately began building a twenty-meter-high hill atop the tattered, scenic remains of the Horti Aciliorum, obliterating them almost completely. A spiral staircase once surrounded the hill, and a straight staircase ran up the front to a fountain pavilion. Water channels once ran along both sides. Later there was Felice water for the palace and the Fontana della Palla di Canone (Cannonball Fountain) in front of the villa. Henry James found it "perhaps on the whole the most enchanting place in Rome."

Cardinal Flavio Orsini owned a small garden down the hill from Villa Medici. Like Ricci, he was a member of the water committee, which "donated" water for his garden in 1576. There were delicious fountains—one was a Bacchus pouring water, another with gilded fruit, putti, and marine beasts, another with five-petal roses emitting water sprays, and two fishponds—all set beside parterres with

120 bitter orange (Seville) trees in each. The fountains were not only whimsical; they can also be understood as the fontanieri's experiments to understand how water could be used in specific gardens with a unique relationship to its principal source—in this case, the Vergine's underground springs, about sixteen kilometers away, and its local source, a distribution castello a few hundred meters away. Few fontanieri were formally educated, but they learned the physics of water by working with water—the stuff, not the theory—within specific topographic settings. The larger gardens had a fontaniere on staff to maintain the fountains and their plumbing, and to turn the key when it came time to spray the guests with giochi d'acqua of their own design.

Among ancient gardens, the **Horti Sallustiani** (owned by Julius Caesar in the first century BC) is better known. It occupied the deep gorge between the Pincian and Quirinal hills, with a sheer drop on the Quirinal where the Mura Serviane (Servian Walls) ran near its crest. Springs, and a formidable stream, the Sallustiana, flowed here. The gardens, which probably extended west to today's Piazza Barberini, are best known for the sculpture found there, but there was also an elaborate nymphaeum and a huge water reservoir measuring about fifty-three by six meters, which suggests something like a swimming pool rather than a tank.

Abandoned after Alaric's 410 Sack of Rome, the springs were already buried when dirt, scraped away to create a site for the Thermae Diocletiani (Baths of Diocletian), was dumped into the valley eighty years earlier. Sixtus V pitched in more earth when he built his road connecting the Quirinal and Pincian hills. In all, Piazza Barberini now lies 11.75 meters above the virgin soil of the valley. Archaeologist Carlo Fea rediscovered the stream in 1790 and immediately lobbied to reactivate it as a public water source for the Campo Marzio. In 1886, the Sallustiana waters held "a high degree of purity." The stream still flows today.

By the sixteenth century, vineyards were everywhere among the ruins. Cardinal Ludovico Ludovisi, nephew of Gregory XV (r. 1621–23), purchased several vineyards on the upper slopes, among them the Vigna Giovanni Antonio Orsini, bordering the Aurelian Walls. In 1580, Michel de Montaigne described the ground as "hunchbacked and hilly," but he also praised it for its "open beauty." Ludovisi combined the Orsini property with others and built a sumptuous villa, completed within Gregory's short reign, that was supplied with Felice water. A Carlo Maderno drawing of 1622 shows how, with aqueduct water, a manicured garden and casina artfully replaced the lumpy ground. The vineyard had become **Villa Ludovisi.**

Later generations added to the property, and it was, until 1886, the largest villa garden within the walls (36.25 hectares), stretching from the walls to today's Via Veneto with alleés of cypress and walls of laurel and myrtle. Henry James reports of "groves and dells and glades and glowing pastures and reedy fountains and great flowering meadows studded with enormous slanting pines." He describes Villa Borghese as less formal but more joyous; it is a place where

schoolboys play and, because of that, "the setting, the air, the chord struck, make it a hundred wonderful things." So different! The Villa Ludovisi remained private, while the Villa Borghese was already a public retreat in 1873 when James visited. There is little left of the Ludovisi garden. Developers gobbled it up in the late nineteenth century, while the villa building has been for sale since 2021. One new villa, now called Palazzo Margherita, is now the American embassy.

~⁓~

The **Palazzo del Quirinale** site differs completely from the low-elevation papal Palazzo Apostolico (Vatican Palace), where summers were hot, muggy, and ripe for malaria (fig. 12.7). So, to escape, but not too far, the Quirinal was perfect. The palace stands on the edge of its hill at the city's perimeter, above the heat and fray, with breezes from several directions. And, because of its position on the hill's slope, the retaining walls created a defensible barrier.

There was a *fontana rustica* by 1568 that must have been watered from cisterns, a local spring, or wells because aqueduct water didn't arrive here until 1587. Set inside a four-meter-high artificial hill, this was a grotto environment, with statues posed in ivy-covered niches set into the rockwork, down which water

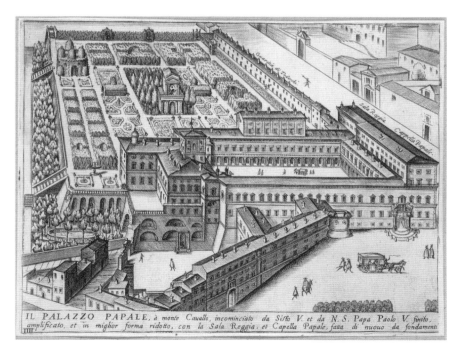

Fig. 12.7. *Papal Palace on Monte Cavallo*. Matthäus Greuter, 1623. Rijksmuseum, on loan from the Rijksackademie van Beeldende Kunsten.

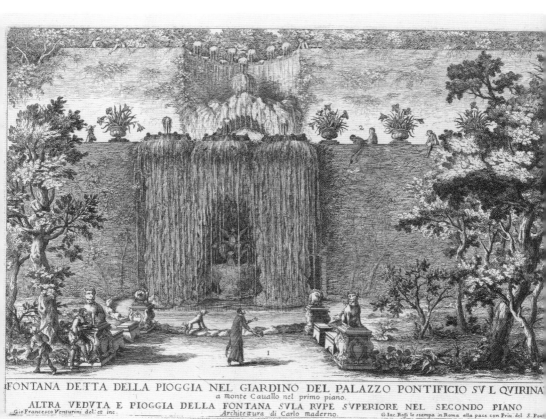

FONTANA DETTA DELLA PIOGGIA NEL GIARDINO DEL PALAZZO PONTIFICIO SVL QVIRINA
a monte Cauallo nel primo piano.
ALTRA VEDVTA E PIOGGIA DELLA FONTANA SVLA RVPE SVPERIORE NEL SECONDO PIANO
Gio Francesco Venturini del: et inc.     Architettura di Carlo maderno.     G·Iac·Rossi la stampa in Roma alla pace con Priu. del S. Pont

Fig. 12.8. *Rain Fountain in the Gardens of the Papal Palace on the Quirinale.* Giovanni Francesco Venturini, 1653–91. Rijksmuseum.

trickled into a pool. Like many cistern-fed fountains, it probably only "played" at specific times, for example, when Montaigne visited in 1580 and proclaimed it "most beautiful." Later, fountains gushed with aqueduct water, including the Fontana della Pioggia (Rain Fountain, fig. 12.8). This wasn't a gentle rain, but a drencher, cascading from two levels. There was also a peschiera surrounded by plane trees, and thousands of trees throughout. The garden's most esteemed ornament, an immense water organ, was completed in 1597. To play, water dropped about eighteen meters, forcing air into the pipes.

Since one urban villa might not be enough for a pope, Sixtus V bought it in 1587 and sent Felice water its way. You ask, "Why did Sixtus need this villa if he owned another only one kilometer away?" Although he often visited the Quirinal villa and worked prodigiously to enhance its gardens, technically he bought it for the Church, not for himself. It became a summer residence for succeeding

popes. Today, it is the official residence of the president of the Italian Republic.

Remember that rather ragged Colonna property at the top of the Quirinal in chapter 9 (see fig. 9.2)? It is nearly impossible to puzzle out its venerable ancient bones. In the twelfth century, the family hunkered down in a defensive tower they built within the ruins of the Tempio di Serapide (Temple of Serapis), itself taking advantage of the ruined Servian Walls that protected Rome in the early fourth century BC. Pope Martin V, a Colonna, built a new palace just down the slope, and his heirs built a more splendid one on Piazza dei Santi Apostoli that links to the higher-level property via bridges across Via della Pilotta.

The **Giardino Colonna** is an urban example of the countryside practice of separating formal and rustic gardens. By 1617, a wall separated a small, formal parterre from a larger park filled with trees, ancient ruins, and the former defensive tower. There was another walled formal garden at the back with an entry for guests. Henry James loved this garden, calling it "an adventure that would have reconverted me to Rome if the thing weren't already done. It's a rare old place— rising in moldy bosky terraces and mossy stairways and winding walks" from the palace to the top of the Quirinal. In the late nineteenth century, much of the back garden and most of the ruins disappeared, and the ground was lowered to meet the new Via Nazionale. Fortunately, the manicured terraces still climb the hill (fig. 12.9).

The water-stair fountain deserves attention. It begins in front of a little temple and flows down three levels to end at a wall fountain, originally fronted by flat French parterres with foliate topiary. The fountain isn't very grand—space is tight—but its designer, Alessandro Specchi, who created the flowing Ripetta staircase, took advantage of the changing topography. Unlike the shallow cascade at Villa Albani, with its topography erased and the ground leveled, this water-stair, as David Coffin points out, takes advantage "of a hill terrain to provide ample water for noisy cascades and jets," while in France, where water for gardens was often more limited, there were "quiet, wide, level lakes and canals."

**Villa Olgiati** occupied a swath of land on the Viminal Hill behind Diocletian's baths, adjacent to the ancient Castro Pretorio, barracks of the Pretorian Guards. Over the long medieval centuries, there were small farms. In 1575, the Jesuits purchased the castro as a summer residence for their novitiates at Sant'Andrea al Quirinale (who, seventy-five years later, hired Bernini to design their church). Felice water arrived before the end of the century.

The villa wasn't particularly important, but in the late nineteenth century, a major road cut through it during the reorganization of the new Roman capital. In its place, we have Piazza Indipendenza, essentially a traffic island surrounded by office buildings with some grass, trees, and a bus stop. Abandoned in the 1990s, one building later became a semilegal squat for hundreds of refugees. Many were Eritrean survivors of the 2013 Lampedusa shipwreck, where 368 persons died. On

Fig. 12.9. Water cascade, Giardino Colonna. Girolamo Rainaldi, 1599–1608. The nymphaeum is at top center. The cascade flows within the staircase.

August 17, 2017, the residents were evicted by force. About two hundred of them occupied and barricaded the ironically named piazza. Their stay was short. At six o'clock a.m. on August 24, police arrived with water cannons for a "cleaning operation." Refugees seeking sanctuary after nearly drowning at sea were power-hosed into submission as though they were garbage being washed into a gutter.

Because the Aqua Marcia and Aqua Anio Novus afforded the Esquiline enormous amounts of water, by the first century BC, it was a popular site for gardens, including one of ancient Rome's most sumptuous, the **Horti Maecenatis,** built in 36 BC over the paupers' graves outside the Servian Wall. The southeast portion of **Villa Montalto** also overlay the horti. Apparently, Maecenas had a heated swimming pool, a dining hall, and the so-called Auditorium with cascading fountains. You can visit it, although the cascade no longer functions. It was later an imperial property, and Nero purportedly fiddled here while Rome burned—if not fiddled, at least he watched from a garden tower on the hill's highest point.

Today, there is a public garden, **Piazza Vittorio Emanuele II,** where the ancient trophies of Marius stand in ruins. Opened in the 1880s, this English-style landscape was originally designed with romantic walks, lawns, palm trees,

an artificial lake with geese, and chalet-style service buildings enclosed by a high cast-iron fence. A newly built bourgeois neighborhood with arcaded façades surrounded it. The park resembled other late nineteenth-century European parks. Rome was a new capital, and its government ached to become a modern city like Paris and London; English gardens with luscious lawns, overarching trees, and tall enclosing gates, locked at night, were essential. This wasn't a Roman space—it was Northern Italian, French, or English. Romans thought it sad and suffocating. Gabriel Faure thought everything except the trophies was "entirely banal."

Continuing to fly above Rome, we pass over the **Colle Oppio (Oppian Hill)** on our way to the **Parco Archeologico.** It's possible to spend days in the park because it's public, and except for the **Thermae Caracalla (Baths of Caracalla),** which are part of the park, it's free. Originally proposed in 1870, the park was intended to encompass everything from the Sette Sale on the Oppian Hill to the Palatine, the Forum Romanum (Roman Forum), Fori Imperiali, Forum Boarium (Cattle Market), Circus Maximus, the Colosseum, and then sweeping up to the Caelian to include the Villa Mattei and Santo Stefano Rotondo, and finally to the Aurelian Walls, and also everything between the walls and Caracalla's baths. This heady dream was only partially realized.

A much-reduced park was authorized in 1909, and construction continued until 1917. Today, the park begins at the Tiber end of the Circus Maximus. It includes some of the Caelian and Palatine slopes, Caracalla's baths, and a strip of land leading to the Aurelian Walls—about a third of the original proposal. Still, a continuous green (and brown) swath gives visual connections to other parks, like Parco del Colle Oppio, and physically links to other parklike spaces, including the Palatine, which although not free, are still public.

Today, the Roseto Comunale (Municipal Rose Garden) (with about one thousand species) hugs the Aventine slope on the south side of the circus. Open from late April through June, it is both a garden and a memorial to the Jews buried here from 1645 until 1934, when Mussolini confiscated the land. In the early 1950s, Rome's city council worked with the Jewish community to create the garden. Visitors pass a plaque with the Ten Commandments at the entry and trace a menorah with each step while walking along the paths. The garden deserves, but lacks, a beautiful fountain.

Caracalla's baths are enormous. In the twelfth century, when the carcass hadn't yet been stripped of its marble ornaments and sculptures (that didn't begin until Paul III, who was voracious), it was in ruins. Yet, the *Mirabilia Urbis Romae* (Marvels of the City of Rome) pilgrim's guide called it one of the "Seven Wonders of Rome." Its location along Via Appia was strategic: this was the first monument that dusty travelers on the Via Appia saw after entering through the Aurelian Walls. The site, known as Piscina Publica (Public Pool), had until 215 BC been a

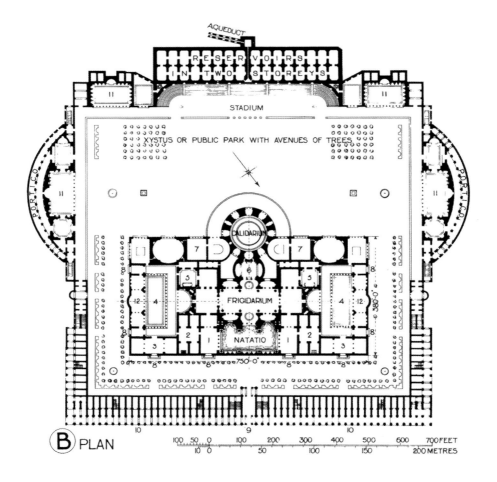

Fig. 12.10. *Baths of Caracalla*, no date. Wellcome Collection. After entering from the north (center bottom), once there were four entries along the north elevation (approximately 230 meters long). Changing rooms were to either side. Moving from south to north along the central axis, the bather went from the round caldarium to the tepidarium (a small transitional room), to the frigidarium, which led to the natatoio. The castellum stood at the far south, behind the stadium at the top of the plan.

recreational public reservoir fed by local springs. The area between the Caelian and Aventine hills carried the name long after the pool evaporated from memory, yet the site remained damp, so much so that excavations at Caracalla's baths were halted in 1869 because spring water continually invaded the site.

   Unlike Diocletian's baths, where a church and major museum are nestled into the ruins, here there are only ruins, which I think makes it seem larger. But the two baths are about the same size, and perhaps because Caracalla's were built in a wide, relatively unpopulated valley, and raised upon a podium 15.5 meters above the surrounding area, they appear more monumental. Romans really loved moving earth, and here they did so working by hand! Archaeologist Janet DeLaine

hypothesizes that four thousand men were needed to build the central block alone (fig. 12.10).

The baths are famous for their fluidity, meaning that bathers moved almost effortlessly from one state of the bathing experience to the next: from the entry sequence to the changing areas (perhaps with a massage), then to the palaestra for exercise, followed by a sauna, before heading to the *caldarium* (hot bath), after which the bather's body was scraped clean with a strigil. Then followed the tepidarium (warm bath), then the frigidarium (cold bath), followed by the *natatoio* (swimming pool)—in this case, probably open to the sky—before finally returning to the changing rooms.

As at the Thermae Traianae (Baths of Trajan), there was a huge cistern, holding approximately ten thousand cubic meters, positioned within the south precinct wall. Leonardo Lombardi and Angelo Corazza estimate that the baths used fifteen thousand cubic meters of water daily. Fresh water flowed into the cistern at about 175 liters per second, filling it to capacity during the night for the new day.

Wood was delivered, water heated, and drains cleaned in subterranean rooms. There was a mill, probably built concurrent with the baths that used the runoff water—and a Mithraeum, a later addition, tucked in there, too. A new fountain, flat as a mirror, suggests the scale of the natatoio with water jets and misters breaking the surface every thirty minutes. Very Las Vegas, but somehow perfect.

～※～

The Parco Archeologico extends to the Aurelian Walls, but once you are outside, the Parco Regionale dell'Appia Antica is less than a kilometer away. If you ignore twentieth-century development intrusions, the park is a giant swath of green reaching to Romavecchia. If you want to temporarily touch ground, you can catch the number 118 bus at Caracalla's baths or walk. The narrow and scenic Via di Porta di San Sebastiano will take you to the walls, but the street is not for the faint of heart. At the walls, it becomes Via Appia Antica. The streets divide just as you pass Caracalla's baths, where the Early Christian churches of San Sisto Vecchio to the east faces Santi Nereo e Achilleo and San Cesareo in Palatio on Via di Porta San Sebastiano. Of the three, San Cesareo is most likely to be open. Step in. The frescoes disappeared long ago, but when Cardinal Cesare Baronio restored this church in 1603, cosmatesque features were moved here from other churches undergoing rebuilding. The holy water font from the same year is intended to resemble an Early Christian example that might have stood in the church. The so-called Arco di Druso (Arch of Drusus), a fragment of the Aqua Antoniniana (a branch of the Aqua Marcia), stands at the end of the road just before **Porta San Sebastiano** and the Museo delle Mura (Museum of the Walls).

Flying above the **Via Appia Antica** to the **Parco Regionale** (perhaps along with the falcons that frequent the park), it's easy to see how it differs from

Romavecchia. It has information kiosks and maps with itineraries you can follow along well-maintained paths, and bikes you can rent. There are significant standing ruins of ancient tombs and temples, long stretches of the Via Appia Antica with ancient paving where you can walk and bike, a medieval water mill, ruins of an enormous cistern, the Vaccareccia farm (parts still functioning), and catacombs carved into pozzolana caves. If you like being in dark, dank, narrow underground spaces, that's the place for you. Otherwise, the experience is al fresco.

As you walk along Via della Caffarella beneath umbrella pines and cypresses near the Almone—another of the Marrana's names—to reach the Bosco Sacro (Sacred Grove), you'll see another spring of Egeria (see fig. 12.2). That's a problem with fame: everyone wants a piece of you. This spring has held her name since the second century AD. Here in this damp and verdant spot, there really is a numinous quality of entering an enchanted place. This is one of fifteen springs that emerge in or at the park perimeter in pozzolana caves. Most likely this nymphaeum belonged to a villa.

Nearby is a spring called L'Acqua Santa (Holy Water), where Egeria L'Acqua Santa di Roma, a slightly frizzante water, is bottled. It has long been considered therapeutic (sixteenth-century doctors agreed about its salubrity), and since every fifth person in Rome apparently suffers from gallstones (it could be the high levels of calcium in Rome's waters), Egeria seems to offer a cure. The bottling plant opened in 1895, with buses from Porta San Giovanni for day-trippers to the springs, where people filled bottles to take home. You can still visit the bottling plant. It's difficult to believe that a spring so close to the city could provide pure water, yet as recently as 2019, L'Acqua Santa won international prizes for taste and purity. One "could take the waters" at a public bath first operated by the Ospedale di San Giovanni in the nineteenth century.

Like you, I would love to spend the day here, but we must hasten to our next aqueous assignation, which is at **Villa Pamphilij** (now Doria Pamphilij), across the Tiber on the Janiculum Hill. Here, on a formerly dry, south-facing hillside with a few seasonal springs, the Pamphilij garden became one of Rome's most elegant environments filled with fountains, sculpture, spreading trees, and parterres—a beautiful milieu for princes, and, today, the Roman people. Henry James marveled at the "great groups of stone-pines, so clustered and yet so individual" within this "altogether princely disposition." In the winter, this is Rome's most inviting park because it boasts so many broad, open, sunny fields. And if you are in the mood, there is always a pickup soccer game.

Villa Pamphilij began small—about eleven hectares in 1630. By 1668, there were ninety-seven hectares with Acqua Paola water and fountains galore. David Coffin relates an unrealized proposal that included parapets built along the walks. While guests ate lunch after their morning stroll, water could be released to inundate the walks, so guests could ride around in little boats! By 1707, there was "an

Fig. 12.11. The *peschiera* at the Giardino Segreto (Secret Garden) at Villa Pamphilij.

infinity of fountains and jets." This infinity includes a 350-meter-long canal flow-ing from a spring-fed nymphaeum built into a valley with an oval lake, originally set in the hunting park. Some features exist in modified form.

Under later owners, the property grew to eight hundred hectares by 1849. In 1957, a new road, Via Olimpica, divided the grounds, with the larger portion finally becoming a public park in 1967. Like Romavecchia on a smaller scale, this is an aqueduct park. The Aqua Traiana/Acqua Paola forms the northern prop-erty wall along Via Aurelia. Here, you can draw close and look at brickwork and stonework and the restorations that have kept the aqueduct standing. An inscrip-tion praising Paul V's restoration ornaments an arch where the aqueduct crosses Via Aurelia.

Because of gently rolling ground, the aqueduct will disappear for a stretch and then reappear when the land drops away. You can stroll along one stretch

of the ruins for about eight hundred meters. What you'll see most often will be a mishmash of ancient and Renaissance construction. The most telling feature for the ancient portions will be *opus reticulatum*. Bricks (made from tuff) with square faces and pointed back surfaces jutting into a cement core have been laid in a diamond pattern. Not only is it handsome, but it is also structurally sound.

The view into the manicured Giardino Segreto (Secret Garden) closest to the main villa building is stunning. Surrounded by a high wall, the flat garden, oriented east–west, inhabits a miniscule portion of the property, but looms large in imagination and memory (fig. 12.11). The villa building is at the north edge, with a broad parterre in the French broderie style divided by gravel paths below. There is never anyone there, or so it seems, and the parterre looks a bit like a game board where tokens would twirl from one embroidered square to another. Once opened to the public, the park suffered greatly, so this portion remains closed. Statues and inscriptions disappeared to parts unknown, flower beds were trampled, fountains were defaced, and valleys became trash dumps. Happily, things have improved, and what remains is glorious.

The Acqua Paola, which will soon dip back underground, points toward the park's main entrance. Traffic-wise, this is treacherous territory outside the gate, so don't be shy about taking the longer route to avoid Via Aurelia. We're headed to the crest of the Janiculum Hill and want to arrive unscathed. So, go slowly and pay attention. You're in for a breathtaking treat. One of Rome's most spectacular views and the great "Fontanone," the mostra fountain of the Acqua Paola, are waiting down the street and around the corner at **Porta San Pancrazio.**

# Bibliography

For fountains in general, see subject bibliography (especially D'Onofrio 1986), Faure 1926, James 1995, Taine 1965, and Tchikine 2010; for Villa Madama, see Shearman 1983; for theory, see Rowland 2011 and Soderini 1904; for Villa Borghese, see Di Gaddo 1985; for Frontinus, see Herschel 1913; for Villa Giulia, see Davis 1976 and Falk 1971; for Pincian Gardens, see Lanciani 1880 and Rovere 1877; for Napoléon, see Vandiver Nicassio 2005; for Villa Ada and carbon sequestration, see Gratani et al. 2016; for military installations, see Cajano 2006; for Villa Albani, see Campitelli 1994, D'Annunzio 1925, Gasparri 2022, and Taine 1965; for horti, see Broise and Jolivet 1998, Hartswick 2004, Purcell 2007, and Serlorenzi 2021; for Egeria, see Livy 1:19; for Villa Medici, see Andres 1976, Butters 1989–91, and Lombardi 2008; for Villa Ludovisi, see Hibbard 1971 and Montaigne 1903; for the Regionary Catalogue, see Lanciani 1880; for Villa Cesi, see Bentz 2013; for Giardino Orsini, see Rinne 2014; for Palazzo del Quirinale, see Eiche 1986, Frommel 1999, Montaigne 1903, and Wasserman 1963; for Giardino Colonna, see Coffin 1979 and 1991; for refugees, see Camilli 2017; for the nineteenth- and twentieth-century parks, see Campitelli 1994 and De Vico Fallani 1992; for Villa Mattei, see MacDougall 1983; for baths, see DeLaine 1997, Lombardi and Corazza 1996, and Yegül 1992; for Parco Archeologico and Acqua Santa, see Campitelli 1994 and D'Onofrio 1986; for Villa Pamphilij, see Beneš 1989; for bricks, see Giustini 1997.

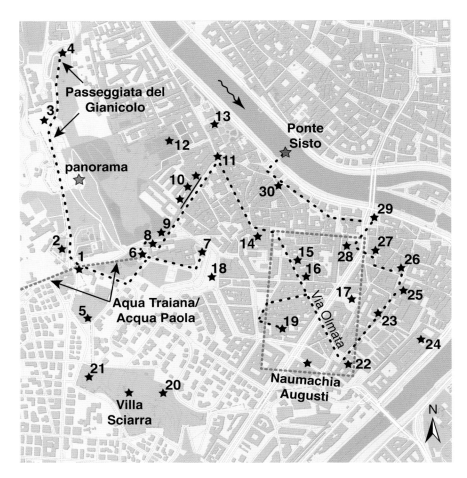

Fig. 13.1. TRASTEVERE PILGRIMAGE: 1) Porta San Pancrazio, 2) Casa di Michelangelo, 3) statue of Anita Garibaldi, 4) Fontana di Torquato Tasso, 5) Galileo's telescope, 6) Il Fontanone, 7) La Castigliana (The Castillian, or Spanish Fountain), 8) industrial district, 9) Bosco Parrasio (Parrasian Grove), 10) mills, 11) Porta Settimiana, 12) Orto Botanico (Botanical Garden), 13) Villa Farnesina, 14) Santa Maria in Trastevere, 15) Fontanella della Cisterna, 16) Fontana Secca (Dry Fountain), 17) Piazza Mastai, 18) Il Prigione (The Prisoner), 19) San Cosimato, 20) Lucus Furrinae, 21) Fontana dei Satiri (Satyr Fountain), 22) San Francesco a Ripa, 23) Santa Maria dell'Orto (St. Mary of the Vegetable Garden), 24) Ospizio Apostolico di San Michele, 25) Santa Cecilia, 26) synagogue, 27) fire brigade ruins, 28) San Crisogono, 29) Piazza Sonnino, 30) flood marker.

# 13

# The Janiculum and Trastevere

〰️ Trastevere Pilgrimage: Passeggiata del Gianicolo, ~1 kilometer; Porta San Pancrazio to Santa Maria in Trastevere, ~1.1 kilometers; Santa Maria in Trastevere to San Cosimato or San Francesco a Ripa, ~1 kilometer; San Cosimato to Villa Sciarra by bus, ~2 kilometers (round trip); San Francesco a Ripa to Ponte Sisto, ~1.5 kilometers

Paolo Sorrentino's 2013 film *La Grande Belleza* (The Great Beauty) opens like a 1960s travelogue with the camera sweeping through Rome and finally alighting on the Janiculum Hill, as bused-in tourists goggle at the dramatic view. Behind them, Il Fontanone, which means "the big fountain," drowns out traffic noise. This panorama of Rome's domes, cupolas, bell towers, walls, river, and horizon are too much for one tourist—there is too much *belleza;* he keels over, apparently having died because of beauty.

The Janiculum—not one of the original seven hills—has always been the best place to overlook Rome; its elevation is a favored artist's vantage. Piazza Garibaldi is an ideal spot to study Giuseppe Vasi's magnificent 1765 **panorama** (fig. 13.2)—to enter this reflective frame for surveying the city as your eyes sweep from St. Peter's façade to Il Fontanone (also called the Fontana dell'Acqua Paola).

St. Peter's anchors the far left, with the Tiber's swing encompassing the Prati seen behind Castel Sant'Angelo. There is a long stretch of Trastevere in the foreground, with the Regina Coeli prison where Nazis jailed one thousand Roman Jews in 1943. The Orto Botanico (Botanical Garden) and Palazzo Corsini are next. In the middle distance, the Tiber oxbow, then Piazza del Popolo behind Castel Sant'Angelo, lead to the arrow-straight Via del Corso, which heads right. The Villa Medici and the Palazzo del Quirinale hug the ridgeline. The Pantheon's pillow dome peeks out toward the center, with the Capitoline Hill to the right. Towers from the Mura Aureliane (Aurelian Walls) dot the middle horizon. In the distance, across the Roman Campagna, Monte Soratte rises, as Goethe writes, in "magnificent solitude" slightly to the north. The Alban Hills, with underground

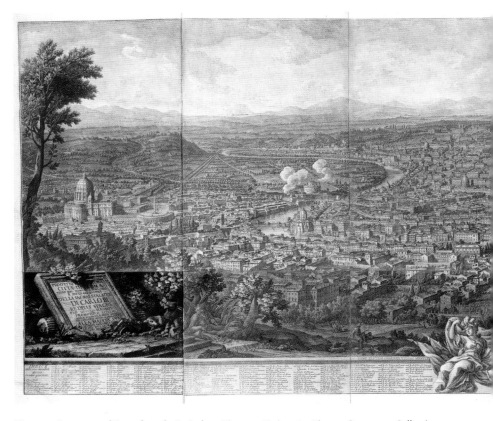

Fig. 13.2. *Panorama of Rome from the Janiculum.* Giuseppe Vasi, 1765. Vincent Buonanno Collection.

springs serving six aqueducts, are slightly to the right. Il Fontanone stands watch at the far right.

～∿～

Via Aurelia, the ancient Roman road built in 241 BC, began in the Forum Boarium, crossed the Tiber at Pons Aemilius—later known as Ponte Santa Maria—to cut across Transtiberim and up the Janiculum, continuing northeast to Pisa. Via Aurelia was the backbone of ancient Transtiberim and medieval Trastevere, along which its earliest and most important buildings clustered and most important roads connected.

Transtiberim became part of Rome when Emperor Aurelian built defensive walls beginning in AD 271 that, rising to the apex of the Janiculum, protected the Aqua Traiana where it entered the city. After that, Via Aurelia passed through Porta Aurelia, now Porta San Pancrazio. As the road heads west, the Aqua Traiana heads east, emerging about two hundred meters inside the walls, where its motive

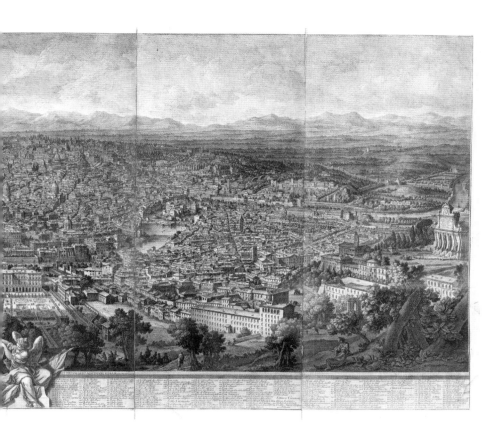

force once powered Rome's grain mills. The seventeenth-century Acqua Paola also entered Rome here and eventually powered mills along the Janiculum slope in a slightly different location.

Standing at **Porta San Pancrazio,** facing west toward Villa Pamphilij, there is a gate through the Aurelian Walls to your right leading to the Passeggiata del Gianicolo, one of Rome's public parks, dedicated in 1881. Inside the gate, a small Renaissance palazzo façade, absorbed into a twentieth-century building, is to your left. The façade is all that remains of the so-called **Casa di Michelangelo** that originally stood at the foot of the Capitoline Hill. This elegant portal leads to a huge subterranean cistern. This space isn't beautiful, but it is serene, even eerie, like entering an ice cave, only not as cold.

The Passeggiata is delightful, with plentiful plane trees providing deep, welcoming shade, one of the city's most spectacular views, some drinking fountains, a children's carousel, equestrian statues, and scores of statuary busts of *garibaldini,* the heroes of the revolutionary army of 1848 to 1849. Forced to flee during

a popular uprising in November 1848, Pius IX left Rome without a government. Revolutionaries held popular elections in his absence and declared a new Roman Republic. In exile, Pius sought aid from French troops who launched an assault on Rome in April. Giuseppe Garibaldi's revolutionary army, with hundreds of citizen-soldiers, resisted until late June 1849, when they surrendered at Porta San Pancrazio. Once the French gained entry, they returned Pius to Rome and his papal seat. The defeated heroes were finally honored after Rome became the Italian capital.

Farther north is an animated **equestrian statue** of the fierce revolutionary Anita Garibaldi on a galloping horse with a pistol in her right hand and a baby tucked under her left arm. If you follow the road to the end, you'll eventually reach St. Peter's, but before that is a drinking fountain, then a simple fountain at the church of Sant'Onofrio with a view over the city (with a bench for viewing), a curved staircase (a small amphitheater, really) built in 1619 for oratory recitals, and finally a strange drinking fountain from 1924 at an ancient tree, "Tasso's Oak." Dedicated to the sixteenth-century poet Torquato Tasso, who died in 1595 at Sant'Onofrio, it replaced an earlier grotto fountain built into the hillside with a drinking trough. The ornaments of the new **Fontana di Torquato Tasso**—a lyre framed by limp volutes resembling a pageboy hairdo, and water flowing from a sword—refer to epic poetry.

Unless you want to continue to St. Peter's, you need to head back to the Passeggiata. From Piazza Garibaldi you can follow the same road to Porta San Pancrazio or choose the road to the carousel. I suggest returning to the gate. If you stand inside the gate facing east, the road bifurcates. Head to Via Angelo Masina on the right and you'll pass the American Academy in Rome. From the street you'll see a handsome fountain, with its serene wide and shallow basin. If you are allowed to enter, you'll see a bronze and marble fountain of Heraclitus by Paul Manship in the courtyard, and perhaps be able to see remains of the Aqua Traiana channel in the basement. Passing through another gauntlet leads to the gardens, where, at its highest point, Galileo demonstrated his **telescope** for the first time to scholars in April 1611.

There is a children's park further along Via Angelo Masina to your left. If you look closely, you'll see a humpbacked wall at the property line. That is the Paola worming its way aboveground to **Il Fontanone.** At the next corner, turn left and you'll practically slam into its sidewall. But one treat at a time; another spectacular sweeping view is before you. The distant Alban Hills shimmering in the haze. Charles de Brosses thought sunset an ideal time to visit and "look down on this crowd of domes, towers, and golden cupolas, churches, palaces, verdant trees, and sparkling waters. No view in Paris equals this."

But then, turn around. Il Fontanone was the grandest and most glorious fountain in Rome (fig. 13.3), if not Europe, for 150 years, until its new crosstown rival,

the Trevi, stole that title in 1762. It incongruously crowns the hill with waterfalls and a wind-whipped lake, providing instant hydration to weary travelers; the temperature drops a few degrees as you approach. If you can't be sitting along a lakeshore or stream, you can sit here and pretend.

This is the Janiculum's most prominent feature, and like an enormous billboard, it can be seen from across the city—the intent from the beginning. Resembling a church façade and built at a triumphal scale (wider than the Arch of Costantine by several meters), Il Fontanone trumpets the Paola's arrival into Rome with five rushing cascades filling the basin lake. There is no better spot in Rome for a private conversation than sitting along the fountain rim. No one can hear you over the rumble; this is a place to share secrets.

Like countless papal building schemes, the fountain reuses spolia, in this case from the Forum Nervae (Forum of Nerva) and from Old St. Peter's, which had been razed and rebuilt. Large sculptural reliefs were simply turned around before carving the grand entablature; the angel on the left bears an egg-and-dart frieze on its back. As at the Capitoline, only grander, this mostra fountain is an elegant snub to Sixtus V's ponderous 1587 Fontana del Mosè (Moses Fountain) at the Acqua Felice terminus, facing off from the Quirinal Hill.

After a circuitous journey under hills and across valleys, the Acqua Paola ends here and begins to ramify through the city. Pause for a moment to think about where the water came from, where it will go, the beauty it will bring, and the work

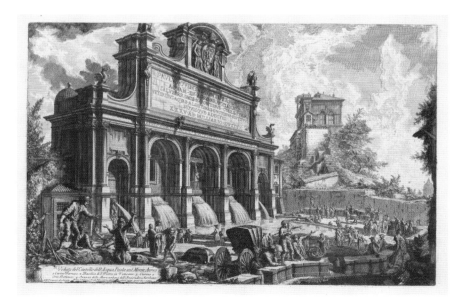

Fig. 13.3. *View of the Acqua Paola Castello on Monte Aureo.* Giovanni Battista Piranesi, 1751. Rijksmuseum.

it will do. Built between 1607 and 1612, the Paola story began in AD 109 at Lake Bracciano, about forty-three kilometers to the northwest. Emperor Trajan's engineers tapped multiple springs in the area for a new Roman aqueduct, the Aqua Traiana. He built the aqueduct, in part, to serve his new imperial bath complex on the Caelian Hill (see fig. 10.7).

With the Traiana out of commission for centuries, Paul V acquired water rights to many of the springs, in part to serve water-starved Trastevere. Private palaces and houses, villa gardens, public fountains, and mills for grinding grain and other things, including artists' colors, all benefited. Six mills, fulling facilities, an iron foundry, and a paper mill used Paola water by 1789, as did the state tobacco works in the nineteenth century.

Here's an outline of the original Paola plan (modified many times since then): there were two branch lines, one to the Vatican and Borgo that continued under the roadbed of Ponte Sant'Angelo to the Palazzo Orsini at Monte Giordano (northern Campo Marzio). The other branch, to Trastevere, flowed from Il Fontanone to fountains in Piazza San Pietro in Montorio and Piazza Santa Maria in Trastevere; north along Via della Lungara to villa gardens; south to the church of San Francesco a Ripa and the Ripa Grande; to mills along Via Garibaldi; down to Ponte Sisto, where eight smaller pipes slipped under its roadbed to Piazza Farnese, nearby left bank palaces and to the Jewish Ghetto, bringing its first dedicated water for drinking, laundry, animals, and rituals.

The Aqua Traiana was different from all but one of Rome's eleven ancient aqueducts because it arrived from the northwest. Also, here the embodied pressure in the flowing water is prodigious. The source springs, now feeding the Paola, are at much higher elevations than those of the Felice or the Vergine, and the water flows faster. Controlling the pressure at the top of the Janiculum is critical because the drop is steep. There were problems from the start because the new fountain basin couldn't withstand the constant pounding of the water. So, in the late seventeenth century, the lower basin of Il Fontanone was widened and reconfigured to keep the water from cracking it and cascading down the hill. This solved the problem. Now waves lap the shore of a miniature lake about twelve meters wide. Perhaps Nicola Salvi found inspiration here for his Trevi's lake.

Fountains were also distribution and calming centers. **La Castigliana (The Castillian, or Spanish Fountain)** stood in front of the church and convent of San Pietro in Montorio and Bramante's sublime Tempietto chapel (fig. 13.4). A castle tower, four lions spewing water, royal crests, a crown, eagles, and three fat jets shooting from the center filled the fountain's octagonal basin. These were symbols of Spanish monarchs King Ferdinand and Queen Isabella, who commissioned the Tempietto in 1500. The fountain was a distribution castello for conduits heading down the hill. Unfortunately, the 1849 bombardment destroyed it. For a while after that, the original fountain from Piazza del Popolo sauntered

FONTANA SVL MONTE GIANICOLO
auanti la Chiesa di S.Pietro Montorio Archit.°di Gio. Fontana.

G.B.Falda del·et inc.                                    G.Iac.Rossi le stampa in Roma alla pace co Priu del S.P.   13

Fig. 13.4. *Fountain on the Janiculum*. Giovanni Battista Falda, 1676. Vincent Buonanno Collection.

over after having been replaced by four lions, only to be moved to Piazza Nicosia in 1950, where it remains.

⚜

From San Pietro in Montorio, I suggest walking back up the hill. If you are tired, there is often a cab waiting alongside the fountain, but really, if you simply sit for a while with your hand dangling in the water, you'll be refreshed. Returning to the fountain is also an easier way to get down the hill by taking the steps to the far left of the overlook. Pay attention, as they aren't in very good repair.

With its embodied pressure, Paola water, like the Traiana, powered grain mills, which were built about the same time that the new basin was reconfigured. The mills stair-stepped down the hill along Via Garibaldi. There were also cisterns placed at intervals to distribute the water and decrease the pressure. The abundant high-pressure water allowed this area to become an **industrial district** by the mid-eighteenth century. Not only were there several types of mills—tobacco, paper, grain, colors—there was also a *lanificio,* for wool.

Soon there is a drinking trough to your right and, on your left, the entry to the Accademia degli Arcadi, a cultural academy founded under Queen Christina of Sweden's patronage in 1656. After 1723, the members met during the summer in this garden called the **Bosco Parrasio (Parrasian Grove)**. Members Nicola

Salvi and Antonio Canevari designed the garden in the fluid spirit of the Porto di Ripetta and Spanish Steps. The garden and stairs ripple down the slope, and near the apex of this narrow, triangular site there is a small fountain and hidden spring. From 1903 to 1906 it served as a kindergarten for poor girls.

There are several ways down the hill, all with interesting water features. But I suggest continuing to the left. The little church and monastery of the Sette Dolori (Seven Sorrows) will be at the first bend on your right. Designed by Francesco Borromini, it is now a swank hotel, but you can enter the church and the hotel courtyard with its fountain. On the left side of the street there was a distribution castello and three **mills** built in the 1680s. The mills echeloned down the hill, lowering the pressure so that the conduits wouldn't burst. There are some remains of the mills in basements, but most of the original footprint is now a Carabinieri headquarters.

~~~

Via Garibaldi leads you to **Porta Settimiana,** the **Botanical Garden,** and the **Villa Farnesina.** If you didn't visit them before (in chapter 3), this is your chance. Otherwise, you can noodle your way around the neighborhood to your right and head either toward Ponte Sisto, or better yet, toward **Santa Maria in Trastevere,** a glorious medieval church with a Renaissance fountain, restored by Bramante and later by Bernini.

Before entering Santa Maria in Trastevere, look toward the twelfth-century mosaic façade. With shining saints, it is a prelude to what is inside. The early morning sun slanting through high clerestory windows illuminates the rippled surfaces of golden mosaics (also twelfth century), behind the altar. Whether you are religious or not, the sight will calm your weary mind and body, while at your feet the swirling cosmatesque floors will set your heart aflutter with whorls within whorls. To be calmed and invigorated at the same time is something to be desired.

Your guidebooks can tell you all you want to know about the church and its sacred font of oil, but not enough about the fountain (fig. 13.5). They dwell on Bernini's 1669 restoration, but that isn't enough. Centuries of water history precede that moment. First, there were, and still are, many natural springs along the east face of the Janiculum. One of them emerged close by, the Acqua Inno-cenzia. It was "discovered" in 1682, during construction of the Janiculum mills. It must have been forgotten once the Paola began watering Trastevere, but then rediscovered nearly seventy years later during the mill construction. There has probably been a fountain in the piazza since the late eighth century, when Pope Hadrian I restored the Traiana. By the tenth century, when the Traiana failed, the Innocenzia (or whatever it was called then) probably served, via a conduit, a fountain standing before the church until the fifteenth century.

There were also sacred springs. Cicero records a group of springs, the Fontis

Fig. 13.5. Piazza
Santa Maria in
Trastevere.

Arae, along the foot of the Janiculum, consecrated with votive altars. Angelo Corazza and Leonardo Lombardi place the Innocenzia in this group. In 1430, Flavio Biondo mentions a Fontis Arae along the slope that Rodolfo Lanciani suggests might have been the Innocenzia.

Piazza Santa Maria in Trastevere held one of only three ornamental fountains in mid-fifteenth-century Rome—the Old Trevi and Fontana di Santa Caterina at St. Peter's were the other two. The earliest known representation of a fountain at Santa Maria appears in Pietro del Massaio's 1471 pictorial map of Rome. It shows what might be a hexagonal lower basin, rather than its current octagonal one, with a central pedestal featuring two superimposed chalices. The chalices suggest a central jet of water, and that in turn suggests a spring at a higher elevation than the fountain.

When Bramante restored the fountain for the 1500 Jubilee, he removed the upper chalice; perhaps the spring was weaker, and with less water there would be less pressure. Spring water may have failed completely by 1590, when a branch conduit from the Acqua Felice crossed the Tiber in the bed of Ponte Santa Maria to the fountain. When the 1598 flood destroyed the bridge, Felice water ceased flowing into Trastevere.

Everyone tinkered with this fountain. Something beautiful by Bramante— you know it must have been—was replaced or rebuilt a century later by Giro-lamo Rainaldi, by which time it became eight-sided. When Bernini restored the fountain, he added four outward-facing shells and moved it to the center of the piazza. Carlo Fontana restored the fountain in 1690 and carved new shells (as we see today) to face inward. The fountain was completely rebuilt in 1873 and again in 1930.

Paul V's master plan for the Acqua Paola included new water lines laid under the road between Santa Maria in Trastevere and San Francesco a Ripa, and rows

Fig. 13.6. Fontanella della Cisterna, Via della Cisterna. Pietro Lombardi, 1927–29.

of trees planted along the roadsides, which became known as Via Olmata (Elm Tree Street). It was Alexander VII's goal to plant fifty-five hundred trees, mostly elms, here and elsewhere around the city. As Bernini restored the fountain, Alexander planted new Olmata elms, filling in as needed. The fountain's inscription refers to both.

Walking toward San Francesco a Ripa there is the **Fontanella della Cisterna,** another rione fountain, on the Via della Cisterna corner (fig. 13.6). The barrel refers to wine, not water—as you can see by the carved carafes—and to the wine taverns that still crowd the rione. The mysterious **Fontana Secca (Dry Fountain)** was on the next corner. It was *bagnata* (wet) in 1718, when described as a distribution fountain for the neighborhood, yet the Falda map of 1676 calls it "Fontana Secca," as does a 1756 print by Giuseppe Vasi, which incongruously shows it with a huge cascade. Whatever its original name, it's no longer there.

If you've run out of watercolor paints, brushes, or paper, there is an art supply store one block away on Via delle Fratte di Trastevere. At the end of that street, across Viale Trastevere, Pius IX built a new factory and piazza for the tobacco workers, with some housing, a laundry, and a public fountain at **Piazza Mastai** in the 1860s. Once you've satisfied your hunger for watercolor supplies, return to the Fontana Secca, then head toward the Janiculum. There is a fountain at the end of the street, built into the retaining wall below San Pietro in Montorio

in 1923. Called **Il Prigione (The Prisoner),** it once stood in Sixtus V's Villa Montalto. Why this fountain, already missing its original sculptures (the Prisoner, Apollo, and Venus) was saved, when there were more beautiful ones, is a mystery. Although its architectural frame is handsome, it's often neglected and easily defaced in this position, imprisoned against the hillside.

Just above Il Prigione on the slope of Via Garibaldi was an ancient latrine, complete with lovely frescoes and lurid graffiti. It seems an odd location, unless Traiana water flushed it. What latrine facilities were available once the ancient baths closed? There were always the streets, and apparently riding across the river in a *traghetto* (ferry) provided a convenient relief opportunity, at least for men. After 1870, the new government provided public toilets and baths, including al fresco latrines; by the early 1970s, most had disappeared. Of course, these were more convenient for men. I guess women went home after doing the shopping. My husband, who seemingly knew every church in Rome, also knew the location of the remaining *vespasiani,* public urinals named for Emperor Vespasian (who built the first ones in Rome and collected a tax on the urine that was a source of ammonia): there was one outside Porta San Pancrazio and outside Porta Portese (perhaps the last to disappear).

The Naumachia Augusti stood below the hill to the southeast. Mock naval battles of enormous scale were reenacted here as public entertainment. Provided with Aqua Alsietina water, the theater, at 355 by 533 meters, purportedly could hold several ships and smaller craft. One reenactment of a battle between Athenians and Persians at Salamis featured thirty biremes and triremes, and three thousand combatants who fought to the death. As at the real battle, the Athenians (read: Augustus) won. It's difficult to imagine the carnage—perhaps fifteen hundred men dead—and the smell and filth from the river of blood before the bodies had been removed at the end of the battle.

Augustus built his naumachia in the soggy area known as the Codeta, which filled with spring water flowing down the Janiculum. But the water exited slowly in the precariously low area. Therefore it was necessary to build a viaduct over the Codeta so that Via Aurelia could connect to Pons Aemilius, and so that the constantly flowing water could move freely beneath it. Rabun Taylor suggests that the rarely used expansive basin might have been part of Augustus's flood control plan, acting as a holding tank. Once the floodwater receded, water held in the naumachia could be released into the river.

Occupying part of the naumachia territory there is the piazza, church, and former convent (now a hospital) of **San Cosimato.** The piazza is delightful. It's one of the rare places where you can do your morning shopping, sit under trees with friends, watch children play, and feel that you are in a real Roman neighborhood. There is even a new fountain—made of mosaics, of all things—in front of the church. The idea was charming: a swimmer diving into the lower basin. But

Fig. 13.7. Fontana di San Cosimato, San Cosimato. Artist and date unknown.

the mosaic grout, constantly eroded by water and attacked by mold, has deteriorated quickly.

A little further along there is a pedestrian path at the driveway gate to the hospital. Once inside, you can walk around the various cloisters. At the church entry (reached through the hospital) is a much older fountain (fig. 13.7). Interestingly, it predates the Acqua Paola (its water source is unknown), with a basin from an ancient bath. The central chalice came later and is similar to the Piazza Farnese fountains.

From here you can walk to Villa Sciarra or simply rest. If you choose the villa, you can catch a bus at the hospital or walk uphill. Its lower entry on Via Dandolo is alongside the **Lucus Furrinae,** originally a cult site and grove from the regal period (753–509 BC) at a grotto spring dedicated to a Roman water deity. In a cleft in the Janiculum there is a well (nearly eleven meters deep) with underground conduits leading to the spring with a vast grotto, described by Paul Gauckler (in a Nicholas Goodhue translation) as "hung with stalactites, a dark and secret cavern [that was] the mysterious retreat of the divinity of the place." By the first century AD, a new cult site and later Syrian deities populated the sanctuary.

The gate is usually locked, but you can follow the road up the hill to a park entry. If you admire Richard Wilbur's poetry, one of his most important poems is dedicated to a fountain at the top of the park where "Sweet water brims a cockle

Fig. 13.8. Fontana dei Satiri (Satyr Fountain), Villa Sciarra. Artist unknown, ca. 1830s.

and braids down / Past spattered mosses." Living on the Janiculum, Wilbur walked through Villa Sciarra nearly every day and fell in love with the **Fontana dei Satiri (Satyr Fountain),** with its crown and satyrs and its nymph and goose, jostling for space along the crowded wall within the scalloped basin and dripping moss (fig. 13.8). Because the moss often drips a bit too much, it's difficult to appreciate the beauty that Wilbur extolled.

<p align="center">⌇</p>

You can spend hours in the garden. A plan to restore the gardens and the tattered and often dry and broken fountains was launched in 2024. Then walk back toward San Cosimato (or you can catch a bus to take you downhill) to Viale Trastevere. From there, you can take a side trip on the number 8 tram outside the walls, or head to **San Francesco a Ripa** along Via Morosini. The southern boundary of Augustus's naumachia was nearby, and its western edge ran straight to Piazza Santa Maria in Trastevere. The ancient water theater was near the Horti Caesaris (where Julius Caesar entertained Cleopatra in 44 BC) that continued

south along the river. After his death, he left the gardens to the Roman people for recreation.

Excepting its location at the Tiber, San Francesco a Ripa offers little for the water pilgrim. It seems odd that such a spacious piazza never had an ornamental fountain (or if it did, I've found no reference)—after all, the main conduit came down Via Olmata (Via di San Francesco a Ripa). In any case there was some type of drinking fountain in 1805, and unlike the Fontana Secca down the street, this was bagnata (wet). Lacking a beautiful fountain, the lengthy commemorative inscription on the church façade lauding Paul V for the Acqua Paola and rebuilding Trastevere offers little consolation.

Heading northeast on Via Anicia you arrive at the church of **Santa Maria dell'Orto (St. Mary of the Vegetable Garden)**. Greengrocers, fruit sellers, chicken sellers, and even cobblers centered their confraternities at this church. Everything is quite modern inside, meaning eighteenth century, but the bones of the church date to the late fifteenth century. The façade, which would have been seen from the Ripa Grande before the embankment wall, is late sixteenth century. Step inside. The floor is covered with emblems of the various trades. While there isn't the same emotional impact of cosmatesque floors, the insignia of the prestigious Università dei Fruttaroli, the fruit sellers, is beautiful, with its wreath of pears and grapes and lemons surrounding a twelve-point star.

There are also five holy water fonts, among them one of Rome's few surviving Renaissance fonts; many were destroyed in the 1527 Sack. Covered with garlands decorated with leaves, flowers, and fruit (emblems of the Fruttaroli) surrounding an image of the Virgin, the marble font dates from around the year 1500.

The **Ospizio Apostolico di San Michele** is straight ahead. Stretching far to the south, it eventually housed orphans, at-risk children, invalids, and abandoned elderly in what was essentially a jail where they provided forced labor at a tapestry factory built there in the eighteenth century. There were income-producing shops on the ground floor. Once at the *ospizio,* turn left. Soon **Santa Cecilia** will be on your left. There is an atrium paradiso fronting the church, as formerly at the entries to many medieval churches. In the atrium there is a cantharus pool built in 1929. In its center is an oversize ancient two-handled drinking cup that might even have served for ablutions many centuries before.

Again, your guidebooks will ably lead you to the altar to see one of Rome's most exquisite sculptures, the marble effigy of St. Cecilia by Stefano Maderno of 1600, and to the marble *baldacchino* by Arnolfo di Cambio of 1293, and the remains of Pietro Cavallini's fresco of the Last Judgment. If you have time, visit the crypt, with its cosmatesque floors and its museum, to see where tradition places the saint's martyrdom beneath the church.

Whether or not St. Cecilia lived here in the fourth century, the archaeological exhibits hold great interest. First, there is a fourth-century bath complex with a

hypocaust heating system. Even at the modest scale of this building, the structure and sequence of rooms and many bathing experiences would have been similar to larger baths. There was also a tannery (or perhaps a dye works) at this convenient riverside location; seven brick-lined, ground-level vats still remain. The real jewel in this gloomy basement is a distinctive font. Its stem resembles a tree trunk with pruned branches. It rises from a delicately incised base circled with a lattice pattern topped by a basket-weave band, as though the tree stood in a garden. And perhaps it did reside in one of the monastery courtyards holding a birdbath, since a tree is a perfect setting for birds.

Trastevere is layered with the *pentimento* of medieval Rome. Some of Christianity's earliest footprints are here: Santa Maria in Trastevere (known first as San Callisto), San Cosimato, and Santa Cecilia were established by the fourth century in already densely populated neighborhoods near the Via Aurelia. Rome's earliest surviving **synagogue** is also here. You'll find it by keeping to the left when you leave Santa Cecilia and turning left at Via dei Genovesi, and then right on Vicolo dell'Atleta. It's there at number 14. Built upon the foundations of a Roman imperial building, it dates from the year 980; the synagogue moved in about a century later. Now a restaurant, the current owners will take you to the basement to see a Roman arch made of bipedale bricks. There's also a medieval well that tapped a spring. Yes, another well, and another spring.

Heading to San Crisogono, you might visit the nearby **ruins** of one of ancient Rome's fire brigades (*vigili*), an institution founded by Augustus with perhaps thirty-five hundred men divided among seven cohorts around Rome. Take Via della Lungarina, which becomes Via della Lungaretta. Beneath the roadbed is the ancient Via Aurelia viaduct that once crossed the low-lying Codeta (perhaps the northern boundary of Augustus's naumachia). From here, turn to Piazza del Drago, then left to Via di Monte Fiore. On the corner of Via della VII Coorte (Street of the Seventh Cohort) is the firefighter's headquarters, the Excubitorium della VII Coorte dei Vigili.

Slotted into an existing building, the guardhouse operated in the early third century AD. Like firefighters everywhere, they lived here while on duty, which, since they were slaves, was probably always. Fire was rampant, and the vigili were kept busy. Much of Rome was still built with timber, and brick and stone buildings had wooden rafters and beams. Householders were expected to keep buckets of water ready, but of course that wasn't enough. The vigili came prepared with a hand-pump siphon device that must have used nearby cisterns, fountains, or wells, with their constant water supply. This same strategy continued long into the modern era. You'll see very few fire hydrants in Rome, but there are underground taps and nasoni everywhere.

Artisans, potters, tanners, sailors, and millers filled this neighborhood. Some trades are still reflected in street names like Via dei Vascellari (Potter's Street)

and Via della Mola (Mill Street). The district remained largely working class, impoverished even, from the late antique and Early Christian periods well into the twentieth century, when multitudes of tourists began arriving in Rome in the 1960s. Now, the buildings remain, but the people—"*de Noiantri,*" literally, "we others," to differentiate themselves, the Trasteverini, from the rest of Rome—have nearly vanished from their neighborhood.

San Crisogono, the remaining fourth-century church (rebuilt in the twelfth century), lies across Viale Trastevere. Its interior was almost completely remade in the seventeenth century, so, although there are magnificent cosmatesque floors, they're now tabletop flat. There should be a beautiful fountain in the church's piazza, but I've never been able to fathom why there isn't. Why not include a fountain to the program when Cardinal Scipione Borghese (nephew of fountain-builder Paul V) restored the church in the 1620s?

Across the street, the fountain in **Piazza Sonnino** is surrounded by roses and grass. It is dedicated to a revered nineteenth-century Roman poet, Giuseppe Gioachino Belli, who wrote in the local Romanesco dialect. He gazes at a mini-statue of the Quattro Capi to his left. Father Tiber reclines beneath his feet. When the roses are blooming, it's a pleasant place to wait for the number 8 tram.

Taking Via della Lungaretta to the west leads to Santa Maria in Trastevere. Several hours will have passed since you were last here, and the scene around the fountain reflects and attracts those changes. But unless you want to retrace your steps, turn right at Piazza di Sant'Apollonia, which becomes Via del Moro, which in turn leads back to Ponte Sisto. If you don't need to hurry anywhere, this neighborhood is a fine place to wander. If you decide to follow Via del Moro, pause just before you reach Piazza Trilussa. There, near the ground on the left, is one of Trastevere's few surviving **flood markers,** this one from 1870. Two more are at Palazzo Corsini (from 1870 and 1900) and another two near the Ospizio di San Michele (from 1900 and 1937). None are distinctive. The commemorative inscriptions from 1598, 1606, 1637, and 1660, with carved epitaphs, flooded houses, waves, boats, and the "hand of God," have disappeared, existing only in drawings and notes. The most compelling, dedicated by Francesco Todino Romano in 1598, translates as, "Poor Rome, poor me who once submitted the golden scepters, and now the vile wave of the Tiber destroys me." Who was Todino Romano, and what were the golden scepters? Since he posted this inscription (and another by him from 1606) at the Dogana Vecchia, the Ripa Grande's old customs office, he might have held a prominent position there.

Back at **Ponte Sisto,** you can look down to the river and recall stories of its past lives: of floods, laundresses, stevedores, millers, the nude swimmers who favored a spot at the sandy shore just below the bridge, and lament the vanished *Triumphs and Laments* mural by William Kentridge.

Bibliography

For panoramas, see De Brosses 1897, Goethe 1970, and Maier 2016; for Porta San Pancrazio, see Richmond 1930; for Casa di Michelangelo, see Coppa et al. 1984; for the Passeggiata del Gianicolo, see De Vico Fallani 1992; for Garibaldi and revolutionary forces, see Bosworth 2011; for Torquato Tasso, see Ghisalberti, vol. 95; for Il Fontanone, see D'Onofrio 1986, Heilmann 1970, and Rinne 2010; for the Acqua Paola, see Ashby 1935 and Taylor et al. 2010; for Janiculum mills, see D'Onofrio 1986; for the Bosco Parrasio, see Dixon 2006; for Fontis Arae, see Corazza and Lombardi 1995 and D'Onofrio 1986; for Cicero and Flavio Biondo, see Lanciani 1880; for Pietro da Massaio, see Maier 2016; for mosaics, see Severino 2012; for Fontana di Santa Maria in Trastevere, see D'Onofrio 1986; for Via Olmata and tree planting, see Krautheimer 1984 and Petrucci 1995; for rioni fountains, see Matitti 1991; for the Università dei Fruttaroli, see Gigli 1987, vol. 13, pt. 4; for Piazza Mastai and the tobacco factory, see Cacchiatelli 1863 and Gigli 1987, vol. 13, pt. 4; for the Ospizio Apostolico di San Michele, see Gigli 1987, vol. 13, pt. 4; for the synagogue, see Gigli 1982, vol. 13, pt. 3; for Lucus Furrinae, see Goodhue 1975; for Villa Sciarra, see Campitelli 1994 and Wilbur 2004; for the naumachia, see Taylor 1997; for the Codeta and Via Aurelia/Via della Lungaretta, see Robbins 1994 and Taylor 1997; for Early Christian and medieval churches, see Krautheimer 2000 and Krautheimer et al. 1937–77; for the synagogue, see Gregorovius, vol. 1; for bipedales, see Blake 1947; for firefighters, see Ramieri 1990; for Todino Romano, see Di Martino et al. 2017.

14
Northern Campo Marzio

〰 Acqua Vergine Pilgrimage: Piazza di Spagna to Il Moro, ~2.6 kilometers

In 1570, **Piazza di Spagna** was an irregular patch of uneven ground with a rough path heading east up the hill. The Fontana della Barcaccia, which means "the little, or worthless, boat," wasn't completed until 1629, and the Spanish Steps not until 1725. Once you remove them from your view, there's little to see but low surrounding buildings with streets heading north and south, and Via Trinitatis heading west. That street is now called Via dei Condotti (Conduits Street, fig. 14.2).

The Acqua Vergine's first distribution line headed north to Piazza del Popolo, where a new fountain greeted thousands of thirsty pilgrims arriving through the gate during the Holy Year of 1575. But the second line went west from here into the heart of the Campo Marzio. With conduits installed and private buildings receiving water, the street's new name reflected the changes. Our goal is to follow the first conduits that headed to Piazza Navona in 1570. A few small whirlpools of aquatic interest will momentarily spin us off course along the way, but we will always return to the main channel.

I know we have only begun, but **Caffè Greco,** a legendary coffee bar, is right here. Apparently, we have Pope Clement VIII to thank for Rome's coffee bars. Sometime between 1600 and 1605, he gave his blessing to this drink from Arabia. It seems he found it to be delicious to the last drop; its popularity then spread throughout the Christian world. Some older Romans will tell you that Vergine water makes the best coffee. That may once have been true. When Caffè Greco opened in 1760, it used only Vergine water. Of course, nothing else was available. As then, it remains cold and delicious, but now it's treated, and only a handful of buildings in the Campo Marzio still receive Vergine water; most others receive water from the Pia Antica Marcia or Peschiera-Capore. Gustatory memory is powerful. Older Romans can effuse about their favorite coffee bar, often saying the Vergine water explains its superiority, even when there is now a different source.

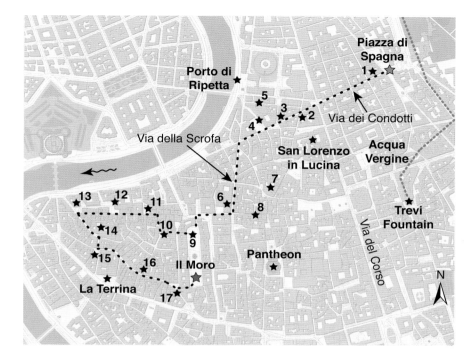

Fig. 14.1. ACQUA VERGINE PILGRIMAGE: 1) Caffè Greco, 2) Fontanella Borghese, 3) inscription, 4) Palazzo Borghese, 5) flood marker, 6) La Scrofa, 7) laundry fountain, 8) Piazza delle Coppelle, 9) Fontana del Nettuno (Neptune Fountain), 10) Piazza di Santa Maria della Pace, 11) Piazza di San Simeone, 12) drinking fountain, 13) Vada Tarenti, 14) Palazzo Orsini, 15) clock tower, 16) Via Papale (Papal Road), 17) Pasquino.

When you reach Via del Corso, scoot one block south to Piazza di San Lorenzo in Lucina, filled with expensive shops but, alas, no fountain. Still, you can linger for hours under the café umbrellas with a single espresso. Whichever bar you choose, the water will be the same. The church of San Lorenzo has been here longer than anything else. The oldest parts date to the twelfth century, but its earliest foundations are fourth century; Pope Damasus I was elected there in 366. A large fourth-century immersion baptismal font was found beneath the reconstructed twelfth-century building. Beneath it there was an ancient marble-clad basin, perhaps a courtyard fountain.

From the piazza, turn right on Via del Leoncino and there will be a barnacle fountain, the **Fontanella Borghese,** on the corner, just as there has been for at least four hundred years. Walking west, you'll see an Acqua Vergine water pressure **inscription** on your right at number 36 Via della Fontanella di Borghese. It mentions Botte di Gaetani, the local distribution point at the corner of Via del Corso (now Largo Goldoni). The inscription (although later than 1570) reminds

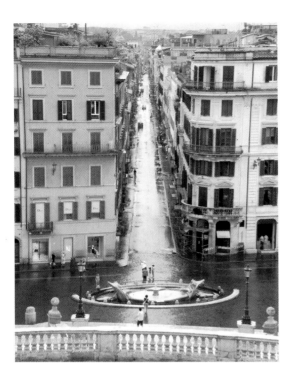

Fig. 14.2. Via dei Condotti, heading west from the Spanish Steps (with the Fontana della Barcaccia in the foreground).

the residents of this beautiful palazzo that only the ground floor received water. There was probably a pulley system in the courtyard to heave buckets upward.

Palazzo Borghese, literally dripping with fountains, is to the west. You can barely spy one of them through the front gate—in part because the guards are good at guarding, but also because the fountain basins are about a meter below grade in the back garden, where you glimpse the upper part of a wall niche and a jet of water in a central chalice bowl. There was plenty of water, yet, Howard Hibbard reports, only one of the many sculptural fountains, the central one with a statue of Venus, makes use of "water as an essential part of the *tableau vivant."* The rest are effectively sculptures, effusively carved but inflexibly constrained in architectural frames.

Around the corner to your left, facing the palace guards, is another entry to the palace with its own piazza, but where is a beautiful fountain? I don't understand this. After all, Paul V's family owned Palazzo Borghese. And Paul built fountains all over the city, so why not here? At the corner where the road becomes Via del Clementino, there are, however, two drinking troughs relegated to this corner out of sight of the palazzo.

The Borghese kept an eye on their economic interests at the Ripetta port. From the loggia and conservatory (built in the 1670s) of their palace facing the

river, they could watch boats arriving and goods being unloaded. The palace appears in the distance in Alessandro Specchi's 1704 view of Porto di Ripetta, with its fountain and swirling stairs (see fig. 3.7). The piazza has disappeared, and today the loggia and conservatory overlook the nomadic Ripetta fountain, moved to a traffic island, where it shares the space with two hydrometers that once stood at the port. They all sit higher than their original positions. Sadly, the little fountain is often dry and filled with sandwich wrappers. Two inscriptions, a **marker** for the 1805 flood (at 16.42 meters above sea level), and a hydrometer lurk around the corner on the north wall of Via dell'Arancio. Stand next to one of them for a sense of how you would have fared in that flood (fig. 14.3a–b).

Return to Piazza Borghese and cross to Via del Clementino at the southern corner. Turn right and you will reach two drinking troughs at the corner, and then turn south at Via della Scrofa—an extension of Via di Ripetta leading to San Luigi dei Francesi. If you follow the street for about 150 meters, you'll meet **La Scrofa,** which means "the sow," set into the wall at the Sant'Agostino convent (fig. 14.4). La Scrofa belonged to a menagerie of the earliest drinking fountains that included the Aquila, Bufalo, Delfino, Drago, Leone, Lupa, and Orso (eagle, water buffalo, dolphin, dragon, lion, wolf, and bear, respectively). The popes put their personal emblems everywhere. Lions proliferated on Sixtus V's fountains, eagles and dragons on those of Paul V.

Like Il Babuino, which means "the baboon," La Scrofa fell victim to street widening, this time in 1874. The sow originally guarded the water spigot (held in its mouth) and basin, now missing. In this case, the sow remains waterless in its original spot, while the basin is up the street on the corner. An inscription above La Scrofa indicates the level of Acqua Vergine pressure from its distribution castello at the Trinità dei Monti (Piazza di Spagna).

As frustrating as it is to have your view of garden fountains blocked, as at the Borghese, it is even more frustrating to try to "see" something that isn't there at all. Heading to Santa Maria in Campo Marzio provides an opportunity to visualize and think about Rome's laundry women in the sixteenth century. You get there by walking back up Via della Scrofa and turning right at the first intersection until you reach Piazza Santa Maria in Campo Marzio. You can't see much today, but you do get a peek into the cloister from the courtyard just off the street, so walk in.

The **laundry fountain** in the monastery courtyard bore an inscription set between the washbasins that summed up the idea of redemption—in this case, of former prostitutes becoming laundresses—by washing away sins through the honest labor of washing clothes. The adage read: "*Si come panni bianchi qui voi fate / Le consciencie monde aver curate*" (Since you whiten your linens here [in this monastery] / Take care that your conscience too is clean). The women, probably overworked and overscrutinized, were, nonetheless, expected to examine their

Fig. 14.3a–b. An 1805 flood marker (left) and a hydrometer (right) are about fifty meters apart on Via dell'Arancio. The flood reached 16.42 meters above sea level (masl).

Fig. 14.4. La Scrofa (original location, Via della Scrofa). Water emerged from the sow's snout. The upper inscription indicates the water's source, "Trinità dei Monti," and the pressure available at this location.

souls while working. I doubt that most of them could read; perhaps they listened to a recitation.

After you've thought about your laundry or the state of your soul, there is the little **Piazza delle Coppelle,** with its morning market. The beauty of this small market is that it offers a surviving example of Rome's microeconomics, where this type of produce market with four or five vendors could be found throughout the city in dense neighborhoods. Not many remain while minimarts proliferate. Romans still live in this quarter, but increasingly the markets serve the small restaurants in the area. Some surrounding streets are too narrow for delivery trucks, so it's easier for the market squares to act as distribution centers.

By walking two short blocks along Vicolo della Vaccarella, you'll return to Via della Scrofa. Turn left and the next intersection is Via di Sant'Agostino. Turn right, like the conduit, and pass under the arch and walk to the intersection—traffic is fierce here, so be patient—and you can enter Piazza Navona, following the conduit under the short street that enters from the north.

Piazza Navona: this is Emperor Domitian's ancient racecourse transformed into a piazza with three ornamental fountains. Fountain sculptures at the **Fontana del Nettuno (Neptune Fountain)** (to the north) and Fontana del Moro (Moor Fountain, also known as Il Moro, the Moor) (to the south) face the center, paying homage to the more famous Fontana dei Quattro Fiumi (Four Rivers Fountain). But the north and south basins arrived first, in 1575. There was a drinking and animal trough fountain where the Four Rivers Fountain now stands.

Mentally rid the north and south fountains of their sculptures and strip them down to their billowing basins, which nestle into the ground like pools. Originally, two shallow steps led toward each basin, with stanchions for filling water jars and low surrounding marble balustrades. A small, broken column fragment stood in each center, with a low water jet fanning out from the top and raining into its basin. These fountains are notable because, unlike contemporary fountains in other big cities, including Florence, Naples, and Paris, water is the focus, not sculpture; they are horizontal, not vertical. These weren't typical urban fountains. Rather, the broad pools seem to have migrated from villa gardens.

The basins became even more beautiful when Francesco Borromini proposed removing the stairs and adding the surrounding pools. As the center of the piazza shot skyward with the obelisk, the basins spread out to fill more of the piazza. When the Neptune and Moor fountains arrived, the basins began to resemble Renaissance fountains in other Italian cities that overflowed with sculptures. The Neptune, octopus, and nymphs in the north basin arrived in 1878 (fig. 14.5). The Moor waded into the southern fountain with a reluctant dolphin and a conch shell in 1653. More about him later.

The Neptune, the Moor, and the Four River gods help transform this vast public space into three great "rooms," with two smaller rooms between. Small

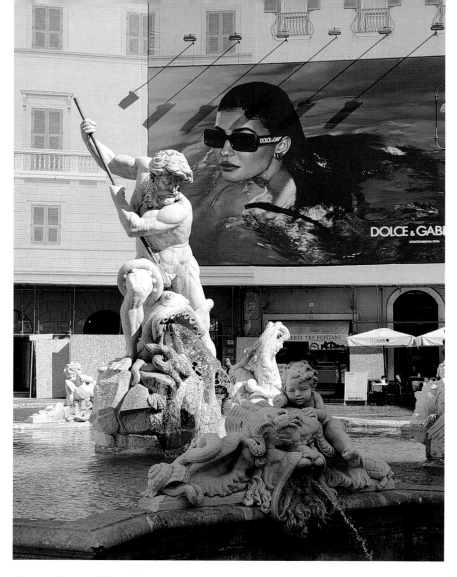

Fig. 14.5. Fontana del Nettuno (Neptune Fountain) (detail), Piazza Navona. Antonio della Bitta and Gregorio Zappalà, 1878.

children, their parents, and grandparents spend sunny mornings in the bright northern room. Teenagers—especially those locked into passionate embraces—hang out in the shady southern room around the Moor. The Four Rivers room is for tourists with sketch artists and "artists" of paint-by-the-numbers "original" paintings at its northern edge; musicians and magicians populate its southern edge, and chess players occupy the perimeter benches. Everyone has made it their home, and this is a good place to pause if you're feeling weary.

Our goal is Il Moro at the south end of Piazza Navona, but the route is circuitous. Leave the piazza and head west on Via dei Lorenesi opposite the Neptune Fountain. Cross Via di Santa Maria di Anima to Vicolo della Pace, then slip into the alley to your left, and suddenly you have washed ashore in **Piazza di Santa Maria della Pace,** an alfresco theater, with you on the stage and in the audience. Architect Pietro da Cortona created the piazza when he restored its church between 1656 and 1667 for Alexander VII. Before that, the old water-carriers church, Sant'Andrea "de Acquaricariis," stood here. In the late twelfth century, the water carriers lived and worked nearby at Vicolo degli Acquaroli. That street led to Porto degli Acquaroli at the Tiber, an area reserved for them to collect water.

What's going on here? Standing on axis as you face the church, you see an unusual semicircular porch jutting into the tight piazza. Here, you can appreciate the symmetry of the space created by carving away from existing buildings to create new theatrical wings to either side. We'll meet another example of carved symmetry a little later. Meanwhile, it's worth visiting the church, and as you enter, notice the flood markers on the doorjamb: 1530 to the left and 1598 to the right. Each has a little finger pointing to the flood lines, and again, your body registers the tragedies.

A museum is to the left of the church façade. You can freely enter the former monastery to visit the cloister, designed by Bramante (1501–4). Sadly, no fountain bubbles here, but the symmetrical perfection (like San Pietro in Montorio) engenders calm and reflection. Leaving the cloister, the divining rod that is your own attuned body pulls you to the right at Arco della Pace to Via dei Coronari (Street of the Rosary Makers). This straight street, one of the few to survive into the Renaissance, is the ancient Via Recta, the "Straight Street" that led to early Tiber River ferry crossings and later to bridges. But first there is **Piazza di San Simeone,** where another peripatetic fountain resides, after bopping around from its original home in Piazza Montanara. It's heartening to see another wandering fountain that found a home rather than disappear completely. This Giacomo della Porta fountain is small and somewhat plain, in large part because the Roman Council, not the pope, paid for it. When Mussolini's Via del Mare slashed through its neighborhood at the foot of the Capitoline in 1932, he moved the fountain to Giardino degli Aranci, which means "garden of the oranges," on the Aventine. In 1973, it came here.

One of Rome's sweetest and oldest surviving **drinking fountains** was for animals. It's down the street in Piazza San Salvatore in Lauro. Just past the church façade, there is a ground-level niche with a badly bruised lion crouching in a grotto. The inscription refers to "the dragon who rules the world," that is, to Gregory XIII, whose crest includes a dragon. This menagerie fountain originally stood south of Ponte Sant'Angelo, but like La Scrofa, it impeded traffic's flow.

Fig. 14.6. *Fountain in the Court-yard of the Palace of the Duke of Bracciano*. Giovanni Battista Falda, 1675. Vincent Buonanno Collection. The bears no longer exist.

FONTANA NEL CORTILE DEL PALAZZO DEL SIG. DVCA DI BRACCIANO.
à Monte Giordano, nel Rione di Ponte. Architet.º di Antonio Casoni.

Step into the adjoining fifteenth-century cloister, where a Renaissance wellhead (set on a modern base) centers the space. Beyond is a cortile with a seventeenth-century fountain. Monasteries and palaces, especially in the congested Campo Marzio, required protected open space. There were paved courtyards—two or more, if possible—one that served as a workspace and was perhaps large enough for carriages to enter and turn, and another with a wellhead above a cistern. Although the San Salvatore in Lauro wellhead is now only decorative, it once kept the monastery hydrated, and the fountain we see today was only made possible after Vergine water arrived.

Returning to Via dei Coronari, turn west to Via di Panico and the vanished area of the Tarentum, once located near the Tiber somewhere between Pons Neronianus and Pons Aelius, both built later. In fact, everything was later, including the Via Recta. The soupy soil at the Tarentum flooded often. Still, it was sacred. Agrippa's eripus, the long channel flowing from his Stagnum, made a sharp turn to the north, most likely to avoid this sanctified precinct with a subterranean altar. Of course, nothing remains. Turning north on Via di Panico, you'll be at Ponte Sant'Angelo, and near the spot where ruins of the eripus were discovered at the river's edge. The **Vada Tarenti**—an ancient river ford near the spot where Pons Neronianus spanned the Tiber—was to the west.

The original home of the crouching lion fountain (now at San Salvatore in Lauro) was on Via di Panico, conveniently located near the bridge. It migrated when the car park replaced it. If you turn left, you'll soon reach **Palazzo Orsini** on your left. I've discovered that if you walk in as if you own the place (and especially if you look like an architecture student or professor), no one will bother you in the courtyard. Once inside, you can marvel at this crazy Acqua Paola fountain with bears (an Orsini family emblem—"*orso*" means bear) designed by Felice Antonio Casone in 1616 (fig. 14.6). Giovanni Baglione, a contemporary

biographer, called it a "very bizarre fountain, excellently made from a book of whimsical designs of his [Casone's] own making." That sounds like a backhanded compliment to me, when, at the time, an artist's *ingegno* (ingenuity), not whimsy, was most prized. Unfortunately, the bears have wandered off.

This fountain is also interesting for political reasons. We've met the Orsini before: at Castel Sant'Angelo across the river, which they commandeered in the thirteenth century as their fortress. They grew wealthier every minute. The various branches of the family owned three palaces in Rome and large properties in the Campagna, and around Lake Bracciano, where the Paola springs are located. As part of the agreement with Paul V, who bought water rights from the Orsini in 1607, the conduit that headed to the Vatican and the Borgo would cross the Tiber on Ponte Sant'Angelo bearing a "gift" of water for Palazzo Orsini.

Via degli Orsini at the palazzo gate leads to Piazza dell'Orologio and a **clock tower** designed by Borromini with sublime convex and concave curves. It stands at the corner of the former monastery of the Filippini, followers of St. Filippo Neri, that today houses the Archivio Capitolino. Via dei Filippini, the straight street to the left, leads to Piazza della Chiesa Nuova and a fountain known as La Terrina, which means "the tureen" (fig. 14.7). This is another of Rome's wandering watering holes. La Terrina's first assignment—without its lid—provided the fruit and vegetable sellers in Campo dei Fiori with Vergine water. It was meant to be a workhorse, not simply to ornament the Campo, which it left in 1889 to make way for the statue of Giordano Bruno. After three decades in storage, La Terrina arrived here in 1924 in this relatively mundane piazza that was created when Corso Vittorio Emanuele II sliced through a venerable medieval and Renaissance neighborhood in the 1880s.

Giacomo della Porta completed the fountain in 1594. Four small bronze dolphins, originally intended for the Mattei fountain, spewed water into the basin.

(The Mattei got turtles instead.) A travertine cover replaced the dolphins in 1622 and protected the water from trash and debris. Most people look at La Terrina, then (if they even notice it) walk away. But observe its graceful curves and how the fountain is recessed into the ground, like the low-pressure Barcaccia and Piazza Colonna fountains. Like many of Rome's fountains, it is battered and bruised (you can see it has been broken and repaired many times), but the five-petal rosettes (another Orsini symbol) still spout water from basin lobes that clearly represent breasts. Although they are not meant to, I've seen people cooling their bare feet in the pool on hot days.

Return to Piazza dell'Orologio, then turn right to follow Via del Governo Vecchio to Piazza di Pasquino. The street retraces a portion of a papal processional route formerly called **Via Papale (Papal Road)** for this reason (fig. 14.8). The procession originated at St. Peter's. Once across Ponte Sant'Angelo, the entourage turned left at Via dei Banchi Nuovi, which becomes Via del Governo Vecchio at Piazza dell'Orologio. Each newly elected pope followed a ceremonial route, first called a *processo* (procession) and eventually a *possesso* (possession), from St. Peter's, with stops along the way, to San Giovanni in Laterano—where he was crowned and formally took possession of San Giovanni, the bishop's church. Hundreds of men rode horseback, and clutches of cardinals marched between

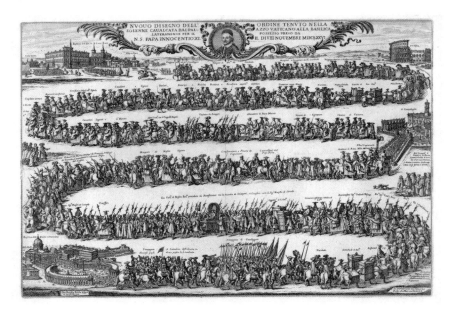

Fig. 14.8. *Procession of Pope Innocent XI near San Giovanni in Laterano.* Giovanni Battista Falda, 1676. Rijksmuseum. The pope and his entourage leave St. Peter's (lower left) and arrive at San Giovanni in Laterano (upper left).

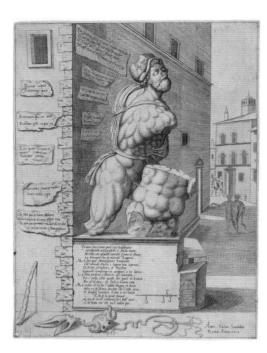

Fig. 14.9. "Statue of Pasquin in the House of Cardinal Ursino." Published in Nicolas Beatrizet, *Speculum Romanae Magnificentiae* (1550). Metropolitan Museum of Art.

decorated buildings and flying banners along the way. Their immediate objective, like ours: Palazzo Orsini.

Although the street still conveys medieval and Renaissance gravitas, today window-shoppers carry on its processional tradition. When the street isn't crowded, say between two o'clock and eight o'clock a.m., it's pleasant to saunter along, but otherwise—and especially at night—it is jam-packed, and it's wise to simply follow the slipstream and let it pull you through the ambient crowds to the end of the street. We are heading toward that lump of stone on the corner of Palazzo Orsini (fig. 14.9). Yes, another Orsini palace; this one is now the Museo di Roma, the museum of the city. That lump is **Pasquino,** perhaps the most famous piece of street sculpture in Rome. Since 1501, he has been the rascal who spared no one; saints and sinners were all fair game for his barbed pasquinades. Il Babuino, Marforio, and Madama Lucrezia were his collaborators. Two other statues are sometimes included in the dialogues: Abate Luigi, whose headless statue stands outside Sant'Andrea della Valle, and Il Facchino, a small drinking fountain near the Corso.

Pasquino is quieter now. A twenty-four-hour minicam focuses on his twisted torso. But his head still tilts toward Piazza Navona, leading you to the fountain at its south end. In 1653, Gian Lorenzo Bernini added the central sculpture that to me resembles a swarthy buccaneer more than the sea god he is meant to represent

Fig. 14.10. Fontana del Moro (Moor Fountain) (detail), Piazza Navona. Upper basin, Giacomo della Porta; lower basin, Francesco Borromini; Il Moro (The Moor), Gian Lorenzo Bernini.

(fig. 14.10). Either way, he is called **Il Moro,** and he really sets the fountain in action. He perches improbably and precariously on a giant conch shell while he attempts to wrestle a wriggling dolphin into submission. In comparison, Bernini's Fontana del Tritone (Triton Fountain) in Piazza Barberini, with a similar muscular sea god, dolphins, and a giant shell, is almost languid.

As Sergio Bosticco explains, the south end is where the big players lived and prayed, including one of the Orsini clans. It was also the busiest part of the piazza and closest to their palace. Il Moro arrived two years after the Fontana dei Quattro Fiumi. He turns his head upward for inspiration or encouragement, toward the dove perched on top of the obelisk—the dove, a reference to Pope Innocent X (r. 1644–55), its sponsor—and to the Holy Ghost. No help will arrive from that quarter, since the dove will forever focus its attention on the façade of Sant'Agnese.

Before you leave the piazza, turn toward the corner building, number 7 Piazza Navona, where there is another flood marker about two meters above the pavement, this one from 1870. There is nothing distinctive about it—there is another from the same flood on the opposite side of the piazza. But I like knowing it's here, and I am reminded that the piazza was once intentionally filled to become a shallow lake—probably less than a meter deep—on some summer nights (see fig. 16.7).

It's probably time to take a break, rest your weary feet, and gird your touristic loins for the next walk: it's a long one. You can begin by returning to La Terrina.

Bibliography

For Acqua Vergine distribution and fountains in general, see Rinne 2010; for Caffè Greco, see Standage 2005; for San Lorenzo in Lucina, see Brandt 2012; for Palazzo Borghese, see Hibbard 1958; for Porto di Ripetta, see Marder 1991; for flood markers, see Di Martino et al. 2017; for La Scrofa and menagerie fountains, see D'Onofrio 1986; for laundries, see Rinne 2021; for Piazza Navona and its fountains, see Bosticco 1970, D'Onofrio 1986, Martinelli and D'Onofrio 1968, and Rinne 2010; for Piazza Santa Maria della Pace, see Krautheimer 1982; for water-carriers, see Sanfilippo 2001 and Rinne 2021; for Vada Tarenti, see Gilman Romano; for Palazzo Orsini, see Ajello Mahler 2012 and Triff 2013; for the Orsini fountain and Giovanni Baglione, see D'Onofrio 1986; for La Terrina, see Rinne 2010; for the Via Papale, see Cafà 2010 and Ceen 1977 and 2022; for Pasquino, see Dennis 2005.

15

La Terrina to Piazza Sant'Ignazio

❧ Campo Marzio Pilgrimage: La Terrina to Piazza Sant'Ignazio,
~3.7 kilometers

Despite horrendous traffic on Corso Vittorio Emanuele II, sitting at the fountain known as **La Terrina,** which means "the tureen," in Piazza della Chiesa Nuova can be restful. With its enormous shady tree, benches, a bus stop, a baroque church façade, and of course water, this a good place to launch yourself backward three thousand years into the Campo Marzio's sodden history while walking about three kilometers.

Cross the road and slip down Via dei Cartari (Paper Makers' Street) to arrive at a five-corner intersection. Before this forlorn piazza existed, this was a tight little area that marked the edge of ancient Rome's sacred, legal, and military boundary—the *pomerium.* The earliest pomerium encompassed only the Palatine. It was a narrow strip of land surrounded by a low earth wall created when a plow furrowed a course around the sacred space. Rome, the city, lay inside, while everything else lay outside. As Rome expanded, so too did its sacred threshold, marked by boundary cippi rather than a ditch. Sulla expanded the pomerium, as did Caesar and Augustus; yet they excluded the Campus Martius, even as the Quirinal, Esquiline, Caelian, and Aventine hills were encompassed.

An inscription immediately to your left as you enter the piazza records that "upon the enlargement of the territory of the Roman people," Emperor Claudius "increased and delimited the pomerium." It has no date, but Tacitus gives AD 49. Claudius extended the pomerium in the north, east, and south either slightly beyond or within where the Mura Aureliane (Aurelian Walls) were later built.

"Why did the pomerium stop here?" Low-scale buildings with some funerary monuments and small temples lined a street that ran from the Teatro di Marcello

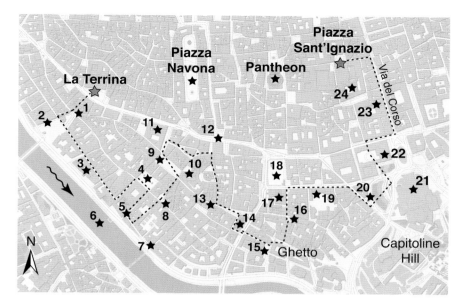

Fig. 15.1. CAMPO MARZIO PILGRIMAGE: 1) *pomerium,* 2) Chiavica di Santa Lucia, 3) Via Giulia, 4) Piazza Farnese, 5) Il Mascherone, 6) "Ponte fra le Epoche," 7) Ponte Sisto fountain, 8) Piazza Capo di Ferro/Palazzo Spada, 9) Campo dei Fiori, 10) Teatro di Pompeo, 11) Palazzo Cancelleria/San Lorenzo in Damaso, 12) Sant'Andrea della Valle, 13) Via dei Giubbonari, 14) Piazza Benedetto Cairoli, 15) Piazza delle Cinque Scole, 16) Palazzo Mattei, 17) Fonte dell'Olmo (Elm Tree Spring), 18) Largo Argentina/*curtes,* 19) Crypta Balbi, 20) Piazza d'Aracoeli, 21) Monumento Nazionale a Vittorio Emanuele II, 22) San Marco/Palazzo Venezia, 23) Santa Maria in Via Lata, 24) Collegio Romano.

to Pons Neronianus. The answer lies, most probably, with topographic changes and the Petronia Amnis stream that acted as a boundary between west and east. Even as new drains created solid ground to the east, the diminished Palus Caprae continued its course to the Tiber in what came to be called the **Chiavica di Santa Lucia.** Meanwhile, the western Campus Martius was still a boggy mess reserved for military training. All military activity, including carrying weapons, was forbidden inside the pomerium.

We want to head southeast, staying inside the sacred boundary. The street doesn't matter—they are all steeped in history, although today they are essentially shopping streets. The Renaissance **Via Giulia** at the far west end of the piazza gives a straight shot. It's the most elegant of the three, with palace courtyards, some with fountains that you can glimpse from the street. Via di Monserrato is an easy slipstream that follows a medieval path. Via del Pellegrino (Pilgrims' Street) follows another medieval processional route across Rome used by the newly crowned pope as he returned to St. Peter's from San Giovanni in Laterano.

Fig. 15.2. "Piazza Farnese fountain." Girolamo Rainaldi, 1627–29. Published in Giulio Magni, *Il barocco a Roma nell'architettura e nelle scultura decorativa* (1911–13), 3:24.

This medieval street and Via del Governo Vecchio were among the most direct, although by no means straight, crosstown roads until Corso Vittorio Emanuele II was built in the late nineteenth century. Whichever path you choose, history and complexity are deep. You can use the small cross streets to shuttle back and forth to weave a circuitous route.

Piazza Farnese, with its crisp rectangular space (it reflects the proportions of the palace façade), is our goal. In antiquity, the Aqua Marcia probably flowed to this area. When the Paola crossed Ponte Sisto, it claimed a wide strip of the left bank from Ponte Umberto that included this piazza, another nearby Orsini palace at Campo dei Fiori, and the Jewish Ghetto. Today, the Pia Antica Marcia and the Peschiera-Capore serve it, with Paola water in the ornamental fountains.

Cardinal Odoardo Farnese chose to use part of his share of Paola water for the two fountains in front of his palazzo, both crowned with a fleur-de-lis, a Farnese symbol (fig. 15.2). They tell another story of fountain wanderlust, moving around the city searching for a permanent home. Girolamo Rainaldi designed the central chalices and fluted basins, but the huge tubs were vagabonds from the Thermae Caracalla (Baths of Caracalla). In 1466, Paul II moved them to Palazzo Venezia. Then, in the 1540s, one tub arrived at the center of Piazza Farnese, where

bullfights were staged. The other arrived in 1580 with the fervent hope of Acqua Vergine water; but with very little pressure, the water only reached the palace's ground floor and basement.

Fountain water arrived with the Paola in 1626. At that time, Rainaldi's fountains were the absolute last word of water design, a sophisticated mélange of ancient and new with water jets rising several meters into the air, unlike today's meager burble. But by 1629, fountain design changed radically when Bernini unveiled his sinking boat fountain, the Barcaccia, across town (see fig. 1.6). Even so, this remained a festive piazza, with celebrations happening like clockwork. The annual Festa della Chinea (Festival of the Ambling Nag) occurred on June 28, when the viceroy of Naples paid homage to the pope. A horse guided along the processional route to St. Peter's Basilica was allowed to walk around inside the church until the pope blessed it. In the mid-eighteenth century, a procession from St. Peter's led to Piazza Farnese, the seat of French power in Rome since the sixteenth century. Transforming the piazza into a stage set could take two months (fig. 15.3). There were fantastic ephemeral decorations here and elsewhere in the city. While Rainaldi's fountains gushed water, two large temporary fountains dispensed wine to the public during the evening: one with white wine, the other with red. A temporary drinking fountain dedicated to Bacchus stood in the piazza.

Fig. 15.3. *The Temples of Apollo and Diana Built for the First Day of the Fireworks at SS. Peter and Paul.* Paolo Posi, 1763. Cooper Hewitt, Smithsonian Design Museum. Palazzo Farnese is at the rear.

Fig. 15.4. Il Mascherone, Via Giulia. Girolamo Rainaldi, 1624–26.

As John Moore describes it, providing wine and drinking water was a complicated process that involved more than just temporary plumbing. In the case of the water fountain, temporary modifications were made to Rainaldi's fountains. Ditches were dug in the piazza to install new drains and conduits, and so the Acqua Paola water supply was turned off. The supply originated at the summit of the Janiculum, which meant that everyone between the hill and the piazza who received water from the same distribution conduit would be inconvenienced during construction. The water was shut off again when the temporary fountains were dismantled and when the permanent fountains were reconstituted.

Drifting toward Via Giulia on Via del Mascherone, you'll see a wonderful and quite outrageous fountain straight ahead. **Il Mascherone,** which means "the big mask," was originally a trough for Farnese horses stabled next door (fig. 15.4). These big faces, sometimes with blubbering lips like this one, are common. The Bocca della Verità, whose lips do not blubber, comes to mind, but there were others, including those in the Villa Borghese, at Palazzo Mattei, and the Forum Romanum (Roman Forum). The backside of this fountain originally held another horse trough. A private ferry crossed from the palace to the Villa Farnesina on the opposite bank. Michelangelo made an unrealized proposal for a Tiber bridge to link the two properties. In 2021, French artist Olivier Grossetête created **"Ponte fra le Epoche,"** a cardboard replica tethered to balloons that floated above the river for five days to celebrate Bastille Day.

Fig. 15.5. *Ponte Sisto Fountain in Rome*. Giovanni Battista Falda, 1653–91. Rijksmuseum. This was the main water distribution center for the Acqua Paola in the southern Campo Marzio.

As you turn to face the southeast end of the street, try to image the **Ponte Sisto fountain** in its original location, where it terminated the view until it was dismantled in the late nineteenth century to build the embankment, and then reinstalled across the Tiber (fig. 15.5). That fountain, with its crashing cascade, drinking spouts, and animal trough, was the main left bank distribution point to Via Giulia and east to the Jewish Ghetto. A stoplight that offers its own kind of pulses and flows now marks the site.

Another counterclockwise whirlpool leads into **Piazza Capo di Ferro** with its strange fountain, a reconstruction of the vanished original by Francesco Borromini (fig. 15.6). A painted niche behind the basin represents architectural rustication. A replica of the original female herm—a type of square pillar topped with a human head—was added in 1998. Water, intended to spurt from the herm's breasts, now only flows from a lion's head. It is an unusual urban fountain, since herms usually stood in garden settings.

The fountain played important scenographic and symbolic roles for **Palazzo Spada.** It is on axis with the main entry of the palace. Herms were boundary markers, somewhat like the cippi that marked the edges of the pomerium or the Tiber banks. The Spada family controlled the piazza as a *"piazza privata,"* included as part of their palace, which effectively took it out of the public domain.

Fig. 15.6. Fountain in Piazza Capo di Ferro. Francesco Borromini, 1632.

You can pay to visit the museum upstairs, but when it's open, anyone can walk around the central palace courtyard—filled with sculptures of Roman emperors. To do so is a treat because this is another chance to appreciate Borromini's genius. Stand in the courtyard's center (facing the entry), then turn to your right. Here is Borromini's famous sleight-of-hand colonnade with a forced perspective that expands the palace footprint. You think you're looking down a long wing of the palace into a small sculpture garden, but really, it is more of a wide hallway—only eight meters long, rather than the thirty-six meters it appears to be. The next garden, to the right, originally expanded the palace toward the river. Turning back to face the entry, Borromini's fountain—also on axis to the entry—you'll see that the palace visually claims the *piazza privata.*

Via dei Balestrari, off Piazza della Quercia, where an ancient oak tree stood until 2019, leads to **Campo dei Fiori.** In 1450, one branch of the Orsini family inserted themselves into a portion of the **Teatro di Pompeo,** with its temple of Venus Victrix at the top; parts of the building had been continuously occupied since antiquity. The theater (now with a movie theater) was a tantalizing defensible edifice. The entire neighborhood had been busy and occupied through much of the medieval period with small churches, a public bath, industries like lime burning, and residences, some of them fortified, and small gardens.

An open-air market with nasoni separates the theater from an ornamental fountain at the opposite end of the *campo* that replaced the original Terrina.

Because the original fountain used low-pressure Vergine water, it sank into an excavated and paved area that was "about the height of a man." A parapet surrounded it. People stepped down into the paved area to fill buckets and jugs. Displaced in 1889 for Giordano Bruno's statue, a new fountain (in the flower zone, where it keeps bouquets fresh) replicates the original basin, but without its lid. Because the new fountain receives Paola water, there is enough pressure to raise it on a pedestal. There is little to draw Romans to the campo, which is now almost entirely conquered by tourists. Nonetheless, it is picturesque and lively, if unconscionably overpriced. Looking at the fountain is free.

Where the Campo dei Fiori throbs with life, Piazza della Cancelleria is sedate—and its palazzo, extending the full length of the piazza, is one of Rome's most cerebral palaces. Fabulously expensive, this was Rome's first Renaissance palace "*da zero*," built from the ground up. It took forever: from 1489 to 1513. Like Rome's other palaces at that time, it relied on Tiber water, well water, or perhaps, in this case, water from the eripus of the Thermae Agrippae (Baths of Agrippa), which recent excavations confirm still flows under the **Palazzo Cancelleria.**

A five-petal rose ornaments the small drinking fountain off to the right in Vicolo dei Bovari. Here, the rose refers not to the Orsini, but Cardinal Raffaele Riario, who built the Cancelleria. The five-petal rose is everywhere inside the building, where you are usually free to walk around the courtyard. Its spare beauty and proportions make this one of the most restful places in Rome. Off to the far right is an entrance into San Lorenzo in Damaso, formerly an independent building that the palace absorbed during construction. The only bits of water infrastructure you'll see are the courtyard cistern drain and a defunct well in a smaller courtyard in the far-right corner. Fervently hoping to return and reclaim their treasure, Romans hid their money and valuables in private wells and drains like these during invasions. Sometimes the owners never returned, as after the 1527 Sack, or were tortured by the invaders. Pietro Narducci, who oversaw building new sewers and drains in the 1870s and 1880s, reports that jewel thieves did this as well. Valuables might remain hidden for centuries or wash into the Tiber during a flood.

San Lorenzo in Damaso is worth a visit if only to luxuriate in solitude for a few minutes. A mithraeum on this site may have continued in use until Pope Damasus I founded the church. He endowed San Lorenzo with income from a bath that he either built or that already stood next to it. Ruins of both, and the eripus, were discovered under the current church and the Cancelleria. The church, which stood along what became a major east–west street, remained important throughout the medieval period as the neighborhoods around it changed drastically. Not far away there was a presumed temple to nymphs. By the sixth century AD, hovels occupied its crumbling colonnade.

Water was also part of the allure, including a public well owned by the church. It would have been especially useful when Virgo water no longer reached here,

Fig. 15.7. Holy water font, Sant'Andrea della Valle. Artist and date unknown.

perhaps around the year 1000. A new pulley mechanism was mounted at the old church in the late fifteenth century. Once Vergine water arrived, the well probably became redundant.

Head to Corso Vittorio Emanuele II and turn right toward Piazza del Paradiso. **Sant'Andrea della Valle** is nearby. Opera lovers will recognize the church from Act I of Giacomo Puccini's opera *Tosca* where an escaped political prisoner hides. Opposite the main doors and across the busy street is a modest fountain, overlooked by many due to the traffic. In its former life in Piazza Scossacavalli in the Borgo, acrobatic water jets leapt from the basin into the antique chalice bowl. Now there is only a burble, but a welcome one nonetheless. Once inside, you might wonder about the holy water fonts (fig. 15.7). Their beauty overwhelms— you can see whorls and eddies flowing across and up the stems as though carrying water to the honey-gold marble basins.

~❧~

The next current in Rome's water history begins in **Piazza Benedetto Cairoli.** To get there from Sant'Andrea, turn into Via dei Chiavari and the Largo del Pallaro, then left on **Via dei Giubbonari.** Piazza Benedetto Cairoli, to the left, is a convenient place to return to Piazza delle Cinque Scole, if you like. Cross Via Arenula at the southeastern corner of the piazza, near the fountain, and enter Via di Santa Maria de' Calderari. An inscription for the 1598 flood is halfway along the street on your left, at number 27. The street level has risen since then; still, standing next to the marker today, you gain a visceral sense of how difficult it would have been to keep your head above water.

Piazza delle Cinque Scole is straight ahead. Depending where you stand in the piazza, you are either inside or outside the ghetto or hovering above the wall that once imprisoned it. If you are inside, you might be standing near the travertine fountain (no longer extant) that Antonio Nibby described in 1838 as placed against a wall, with a large water jet in the center. More water fell from the mouths of two laterally placed stone dragons. An *abbeveratoio* for drinking and a *lavatoio* for washing stood on either side of the central fountain. Each basin, shaped like a shell and decorated with a "Jewish candelabra" (presumably a menorah), had a small water jet. Paul V—the dragons refer to him—sponsored the fountain in 1614.

Heading up Via Paganica leads to **Largo Argentina.** This ordinary Roman street brims with water history. First, a spring called Fonte di Calcarara (Limestone Spring) originated outside **Palazzo Mattei** in a neighborhood known in the ninth century as Balneum Miccine (Micina Baths). The spring was probably commandeered for use by owners of a defensible compound, a *curtes,* like those on the slope of the Quirinal, Viminal, and Esquiline hills. Here, an elite family built a fortified complex set among temple ruins near the ruins of Porticus Pompeiana (the site of Caesar's murder). There was a domus, well, stables, a small church, and other outbuildings comprising perhaps fifty-five hundred square meters, surrounded by a wall. By the fifteenth century, the spring was called **Fonte dell'Olmo (Elm Tree Spring).** A nearby dye-works spewed contaminated wastewater into an ancient drain that led to the Tiber.

But, before all that, the Petronia Amnis—first encountered in the "Floating City"—flowed from the cleft between the Quirinal and Pincian hills into this area. This was the muddy Palus Caprae that Pompey drained before building the porticus that fronted his theater (which the Orsini inhabited by the thirteenth century). Built in 55 BC, the porticus was ancient Rome's first public park, filled with fountains and statuary set amidst shady plane trees (*Platanus orientalis*).

From here you can walk down Via delle Botteghe Oscure (Street of the Dark Shops) or wander through the tangle of streets to the southeast heading back to Piazza d'Aracoeli, with its forlorn and neglected fountain. The **Crypta Balbi** museum along Via delle Botteghe Oscure might tempt you, especially if you are interested in medieval Rome. From **Piazza d'Aracoeli** the traffic is fierce, and during November and December the streets are slippery with bird poop from the millions of starlings, swarming and strafing like an aerial army; they return home to Rome's welcoming trees in the evening. During starling season, the odor of their guano permeates Rome's air, where, to paraphrase my friend Debra Miles, it smells like a place where something really big died. Not unlike Martial's description of the smell of "pilchards and decayed herrings . . . wafted by the breeze from a pond of stagnant water."

The **Monumento Nazionale a Vittorio Emanuele II** (also called the Altar

Fig. 15.8. Fontana del Tirreno (Fountain of the Tyrrhenian Sea), Monumento Nazionale a Vittorio Emanuele II. Emilio Quadrelli, 1911.

of the Fatherland), in Piazza Venezia, is the immediate goal. Completed in 1911, it displaced hundreds of Romans, eradicated houses (like the "Casa di Michelangelo" now on the Janiculum), several gardens, many small fountains, at least one nymphaeum, large portions of the Aracoeli monastery, the tower of Paul III, and little churches.

Rather than dwelling on the monument's vices and virtues, think about the watery history hidden inside its base, where there is a distribution castello for the Acqua Pia Antica Marcia, Rome's newest aqueduct at the time. This fed the fantastically hungry fountains (that now recirculate their water) with reclining water deities framing the ceremonial stairs—they recall the two ornamental cascades in Piazza del Popolo, where Dea Roma is to the east and Neptune to the west, and the Capitoline river gods. But these aren't river gods. These fountains represent more than Rome, and river gods weren't inclusive enough for the new Italian nation. These are gods of the seas. The Adriatic (left and east) and the Tyrrhenian (right and west, fig. 15.8) bracket the building, just as they do the peninsula and define its boundaries. The monument itself faces north, with Rome at its back; much of the country unfolds symbolically before it.

Across the piazza—again through harrowing traffic, although with a stoplight—is the fountain known as La Pigna (The Pine Cone, fig. 15.9). Think of blazing summer days when your greatest desire is to drink cold water: during

the long medieval centuries, the well at **San Marco,** with its inscription inviting people to drink (and cursing anyone who charges for water), could have been the answer. Beautiful in its craggy demeanor, its ninth-century wellhead (no longer functioning) is seen in the atrium. Today, La Pigna invites us. The pine cone refers to the colossal ancient bronze pine cone found in this area in the eighth century and taken to St. Peter's, where it served for centuries as a fountain (perhaps for ablutions) in the atrium (see fig. 11.7). Madama Lucrezia, another of Rome's talking statues, lurks behind the fountain. She is always guarded, so chances of a pasquinade are slim. Nonetheless, she is impressive. Only her upper torso survives, but that is just over two meters high.

The Venetian Pietro Barbo, later Paul II, built **Palazzo Venezia,** which became the center of Venetian influence in Rome. (In 1564, it became the official residence of the Venetian embassy.) Paul III made it his summer palace. In 1535, he joined it to Santa Maria in Aracoeli on the Capitoline with a wood bridge (later in stone). He then built a tower residence with a deep well in the adjoining garden of the convent. Demolished in 1886, the tower stood in the middle of what is now the Vittorio Emanuele monument.

Palazzo Venezia is now a museum, and its green courtyard is a public park. If you crave quiet and coolness, you'll find it here. Fir and magnolia trees create a rustic frame for an inner ring of palm trees surrounding a dramatic fountain from 1730 that symbolizes the marriage of Venice to the sea. Dolphins swim in the basin, putti cluster at the edge, while tritons support a giant shell as Venice, personified as St. Mark (although some people see a young woman), holds

the wedding band, ready to drop it into the sea. The lion of St. Mark roars at the statue's feet.

Baptisms were performed at San Marco as early as AD 366. Ruins of the ancient building were found beneath the modern, that is, ninth-century sanctuary. A larger fifth-century font (for mass baptisms perhaps) was sunk into the floor in the shape of a cross and lined with marble. That too lies beneath the pavement.

Wander to the north up Via del Corso to two other medieval churches: **Santa Maria in Via Lata,** which catered to the health of pilgrims' bodies, and San Marcello al Corso, which catered to the health of the soul. All three churches, San Marco, Santa Maria, and San Marcello, flooded often and were rebuilt at higher levels in the eleventh century. Their earliest water histories lie underground. Santa Maria in Via Lata began as a *xenodochium,* a charitable institution providing shelter and food, founded by Belisarius in the early sixth century. Later it became a diaconia with a chapel and perhaps access to some bathing facilities that diaconiae typically offered to pilgrims. By the ninth century, it was a monastery. You can visit its subterranean ruins with frescoes and a well. Baptisms were performed at San Marcello, as at San Marco. The San Marcello font, with a graceful, six-lobed basin, could accommodate partial-immersion, group baptisms. It's now possible to see the restored font, which is visible from the Hotel Six Senses building next door.

Michel de Montaigne found Rome to be "nothing but palaces and gardens . . . coaches, prelates, and ladies." Yet, in this neighborhood, in March 1581, he found a stufa, a bath house, to frequent located near San Marco, considered "the noblest" at the time. Apparently, as Montaigne explained, that meant that a gentleman could take his "lady friend" with him and they could be "rubbed down" at the same time. Would we call that a sex club? In any case, small baths like this one catered to every taste.

While Montaigne noticed ladies and baths, he rarely mentioned fountains. His attention never lingered on Rome's waterworks (although he wrote about gardens outside the city). Rome had many new fountains by 1581, including the two in Piazza Navona (surely, he visited there) and one each in Piazza della Rotonda, Piazza del Popolo, and Piazza Colonna. These beautiful fountains, graceful and fluid in design, were unlike the boxy ones in Paris that resembled clock towers. Drinking fountains began appearing everywhere in Rome, including two near his hotel, the Orso. How could he miss those (or others, like Il Babuino, which means "the baboon"), when water flowed continuously? Parisian drinking fountains had on/off spigots. He suffered from kidney stones, so perhaps he despised Rome's water because of its high calcium content.

The fountain known as Il Facchino, which means "the porter," the wine seller who dispenses free water, hadn't been built when Montaigne visited. Would he even have noticed it? Badly damaged, Il Facchino is among Rome's most prized fountains. Like other semipublic fountains, it brought prestige to its private

sponsors, who trumpeted their public spirit. Whatever the sponsors' motives, and no matter Montaigne's impaired vision regarding Rome's fountains, we can take a drink and be thankful that, with only minor interruptions, Il Facchino has kept water flowing since 1588.

Refreshed, head west toward the **Collegio Romano** and then slip up Via del Collegio Romano to the north. This is the flank of the Jesuit college founded by Ignatius Loyola in 1551. The college became a beacon for the study of science. Galileo lectured here, and we'll soon meet another professor, Athanasius Kircher. In any case, the Jesuits ended up owning the entire block, including Sant'Ignazio, just around the corner and fronted by **Piazza Sant'Ignazio,** a pilgrimage site for many architects. Recall how, on the Quirinal Hill, the façade of San Carlo alle Quattro Fontane mimics water's flow; it seems to have been modeled by water. In Piazza di Sant'Ignazio, designed by Filippo Raguzzini and completed in 1728, water has carved not only the façades, but also the entire piazza and the roofline. Everything flows here. The piazza shares the vibrancy of the Ripetta, the Spanish Steps, and the Fontana di Trevi (Trevi Fountain), liquid spaces all designed in the early eighteenth century. Raguzzini created this outdoor room by, in a sense, lifting off the roof. Voilà, a piazza! This one is more playful than Piazza di Santa Maria della Pace, from seventy years earlier, but shares the same spirit of urban surprises, via architectural facelifts. Raguzzini built one new building—opposite the church door—then, like a sculptor, carved the façades of the existing buildings to create a unified whole. The roofline is especially revealing. As you walk by, you might spot students sitting in the cobbled piazza attempting to draw or photograph the space created at the roofline.

Piazza Sant'Ignazio is a convenient place to pause. There are coffee bars nearby, or you can sit on the steps and think about stagecraft, sit down in the piazza to draw, or slip inside the church and rest your weary bones. Whichever option you choose, the final lap of this water pilgrimage begins at the Trevi.

Bibliography

For the pomerium, see Koortbojian 2020 and Tacitus 1942; for drains, see Narducci 1889; for the Chiavica di Santa Lucia, see Long 2018; for Via Giulia, see Salerno et al. 1975; for Piazza Farnese, see Moore 1998/99; for Ponte fra le Epoche, see Ambassade de France en Italie; for Piazza Capo di Ferro, see D'Onofrio 1986; for Campo dei Fiori, see Ajello Mahler 2012, D'Onofrio 1986, and Nibby 1841; for San Lorenzo in Damaso, see Krautheimer 2000; for Largo Argentina, see Santangeli Valenzani 2007; for the demolished Jewish Ghetto fountain, see Nibby 1841; for the Crypta Balbi, see Comune di Roma 1991 and Manacorda 2001; for smells, see Martial *Epigrams* book 12:32; for the Monumento Nazionale a Vittorio Emanuele II, see Coppola et al. 2005; for the Capitoline Hill, see subject bibliography (especially Brancia di Apricena 2000); for Palazzo Venezia, see Müntz 1878; for *xenodochium*, see Dey 2008; for *stufe*, see Montaigne 1903.

16

An Ocean Deity Talks with Some River Gods

〰 Full-Circle Pilgrimage: Trevi Fountain to Piazza Navona, ~1.5 kilometers

As you walk through Rome and the Campagna with your senses open to the tangible world of fountains, aqueducts, rivers, rain, and floods, and to water's sounds and hidden pulses and flows, one reward is a deepening spatial understanding of Rome's topography and history. You'll have built a framework to tether haptic, cognitive, and visceral perceptions of objects, facts, and stories that flow above and belowground. I see this water framework as the warp of Rome's urban fabric onto which the weft of all the city's history and daily life are continuously woven. Your steps extend an ever-incomplete tapestry, and will continue to do so whenever you walk through Rome.

We begin at the **Fontana di Trevi (Trevi Fountain),** where our first walk ended (fig. 16.2). Like all Rome's iconic places, the Trevi enfolds the city's entire history, as its urban stage set embraces us completely in its wholly baroque façade. Seated before a secular travertine and marble temple dedicated to water, we see the beginning of a particular water history that flows through the Campo Marzio—through the "veins of the earth," as its designer, Nicola Salvi, wrote. We sense millennia of water flowing across the Roman Campagna before reaching here; we see the story of the Virgin finding the springs and showing them to Agrippa; we know how the water arrived here two thousand years ago; and we understand the hydrological cycle as narrated by Salvi.

From the Trevi, we follow Vergine water as it streams through the Campo Marzio. Our goal is the Fontana dei Quattro Fiumi (Four Rivers Fountain) in Piazza Navona, designed by Gian Lorenzo Bernini and completed in 1651. The Vergine's flow doesn't end there, barely a kilometer away; rather, it is the beginning of dialogues between water and stone, Bernini and Salvi, and contemporary science and natural philosophy concerning the hydrological cycle. Bernini articulated his

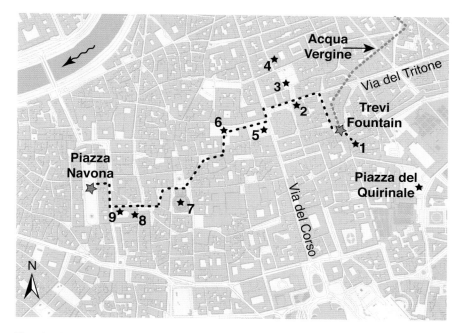

Fig. 16.1. FULL-CIRCLE PILGRIMAGE 1) La Città dell'Acqua (The City of Water), 2) Santa Maria in Via, 3) public laundries, 4) San Silvestro in Capite, 5) Piazza Colonna, 6) Horologium Solare, 7) Pantheon, 8) Sant'Ivo alla Sapienza, 9) Fontana dei Libri (Book Fountain).

eloquent case in 1651. Beginning in 1732, Salvi presented new evidence—not to refute Bernini, but to advance our understanding of the water coursing through the veins of the earth. Our route between the two theories isn't straight, although it follows distribution conduits under the streets. Rather, topography, archaeology, myths, and patrons—all insistent for our attention—will cause us to swerve away to hear their stories and then return with new threads for our loom.

La Città dell'Acqua (The City of Water) is on Vicolo del Puttarello, behind the church of Santi Vincenzo e Anastasio opposite the Trevi. Nine meters underground there is a small archaeological site on the ancient Vicus Caprarius. It's a truism in Rome that you can't put a shovel into the earth without encountering ruins. That was the case during the Cinema Trevi's 1999 restoration. Bam! Work stops and owners gripe, but treasures emerge. Here are the remains of interconnected, rectangular chambers from a distribution castellum of the ancient Virgo. Frontinus tells us there were eighteen beneath Campo Marzio streets, each one assigned to a specific neighborhood. Apparently, none survive; this castellum dates from the reign of Hadrian, when existing rooms were reinforced (double-thick walls) and lined with waterproof cement to make a new holding tank. This is our one chance to gain a small behind-the-scenes sense of how water moved from an

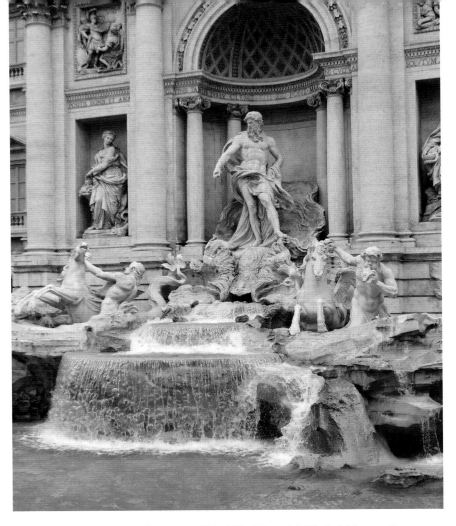

Fig. 16.2. The god Oceanus at the Fontana di Trevi (Trevi Fountain). Nicola Salvi, 1732–62.

aqueduct to ramify through ancient Rome. Water entered from the northwest and then headed to public and private fountains.

As you emerge into the light and swing around, you are back at the Trevi, which once centered a small-scale industrial neighborhood, rather than a tourist destination. Purging basins for wool were located at the palace that is now behind the Trevi. They were built here during the Vergine's 1570 restoration. Later, Sixtus V built a sundeck above the palace for the wool-workers to spread out and block the clean cloth. Wool-working was a dirty business. They used fuller's earth (alum) and urine to clean the wool and needed lots of water, just like the laundry women, who had their own basin here (fig. 16.3). Moving the dirty water to the river was a constant problem. It flowed into a foul and unhealthy ground-level

Fig. 16.3. *SS. Vincenzo and Anastasio at the Trevi Fountain.* Giovanni Battista Falda, 1669. Vincent Buonanno Collection. The laundry fountain appears in the lower left.

ditch, the Chiavica di San Silvestro, that ran north past **San Silvestro in Capite** toward the Mausoleo di Augusto, where there was an ancient drain. The stench was reported to be appalling. An underground drain, built in the late sixteenth century, helped solve that problem.

After that, Piazza San Silvestro became a hub of fountain activity, most of it to do with laundry. There were two privately sponsored **public laundries** (how big we don't know) in the piazza by the end of the sixteenth century. And a large facility stood inside the monastery at the church, where as many as sixteen women could work. Some former prostitutes known as *convertite* worked as laundresses (a profession considered appropriate for them), and some of them might have worked here. The church is still active, but the monastery is now a post office, and you can wander around the ground-floor hallways and peer into the cloister where the laundry once stood, and where two other ornamental fountains survive in weedy isolation.

The path from the Trevi follows the drain for 350 meters to the little church of **Santa Maria in Via** (not to be confused with Santa Maria in Via Lata), where a well in Cardinal Pietro Capocci's stables overflowed one night in September 1256. The cardinal saw an icon painted with the Virgin's image floating in the water. This inspired him to build a chapel on the site of the "miraculous" well. Water still flows—perhaps from the Aqua Sallustiana, which runs underground nearby—and on the celebratory anniversary (September 26), anyone can enter the Madonna del Pozzo chapel for a sip from the miraculous spring.

Having quenched your thirst, it's time for serious fountain-hopping. Our first stop is **Piazza Colonna.** Don't be upset if you don't see the basin right away. The Colonna di Marco Aurelio (Column of Marcus Aurelius) is a limelight hog and pretty much steals the show if you aren't paying attention to the subtle beauty at ground level. There is an easy, almost careless artistry to this fountain, a swoop here, a billow there, and ripples everywhere.

Designed by Giacomo della Porta and carved by Mastro Rocco da Fiesole of Porta Santa marble, it is a masterpiece. It shares the same graceful lines of the underappreciated Capitoline fountain: it is refined, understated, and exquisite. I could go on for pages about this fountain (in fact I have, elsewhere), but the most important thing to see, aside from its elegance, is how it unfurls and nestles into the ground (as the Barcaccia would fifty years later). Pressure is low, so there aren't any fancy skyward shooting jets. Water spills from the chalice in a carousel that creates ripples and wavelets in the basin. In 1588, Girolamo Ferrucci acclaimed the subtle intimacy of the Mattei Fontana delle Tartarughe (Turtle Fountain) as the most perfect fountain in Rome. That may be so; there weren't too many by that time. I, however, argue for the Colonna, completed in 1577.

Around the corner is an Egyptian obelisk in Piazza di Montecitorio. This is a memento of Augustus's **Horologium Solare**—his giant meridian of 10 BC that stood opposite his mausoleum and near the Ara Pacis. The obelisk was its needle. White marble lines shaped like a butterfly with a short body and long wings were laid on the pavement (about 75 by 160 meters) and marked with bronze rods to measure the months. A water channel (eripus) filled with Virgo water about a meter deep and six meters wide was added along the center of the meridian graph about a century later. At one time, you could slink into the bar around the corner and request to see the ruins.

Heading south from Montecitorio, you will soon be in the heart of the Campo Marzio, where the transformation of the waterlogged Palus Caprae into the marble domain of Agrippa and Augustus began. The Aqua Virgo is emblematic of the foundational contradiction that is Rome, where valleys were drained to establish the city and then rehydrated with aqueduct water to thrive. Agrippa built his urban complex—with the **Pantheon** and baths—in the middle of the Palus Caprae. One of its massive drains still runs under the Pantheon; a hole in the middle of the floor, directly under the oculus, opens to its modern iteration. When you stand directly under the oculus, you symbolically inhabit and become the *axis mundi* (center of the world), in a building originally dedicated as a temple to all gods and built as a sacred center. The oculus connects you to the atmospheric sky of mists, clouds, and rain as you are bound to the earth and connected to its underworld and subterranean streams.

The original Pantheon, built by Agrippa in 31 BC, burned in AD 80. Domitian restored it, but it burned again in 110. It faced south toward the Thermae

Agrippae (Baths of Agrippa). When emperors Trajan and Hadrian built the entirely new Pantheon, its orientation shifted to the north—facing toward the Mausoleo di Augusto—and its shape transformed from rectangular to round. A precinct with a luminous marble pavement surrounded by colonnades stood before it, with fountains at the foot of a flight of stairs leading up to the podium. Even so, the threshold is only thirteen meters above sea level—low indeed in an area that flooded often. So, before entering the church, try to imagine the scene during the 1598 flood, when water rose to 19.56 meters above sea level, nearly to the top of the bronze doors.

By the time Giacomo della Porta built a fountain in Piazza della Rotonda in the 1570s, the ground level had risen several meters, so that new steps led down to enter the Pantheon. In 1662, Alexander VII cleared and lowered the piazza to the level of the Pantheon entry. This left the fountain floating above the piazza, so additional stairs were added to connect it to the new level of the piazza (fig. 16.4). It was less expensive to build the stairs than dismantle and lower the fountain, although that would have meant more air space for a water display. The obelisk replaced an original chalice in 1711. Bollards and iron railings were added at the same time at the base to protect it from carriages, but also from people. This kind of imprisonment happened at other ornamental fountains, including Santa Maria in Trastevere.

Fig. 16.4. Fountain in Piazza della Rotonda, seen from the Pantheon loggia.

Fig. 16.5. Façade of Santa Maria sopra Minerva with six flood inscriptions.

The *ortolani* (fruit and vegetable sellers) worked in Piazza della Rotonda with their own basin that used the fountain's runoff water. In fact the hurly-burly of buying and selling engulfed the entire piazza. Shacks were built between the Pantheon columns and congregated under its porch. Alexander VII moved the ortolani out when he restored the piazza and "liberated" the Pantheon from these excretions. The Rotonda fountain served as a Vergine distribution point. In the piazza, an inscription (usually hidden behind outdoor tables) shows the level at which the water left the basin in 1758.

Santa Maria sopra Minerva is to the south, where it's possible to gain a profound corporal sense of the impact of Tiber floods. On the façade are six flood inscriptions (fig. 16.5). Three are close to eye level. The one with gothic script recalls the 1422 flood that, an eyewitness stated, covered most of Rome, meaning the Campo Marzio. The other two recall the 1495 and 1870 floods. Clustered far above your head are inscriptions that commemorate Rome's fiercest floods, in 1530, 1557, and 1598. The message is clear. Father Tiber ruled.

There are still more fountains before reaching Piazza Navona. A fontanella stood in Piazza di Santa Maria Maddalena north of the Pantheon as early as 1447—one of the few public fountains at that time with a direct supply from the Trevi. Before 1570, Vergine water only extended this far, which helps explain

why the little fountain was placed here rather than at the Pantheon, 150 meters farther away. The Maddalena fountain seen today probably dates to the eighteenth century.

Today, nasoni drinking fountain are commonplace. In 1991, there were twenty-one hundred drinking fountains of various kinds in the streets and parks of the Greater Roman Metropolitan District; nineteen hundred of them were cast-iron nasoni. A few, like the one at the Pantheon, originally sported three or four dragon spouts rather than the ubiquitous curved "nose." More than two hundred travertine drinking fountains are found in the parks and public gardens. By now you've seen them around Rome and known the boon they bring to the thirsty. But, I know. You're right. "This is not that"—the nasoni can't compare to fountains like Il Babuino, which means "the baboon." Still, Romans have great affection for them and their rituals: parents teaching their children how to turn the blowhole into a drinking spout; students filling balloons on the last day of school for fierce water fights; the ease with which buckets are filled at the market stalls; and the effortless access for their beloved dogs.

This is the precinct of Agrippa's and Nero's baths, where there were scads of fountains. Among these were four round basins unearthed during excavations. In 1987, the Roman Senate installed one of them (with a 4.3-meter diameter basin) in Piazza di Sant'Eustachio along the route to **Sant'Ivo alla Sapienza.** Now water burbles quietly from the center of the fountain, but in antiquity, the ground level was several meters lower, and the jet was higher. This means that in contrast to today's reflective pool, the water would have been animated and snapped in the light more fiercely.

Pietro Lombardi's fountains always invite affection, if not outright passion, like the **Fontana dei Libri (Book Fountain)** a few steps west along Via degli Staderari (fig. 16.6). Built into the wall of the Università della Sapienza, it is named for the Sant'Eustachio neighborhood; the stag refers to St. Eustace, the books to the university, and the balls to the Palazzo Medici across the street. It's nearly impossible to drink directly from it without becoming drenched, but who cares when you are kissing. Animals love it, and you can always fill your water bottles once the passion dies down.

Around the corner is Francesco Borromini's church of Sant'Ivo alla Sapienza (St. Ivo of Wisdom), begun in 1642 and so named for its location at the university. Don't be surprised if you feel weak in the knees when you enter, as its fluid space, united with an exacting geometrical order, surrounds you. There are plenty of benches where you can rest until your head stops spinning. You already experienced how Borromini channeled the flow of water at San Carlo alle Quattro Fontane. Here triangles and hexagons contain the bulging energy until it is finally released into the dome. Historian Joseph Connors suggests that Borromini's friendship with the scientist Benedetto Castelli, with whom he shared a

Fig. 16.6. Fontana dei Libri (Book Fountain), Via degli Staderari. Pietro Lombardi, 1927–29.

profound interest in geometry, especially hexagons, may have influenced Sant'Ivo's rigorous geometric order. Castelli was a student of Galileo, hydraulic advisor to Urban VIII, author of a 1628 groundbreaking treatise on hydraulic velocity, and a reader in mathematics at the Sapienza when Borromini designed Sant'Ivo. The idea that they might have collaborated is an exciting premise and illustrates the currents of science, art, and technology that were flowing in Rome at that time.

The void is like a fountain basin, and it makes me wonder about Borromini's difficulty designing one for **Piazza Navona** (his competition entry was tepid). But here, as at San Carlo, you can mentally cut a horizontal section above the entablature where the dome meets the walls, and then flip the dome over to reveal the outline of an exceptionally beautiful fountain basin—lyrical, like della Porta's basins in Piazza Navona and Piazza Colonna. No one has really explained Borromini's limp competition design, except to suggest that Bernini was a better architect or that he better understood water.

Bernini, already the most famous artist in Rome, became even more celebrated when his breathtaking fountain was inaugurated on June 12, 1651. Everything about it is audacious. Charles de Brosses visited Rome between 1739 and 1740. He found Rome's fountains—their sheer number and "the rivers that issue from them"—to be more interesting than its buildings, and the Four Rivers Fountain made the greatest impression; "nothing grander or richer in the way of design."

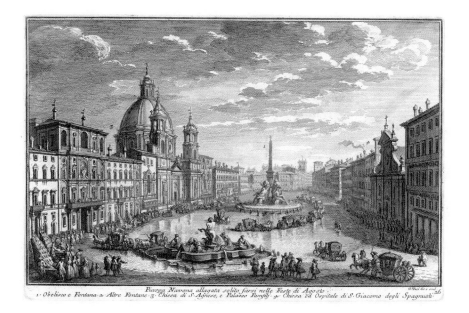

Piazza Navona allagata solito farsi nelle Feste di Agosto.
1. *Obelisco e Fontana* 2. *Altre Fontane* 3. *Chiesa di S. Agnese, e Palazzo Panfilj* 4. *Chiesa ed Ospitale di S. Giacomo degli Spagnuoli*

Fig. 16.7. *Festival Flooding at Piazza Navona in August.* Giuseppe Vasi, 1752.
Vincent Buonanno Collection.

But Bernini didn't do it alone; he had help. His rival, Borromini, had already analyzed the available water pressure from the Trevi basin and found it sufficient for about a two-meter-high jet. It was also Borromini who, as Simon Schama states, "engineered the hydraulics that made this [water display] possible" as "the greatest water spectacle in any urban space in Europe" at the time. The dramatic obelisk substitutes for the water jet that nature didn't allow. That wasn't Bernini's idea—it was his client's. Even the greatest artists don't work in a vacuum.

The Four Rivers Fountain displays a dizzying array of water effects. A hula skirt erupts beneath the Danube's feet, and there is a shimmying fan dance there too; bridal veils scribble the air beneath the Rio della Plata; water shoots from a blowhole beneath the Ganges; cascades erupt beneath the Nile; the lion comes to the pool to drink while the horse leaps over a watery chasm; a serpent comes up for air but gets a mouthful of water; and the ocean contains the world.

The piazza and its fountains created a spectacular theater for urban extravaganza. As John Moore writes, "Ritual was Rome's business, and building (whether permanent or temporary) its principal industry." Temporary frivolity includes a tradition begun under Alexander VII of flooding Piazza Navona on Saturday nights during August. With the fountain drains closed, the continuously flowing water flooded the piazza overnight (fig. 16.7). It was rather like opening New York's fire hydrants on summer days. On Sundays, rich folk rode around in their

coaches—some shaped like a gondola or fish for the occasion—while throwing coins to the urchins.

Even when Piazza Navona isn't intentionally flooded, it is always filled with water; because of this, it has its own microclimate, as do the other saturated spaces, including Piazza di Trevi and Piazza di San Pietro. But oddly, it is here that a localized change in the weather is most apparent as the air is suffused with mist. On very still winter days, the vaporous air in the piazza is enveloping, like a gentle fog. The water in each fountain behaves on these days—falling in a cascade or arc as designed, almost to specifications, and filling the pools to the brim. On breezy days, the water misbehaves, especially when the wind whips the Four Rivers cascades into a frenzy. One almost feels caught in a storm. This happens in other large open spaces, with the lions' rippling veils in Piazza del Popolo and the plumes at Piazza San Pietro.

The Four Rivers Fountain is more than a pretty face. It stands not only at the midpoint of Piazza Navona, but also at the center of a scientific debate about the hydrological cycle, still a mystery to natural philosophers and scientists in 1651. One long-held theory explained that rivers were like arterial bloodstreams. Leonardo da Vinci held that water rose to mountain summits, that in plants it rose from roots throughout the plant, and that water, which he saw as a living being, mimicked the flow of blood in animals.

Athanasius Kircher, a professor at the Sapienza university and advisor to Bernini, was central to the debate. Ingrid Rowland explains that the Four Rivers Fountain reflects Kircher's concept of geology: "He believed that mountain ranges stood hollow over vast underground reservoirs in which all the rivers of the world had their origins." Bernini's hollow mountain is not only structurally sound, it is also "an expression of the latest in scientific thinking" (fig. 16.8). His understanding of the hydrological cycle is demonstrated here. Rowland continues Kircher's thesis, writing, "As water leached the volcanic minerals back into the soil, it also washed mountains into the sea, where huge underwater vortices, like Charybdis in the Straits of Messina . . . sucked cascades of water into the earth's *hydrophylacia,*" that is, water reservoirs, from which "underground springs gushed forth."

The four rivers—the Danube, Ganges, Nile, and Río de la Plata—anchor the corners of the known world, and also represent the world of the Catholic Church. Their waters flow unceasingly from "underground springs" into the mythological ocean surrounding the continents. Water gushes in shutes and cascades, thick and thin: the Plata's veils are the most animated in the wind, and the Ganges and the Danube spew water in fantastic frilly tutus of twirling water. Everything is spinning.

The full story of the Four Rivers Fountain isn't revealed unless you are as active as the water, walking round and round the basin trying to read its narrative, which has no beginning and no end. The Trevi is equally active, if not more so, but

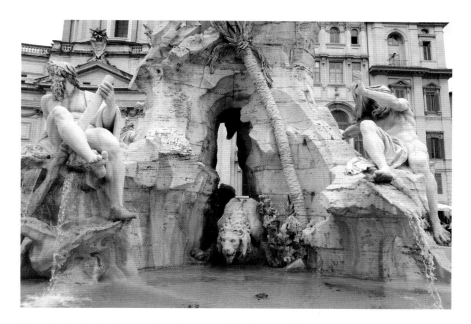

Fig. 16.8. The "hollow" mountain at the center of the Fontana dei Quattro Fiumi (Four Rivers Fountain), Piazza Navona. Gian Lorenzo Bernini, 1648–51.

the tableau is set before you. All you need do is sit down and look. Unlike aloof Oceanus striding his shell on the Trevi stage twenty-five meters away from you, the river gods in Piazza Navona are close enough that here is that "imminence of touch" Eleanor Clark writes about (fig. 16.9). In spite of the river gods apparently having just woken from naps, they look as though they've come from the gym. Those biceps, those thighs, those buttocks are tangible and alive.

Eighty years later and about a kilometer away, the conversation had changed. In the interim, Giovanni Poleni published his scientific findings that he discovered through on-site research about the hydrological cycle. Whether Salvi knew Poleni personally is irrelevant. It's likely he would have been familiar with his work, *De motu aquae mixto libri duo* (On the Movement of Waters) of 1717. Both were members of the Accademia degli Arcadi. If not through Poleni, Salvi would certainly have read Aristotle and other ancient philosophers' theories on water cycles in nature, or, as John Pinto points out, through a familiarity with Torquato Tasso (one of Rome's most famous poets), who describes Oceanus as the principle that "nourishes all living things with life-giving rain." Salvi translated that concept into his dramatic demonstration at the Trevi.

The Four Rivers Fountain and the Trevi continue a dialogue and share secrets about the movement of "hidden waters," although most people aren't aware of it, or even interested. The rimbombare of the thundering Trevi differs from the

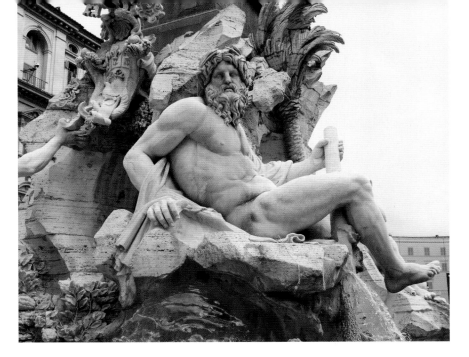

Fig. 16.9. Personification of the Ganges River, Fontana dei Quattro Fiumi (Four Rivers Fountain), Piazza Navona. Gian Lorenzo Bernini, 1648–51.

whooshing Four Rivers, yet they speak the same language, and water pilgrims can hear them whispering or roaring across time and space. Rome's two most famous fountains—complete, yet ever flowing and ever evolving—reveal hidden histories, particularly of the hydrological cycle and the secrets of Rome's specific ongoing translation and engagement with it, with topography, and the specificity of place. The fountains pull us into the endless river of time, which, although you cannot step into the same river twice, you can walk with Rome's waters for the rest of your life.

Bibliography

For fountains, see subject bibliography and Matitti 1991; for Ferrucci, see D'Onofrio 1986; for the Trevi Fountain and Nicola Salvi, see Pinto 1986; for La Città dell'Acqua, see Vicus Caprarius; for wool-working, see Martini 1965; for the Chiavica di San Silvestro, see Long 2018; for laundresses, see Rinne 2021; for Santa Maria in Via, see Armellini 1942; for Horologium Solare, see Boatwright 1987; for Montecitorio, see Collins 2004; for Palus Caprae, see Coarelli 1997 and Narducci 1889; for the Pantheon, see Hetland 2015, Krautheimer 1982, and Marder 1991; for Sant'Ivo, see Connors 1996; for hydraulics, see Poleni 1717; for urban theater, see Moore 1998/99; for Piazza Navona and Fontana dei Quattro Fiumi, see Bostico 1970, Clark 1952, de Brosses 1897, Martinelli and D'Onofrio 1968, Rowland 2001, Schama 1995, and Spinosi 1970; for Athanasius Kircher, see Rowland 2000 and 2001.

Bibliography

Abbreviations

AB	*Art Bulletin*
AJA	*American Journal of Archaeology*
Bur.M	*Burlington Magazine*
Cap.	*Capitolium*
DOaksLA	*Dumbarton Oaks Colloquium on the History of Landscape Architecture*
JRA	*Journal of Roman Archaeology*
JRS	*Journal of Roman Studies*
JSAH	*Journal of the Society of Architectural Historians*
MAAR	*Memoirs of the American Academy in Rome*
PBSR	*Papers of the British School at Rome*
RJK	*Römisches Jahrbuch für Kunstgeschichte*
WROP	*Waters of Rome Occasional Papers* (www.iath.virginia.edu)

Maps Cited

Bufalini, Leonardo. *Roma.* 1551. Reprint, Rome: Antonio Trevisi, 1561.

Ceen, Allan. *Rome 1748: La pianta grande di Roma di Giambattista Nolli in facsimile.* 2nd. ed. Highmount, NY: H. Aronson, 1991.

Chiesa, Andrea, and Bernardo Gambarini. *Delle Cagioni e de'Rimedi delle Inondazioni del Tevere.* Rome: Stamperia di Antonio de'Rossi, 1746.

Falda, Giovanni Battista. *Nuova Pianta ed alzata di Roma.* Rome, 1676.

Lanciani, Rodolfo. *Forma Urbis Romae.* 1893–1901. Reprint, Rome: Edizione Quasar, 1990.

General Bibliography

Ackerman, James. *The Cortile del Belvedere, Studi e Documenti Per la Storia del Palazzo Apostolico Vaticano.* 3 vols. Vatican City: Biblioteca Apostolica Vaticana, 1953.

Adinolfi, Pasquale. *Laterano e la via Maggiore.* Rome: Puccinelli, 1857.

———. *Roma nell'età di mezzo.* 2 vols. 1881. Reprint, Rome: Fratelli Bocca, 1980.

Aicher, Peter. *Guide to the Aqueducts of Ancient Rome.* Wauconda, IL: Bolchazy-Carducci, 1995.

Ajello Mahler, Guendalina. "Afterlives: The Reuse, Adaptation and Transformation of Rome's Ancient Theaters." PhD diss., New York University, 2012.

Alberti, Leon Battista. *On the Art of Building in Ten Books.* Translated by J. Rykwert, N. Leach, and R. Tavernor. Cambridge, MA: MIT Press, 1988.

Alessio Angeli, Fabrizio, and Elisabetta Berti. *Nascita di un fiume: La Marana.* Rome: Associazione Culturale Sesto Acuto, 2007.

Ambassade de France en Italie. "'Pont Farnèse,' un pont entre les époques: À Rome L'oeuvre de l'artiste Olivier Grossetête." July 1, 2021. https://it.ambafrance.org.

Ammerman, Albert. "On the Origins of the Forum Romanum." *AJA* 94 (1990): 627–45.

———. "Environmental Archaeology in the Velabrum (interim report)." *JRA* 11 (1998): 213–23.

Andres, Glenn M. *The Villa Medici in Rome.* 2 vols. New York: Garland, 1976.

Armellini, Mariano. *Le chiese di Roma dal secolo IV al XIX.* Rome: Tipografia Vaticana, 1942.

Ashby, Thomas. *Wanderings in the Campagna Romana.* Boston: Houghton Mifflin, 1909.

———. *The Aqueducts of Ancient Rome.* Oxford: Oxford University Press, 1935.

Augenti, Andrea. *Il Palatino nel medioevo: Archeologia e topografia (secoli VI–XIII).* Rome: L'Erma di Bretschneider, 1996.

Averett, Matthew K. "'*Redditus orbis erat*': The Political Rhetoric of Bernini's Fountains in Piazza Barberini." *Sixteenth Century Journal* 45, no. 1 (Spring 2014): 3–24.

Bariviera, Chiara, and Pamela O. Long. "An English Translation of Agostino Steuco's *De Aqua Virgine in Urbem Revocanda* (Lyon: Gryphius, 1547)." *WROP* 8 (2020).

Belloc, Hilaire. *The Path to Rome.* New York: Longmans, Green, 1902.

Benedetti, Simona. "Le Quattro Fontane." In *Sisto V Architetture per la Città,* by Maria Piera Sette and Simona Benedetti, 130–57. Rome: Multigrafica, 1992.

Beneš, Mirka. "The Villa Pamphilij (1630–1670): Family, Gardens, and Land in Papal Rome." PhD diss., Yale University, 1989.

Benocci, Carla, and Enrico Guidoni. *Il Ghetto.* Rome: Bonsignori, 1993.

Bentz, Katherine. "The Afterlife of the Cesi Garden: Family Identity, Politics, and Memory in Early Modern Rome." *JSAH* 72 (June 2013): 134–65.

Bermann, Karen, and Isabella Clough Marinaro. "'We work it out': Roma Settlements in Rome and the Limits of Do-It-Yourself." *Journal of Urbanism* 7, no. 4 (2014): 399–413.

Bevilacqua, Mario. *Il Monte dei Cenci.* Rome: Gangemi, 1988.

Bianchi, Lorenzo. *Case e torri medioevale a Roma.* Rome: L'Erma di Bretschneider, 1998.

Birch, Debra J. *Pilgrimage to Rome in the Middle Ages: Continuity and Change.* Woodbridge, UK: Boydell and Brewer, 1998.

Blake, Marion E. *Ancient Roman Construction in Italy from Tiberius through the Flavians.* Washington, DC: Carnegie Institution, 1947.

Boatwright, Mary Taliaferro. *Hadrian and the City of Rome.* Princeton: Princeton University Press, 1987.

Bober, Phyllis Pray. "The Coryciana and the Nymph Corycia." *Journal of the Warburg and Courtauld Institutes* 40 (1977): 223–39.

Borgia, Gregorio. "Packs of Ravenous Wild Boars are Ransacking Rome." NPR News, Associated Press, September 28, 2021. https://www.npr.org/2021/09/28/1041124299/wild-boars-rome-streets-food.

Bosworth, R. J. B. *Whispering City: Rome and Its Histories.* New Haven: Yale University Press, 2011.

Bosticco, Sergio. *Piazza Navona Isola dei Pamphilj.* Rome: Aster Arti Grafiche, 1970.

Bradley, Mark, and Kenneth Stow, eds. *Rome, Pollution and Propriety: Dirt, Disease and Hygiene in the Eternal City from Antiquity to Modernity.* Cambridge: Cambridge University Press, 2012.

Brancia di Apricena, Marianna. *Il Complesso dell'Aracoeli sul Colle Capitolino (IX–XIX secolo).* Rome: Quasar, 2000.

Brandt, Olof. *San Lorenzo in Lucina: The Transformations of a Roman Quarter.* Stockholm: Swedish Institute in Rome, 2012.

Brentano, Robert. *Rome before Avignon: A Social History of Thirteenth-Century Rome.* Berkeley: University of California Press, 1991.

Brocchi, Giambattista. *Dello stato fisico del suolo di Roma.* Rome: De Romanis, 1820.

Broise, H., and Vincent Jolivet. "Il Giardino e l'Acqua: l'Esempio degli Horti Luculliani," in *Horti romani: Atti del Convegno Internazionale. Roma, 4–6 maggio 1995.* Maddalena Cima and Eugenio La Rocca, editors. Rome: L'Erma di Bretschneider, 1998, 189–202.

Brummer, Hans Henrik. *The Statue Court of the Vatican Belvedere.* Stockholm: Almqvist und Wiksell, 1970.

Butters, Suzanne. *Le Cardinal Ferdinand de Médicis,* in *La Villa Médicis.* 5 vols. Rome: Académie de France and École française, 1989–91.

Cacchiatelli, Paolo. *Le scienze e le arti sotto il pontificato di Pio IX.* Rome: Tip. Forense, 1863.

Cafà, Valeria. "The Via Papalis in Early Cinquecento Rome: A Contested Space between Roman Families and Curials." *Urban History* 37, no. 3 (2010): 434–51.

Cajano, Elvira. *Il sistema dei forti militari a Roma.* Rome: Gangemi, 2006.

Camerlenghi, Nicola Maria. *St. Paul's Outside the Walls: A Roman Basilica, from Antiquity to the Modern Era.* Cambridge: Cambridge University Press, 2018.

Camilli, Eleonora. "There Is No Home: Tales from the Refugees Who Used to Live on Via Curtatone." Open Migration, September 17, 2017. https://openmigration.org/en/.

Campitelli, Alberta. *Le ville a Roma: Architetture e giardini dal 1870 al 1930.* Rome: Argos, 1994.

———. *Orti di Guerra.* Rome: Fratelli Palombi, 2019.

Caneva, Giulia, and Lorenza Bohuny, "Botanic Analysis of Livia's Villa Painted Flora (Prima Porta, Rome)." *Journal of Cultural Heritage* 4 (2003): 149–55.

Canevari, Raffaele. *Studi per la sistemazione del Tevere nel tronco entro Roma.* Rome: Giornale del Genio Civile, 1875.

Cardilli Alloisi, Luisa. *Fontana di Trevi: La storia, il restauro.* Rome: Assessorato alla Cultura, 1991.

Carocci, Sandro. *Baroni di Roma.* Rome: École française de Rome, 2016.

Cassio, Alberto. *Corso dell'acque antiche portate sopra XIV. Aquidotti da lontane contrade nelle XIV* […] 2 vols. Rome, 1756–57.

Cassius Dio. *The Roman History, the Reign of Augustus.* London: Penguin, 1987.

Casson, Lionel. "Harbour and River Boats of Ancient Rome." *JRS* 55, no. 1/2 (1965): 31–39.

Castelli, Benedetto. *Della Misura dell'Acque Correnti.* Rome: Nella Stamparia Camerale, 1628.

Ceccarius (Giuseppe Ceccarelli). *La "Spina" dei Borghi.* Rome: Danesi, 1938.

———. *Strada Giulia.* Rome: Danesi, 1940.

Ceen, Allan. "The Quartiere de' Banchi: Urban Planning in Rome in the First Half of the Cinquecento." PhD diss., University of Pennsylvania, 1977.

———. *Roma Traversata: Tracing Historic Pathways through Rome.* Ithaca, NY: Cornell University Press, 2022.

Ceen, Allan, Bruno Leoni, Lucas Dubay, and Cothran Ceen. *Roma Pontificata: The Ancient Bridges of Rome.* Rome: Studium Urbis, 2015.

Cellauro, Louis. "The Casino of Pius IV in the Vatican." *PBSR* 63 (1995): 183–214.

Celli, Angelo. *The History of Malaria in the Roman Campagna from Ancient Times*. London: John Bale and Danielsson, 1933.

Çelik, Zeynep, Diane Favro, and Richard Ingersoll. *Streets: Critical Perspectives on Public Space*. Berkeley: University of California Press, 1994.

Cellini, Benvenuto. *The Autobiography of Benvenuto Cellini*. Translated by John Addington Symonds. Garden City, NY: Garden City Publishing, 1927.

Cerantola, Alessia. "The Last Eel Catcher of Rome." BBC News, October 8, 2014. https://www.bbc.com/news/magazine-29425984.

Cicero. *On the Republic,* Book 2:6.

Clark, Eleanor. *Rome and a Villa*. Garden City, NY: Doubleday, 1952.

Coarelli, Filippo. *Il foro boario dalle origini alla fine della repubblica*. Rome: Quasar, 1988.

———. *Il Campo Marzio dalle Origini alla Fine della Repubblica*. Rome: Quasar, 1997.

———. *Palatium. Il Palatino dalle origini all'impero*. Rome: Quasar, 2012.

Coates-Stephens, Robert. "The Walls and Aqueducts of Rome in the Early Middle Ages, A.D. 500–1000." *JRS* 88 (1998): 166–78.

———. *Porta Maggiore: Monument and Landscape*. Rome: L'Erma di Bretschneider, 2004.

Coffin, David R. *The Villa in the Life of Renaissance Rome*. Princeton: Princeton University Press, 1979.

———. *Gardens and Gardening in Papal Rome*. Princeton: Princeton University Press, 1991.

Cohen, Elizabeth S. "Seen and Known: Prostitutes in the Cityscape of Late-Sixteenth-Century Rome." *Renaissance Studies* 12, no. 3 (1998): 392–409.

Colini, Antonio Maria, and Italo Gismondi. *Storia e topografia del Celio nell'antichità*. Vatican City: Tipografia Poliglotta Vaticana, 1944.

Collins, Jeffrey. *Papacy and Politics in Eighteenth-Century Rome: Pius VI and the Arts*. Cambridge: Cambridge University Press, 2004.

Comune di Roma. *La Capitale a Roma Città e Arredo Urbano 1870–1945*. Vol. 1. Rome: Assessorato alla Cultura, 1991.

Connors, Joseph. "S. Ivo alla Sapienza: The First Three Minutes." *JSAH* 55, no. 1 (1996): 38–57.

Cooke, Hereward Lester. "The Documents Relating to the Fountain of Trevi." *AB* 38 (1956): 149–71.

Coppa, Giorgio, Luigi Pediconi, and Girolamo Bardi. *Acque e acquedotti a Roma, 1870–1984*. Rome: Edizione Quasar, 1984.

Coppola, Maria Rosaria, Adriano Morabito, and Marco Placidi. *Il Vittoriano nascosto*. Rome: Ministero per i Beni e le Attività Culturali, 2005.

Corazza, Angelo, and Leonardo Lombardi. "Idrogeologia dell'Area del Centro Storico di Roma." In Funiciello 1995, 179–211.

Courtney, William Todd. "Un fiume per *Roma Capitale:* The Socio-Political Landscape of the Tiber Embankment, 1870–1910." Master's thesis, University of Wisconsin–Madison, 2003.

Crescimbeni, Giovanni. *Stato della basilica diaconale, collegiata e parrocchiale di S. Maria in Cosmedin di Roma*. Rome: A. Rossi, 1719.

Curran, Brian, Anthony Grafton, Pamela Long, and Benjamin Weiss. *Obelisk: A History*. Cambridge, MA: MIT Press, 2009.

D'Alessandro, Maria Michela. "How Rome Is Failing to Face the Refugee Crisis in Italy." Euronews, August 28, 2017. https://www.euronews.com/2017/08/28/how-rome-is-failing-to-face-the-refugee-crisis-in-italy.

D'Annunzio, Gabriele. *The Child of Pleasure*. New York: Modern Library, 1925.

Davis, Charles. "Villa Giulia e la Fontana della Vergine." *Psicon* 3 (1976): 132–41.

Deakin, Richard. *Flora of the Colosseum of Rome.* London: Groombridge, 1914.

De Angelis d'Ossat, Gioacchino. "Notizie geologiche sul Quirinale." *Bollettino della Società geologica italiana* 57, no. 2 (1938): 174–85.

———. *La Geologia del Monte Vaticano.* Vatican City: Biblioteca Apostolica Vaticana, 1953.

———. *Geologia del Colle Palatino in Roma.* Memorie Descrittive della Carta Geologica d'Italia 32. Rome: Libreria dello Stato, 1956.

de Brosses, Charles. *Selections from the Letters of De Brosses.* Translated by Ronald Sutherland Gower. London: Kegan Paul, Trench, Trübner, 1897.

DeLaine, Janet. *The Baths of Caracalla: A Study in the Design, Construction and Economics of Large-Scale Building Projects in Imperial Rome.* Portsmouth, RI: Journal of Roman Archaeology, 1997.

Delumeau, Jean. *Vie économique et sociale de Rome dans la seconde moitié du XVIe siècle.* 2 vols. Paris: Hachette, 1957–59.

Dennis, Kimberly L. "Re-Constructing the Counter Reformation: Women Architectural Patrons in Rome and the Case of Camilla Peretti." PhD diss., University of North Carolina–Chapel Hill, 2005.

De Vico Fallani, Massimo. *Storia dei giardini pubblici di Roma nell'Ottocento.* Rome: Newton Compton, 1992.

Dey, Hendrik. "*Diaconiae, Xenodochia, Hospitalia* and Monasteries: 'Social Security' and the Meaning of Monasticism in Early Medieval Rome." *Early Medieval Europe* 16, no. 4 (2008): 398–422.

———. *The Aurelian Wall and the Refashioning of Imperial Rome, A.D. 271–855.* Cambridge: Cambridge University Press, 2011.

Dickens, Charles. *Pictures from Italy.* London: Bradbury and Evans, 1846.

Di Gaddo, Beata. *Le Fontane di Roma.* Genoa: Vitali e Ghianda, 1964.

———. *Villa Borghese, il giardino, l'architettura.* Rome: Officina, 1985.

Di Martino, Vittorio, Roswitha Di Martino, and Massimo Belati. *Huc Tiber ascendit: Le memorie delle inondazioni del Tevere a Roma.* Rome: Arbor Sapientiae, 2017.

Dixon, Susan M. *Between the Real and the Ideal: The Accademia degli Arcadi and Its Garden in Eighteenth-Century Rome.* Newark: University of Delaware Press, 2006.

D'Onofrio, Cesare. *Castel Sant'Angelo e Borgo tra Roma e Papato.* Rome: Romana Società Editrice, 1978.

———. *Il Tevere.* Rome: Romana Società Editrice, 1980.

———. *Le Fontane di Roma.* Rome: Romana Società Editrice, 1986.

Duchesne, Louis. *Le Liber pontificalis.* 2 vols. Paris: E. Thorin, 1886–92.

DuPérac, Étienne. *Vestigi dell'Antichità di Roma.* Rome, 1575.

Edwards, Nancy Elizabeth. "The Renaissance *Stufetta* in Rome: The Circle of Raphael and the Recreation of the Antique." PhD diss., University of Minnesota, 1982.

Eiche, Sabine. "Cardinal Giulio della Rovere and the Vigna Carpi." *JSAH* 45, no. 2 (1986): 115–33.

Estevez, Junno Arocho. "The 'Pope Francis Laundry' for Rome's Homeless Opens at Vatican." *Jesuit Review,* April 10, 2017.

Eternal Tiber. "Triumphs and Laments—Guide." https://eternaltiber.net/triumphs-and-laments-research/.

Evangelisti, Mauro. "Roma, mamma suicida nel Tevere, si cercano ancora le gemelline: Aveva perso un'altra figlia." *Il Messaggero,* December 21, 2018.

Evans, Harry. *Water Distribution in Ancient Rome: The Evidence of Frontinus.* Ann Arbor: University of Michigan Press, 2000.

———. *Aqueduct Hunting in the Seventeenth Century.* Ann Arbor: University of Michigan Press, 2002.

Facenna, Claudio, Renato Funiciello, and F. Marra. "Inquadramento Geologico Strutturale dell'Area Romana." In Funiciello 1995, 31–47.

Fagiolo, Marcello, and Maria Luisa Madonna, eds. *Sisto V. Roma e il Lazio.* Rome: Istituto Poligrafico e Zecca dello Stato, 1992.

Falda, Giovanni Battista. *Il Terzo Libro del'Novo Teatro delle Chiese di Roma date in Luce sotto il Felice Pontificato di Nostro Signore Papa Clemente IX.* Rome, 1669.

———. *Le fontane di Roma nelle piazze, e luoghi publici della città, con li loro prospetti.* Vol. 1. Rome: Giacomo Rossi, 1675–91.

Falk, Tilman. "Studien zur Topographie und Geschichte der Villa Giulia in Rom." *RJK* 13 (1971): 101–78.

Faure, Gabriel. *The Gardens of Rome.* New York: Brentano's, 1926.

Fea, Carlo. *Storia delle acque antiche sorgenti in Roma, perdute, e modo di ristabilirle.* Rome: R. C. Apostolica, 1832.

Filarete (Antonio di Pietro Averlino). *Trattato di Architettura.* Milan, c. 1464.

Finch, Margaret. "The Cantharus and Pigna at Old St. Peter's." *Gesta* 30, no. 1 (1991): 16–26.

Fontana, Domenico. *Della Trasportatione Dell'obelisco Vaticano et Delle Fabriche di Nostro Signore Papa Sisto V.* Rome: Appresso Domenico Basa, 1590.

Fried, Robert C. *Planning the Eternal City: Roman Politics and Planning since World War II.* New Haven: Yale University Press, 1973.

Frommel, Christoph Luitpold. "La Villa e i Giardini del Quirinale nel Cinquecento." In "Restauri al Quirinale." Special issue, *Bollettino d'Arte* 1 (1999): 15–62.

Frommel, Christoph Luitpold, Giulia Caneva, and Alessandro Angeli. *La Villa Farnesina a Rome.* Modena: F. C. Panini, 2003.

Funiciello, Renato, ed. *La Geologia di Roma, il Centro Storico, Memoria, Carta Geologica d'Italia.* 2 vols. Rome: Istituto Poligrafico e Zecca Dello Stato, 1995.

Gamrath, Helge. *Roma Sancta Renovata: Studi sull'urbanistica di Roma nella seconda metà del secolo XVI, con particolare riferimento al pontificato di Sisto V (1585–1590).* Suppl. 12. Rome: Analecta Romana Instituti Danici, 1987.

Gasparri, Carlo. *Villa Albani Torlonia: Architetture, collezioni, giardino.* Milan: Electa, 2022.

Ghisalberti, Alberto Maria, ed. *Dizionario Biografico Degli Italiani.* Rome: Istituto della Enciclopedia Italiana, 1960–present.

Gibson, Sheila and Bryan Ward-Perkins. "The Surviving Remains of the Leonine Wall. Part II: The Passetto." *PBSR* 51 (1983): 222–39.

Gigli, Enrico. "Le Incognite del Colli Quirinale e Pincio." *Cap* 45, no. 12 (1970): 43–75.

Gigli, Laura. *Guide Rionali di Roma.* vol. 13 *Rione XIII: Trastevere.* 5 parts. Rome: Palombi, 1977–87.

Giustini, Laura. *Fornaci e Laterizi a Roma dal XV al XIX Secolo.* Rome: Kappa, 1997.

Gleason, Kathryn. "Porticus Pompeiana: A New Perspective on the First Public Park in Rome." *Journal of Garden History* 14 (1994): 13–27.

Goethe, Johann Wolfgang von. *Italian Journey, 1786–1788.* Translated by W. H. Auden. Harmondsworth, UK: Penguin, 1970.

Goodhue, Nicholas. *The Lucus Furrinae and the Syrian Sanctuary on the Janiculum.* Amsterdam: Adolf M. Hakkert, 1975.

Gratani, Loretta, Andrea Bonito, and Miquel Ribas-Carbo. *The Plants of the Trevi Fountain.* Rome: Scienze e Lettere, 2014.

Gratani, Loretta, Laura Varone, and Andrea Bonito. "Carbon Sequestration of Four Urban Parks in Rome." *Urban Forestry and Urban Greening* 19 (2016): 184–93.

Gregorovius, Ferdinand. *History of the City of Rome in the Middle Ages.* Translated by Mrs. Gustavus W. Hamilton. 8 vols. London: George Bell, 1900–1912.

Grimal, Pierre. *Les jardins romains à la fin de la République et aux deux premiers siècles de l'Empire: Essai sur le naturalisme romain.* Paris: E. du Boccard, 1943.

Guicciardini, Luigi. *The Sack of Rome.* Edited and translated by James H. McGregor. New York: Italica, 1993.

Guidoni, Enrico, and Giulia Petrucci. *Urbanistica per I Giubilei. Roma, Via Alessandrina.* Rome: Kappa, 1997.

Habel, Dorothy Metzger. *"When all of Rome was under construction": The Building Process in Baroque Rome.* University Park: Pennsylvania State University Press, 2013.

Hackett, Lewis Wendell. *Malaria in Europe: An Ecological Study.* Oxford: Oxford University Press, 1937.

Hartswick, Kim. *The Gardens of Sallust: A Changing Landscape.* Austin: University of Texas, 2004.

Hawthorne, Nathaniel. *The Marble Faun.* Boston: Tichenor and Fields, 1860.

Heilmann, Christoph H. "Acqua Paola and the Urban Planning of Paul V Borghese." *Bur.M* 112, no. 811 (1970): 656–62.

Herschel, Clemens. *The Two Books on the Water Supply of the City of Rome of Sextus Julius Frontinus.* 2nd. ed. New York: Longmans, Green, 1913.

Hetland, Lise. "New Perspectives on Dating the Pantheon." In *The Pantheon,* edited by Tod Marder and Mark Wilson Jones. Cambridge: Cambridge University Press, 2015.

Hibbard, Howard. "Palazzo Borghese Studies I: The Garden and Its Fountains." *Bur.M* 100, no. 663 (1958): 205–15.

———. *Carlo Maderno and Roman Architecture 1580–1630.* University Park: Pennsylvania State University Press, 1971.

Hibbard, Howard, and Irma Jaffe. "Bernini's Barcaccia." *Bur.M* 106, no. 733 (1964): 159–75.

Higginbotham, James. *Piscinae: Artificial Fishponds in Roman Italy.* Chapel Hill: University of North Carolina Press, 1997.

Holland, Louise. *Janus and the Bridge.* Rome: American Academy in Rome, 1961.

Hopkins, John N. "The Cloaca Maxima and the Monumental Manipulation of Water in Archaic Rome." *WROP* 4 (2007).

Hubert, Étienne, and Cristina Carbonetti Vendittelli. *Rome au XIIIe et XIVe siècles: Cinq etudes.* Rome: École française du Rome, 1993.

Hüetter, Luigi. "I Mattei, Custodi dei Ponti." *Cap.* 5 (1929): 347–55.

Hülsen, Christian, and Hermann Egger, eds. *Die Römischen Skizzenbücher von Marten van Heemskerck.* 2 vols. Berlin: Bard, 1913–16.

Ingersoll, Richard. "Piazza di Ponte and the Military Origins of Panopticism." In Çelik et al. 1994, 177–88.

Insolera, Italo. *Roma moderna.* Turin: Einaudi, 1962.

———. *Roma, immagini e realta dal X al XX secolo.* 1980. Reprint, Rome-Bari: Laterza, 2002.

James, Henry. *Italian Hours.* 1873. Reprint, New York: Penguin, 1995.

Katz, Robert. *The Battle for Rome: The Germans, the Allies, the Partisans, and the Pope, September 1943–June 1944.* New York: Simon and Schuster, 2003.

Keyvanian, Carla. *Hospitals and Urbanism in Rome, 1200–1500.* Leiden: Brill, 2016.

Kirk, Terry. "Framing St. Peter's: Urban Planning in Fascist Rome." *AB* 88 (2006): 756–76.

Koortbojian, Michael. *Crossing the Pomerium.* Princeton: Princeton University Press, 2020.

Kostof, Spiro. *The Third Rome.* Berkeley: University of California Press, 1973.

Krautheimer, Richard. *Roma Alessandrina. The Remapping of Rome under Alexander VII 1655–1667.* Poughkeepsie, NY: Vassar College, 1982.

———. "Roma verde nel Seicento." In *Studi in onore di Giulio Carlo Argan,* edited by Silvana Macchioni and Bianca Tavassi La Greca, 2:71–82. Rome: Multigrafica Editrice, 1984.

———. *Profile of a City.* 1980. Reprint, Princeton: Princeton University Press, 2000.

Krautheimer, Richard, Wolfgang Frankl, and Spencer Corbett. *Corpus Basilicarum Christianarum Romae: The Early Christian Basilicas of Rome (IV–IX cent.).* 5 vols. Vatican City: Pontificio Istituto di Archeologia Cristiana, 1937–77.

Lanciani, Rodolfo. *Topografia di Roma antica: I comentarii di Frontino intorno le acque e gli acquedotti.* Rome: Accademia dei Lincei, 1880.

———. *L'Itinerario di Einsiedeln e L'Ordine di Benedetto Canonico.* Rome: Accademia dei Lincei, 1891.

———. *The Ruins and Excavations of Ancient Rome.* Boston: Houghton Mifflin, 1897.

———. *Wanderings in the Roman Campagna.* Boston: Houghton Mifflin, 1909.

———. *Notes from Rome.* Edited by Anthony L. Cubberley. Rome: British School at Rome, 1988.

———. *Storia degli scavi di Roma e notizie intorno le collezioni romane di antichità.* Edited by L. Malvezzi Campeggi. Rome: Edizioni Quasar, 1989–2002.

Lazzaro, Claudia. *The Italian Renaissance Garden.* New Haven: Yale University Press, 1990.

Le Gall, Joël. *Le Tibre fleuve de Rome dans l'antiquité.* Paris: Presses universitaires de France, 1953.

Lewis, Michael. *Surveying Instruments of Greece and Rome.* Cambridge: Cambridge University Press, 1999.

Liverani, Paolo. *La topografia antica del Vaticano.* Vatican City: Biblioteca Apostolica Vaticana, 1999.

Livy (Titus Livius). *The Early History of Rome.* Books 1–5 of *The History of Rome from Its Foundation.* Translated by Aubrey de Sélincourt. Hammondsworth: Penguin, 1971.

Lombardi, Leonardo. "Camillo Agrippa's Hydraulic Inventions on the Pincian Hill (1574–1578)." *WROP* 5 (2008).

Lombardi, Leonardo, and Angelo Corazza. *Le Terme di Caracalla.* Rome: Fratelli Palombi, 1996.

Long, Pamela. *Engineering the Eternal City.* Chicago: University of Chicago Press, 2018.

Lusnia, Susann Sowers. *Creating Severan Rome: The Architecture and Self-Image of L. Septimius Severus (A. D. 193–211).* Brussels: Éditions Latomus, 2014.

Macadam, Alta. *Rome.* Taunton: Blue Guide, 2020.

MacDonald, William. *The Architecture of the Roman Empire.* Vol. 1. New Haven: Yale University Press, 1982.

MacDougall, Elisabeth Blair. "L'Ingegnoso Artifizio: Sixteenth-Century Garden Fountains in Rome." In *Fons Sapientiae: Renaissance Garden Fountains,* edited by Elisabeth Blair MacDougall, 85–113. DOaksLA, vol. 4. Washington, DC: Dumbarton Oaks Research Library and Collection, 1978.

———. "A Circus, a Wild Man and a Dragon: Family History and the Villa Mattei." *JSAH* 42, no. 2 (1983): 121–30.

Magni, Giulio. *Il barocco a Roma nell'architettura e nelle sculura decorativa.* Vol. 3. Turin: C. Crudo, 1911–13.

Maier, Jessica. *Rome Measured and Imagined: Early Modern Maps of the Eternal City.* Chicago: University of Chicago Press, 2016.

Manacorda, Daniele. *Crypta Balbi: Archeologia e storia di un paesaggio urbano.* Milan: Electa, 2001.

Marder, Tod A. "Sixtus V and the Quirinal." *JSAH,* 37, no. 4 (1978): 283–94.

———. "The Porto di Ripetta in Rome." *JSAH* 39, no. 1 (1980): 28–56.

———. "Alexander VII, Bernini, and the Urban Setting of the Pantheon in the Seventeenth Century." *JSAH* 50, no. 3 (1991): 273–92.

Mariotti Bianchi, Umberto. *Roma Sparita. I Molini del Tevere.* Rome: Babuino, 1977.

Martial. *Epigrams.* 3 vols. Edited and translated by D. R. Shackleton Bailey. Loeb Classical Library. Cambridge, MA: Harvard University Press, 1993.

Martinelli, Fioravante, and Cesare D'Onofrio. *Roma nel Seicento.* Florence: Vallecchi, 1968.

Martini, Antonio. *Arti mestieri e fede nella Roma dei Papi.* Bologna: Capelli, 1965.

Massimo, Camillo Vittorio Emanuele. *Notizie Istoriche della Villa Massimo alle Terme Diocleziane.* Rome: Salviucci, 1836.

Matitti, Flavia. "Fontane e Fontanelle (1918–1945)." In *Comune di Roma* 1991, 1:198–209.

McPhee, Sarah. *Bernini and the Bell Towers: Architecture and Politics at the Vatican.* New Haven: Yale University Press, 2003.

Meiggs, Russell. *Trees and Timber in the Mediterranean World.* Oxford: Oxford University Press, 1982.

Meijer, Cornelius. *L'Arte di Restituire a Roma la tralasciata navigatione del Tevere.* Rome: L. Varese, 1685.

Meneghini, Roberto. *I fori imperiali e I Mercati di Traiano: Storia e descrizione dei monumenti alla luce degli scavi recenti.* Rome: Istituto poligrafico e Zecca dello Stato, 2009.

Meneghini, Roberto, and Riccardo Santangeli Valenzani. *Roma nell'Altomedioevo: Topografia e Urbanistica della Città dal V al X Secolo.* Rome: Istituto Poligrafico dello Stato, 2004.

Montaigne, Michel de. *The Journal of Montaigne's Travels in Italy by Way of Switzerland and Germany in 1580 and 1581.* Translated by W. G. Waters. London: John Murray, 1903.

Moore, John E. "Building Set Pieces in Eighteenth-Century Rome: The Case of the Chinea." *MAAR* 43/44 (1998/99): 183–244.

Morton, H. V. *The Fountains of Rome.* New York: Macmillan, 1966.

Müntz, Eugene. *Les arts à la cour des Papes pendant le XVe et le XVIe siècle: Recueil de documents inédits.* 4 vols. Paris: E. Thorin, 1878–82.

Narducci, Pietro. *Sulla fognatura della Città di Roma.* Rome: Forzani, 1889.

Neuerburg, Norman. *L'architettura delle fontane e dei ninfei nell'Italia antica.* Naples: G. Macchiaroli, 1960.

Nibby, Antonio *Roma nell'Anno 1838.* Vol. 4. Rome: Tipografia delle Belle Arti, 1841.

Nicassio, Susan Vandiver. *Imperial City: Rome, Romans and Napoleon 1796–1815*. Welwyn Garden City, UK: Ravenhall, 2005.

Nichols, Francis Morgan, and Eileen Gardiner. *The Marvels of Rome: "Mirabilia Urbis Romae."* New York: Italica, 1986.

Nussdorfer, Laurie. *Civic Politics in the Rome of Urban VIII.* Princeton: Princeton University Press, 1992.

Orbaan, Johannes A. F. *Sixtine Rome.* London: Constable, 1911.

Ovid. *Fasti,* Books 2, 5, and 6. Translated by A. J. Boyle and R. D. Woodard. London: Penguin, 2000.

———. *Metamorphoses,* Book 1. Translated by Ian Johnston. 2011. https://johnstoniatexts .x10host.com/ovid/metamorphosespdf.pdf.

Parker, John Henry. *The Aqueducts of Rome.* Oxford: Oxford University Press, 1876.

Pecchiai, Pio. *Acquedotti e Fontane di Roma nel Cinquecento.* Rome: Staderini, 1944.

———. *Il Campidoglio nel Cinquecento.* Rome: Nicola Ruffolo, 1950.

Petrarch, Francesco. *Francesco Petrarca, Letters on Familiar Matters = Rerum Familiarum Libri.* Edited by Aldo S. Bernardo. New York: Italica, 2005.

Petrucci, Giulia. *Una Strada del Seicento a Roma: La Via di S. Francesco a Ripa.* Rome: Kappa, 1995.

Pinto, John. *The Trevi Fountain.* New Haven: Yale University Press, 1986.

Pliny the Elder. *The Natural History.* London: Henry G. Bohn, 1861.

Poleni, Giovanni. *De motu aquae mixto libri duo.* Padua: Typis Iosepi Comini, 1717.

Portoghesi, Paolo. *The Rome of Borromini. Architecture as Language.* Translated by Barbara Luigia La Penta. Rome: George Braziller, 1968.

Procopius of Caesarea. *History of the Wars.* 5 vols. Books 1, 5, and 6. Translated by H. B. Dewing. Cambridge, MA: Harvard University Press, 1914–28.

Purcell, Nicholas. *Human Landscapes in Classical Antiquity.* London: Routledge, 1996.

———. *The Horti of Rome and the Landscape of Property.* Rome: Quasar, 2007.

Quilici, Lorenzo. "Sull'acquedotto Vergine dal Monte Pincio alla sorgente." *Quaderni dell'Istituto di topografia antica della Università di Roma* 5 (1968): 125–60.

Ramieri, Anna Maria. *I vigili del fuoco nella Roma antica.* Rome: Figli Palombi, 1990.

Rea, Rossella. *The Colosseum.* Milan: Electa, 2019.

———, ed. *Rota Colisei. La Valle del Colosseo attraverso I Secoli.* Milan: Electa, 2002.

Richardson, Lawrence. *A New Topographical Dictionary of Ancient Rome.* Baltimore: Johns Hopkins University Press, 1992.

Richmond, Ian A. *The City Wall of Imperial Rome.* Oxford: Clarendon, 1930.

Rinne, Katherine. *The Waters of Rome: Aqueducts, Fountains, and the Birth of the Baroque City.* New Haven: Yale University Press, 2010.

———. "Urban Ablutions: Cleansing Counter-Reformation Rome." In Bradley and Stow 2012, 182–201.

———. "Garden Hydraulics in Pre-Sistine Rome; Theory and Practice." In *Technology and the Garden,* edited by M. Lee and K. Helphand, 111–28. DOaksLA, vol. 35. Washington, DC: Dumbarton Oaks Research Library and Collection, 2014.

———. "Trickle Down: Water in Late Sixteenth- and Seventeenth-Century Rome." *MAAR* 66 (2021): 151–81.

Robbins, Deborah. "Via della Lungaretta. The Making of a Medieval Street." In Çelik et al. 1994, 165–76.

Rodocanachi, Emmanuel. *Rome au Temps de Jules II et Léon X.* Paris: Hachette, 1912.

Romano, David Gilman. Digital Augustan Rome. https://www.digitalaugustanrome.org/records/vada-tarenti/.

Rovere, C. *Una Passeggiata al Pincio.* Rome: Stabilimento Tipografico alle Terme Diocleziane, 1877.

Rowland, Ingrid D. *The Ecstatic Journey: Athanasius Kircher in Baroque Rome.* Chicago: University of Chicago Library, 2000.

———. "'Th' United Sense of th' Universe': Athanasius Kircher in Piazza Navona." *MAAR* 46 (2001): 153–81.

———. *The Roman Garden of Agostino Chigi.* Groningen: Gerson Lectures Foundation, 2005.

———. *The Culture of the High Renaissance: Ancients and Moderns in Sixteenth-Century Rome.* Cambridge: Cambridge University Press, 2011.

Salerno, Luigi, Luigi Spezzaferro, and Manfredo Tafuri. *Via Giulia: Una utopia urbanistica del 500.* Rome: Aristide Staderini, 1975.

Sallares, Robert. *Malaria and Rome: A History of Malaria in Ancient Italy.* New York: Oxford University Press. 2002.

Sanfilippo, Isa Lori. *La Roma dei Romani: Arte, mestieri e professioni nella Roma nel Trecento.* Nuovi Studi Storici 57. Rome: Istituto Storico Italiano per il Medio Evo, 2001.

Sanguinetti, Pietro. *Florae Romanae Prodromus Alter Exhibens Plantas Vasculares.* Rome: Bonarum Artium, 1864.

San Juan, Rose Marie. *Rome: A City Out of Print.* Minneapolis: University of Minnesota, 2001.

Santangeli Valenzani, Riccardo. "Strade, case e orti nell'alto medioevo nell'area del foro di Nerva." *Mélanges de l'École française de Rome* 111, no. 1 (1999): 163–69.

———. "Public and Private Space in Rome during Late Antiquity and the Early Middle Ages." *Fragmenta* 1 (2007): 63–81.

Schama, Simon. *Landscape and Memory.* New York: Alfred A. Knopf, 1995.

Schmölder-Veit, Andrea. "Aqueducts for the Urbis Clarissimus Locus: The Palatine's Water Supply from Republican to Imperial Times." *WROP* 7 (2011).

Segarra Lagunes, Maria M. *Il Tevere a Roma, Storia di una Simbiosi.* Rome: Gangemi, 2004.

Serlorenzi, Mirella. "Caligula's Garden of Delights." *New York Times,* January 12, 2021.

Severino, Nicola. *Pavimenti cosmateschi di Roma: Storia, Leggenda e Verità.* Roccasecca: Ilmiolibro, 2012.

Shearman, John. "A Functional Interpretation of Villa Madama." *RJK* 125 (1983): 241–327.

Shelley, Percy Bysshe. *The Prose Works of Percy Bysshe Shelley.* Edited by Richard Herne Shepherd. London: Chatto and Windus, 1906.

Simoncini, Giorgio. *"Roma Restaurata" Rinnovamento Urbano al Tempo di Sisto V.* Florence: Leo S. Olschki, 1990.

Sinisi, Daniela. "Lavori Pubblici di Acque e Strade e Congregazioni Cardinalizie in Epoca Sistina e Presistina." In Spezzaferro, Luigi and Maria Elisa Tittoni, *Il Campidoglio e Sisto V.* Rome: Carte Segnete, 1991.

Smith, Strother. *The Tiber and Its Tributaries, Their Natural History and Classical Associations.* London: Longmans, Green, 1877.

Soderini, Giovanvettorio. *Il Trattato degli Arbori.* Bologna: Romagnoli Dall'Acqua, 1904.

Spinosi, Franco, ed. *Piazza Navona Isola dei Pamphilj.* Rome: Aster Arti Grafiche, 1970.

Standage, Tom. *A History of the World in Six Glasses.* New York: Walker, 2005.

Steinby, Eva Margareta. *Lexicon topographicum urbis Romae (LTUR).* 6 vols. Rome: Edizioni Quasar, 1993–2000.

Stow, Kenneth. *Theater of Acculturation, the Roman Ghetto in the Sixteenth Century.* Seattle: University of Washington Press, 2001.

Suetonius. *The Twelve Caesars.* Translated by Robert Graves. London: Penguin, 1957.

Tacitus, Cornelius. *The Complete Works of Tacitus.* Edited by J. A. Church. New York: Modern Library, 1942.

Taine, Hippolyte. *Voyage en Italie.* Vol. 1, *Rome et Naples.* Paris: Juillard, 1965.

Taylor, Rabun. "Torrent or Trickle? The Aqua Alsietina, the Naumachia Augusti, and the Transtiberim." *AJA* 101 (1997): 465–92.

————. *Public Needs and Private Pleasures.* Rome: L'Erma di Bretschneider, 2000.

Taylor, Rabun, Katherine Rinne, and Spiro Kostof. *Rome: An Urban History from Antiquity to the Present.* Cambridge: Cambridge University Press, 2016.

Taylor, Rabun, Katherine Rinne, Edward O'Neill, and Michael O'Neill. "A Grotto-Shrine at the Headwaters of the Aqua Traiana." *JRA* 23 (2010): 358–75.

Tchikine, Anatole. "Giochi d'acqua: Water Effects in Renaissance and Baroque Italy." *Studies in the History of Gardens and Designed Landscapes* 30, no. 1 (2010): 57–76.

Thomas, Robert G. "Geology of Rome, Italy." *Bulletin of the Association of Engineering Geologists* 26, no. 4 (1989): 415–76.

Tilly, Bertha. *Vergil's Latium.* Oxford: Basil Blackwell, 1947.

Tomassetti, Giuseppe, Luisa Chiumenti, and Fernando Bilancia. *La Campagna Romana antica, medioevale e moderna.* Florence: Leo S. Olschki, 1979–80.

Triff, Kristin. *Patronage and Public Image in Renaissance Rome: The Orsini Palace at Monte Giordano.* Turnhout: Brepols, 2013.

UN Committee on Economic, Social and Cultural Rights. "General Comment No. 15: The Right to Water." November 2002.

Valone, Carolyn. "Women on the Quirinal Hill: Patronage in Rome, 1560–1630." *AB* 76 (1994): 129–46.

Van Deman, Esther. *The Building of the Roman Aqueducts.* Washington DC: Carnegie Institution, 1934.

Varriano, John. *A Literary Companion to Rome: Including Ten Walking Tours.* New York: St. Martin's Press, 1991.

Vasi, Giuseppe. *Itinerario istruttivo diviso in otto giornate.* Rome, 1752.

Venturini, Giovanni Francesco. *Le Fontane ne Palazzi e ne Giardini di Roma.* Vol. 3. Rome, 1676–89.

Vergelli, Tiburtio. *Le fontane publiche delle piazze di Roma moderna.* Rome: Carlo Losi, 1773.

Vermaseren, M. J. *Corpus Inscriptionum et monumentorum religionis Mithriacae.* The Hague: Martinus Nijhoff, 1956–60.

Vicus Caprarius. *La Città dell'Acqua.* https://www.vicuscaprarius.com.

Villani, Matteo. *Cronica di Matteo Villani.* Vol. 2. Edited by Franc Gherardi Dragomanni. Florence: Sansone Coen, 1846.

Virgil (P. Virgilius Maro). *The Aeneid.*

Waddy, Patricia. *Seventeenth-Century Roman Palaces: Use and the Art of the Plan.* Cambridge, MA: MIT Press, 1990.

Wasserman, Jack. "The Quirinal Palace in Rome." *AB* 65 (1963): 205–44.

Wilbur, Richard. "A Baroque Wall-Fountain in the Villa Sciarra." In *Collected Poems, 1943–2004.* New York: Harcourt, 2004.

Wilson, Andrew. I. "The Water-Mills on the Janiculum." *MAAR* 45 (2000): 219–46.

Wrigley, Richard. *Roman Fever: Influence, Infection, and the Image of Rome, 1700–1870.* New Haven: Yale University Press, 2013.

Yegül, Fikret. *Baths and Bathing in Classical Antiquity.* Cambridge, MA: MIT Press, 1992.

Subject Bibliographies

For aqueducts, see:

Aicher, Peter. *Guide to the Aqueducts of Ancient Rome.* Wauconda, IL: Bolchazy-Carducci, 1995.

Ashby, Thomas. *The Aqueducts of Ancient Rome.* Oxford: Oxford University Press, 1935.

Cassio, Alberto. *Corso dell'acque antiche portate sopra XIV. Aquidotti da lontane contrade nelle XIV* [. . .] 2 vols. Rome, 1756–57.

Coppa, Giorgio, Luigi Pediconi, and Girolamo Bardi. *Acque e acquedotti a Roma, 1870–1984.* Rome: Edizione Quasar, 1984.

Evans, Harry. *Water Distribution in Ancient Rome: The Evidence of Frontinus.* Ann Arbor: University of Michigan Press, 2000.

Fea, Carlo. *Storia delle acque antiche sorgenti in Roma, perdute, e modo di ristabilirle.* Rome: R. C. Apostolica, 1832.

Herschel, Clemens. *The Two Books on the Water Supply of the City of Rome of Sextus Julius Frontinus.* 2nd. ed. New York: Longmans, Green, 1913.

Lanciani, Rodolfo. *Topografia di Roma antica: I comentarii di Frontino intorno le acque e gli acquedotti.* Rome: Accademia dei Lincei, 1880.

Parker, John Henry. *The Aqueducts of Rome.* Oxford: Oxford University Press, 1876.

Van Deman, Esther. *The Building of the Roman Aqueducts.* Washington DC: Carnegie Institution, 1934.

For the Capitoline Hill, see:

Brancia di Apricena, Marianna. *Il Complesso dell'Aracoeli sul Colle Capitolino (IX–XIX secolo).* Rome: Quasar, 2000.

Pecchiai, Pio. *Il Campidoglio nel Cinquecento.* Rome: Nicola Ruffolo, 1950.

Simoncini, Giorgio. *"Roma Restaurata" Rinnovamento Urbano al Tempo di Sisto V.* Florence: Leo S. Olschki, 1990.

For fountains, see:

Di Gaddo, Beata. *Le Fontane di Roma.* Genoa: Vitali e Ghianda, 1964.

D'Onofrio, Cesare. *Le Fontane di Roma.* Rome: Romana Società Editrice, 1986.

Falda, Giovanni Battista. *Le fontane di Roma nelle piazze, e luoghi pubblici della città, con li loro prospetti.* Vol. 1. Rome: Giacomo Rossi, 1675–91.

Morton, H. V. *The Fountains of Rome.* New York: Macmillan, 1966.

Pecchiai, Pio. *Acquedotti e Fontane di Roma nel Cinquecento.* Rome: Staderini, 1944.

Pinto, John. *The Trevi Fountain.* New Haven: Yale University Press, 1986.

Rinne, Katherine. *The Waters of Rome: Aqueducts, Fountains, and the Birth of the Baroque City.* New Haven: Yale University Press, 2010.

Venturini, Giovanni Francesco. *Le Fontane ne Palazzi e ne Giardini di Roma.* Vol. 3. Rome, 1676–89.

Vergelli, Tiburtio. *Le fontane publiche delle piazze di Roma moderna.* Rome: Carlo Losi, 1773.

For geology and hydrology in general, see:

Brocchi, Giambattista. *Dello stato fisico del suolo di Roma.* Rome: De Romanis, 1820.

Corazza, Angelo, and Leonardo Lombardi. "Idrogeologia dell'Area del Centro Storico di Roma." In Funiciello 1995, 179–211.

Facenna, Claudio, Renato Funiciello, and F. Marra. "Inquadramento Geologico Strutturale dell'Area Romana." In Funiciello 1995, 1:31–47.

Funiciello, Renato, ed. *La Geologia di Roma, il Centro Storico, Memoria, Carta Geologica d'Italia.* 2 vols. Rome: Istituto Poligrafico e Zecca Dello Stato, 1995.

Thomas, Robert G. "Geology of Rome, Italy." *Bulletin of the Association of Engineering Geologists* 26, no. 4 (1989): 415–76.

For the Palatine Hill, see:

Augenti, Andrea. *Il Palatino nel medioevo: archeologia e topografia (secoli VI–XIII).* Rome: L'Erma di Bretschneider, 1996.

Coarelli, Filippo. *Palatium. Il Palatino dalle origini all'impero.* Rome: Quasar, 2012.

Schmölder-Veit, Andrea. "Aqueducts for the Urbis Clarissimus Locus: The Palatine's Water Supply from Republican to Imperial Times." *WROP* 7 (2011).

For Palazzo Apostolico (Vatican Palace), Belvedere, and gardens, see:

Ackerman, James. *The Cortile del Belvedere, Studi e Documenti Per la Storia del Palazzo Apostolico Vaticano.* 3 vols. Vatican City: Biblioteca Apostolica Vaticana, 1953.

Brummer, Hans Henrik. *The Statue Court of the Vatican Belvedere.* Stockholm: Almqvist und Wiksell, 1970.

Cellauro, Louis. "The Casino of Pius IV in the Vatican." *PBSR* 63 (1995): 183–214.

Finch, Margaret. "The Cantharus and Pigna at Old St. Peter's." *Gesta* 30, no. 1 (1991): 16–26.

Liverani, Paolo. *La Topografia Antica del Vaticano.* Vatican City: Biblioteca Apostolica Vaticana, 1999.

McPhee, Sarah. *Bernini and the Bell Towers: Architecture and Politics at the Vatican.* New Haven: Yale University Press, 2003.

For the Roman Campagna, its flora and fauna, and malaria, see:

Ashby, Thomas. *Wanderings in the Campagna Romana.* Boston: Houghton Mifflin, 1909.

Celli, Angelo. *The History of Malaria in the Roman Campagna from Ancient Times.* London: John Bale and Danielsson, 1933.

Hackett, Lewis Wendell. *Malaria in Europe: An Ecological Study.* Oxford: Oxford University Press, 1937.

Sallares, Robert. *Malaria and Rome: A History of Malaria in Ancient Italy.* New York: Oxford University Press, 2002.

Tomassetti, Giuseppe, Luisa Chiumenti, and Fernando Bilancia. *La Campagna Romana antica, medioevale e moderna.* Florence: Leo S. Olschki, 1979–80.

For Sixtus V, see:

Fagiolo, Marcello, and Maria Luisa Madonna, eds. *Sisto V. I. Roma e il Lazio.* Rome: Istituto Poligrafico e Zecca dello Stato, 1992.

Gamrath, Helge. *Roma Sancta Renovata: Studi sull'urbanistica di Roma nella seconda metà del secolo XVI, con particolare riferimento al pontificato di Sisto V (1585–1590).* Suppl. 12. Rome: Analecta Romana Instituti Danici, 1987.

Orbaan, Johannes A. F. *Sixtine Rome.* London: Constable, 1911.

Simoncini, Giorgio. *"Roma Restaurata" Rinnovamento Urbano al Tempo di Sisto V.* Florence: Leo S. Olschki, 1990.

For the Tiber River, its bridges, floods, and inscriptions, see:

Aldrete, Gregory S. *Floods of the Tiber in Ancient Rome.* Baltimore: Johns Hopkins University Press, 2007.

Ceen, Allan, Bruno Leoni, Lucas Dubay, and Cothran Ceen. *Roma Pontificata: The Ancient Bridges of Rome.* Rome: Studium Urbis, 2015.

Di Martino, Vittorio, Roswitha Di Martino, and Massimo Belati. *Huc Tiber Ascendit: Le memorie delle inondazioni del Tevere a Roma.* Rome: Arbor Sapientiae, 2017.

D'Onofrio, Cesare. *Il Tevere.* Rome: Romana Società Editrice, 1980.

Le Gall, Joël. *Le Tibre fleuve de Rome dans l'antiquité.* Paris: Presses universitaires de France, 1953.

Segarra Lagunes, Maria M. *Il Tevere a Roma, Storia di una Simbiosi.* Rome: Gangemi, 2004.

Smith, Strother. *The Tiber and Its Tributaries, Their Natural History and Classical Associations.* London: Longmans, Green, 1877.

For villas, gardens, parks, and horti in general, see:

Campitelli, Alberta. *Le ville a Roma: architetture e giardini dal 1870 al 1930.* Rome: Argos, 1994.

Coffin, David R. *The Villa in the Life of Renaissance Rome.* Princeton: Princeton University Press, 1979.

———. *Gardens and Gardening in Papal Rome.* Princeton: Princeton University Press, 1991

De Vico Fallani, Massimo. *Storia dei giardini pubblici di Roma nell'Ottocento.* Rome: Newton Compton, 1992.

Faure, Gabriel. *The Gardens of Rome.* New York: Brentano, 1926.

Grimal, Pierre. *Les jardins romains à la fin de la République et aux deux premiers siècles de l'Empire.* Paris: E. du Boccard, 1943.

Lazzaro, Claudia. *The Italian Renaissance Garden.* New Haven: Yale University Press, 1990.

Purcell, Nicholas. *Human Landscapes in Classical Antiquity.* London: Routledge, 1996.

———. *The Horti of Rome and the Landscape of Property.* Rome: Quasar, 2007.

Credits

Unless otherwise noted, photographs and maps are © Katherine Wentworth Rinne. Exceptions include the base maps for the inside front cover as well as figs. 1.1, 3.1, 4.1, 5.1, 7.1, 8.1, 9.1, 10.1, 11.1, 12.1, 13.1, 14.1, 15.1, and 16.1, which are © MapTiles. © OpenStreet Map. www.openstreetmap.org/copyright.

Frontispiece: Metropolitan Museum of Art, Rogers Fund, 1969. Accession: 69.510.Introduction: Metropolitan Museum of Art, Gilman Collection, Purchase, W. Bruce and Delaney H. Lundberg Gift, 2005. Accession: 200.100.909 (fig. 0.2). Chapter 1: Notman Photo Co. 1909. Library of Congress Prints and Photographs. pan6a23682//hdl.loc.gov/ (fig. 1.3); Rijksmuseum, Lugt 3937. # RP-F-00–3281 (fig. 1.4); © Beth Fagan, 2023 (fig. 1.6); © David Iliff/Wikipedia (fig. 1.9). Chapter 2: C. Facenna, R. Funiciello, and F. Marra. "Inquadramento Geologico Strutturale dell'Area Romana," in *La Geologia di Roma, il Centro Storico, Memoria, Carta Geologica d'Italia* (1995) (fig. 2.1); © Rabun Taylor, 2015 (fig. 2.2); © Elisabetta Bianchi (fig. 2.3); © Roma, Sovrintendenza Capitolina ai Beni Culturali (fig. 2.5); © Camilla Di Nicola, 2020. Circular Water Stories Lab, Dr. Ir. I. Bobbink, Architecture and the Built Environment at TU Delft, the Netherlands (fig. 2.6). Chapter 3: © Jeff Balmer (fig. 3.3); The Vincent Buonanno Collection (fig. 3.4); © Rabun Taylor, 2015 (fig. 3.5); Rijksmuseum, BI-1891–3063–63 (fig. 3.6); The Vincent Buonanno Collection (fig. 3.7); © Thaïsa Way 2013 (fig. 3.8); © Jeboulon/Wikipedia (fig. 3.9); The Vincent Buonanno Collection (fig. 3.10). Chapter 4: © Sebastiano Luciano, 2016 (fig. 4.3); The Vincent Buonanno Collection (fig. 4.4); Rijksmuseum, BI-1936–269–40. Purchased 11 April 1936 (fig. 4.5); © James Hill Architect (fig. 4.8); Rijksmuseum, RP-T-1887-A-871. Purchased with support of the Vereniging Rembrandt (fig. 4.9); Rodolfo Lanciani, 1893–1901, Folio 28 (fig. 4.10). Chapter 5: The Vincent Buonanno Collection (fig. 5.2); Rijksmuseum, RP-R-1941–606 (fig. 5.3); Metropolitan Museum of Art, Edward Pearce Casey Fund, 2016 (fig. 5.4); Rijksmuseum, RP-F-00–5416 (5.5); Google Maps, download August 8, 2023 (fig. 5.6); Metropolitan Museum of Art, Harris Brisbane Dick Fund. 41.72 (fig. 5.7). Chapter 6: Google Maps. © 2023, downloaded July 9, 2023 (fig. 6.1); © Rabun Taylor, 2009 (fig. 6.2); © Lalupa/Wikimedia (fig. 6.3). Chapter 7: Getty Museum, Object number, 84.XO.1378.24 (fig. 7.2); Deutsches Museum, Munich, Archive, BN 31047 (fig. 7.3); Städel Museum, Frankfurt am Main. Gift of Baroness Adèle von Rothschild, 1887 (fig. 7.4); Johann Georg Sturm, *Deutschlands Flora in Abbildungen nach der Natur* (1796), Courtesy, The Biodiversity Heritage Library (fig. 7.5); © Roundtheworld/Wikipedia (fig. 7.7); Cartellina n.800 Sommer Giorgio I; Fondo Becchetti, Inv. # FB005715_20, Istituto Centrale per il Catalogo e la Documentazione. (fig. 7.8); Google Maps. © 2023, downloaded June 20, 2023 (fig. 7.10). Chapter 8: The Vincent Buonanno Collection (fig. 8.2); © Miguel Hermoso Cuesta/Wikimedia (fig. 8.3); The Vincent Buonanno Collection (fig. 8.4); Fondo Beccarini, Inventario CB001988, Istituto Centrale per il Catalogo e la Documentazione (fig. 8.5); Rijksmuseum, RP-P-1941–614, J. W. E. vom Rath Bequest, Amsterdam (fig. 8.6); © Nicke L./Wikipedia (fig. 8.8); Folger Shakespeare Library, call number: BV4817.R6 Cage (fig. 8.9). Chapter 9: Rijksmuseum, Object # BI-1891–3063–31. Acquisition, unknown, 1891 (fig. 9.2); © Roberto Meneghini/Inklink (fig. 9.3); © Beth Fagan, 2023 (fig. 9.4); © Rabun Taylor, 2015 (fig. 9.5);

© Szilas/Wikimedia (fig. 9.6); The Vincent Buonanno Collection (fig. 9.7); The Vincent Buonanno Collection (fig. 9.8); © Stephan Bauer/Wikimedia (fig. 9.11). Chapter 10: The Vincent Buonanno Collection (fig. 10.4); Rijksmuseum, BI-1893-A39–70. Purchase 1893 (fig. 10.5); Clark Art Institute, gift of Paul Katz, 1999.37.1. albumen print (fig. 10.6); © Roma, Sovrintendenza Capitolina ai Beni Culturali (fig. 10.7). Chapter 11: © Burkhard Mücke/Wikimedia (fig. 11.2); The Vincent Buonanno Collection (fig. 11.4); The Vincent Buonanno Collection (fig. 11.5); © Sonse/Wikimedia (fig. 11.6); Metropolitan Museum of Art, Gift of Edward W. Root, Elihu Root Jr. and Mrs. Ulysses S. Grant III, 1937. Accession: 37.17.14 (fig. 11.8); The Vincent Buonanno Collection (fig. 11.10); Archivio di Stato di Roma, Catasto Alessandrino, 433/41, 1661 (fig. 11.11). Chapter 12: © Notafly/Wikimedia (fig. 12.2); Metropolitan Museum of Art, Number 67.828. Pl. 377 (fig. 12.3); The Vincent Buonanno Collection (fig. 12.4); Rijksmuseum, BI-1893-A39. Purchase 1893 (fig. 12.5); Yale Center for British Art, Accession number: B2009.9.99 (fig. 12.6); Rijksmuseum, RP-P-2016–345–19–1. On loan from the Rijksakademie van Beeldende Kunsten, Acquisition, loan 1979 (fig. 12.7); Rijksmuseum, BI-1893-A39–57. Purchase 1893 (fig. 12.8); © Sailko/Wikimedia (fig. 12.9); Wellcome Collection, Open Access, Attribution 4.0 (CCBY4.0) (fig. 12.10); © Carrie Beneš, 2023 (fig. 12.11). Chapter 13: The Vincent Buonanno Collection (fig. 13.2); Rijksmuseum, RP-P-OB-39.318. Acquisition: unknown 2006 (fig. 13.3); The Vincent Buonanno Collection (fig. 13.4); © Rabun Taylor, 2012 (fig. 13.6). Chapter 14: © Samuel D. Gruber, 2023 (fig. 14.5); The Vincent Buonanno Collection (fig. 14.6); Rijksmuseum, XI-RP-P-OB-36.026. Acquisition, unknown 2006 (fig. 14.8); Metropolitan Museum of Art, Harris Brisbane Dick Fund, 1941, Accession, 41.72(2.102), Nicolas Beatrizet, *Speculum Romanae Magnificentiae* (Rome, 1550) (fig. 14.9). Chapter 15: Cooper Hewitt, Smithsonian Design Museum, Gift of Eleanor and Sarah Hewitt, Accession 1924–15–141 (fig. 15.3); © Elizabeth Marlowe, 2015 (fig. 15.4); Rijksmuseum, 22/33. BI-1893-A39–22 (fig. 15.5); © Beth Fagan, 2023 (fig. 15.8). Chapter 16: The Vincent Buonanno Collection (fig. 16.3); The Vincent Buonanno Collection (fig. 16.7). Back Cover: Carrie Beneš, 2023.

Index

Note: Page numbers in *italics* refer to maps or illustrations.

Dickens, Charles, 173
Diemer, Michael Zeno, *Tor Fiscale Where It Meets the Two Aqueducts*, *113*
Dio, Cassius, 60, 76
Dioscuri. *See* Castor and Pollux
disease (including cholera, tuberculosis, typhoid), 49, 52, 78, 79, 89. *See also* malaria; plague
Dogana Vecchia, 246
Dominican order, 182
Domitia, 187
Domitian, Emperor, 56, 102, 156, 187, 253, 280
Domus Augustea, 156
Domus Aurea (Golden House), 35, 48, *166*, 167, 178, 180
domus cultae (cultivated land), 114
Domus Flavia, 156
D'Onofrio, Cesare, *Le Fontane di Roma*, 7
Doria Pamphilij. *See* Villa Pamphilij
drains, 4, 6, 9, 18, 31, 32, 33, 34, 36, 37, 40, 42, 43, 49, 78, 85, 149, 187, 189, 199, 203, 225, 263, 266, 280, 285; cunicoli, 32. *See also* sewers and sewerage
drainage and sewage: in construction of imperial Rome, 31–43; in contemporary Rome, 43; fishing and, 80, 86; gravity systems for, 18; maintenance of, 40–42; need for, 38; noxious odors, 62; of Trevi Fountain, 278–79. *See also entries beginning with* Cloaca; latrines
drinking fountains, 3, 5, 10, 11, 12, 14, 16, 17, 19, 24, 39, 43, 46, 62, 89, 102, 127, 135–36, 139, 150, 155, 162, 179, 180, 199, 202, 203, 204, 233, 234, 236, 237, 244, *249*, 250, 251, 253, 255, 259, 265, 267, 269, 271, 274–75, 283; in Paris, 274. See also *nasoni* (big nose) fountains; *rione* (neighborhood) fountains; water: potability and quality of
drought, 18, 197
DuPérac, Étienne: *Mausoleum of Augustus with a Landscaped Garden in Rome*, *56*; *Ruins of the Septizodium* (Aegidius Sadeler, print after), *157*; *View of the Quirinal Hill* (Aegidius Sadeler, print after), *147*; *View of the Temple of Janus Quadrifrons*, *85*
dye-works, 59, 69, 245, 271

earthquake of 1703, 23
earthworks (Borgo), 199
eels, 80, 86
Egeria (nymph), 29–30, 165, 170, 208, *209*, 226. *See also* Fons Egeria; Grotto of Egeria
Egeria L'Acqua Santa di Roma (bottled water), 226

Egyptian obelisks, 11, 55, 136, 160, *166*, 170–71, 186, *186*, 192–93, 195, 253, 261, 280, 281, 285
Einsiedeln Itinerary, 10, 88, 169
Ekberg, Anita, 20, 21
embankments, 8, 42, 49, 53, 57, 64–65, 69, 71, 75, 78, *79*, 85, 86, 88, 89, 94, 162, 203, 205, 244, 267
Emporium, *84*, 90
encampments (spontaneous housing), 43, 47, 91–92, 95, 221–22. *See also* homelessness
erasure (physical, of buildings and landscapes), 32, 35, 78, 175, 221
Eripus, 36, 256, 269
Eritrean immigrants, 221
Esquiline Hill, 26, 28, 95, 114, 125, 149, 158–59, 165–66, 178, 183, 222, 262, 271
Esquiline Valley, 178
Etruscans, 30, 32, 34, 76, 104
Eustace, Saint, 283
Evans, Harry, 153
Excubitorium della VII Coorte dei Vigili, 245
Esposizione Universale di Roma (EUR '42), 47

Fabretti, Raffaello, 103, 117
Falda, Giovanni Battista, 202, 240; *Fountain in the Courtyard of the Palace of the Duke of Bracciano*, *256*; *Fountain on the Janiculum*, *237*; *The New Map and Elevation of Rome*, *70*; *New Plan and Elevation of Rome*, *200*; *Plan and Elevation of the Vatican Gardens and the Belvedere*, *191*; *Plan of the Borghese Gardens*, *212*; *Plan of the Mattei Gardens*, *174*; *Ponte Sisto Fountain in Rome*, *267*; *Procession of Pope Innocent XI near San Giovanni in Laterano*, *258*; *SS. Vincenzo and Anastasio at the Trevi Fountain*, *279*; *Villa Massimo*, *127*
familia Caesaris (public workforce), 112
familia publica (public workforce), 112
Farnese, Cardinal Alessandro. *See* Paul III, Pope
Farnese, Cardinal Odoardo, 264
Farnese family, 64
Fascists and Fascism, 1, 44, 47, 57, 79, 89–90, 162, 177, 198, 204
Father Tiber. *See* Tiberinus
Faulkner, William, 131
fauna (native species), 23, 30, 33–34, 66, 111, 117, 165
Faure, Gabriel, 173, 208, 215, 223
Fea, Carlo, 218
Fellini, Federico, *La Dolce Vita*, 20, 21, 107, 123
Fendi, 23
Ferdinand, King of Spain, 236